THE OCCULT
Harry Smith

"*The Occult Harry Smith* explores so many fascinating aspects of Harry Smith that have yet to be explored! Through a panoply of voices gathered in this volume, we get firsthand accounts and informed explorations that delve deep into the magician and trickster Harry Smith. Essential reading for anyone who wants to know more about this enigmatic and influential figure who lived his life on the edge and for his art."

RANI SINGH, DIRECTOR OF
THE HARRY SMITH ARCHIVES

"Through his alchemical metaphors and deep appreciation for cultural diversity, Smith's work continues to influence new generations eager to learn more about his gentle blurring of the boundaries between art and magic. *The Occult Harry Smith* is a highly inspiring anthology and an invaluable glimpse into the timeless cosmic prism that was the mind of this polymath magus."

CARL ABRAHAMSSON, AUTHOR OF
MEETINGS WITH REMARKABLE MAGICIANS
AND *OCCULTURE*

"The world is blessed unknown when a Harry Smith enters it, and we are fortunate that enough individuals notice, to record his presence among them. One can only gain—and gain much—from reading this prismatic collection of fascinating views on the polymathic shaman of the city. Smith: all profit with no risk, other than the effect of enlightenment, a mere byproduct of gazing at his mighty works."

—TOBIAS CHURTON, AUTHOR OF *ALEISTER CROWLEY IN ENGLAND*, *ALEISTER CROWLEY IN PARIS*, AND *ALEISTER CROWLEY: THE BEAST IN BERLIN*

"This invaluable collection comes at the right time, as interest in Harry Smith's life expands and his manifold work reaches new and ever-growing audiences. Offered up by the people who knew him best, this volume provides new and nuanced perspectives on Harry Smith: the man, the polymath, the sage."

—JOHN KLACSMANN, ARCHIVIST AT ANTHOLOGY FILM ARCHIVES

"*The Occult Harry Smith* is a long overdue deep dive into this particular aspect of a wonderful, remarkable, and insufferable genius and polymath. In addition, by bringing together the memories and observations of an impressive, indeed close-to-definitive, collection of acolytes, scholars, and friends (not to mention photographic treasures and unpublished texts), Peter Valente presents an unexpected delight in this wide-ranging compendium—endlessly illuminating (as was Harry)—a posthumous banquet."

—SIMON PETTET, POET AND AUTHOR OF *HEARTH*, *AS A BEE*, AND *MORE WINNOWED FRAGMENTS*

THE OCCULT Harry Smith

The Magical and Alchemical Work of an Artist of the Extremes

A Sacred Planet Book

Edited with an Introduction by
Peter Valente

Park Street Press
Rochester, Vermont

Park Street Press
One Park Street
Rochester, Vermont 05767
www.ParkStPress.com

Park Street Press is a division of Inner Traditions International

Sacred Planet Books are curated by Richard Grossinger, Inner Traditions editorial board member and cofounder and former publisher of North Atlantic Books. The Sacred Planet collection, published under the umbrella of the Inner Traditions family of imprints, includes works on the themes of consciousness, cosmology, alternative medicine, dreams, climate, permaculture, alchemy, shamanic studies, oracles, astrology, crystals, hyperobjects, locutions, and subtle bodies.

Copyright © 2025 by Peter Valente

All rights reserved. No part of this book may be reproduced or utilized in any form or by any means, electronic or mechanical, including photocopying, recording, or any information storage and retrieval system, without permission in writing from the publisher. No part of this book may be used or reproduced to train artificial intelligence technologies or systems.

Cataloging-in-Publication Data for this title is available from the Library of Congress

ISBN 979-8-88850-137-5 (print)
ISBN 979-8-88850-138-2 (ebook)

Printed and bound in the United States by Lake Book Manufacturing, LLC

10 9 8 7 6 5 4 3 2 1

Text design and layout by Debbie Glogover

This book was typeset in Garamond Premier Pro with Friz Quadrata Std and Rig Sans used as display typefaces

To send correspondence to the author of this book, mail a first-class letter to the author c/o Inner Traditions • Bear & Company, One Park Street, Rochester, VT 05767, and we will forward the communication, or contact the author directly at **https://www.facebook.com/peter.valente.35**.

Scan the QR code and save 25% at InnerTraditions.com. Browse over 2,000 titles on spirituality, the occult, ancient mysteries, new science, holistic health, and natural medicine.

*The book is in memory of
M. Henry Jones (1957–2022).*

HARRY'S SONG
For Harry Smith

"Sound produces karma."
A trip up
for a hot Sunday
needs a paper
kaleidoscope

Thrill
Listen
Lust of
light and talking
Roar into song
a quick runner a capella

Swing low
cars and pots
Blues are the glue
Car won't turn over?
Wants a riff
a start-up riff
with gear crunch
melody of wang-dang
on top of jet
trumpets
Tibetan plane drones
any item clashing
disguises
"a squeal heard
from the sun"

Open-hearted bells
Boys calling
clatter drums
Whistle sitting
with a young lady
layered there
heard elusively
"Loud noises stop
everything."
It is so very
plural.

PATRICIA PRUITT

Contents

Acknowledgments xi

Introduction: Heaven and Earth Magic: Harry Smith the Alchemist at Work 1
Peter Valente

1 **Mystic Traveler: Thoughts on Harry Smith** 6
Raymond Foye

2 **Harry Stays with Henry for a While** 23
M. Henry Jones

3 **Harry Smith and the Indians: Teaching Film Direction in the Sixties** 33
Marc Berger

4 **Harry Smith: The Alchemy of Caprice** 36
Scott Feero

5 **Intention, Vision, and Action: My Time with Harry Smith** 44
Paola Igliori

6 **The First Surrealist in New York City** 47
Srijita Banerjee

7	Harry Smith on the Holy City: From Boulder to Kathmandu *Darrin Daniel*	53
8	Hanging out with Harry Smith at Naropa: A Collection of Fictional Anecdotes *Rob Pacheco*	58
9	The Women in Harry Smith's Early World *Bret Lunsford*	74
10	Harry Smith's Alchemy and Magic *Charles Stein*	85
11	Harry Smith: Cosmic Collage *Maggie Corrigan*	103
12	The Tree with Roots: Why Harry Smith's *Anthology* Is Such a Big Deal *Mike McGonigal*	108
13	Remembering Harry Smith: A Conversation with Steven Taylor, Harry's Friend and Colleague at Naropa *Interview Conducted at Naropa University by Ariella Ruth during the Summer of 2011*	113
14	At Naropa with Harry Smith (1989–1991) *Tom Banger*	137
15	Automatic Synchronization: Music and Image in the Films of Harry Smith *David Chapman*	156
16	Backstage of a Glyph: The Structure of Harry Smith's *Mahagonny* *Rose Marcus*	173

17	Visionary Charlatan: Harry Smith's Way-Out Science of Thought Forms *Ed Hamilton*	183
18	A Yoyo Shaped Like a Hamburger, or The World According to Harry Smith *Beth Borrus*	196
19	The Paradoxical Life of the Artist Harry Smith *John Szwed*	203
20	*You're the One Who Signs the Checks!:* When Harry Lived with Allen Ginsberg *Bob Rosenthal*	206
21	Harry Smith's Universal (Digital) String Figure *Henry Adam Svec*	209
22	String Figures, Not Cat's Cradles *Marc Berger*	217
23	Like a Talisman for the Guardian Angel: What I Learned from Studying Harry Smith's Work *Peter Valente*	220
24	Essays on Harry Smith's *Tree of Life in the Four Worlds* *James Wasserman and Khem Caigan*	227
25	Harry Taught Me How to Be a Complete Human Being *Pesach Betzalel (Peter Fleishman) Interviewed by Zia Ziprin (2022)*	234
26	A Short History of the Installation *Harry Smith: A Re-Creation* *M. Henry Jones and Friends*	247

27 Correlating Irrationalities in The Moving Maths
of Harry Smith: Essay on Harry Smith's
*The 96 Apparitions of 96 Alchemical Formulae
(1 to 36)*, with the Original Text **261**
Robert Podgurski

28 Unlocking the Secrets of the Unseen Universe:
Essays on Harry Smith's Letter to Arthur M. Young
(August 30, 1960) **276**
Kathy Goss and Elliot Wolfson, PhD

29 Harry Smith Live: Three Interviews with Harry Smith **301**
Harry Smith Interviewed by Dawn-Michelle Baude
(Boulder, Colorado, 1988) 301

A Conversation with Harry Smith Recorded at His
Naropa Cottage on December 18, 1988 312

Interview from *Cantrills Filmnotes*, No. 19
(October, 1974) 319

References **336**

Index **344**

Acknowledgments

I would like to thank Raymond Foye and Rani Singh, who supported this project since the beginning, particularly for their feedback and generosity with images, photos, and texts. I would also like to thank Peter Hale, Scott Feero, Clayton Patterson, Peter Cole, Brian Graham, and Sid Kaplan for their contribution of photos of Harry and Joan Schleicher, and the Anodos Foundation for permission to use the letter from Harry to Arthur M. Young. And I would like to give a special thanks to all the writers and friends of Harry for their contributions to the book, without which none of this would have been possible. Finally, I would like to thank Jon Graham for taking on this project and all the editors, copywriters, and staff at Inner Traditions for making this book a reality.

INTRODUCTION

Heaven and Earth Magic
Harry Smith the Alchemist at Work

Peter Valente

Ever since the doctrine of sympathies was put forth by the ancient Greeks and made popular by Cornelius Agrippa during the Renaissance, there has been an emphasis in occult circles on the necessity of creating correspondences between diverse things as part of a magical working. In the nineteenth century both Charles Baudelaire and later Arthur Rimbaud used the idea of correspondences in their own thinking about poetry. In "Correspondences" Baudelaire writes:

> The pillars of Nature's temple are alive
> and sometimes yield perplexing messages;
> forests of symbols between us and the shrine
> remark our passage with accustomed eyes.
>
> Like long-held echoes, blending somewhere else
> into one deep and shadowy unison
> as limitless as darkness and as day,
> the sounds, the scents, the colors correspond.[1]

Rimbaud describes how colors correspond to letters. For occultists, a convenient way of classifying these correspondences is by using the kabbalistic Tree of Life with its thirty-two paths of wisdom, with their elemental, planetary, and astrological significances. Also, the twelve letters of the Hebrew alphabet correspond to the twelve signs of the zodiac.

Harry Smith grew up in the Pacific Northwest (mostly in Bellingham and Anacortes, Washington) and after a short trip to California in 1944, where he was introduced to the music scenes in Berkeley and San Francisco, he soon moved to the San Francisco Bay Area and became active in the city's folk and jazz scene. In the early 1950s, he received a Guggenheim grant to complete an abstract film. This allowed him to move to New York City, where he became part of the experimental film scene. Smith was one of the first to make abstract animated films (his earliest films were made in the late 40s) and paint directly onto the celluloid using numerous techniques; in doing so he explored the nature of color, rhythm, and abstraction. Smith's *Anthology of American Folk Music*, released as a three-record compilation in 1952, changed the music scene in the 1960s, inspiring many musicians to create their own versions of the songs on the *Anthology*. Smith had a vast knowledge of the occult and esoteric sciences, and often viewed his work in alchemical terms, as the fusion of disparate elements. He was given a Grammy Award in 1991 for his contributions to American folk music.

Throughout his work we see Harry Smith (1923–1991), filmmaker, painter, anthropologist, ethnomusicologist, archivist, and alchemist, creating in a kabbalistic fashion correspondences between various kinds of music, string figures, Seminole patterns, paper airplanes, sound and film, sound and color, and many other things; he's primarily concerned with sets, variables, all with the purpose of discovering a fundamental truth. Harry Smith believed the more examples of something one could find, the more these things collectively would point to a truth about

humanity. Smith used these relationships between different but related things to create a unified assemblage.

The anthropologist Franz Boas, who was an important thinker for Smith, introduced the idea of cultural relativism, which maintained that no culture can be objectively ranked as higher or lower than any other, or better or more correct in their approach to the world; for Boas, all humans see the world through the lens of their own culture and judge it according to their own culturally acquired norms. Harry Smith's anthropological investigations into the things of the world were an extension of the alchemical idea of correspondences.

Harry was a true magician in all senses of the word. He was a trickster with a temper that could frighten people away but was also generous and would help students and recommend books; he also had a wild sense of humor. Harry's knowledge of esoteric things was vast, but he was also interested in things of the world; his magic was both heavenly and earthly. How else could he turn a collection of paper airplanes found in the street into a mesmerizing work of beauty? Or collect a series of commercial recordings made in the late twenties and organize them in such a way that his *Anthology of American Folk Music* is more than a simple anthology of music but rather a tale about the secret history of our own lives? Or make astonishingly complex and wonderful films without a camera? Or listen to musicians so closely that he could translate what he heard into amazing paintings where the colors seem to vibrate and dance before our eyes?

As a young man, Harry made recordings of Native American rituals, and attempted to transcribe their dances. Dance and ritual were the ways in which so-called primitive societies expressed all their collective joy and pain. I recommend listening to the "Social Music" on the *Anthology of American Folk Music* to see some remarkable examples of this. Later in life, Harry obsessively recorded the sounds of the world. Listen to the birds. Tune into their frequencies. Slowed down you can actually hear birds producing more than one note at the same time naturally. When done with a monophonic instrument, like a soprano

saxophone, this technique is called multiphonics. As Harry said in one of the interviews included in this volume: "You understand why it's funny, it's because Charlie Parker was called Bird. I'm recording the birds and I suddenly hear the saxophone." Harry's ear was tuned to the sounds of his environment. For him this was the music of humanity.

Harry was interested in those things that were about to vanish in our increasingly hyper-civilized culture. He was interested in prelinguistic forms of communication, such as the string figures, which are visual expressions of natural processes and ideas. Throughout his life, he privileged the image over the written word because an image was universal, with the potential to be understood by all. His film *Number 18: Mahagonny* is a visual expression of this universality. Harry's laboratory was the entire world. But he always had special affection for the marginalized.

Even though he could be manically disciplined in his various projects Harry could just as well give a painting or film away rather than keep it, or in a fit of anger destroy it. He was an artist of extremes. Harry was not bound to the fleeting things of the world but had his gaze on the unchanging source of being. Call it God or something else. Harry rose above ordinary existence, the petty everyday concerns of a society focused on greed and religious bigotry. One can say Harry Smith chose perfection of art over life. He suffered, as anyone who doesn't play by the rules in this society does, but what he left us was the gold of the alchemists. All the various collections—films, artworks, the Anthology, his painted Easter eggs, his paper airplanes—remain as provocations and challenge to us to pursue our own individual paths of discovery. That was Harry's gift to the future.

The Occult Harry Smith is composed like a collage, which is representative of the eclectic nature of Harry Smith himself. In its pages, readers will find newly commissioned essays by scholars from America and the United Kingdom that probe all aspects of Harry's work in great depth, as well as personal statements from his students at Naropa and reminiscences by friends of Harry. Also included is a let-

ter from Harry Smith to the engineer, astrologer, and inventor of the Bell 47 helicopter Arthur M. Young, from August 30, 1960. There are three interviews with Harry Smith in this collection, including a rare one from *Cantrills Filmnotes*, an Australian film journal. Also included are thirty-one black and white photos of Harry alone and with friends, some of which come from private collections and are published here for the first time. Rather than reproduce film stills, images of his collections, or his paintings, all of which have been reproduced many times in books about Harry Smith, I wanted to create a kind of intimate atmosphere, where a reader could see Harry himself, in the various phases of his life. Finally, there is Smith's unpublished text, *The 96 Apparitions of the 96 Alchemical Formulae (1 to 36)*. *The Occult Harry Smith* contains new anecdotes about Smith and ways of thinking about him and his work, which should prove thought-provoking for readers in the present and future.

PETER VALENTE is a writer, translator, and filmmaker, and the author of seventeen books. Recent works include a collection of essays, *Essays on the Peripheries*, a translation of Gérard de Nerval, *The Illuminated*, a translation of Antonin Artaud's notebooks, *The True Story of Jesus-Christ: Three Notebooks from Ivry (August 1947)*, a series of essays on Artaud, *Obliteration of the World: A Guide to the Occult Belief System of Antonin Artaud*, a translation of *The New Revelations of Being and Other Mystical Writings* by Artaud, and a translation of *Nicolas Pages* by Guillaume Dustan. Twenty-four of his short films have been shown at Anthology Film Archives.

1

Mystic Traveler
Thoughts on Harry Smith

Raymond Foye

There is a photograph of Harry Smith, aged nineteen, sitting in a Lummi Indian smokehouse, at the controls of an audio recorder. It is a remarkable image that freezes Smith in an idealized setting he would live his life attempting to recreate: a tribal group where every person had a valued role, living in harmony with the environment and doing no harm; a culture rich in song and dance and works of art where shared values and meanings were not divorced from everyday life; and a society that placed at its center the honored and respected figure of the shaman. It was a social model that Smith pursued throughout his life, and one that he most closely achieved in the 1960s, when the Chelsea Hotel was the tribe, and he was the shaman.

As a high school student on a weekend visit early in 1974, I met Harry at the Chelsea Hotel at a time when it had not yet taken on the expensive élan of its later years. A room could be rented for $30 per night, slightly inflated from the ten dollars a night when Harry moved in, when the hotel was listed in "New York on Twenty-Five Dollars a Day." I was sitting in the lobby late one afternoon when Harry approached me. I had seen him passing in and out of the hotel

several times that day. Gnome-like, with gray-and-white ponytail and bedraggled beard, he had sensitive blue eyes that peered out from behind enormous spectacles. He wore thrift shop clothes in combinations of plaids and stripes that did not remotely match. The most distinctive feature about him was the way he smelled: a not-unpleasant mixture of tobacco, incense, marijuana, and Miller High Life beer. He ambled up to me in the lobby and struck up a friendly conversation. After several minutes he extended an invitation to visit him later, in his high nasal pitch, a slight twang to a voice that was erudite, sardonic, and inveigling by turns: "Just remember, I'm in Room 731. That's seven planets, three alchemical principles, and *one god*," emphasizing the last two words by holding up a crooked index finger.

I decided to take Harry up on his invitation to visit. Fortunately, I first called up from the lobby on the house phone, as I later learned this was *de rigueur*, and anyone who violated this rule, even unwittingly, would find themselves the brunt of an outburst that would force one backward into the hallway. His room was like stepping into a nineteenth-century cabinet of curiosities. The most prominent feature was the enormous number of books and records, meticulously arranged on gray steel shelving, eight feet high by sixteen feet long, arranged in rows that formed narrow corridors within the room itself. The records were arranged not by subject or artist but by the label they were released on, and by numerical order of serial numbers, as Harry did not so much collect records as entire record labels. On his shelves stood the complete catalogs of Bluebird, Riverside, Vocalion, Smithsonian, UNESCO, Folkways, Das Alte Werke, and so on. Sitting there one idle afternoon I estimated there were almost thirty thousand records in this room. After smoking a joint Harry would stand with arms folded in front of the collection and sigh in his familiar whine, with mock exasperation, "There's *nothing* to listen to!"

Hanging out with Harry mostly consisted of smoking pot and listening to records. In those years the records one listened to most were: 1) Kurt Weill's and Bertolt Brecht's *Rise and Fall of the City of*

Mahagonny (the 1956 recording with Lotte Lenya); 2) Bob Dylan's *Highway 61 Revisited* and *Blonde on Blonde* (especially when psychedelics were consumed); and 3) a tie between *Eskimo Songs from Alaska* and *Sounds of North American Frogs*—both Folkways LPs. The cardinal rule in listening to records with Harry was NO TALKING: absolutely none whatsoever until the record was finished.

His books were arranged by height, a curious system of organization and one I'd never seen before. When I asked Harry about this, he explained that it took up less space, and in any case, he always remembered a book visually by its placement. One was never allowed to touch the books or records—or anything else in the room for that matter. To casually pick something up was out of the question. I would often stand in front of the shelves (and later when he trusted me more, venture down one of the tiny corridors of shelving) to peruse the spines: volumes on Theosophy, Éliphas Lévi, the Elizabethan astrologer John Dee, Athanasius Kircher, alchemists Robert Fludd and Ramon Llull; a complete set of *The British Journal of Psychical Research*; Smithsonian journals on folklore and American Indian studies; the *Oxford English Dictionary*; books on linguistic theory by Ferdinand de Saussure and Roman Jakobson; expensive art books on Eskimos, Tibetan tankas, and ornithology. All were bookmarked with yellow slips of paper and extensively notated in pencil in the back. Occasionally Harry would take a book off the shelf to illustrate a point, and there was never a reference in any of the thousands of books that Harry could not explain in relation to numerous other subjects. In one of my notebooks of the time I have a quote from Harry: "Due to my own inability to cope with the world, I cannot find solutions. It's as if the language was built incorrectly for discussing the subjects I really want to discuss."

Out of reach and wrapped in plastic on a top shelf was the Uher tape recorder that Harry had used for so many of his field recordings. Reel-to-reel tapes, carefully labeled, were also stacked on the top shelves, with the more important ones stored in the dresser drawers. If he was editing a Folkways record or movie soundtrack, he would always

remove the tape from the recorder whenever he left the room, so if thieves stole the recorder they would not also get the tape. The dresser drawers contained a museum-quality collection of Seminole garments, which he once displayed for me, carefully unwrapping each folded piece from its tissue. Sitting on top of the bureau was every book by Frances Yates, and about fifty decks of tarot cards (Italian Renaissance, Romanian Gypsy, The Golden Dawn, and so on) including an original deck that Harry himself had designed (I wonder what became of that?). There was also a collection of Ukrainian hand-painted Easter eggs, stacks of string figures mounted on black cardboard, and the remnants of a collection of paper airplanes that Harry began picking up off the streets in the 1950s, when skyscraper windows could still be opened and bored office workers would sail gliders through the canyons of New York. Down through the years I often thought of Harry's rooms as living beings, and I think he did, too. Every time he would leave, just as he was about to close the door and lock it, he'd peek back in and say, "Goodbye, room."

If Harry ever found a random note on the street, or especially a deranged screed posted to a lamppost, he would preserve it. He had a sense of historicity *in the moment*. Harry's best friend at the Chelsea, Peggy Biderman, had a collection of letters from their mutual friend Jesse Turner—a young hustler and bank robber serving time in prison; Harry was adamant she should donate these to the Smithsonian. During Smith's lifetime (and after), many of his collections found their way into the Smithsonian. The irony of the name of that institution was not lost on Harry.

The Chelsea lobby and rooftop were both hangouts for hotel residents, who were basically a bunch of bad children. Once, when the gaggle of residents socializing in the lobby numbered fifteen or twenty, the manager Stanley Bard emerged from his office, took in the scene with exasperation, and clapped his hands: "I want you all to go to your rooms!"—and everyone dispersed. The Chelsea rooftop was a communal space for all the residents until the early 1980s, when a few of the

wealthy residents with penthouse apartments carved it up for their private use, with tacit permission from management. Harry filmed parts of *Mahagonny* up there, as well as the kaleidoscopic footage of Wendy Clarke doing the Boogaloo in a Rudi Gernreich dress. The Grateful Dead and Jefferson Airplane both played impromptu concerts on the roof. One afternoon Leonard Cohen was waiting in the lobby for his mother to arrive from the airport—he was putting her up at the hotel for a week. When she arrived Leonard proudly introduced her to Harry. "Oh, Mrs. Cohen, you have a lovely son," he whined, "but he has a *horrible* voice." Leonard loved this.

The only other person in the hotel who remotely gave Harry a run for his money was the poet Gregory Corso. Gregory was equally fierce, brilliant, and drunken and/or stoned, and was capable of similar outrageous acts of social disruption. Interestingly, when the two were in each other's company, these attributes seemed to cancel themselves out and they both turned into peaceful and genial personalities toward one another. Sometimes the two of them would gang up on Peggy, their favorite victim, putting her undying love to the test. "In your world," Harry used to tell her, "we are all supposed to be walking around wearing white robes bearing gifts of fruits and flowers. Life is not like that." Peggy used to work at the bookstore of the Museum of Modern Art, and Harry loved to introduce her at cocktail parties as "the curator of postcards" at MoMA.

Throughout his life Smith was a great student of children's literature. He often filmed and taped children's games and songs and made a careful record of hopscotch boards and other chalk-drawn diagrams whenever he encountered them on the sidewalk. (He once praised Pieter Bruegel the Elder's work to me because of the painter's eye for folklore and children's games.) The collected works of Lewis Carroll always occupied a central place in his library, and Smith no doubt sympathized with Carroll's true self, the Reverend C. L. Dodgson: church deacon, graphic artist, early photographer, member of the British Society for Psychical Research, and Oxford mathematics don, who frustrated his

colleagues by being more interested in logic as a game than as a means for testing reasoning. Like Dodgson, Harry's sexuality was ambiguous, although most considered him a non-practicing homosexual.

Harry once told me the only two things he'd ever fucked were knotholes in trees and dogs. On another occasion he said, "I am an Onanist." In the first case he was joking; in the second instance I think he was not. There was one summer when he'd befriended a whole gang of teenagers on Christopher Street; their leader was a kid named Gluey Louie, and they used to sniff glue together. I think fifteen was Harry's ideal emotional age.

Folding card tables were indispensable to Harry's work, and as a project extended in scope more card tables were added. A Bell & Howell 16 mm projector was often perched crookedly on one of these card tables and Harry would project his films on the cream-colored wall, which was cracked and stained; the "throw" as they say was about two feet wide. (I'm amused these days by the many obsessive film purists and wonder if they realize how these films were originally shown by their maker.) Index cards were used extensively to classify and sort data. Charts and diagrams were assembled for nearly every project, whether the making of a film, a painting, or a Folkways recording. These diagrams, often drawn on graph paper and frequently color coded using felt-tip markers, represented the underlying structure, sequence, or plan of the work in progress and were usually expressed in terms of numbers. In the case of particularly ambitious works, such as the film *Number 18: Mahagonny*, these charts eventually filled the entire room. This always represented for me one of the great paradoxes of Harry Smith: on the one hand seldom was there an artist so devoted to the practice of the derangement of the senses, while on the other hand seldom has any artist sought to organize those experiences through such hyperrational systems as these blueprints represented. Perhaps one was a corrective to the other, in the same way that much of Smith's work is poised between formal rigor and lyrical exuberance.

Mahagonny is the apogee of Smith's method of mining images and

subjects from art, science, religion, natural history, and anthropology, to create a work where images and symbols by juxtaposition are divested of their ostensible meanings and then reinvested with the contiguous meanings of their symbolic counterparts. It was a mental game that Smith enjoyed playing, but it was also a profound and imaginative meditation on the interrelated forms of nature and art, as only Smith could imagine. As artistic method, it is the epitome of a post-modernist approach, where associations are formed not on external aspects but through a subtext of encoded meanings and correspondences. Not to mistake this for an up-to-date aesthetic, we should keep in mind it is the principle that animated Hermetic philosophy for nearly a thousand years.

In a sense his films were never completed. Smith used screenings to reconfigure the experience of the films. Live improvised jazz soundtracks in the 1950s were paired with a variable speed 16 mm projector, allowing Smith to adjust the visual rhythm of the film to the tempo of the music. Later, multiple projectors were combined with shaped screens, colored gels, and painted glass slides, and a show would be improvised in the theater. Often at screenings he would provide a running nonsensical commentary and viewers would yell at the obstreperous figure in the back of the theater to shut up, without realizing it was Smith himself.

Throughout Smith's career, the paintings and films informed one another and provided a respite one from the other. An animated film involves twenty–four exposure per second, or 1,440 exposures (image aspects) per minute. "I can't believe I had the energy to do all that," Smith remarked later in life. During the making of *Mahagonny*, from 1970 to 80, Smith still worked in a similarly obsessive way (as we know from endless indexed subject cards and editing charts), but the meticulousness of the earlier films gave way to a looser approach. *Mahagonny* is a work of spontaneous energy and propulsive force. It is shot largely in live action, though it does contain animated sequences that reprise many of his favored techniques: time-lapsed photography, sand and clay animation, stop-frame animation, painting on glass, and "live" animation of

three-dimensional constructions. These sequences are carried out with the gestural economy of an aging master. Frequently Smith's assistant Peggy Biderman was unable to get her fingers out of the frame before Smith tripped the shutter, and on occasion disembodied fingers intrude on the imagery. Smith was delighted with this effect and left them in.

Although exclusively urban in those days, Smith always spent a great deal of time in Central Park, and it was the abundance of nature imagery in *Mahagonny* that most surprised me when I first saw the film. Harry never forgot that nature is the great teacher and creator, the ultimate artist. Once sitting on a park bench in Washington Square as the orange glow of a sunset illuminated a cherry tree in full bloom, Harry said something that risks the mundane, but it was one of the few remarks I ever recall him saying with unabashed heartfelt sincerity: "No work of art can ever be this great."

⁂

Smith left the Chelsea Hotel in the mid-1970s after a tumultuous several years when the idealism of the sixties gloriously crashed and burned around him. After three fires in his room, the incarceration in prisons and mental institutions of numerous friends, the casting of endless black magic curses and spells, and an armed robbery in which he was tied to a chair, slashed with a knife, and pistol-whipped by a drug-dealer "friend," Smith decided it was time to move on. Under great secrecy he moved to the Breslin Hotel on Twenty-Eighth Street and Broadway. At the Chelsea he left behind a bill in the thousands of dollars. Shortly after he left, Stanley Bard confronted me, practically in tears. "What can we do to get Harry back?" he asked. He cared nothing about the unpaid bill. In the history of twentieth-century art, Bard must be included with the greatest of patrons.

For many years no one knew where he was. One day Peggy Biderman was waiting for a light to change on Broadway and Twenty-Ninth Street, and there was Harry, across the street. He was cordial and invited her up to his room. She told me where he was, and I was

permitted to visit but was sworn to secrecy. The Breslin Hotel was a depressing SRO (single-room occupancy) mostly occupied by the indigent elderly. Smith seemed largely oblivious to his surroundings but maintained cordial relations with neighbors and management. Here he lived a peaceful and productive life, concentrating on painting, editing *Mahagonny*, and organizing further Folkways releases (including a box set of shape-note singing that was never released). At one point he was invited to lecture at the Southern Folklore Society at the University of Mississippi at Oxford. He traveled there with Allen Ginsberg (who tried unsuccessfully to leave him behind in care of the locals). I remember his enthusiasm upon returning: in rural Mississippi he befriended and recorded a teenage musician who had rewritten numerous traditional folk songs with drug lyrics. "Froggie went a courtin' and he did ride / with a bong and a banjo by his side . . ." went one version. It was exactly the sort of thing Harry loved: an unsentimental update of a still-evolving tradition.

The Breslin is where I spent most of my time with Harry. Back at the Chelsea I was too young and afraid—you could get killed hanging out with him. The Chelsea Hotel has been idealized by people over time, but in those days there was serious criminality going on in practically every other room. You might be visiting somebody and suddenly the police would burst through the door. At the Breslin he had mellowed, and I would visit once or twice a week. We would smoke pot and listen to records, then go out for Japanese food around the corner on West Twenty-Eighth Street, up a flight of stairs. Mostly Harry ordered soup because his digestion was bad. He always ordered sake and insisted it be served very hot. The proprietors liked him. He was editing some of his Kiowa recordings back then (love songs) and on more than one occasion after a few bottles of sake he would cry as he described their plight. In Harry's room I met his other friends, Charles Compo and Scott Feero, talented musicians in their twenties, both chill and quiet and extremely handsome—Harry always liked being around good-looking young men.

Harry could be a lot of fun to go out with because you never knew what was going to happen—he had a very Dadaist approach to life. He loved the midnight screenings at the Eighth Street Cinema, especially reggae films such as *The Harder They Come*, or *Rockers*, the latter produced by his friend and cinematographer Patrick Hulsey, who helped finance *Mahagonny* with the profits he made from that film. As soon as the lights went down Harry would light up a joint, and then the whole theater would follow. When it came to music, he was pretty much up for anything that I wanted to see. One night I took him to Tier 3 in Tribeca to see a punk/rockabilly band called the Stray Cats, whom he loved. At a Cro Mags show at Irving Plaza he knocked over his grapefruit and vodka on the dirty table and immediately got down and began lapping it up: he always knew how to out-punk the punks. He came with me to see Rick Danko and Eric Andersen at Wetlands, and politely chatted with them in the dressing room afterward, discussing Son House. Parties he was not particularly good at. I took him to a hip literary cocktail party at Dennis Cooper's loft on Thirteenth Street and he took an immediate dislike to every person in the room, walking around insulting them one by one. I wanted to get him out of there as quickly as possible so I began pushing him to the door. Suddenly his hand shot out and clasped on a bookshelf that ran the length of the loft. Despite being tiny and frail he had incredible strength and I could not manage to dislodge him. "Raymond," he said calmly, "how would you like to see this entire bookshelf go flying across the room?" I immediately let him go and he proceeded to insult the few people he hadn't managed to get to, and then left, quite content.

I don't recall Harry caring much about avant-garde films. Once he went with me for a screening of Jack Smith's *Normal Love*, back when Jack's assistant John Zorn was carrying the films and record player and incense to the screenings. Harry and Jack were comradely, catching up on current projects, and I took several photographs of them together.

For movie-going Harry liked the MoMA, where he never missed a screening of Charlie Chaplin films. I have no idea how many times he saw *The Gold Rush*, *The Kid*, or *City Lights*, but I'm sure it numbered in the hundreds.

He was often depressed and maudlin and not always enjoyable to be around. I was also very depressed in those days, and I always assumed I was going to finish my life like Harry—alone in a cheap rented hotel room—so I'd best learn how to make the most of it. Harry could also be cruel and insulting. People have often asked why I spent so much time around him if he was so unpleasant, and I've often asked myself that question. First of all, I knew he was very special, even in the early days when I hardly even knew who he was. The first thing both Allen Ginsberg and Gregory Corso asked me when I met them was, "Do you know Harry Smith?" One time at the Chelsea, Allen Ginsberg walked into the lobby, spied Harry, walked straight up to him, and got down on the ground and began kissing his feet. So, obviously he was somebody.

Harry was like a good boxer. He could size up your weaknesses right off. We all carry around a certain social armor as a barrier against the world. His job was to tear down that armor to leave you naked and vulnerable. I know several people for whom his insults were so devastating they never spoke to him after the first encounter. I always thought one of his big problems stemmed from simply being so much more intelligent than everybody else: he got easily bored, and when he got bored he got malicious. Basically, he amused himself by studying human nature. He could be terribly childish, such as making fun of people's names. "When you step down on the Hollis, don't forget to pull up on the Frampton," he told me when Hollis was in earshot. Brakhage was always "Breakage." He liked to stir things up between people; once I made the mistake of referring to Jonas Mekas as "a professional peasant" and Harry immediately repeated it to him—Jonas was upset with me for a number of years over that remark. Allen Ginsberg was a favorite target of Harry's, who loved to insult his work with lines like, "I saw the best hotdogs of my generation destroyed by mustard . . ." But he was

also wonderfully funny and extremely tender once you earned his trust. And . . . he was truly hilarious, more than any comedian I can think of. One of the things I liked best about John Szwed's biography of Harry was the way it explicated his humor. I laughed out loud on practically every page.

I often kick myself for not taking better advantage of my access to Harry, such as asking him questions about his work. In all the years I knew him I never once had a discussion with him about his *Anthology*. But he disliked being asked direct questions and would often answer with a mute stare as if to say, "none of your business." The truth is he was a very abstract and abstruse person and I am only now beginning to understand the implications of a lot of things that happened in those days. I knew him for seventeen years and it has been thirty-three years now since he died, and every one of those years I feel I have lived my life in a form of guru devotion to him.

❦

Although he was famous for being a magician, with me he was never anything but sarcastic about the subject. He was a radical skeptic no matter the subject—synesthesia, alchemy, Kabbalah, astrology, color theory, and so on. His response was the same: "I investigated that thoroughly and I concluded there is nothing there." Even though the zodiac plays an outsized role in his work as a motif, he told me astrology was just a plaything of capitalism, and anyway the calculations had not been properly maintained—they were all way off. He told me that everybody carries around their own version of the world in their heads and the degree to which you can get other people to agree with your version is called reality. The one exception here is geomancy: he said it was the only form of magic he practiced. And what is geomancy? *Webster's* defines it as divination by means of figures or lines. *Oxford* defines it as the study of patterns, or the position of objects. Isn't this what every artist does? When I heard this remark about being a geomancer, it solved a riddle I had pondered for many years: we would be sitting somewhere and he

would be staring intently at something perfectly ordinary for several minutes with a super-penetrating gaze, as if he had x-ray vision. The scene might be a table with a lamp, a book, a glass. "*What* are you looking at?" I always wanted to ask. So in time that question was answered.

When I was in my twenties he saw me with a Johnson Reprint Corp catalog of books on demonology and got *extremely* upset. It was one of the few times he ever behaved in a paternal way. "Raymond, I don't want to see you getting involved in these things. I've seen too many people go down that path and get destroyed." Later when he calmed down he said, "The thing you have to understand about these things," pointing to the book catalog, "is that these are not *real* laws, they are *imaginary* laws." Now I know he was not this way with everyone, and yes, he was a bishop in the OTO secret society of Aleister Crowley. Like Warhol, Harry Smith was many things to many people—we all had our own version of him. I have nothing but respect for William Breeze, the head of the OTO, and one of Harry's greatest friends and protectors. Nor have we ever had a disagreement about any aspect of Harry's work. I think we just approach it from different angles. My belief is that he was someone who understood human nature better than anybody else and for that reason people called him a magician.

It seemed as if one day out of nowhere Harry was possessed with the drive to suddenly complete his film *Mahagonny*, which had languished for almost ten years. The film's length—two hours and twenty-one minutes—and the fact that it required a four-screen simultaneous projection made the cost of completing the film prohibitive. Funding was eventually provided through Henry Geldzahler, who as New York City's Commissioner of Cultural Affairs committed ten thousand dollars in discretionary funds to its completion, a courageous move considering the risks involved in channeling taxpayer dollars to such a famously unreliable figure. Geldzahler gave Smith a six-month deadline to deliver the film; Smith met his deadline to the day. That was my one chance to

see Harry truly possessed by the creative spirit. Drive, intent, focus, all on a superhuman level. It was his last great masterpiece. He seemed so old to me at the time. He was fifty-five.

Mahagonny premiered at Anthology Film Archives in New York, screened six times in two weeks in 1980, and not again until it was reconstructed in 2002. Smith introduced the film, and I still recall his startled look standing in front of the packed house. He peered out at the crowd through his thick glasses, part incredulous and part suspicious. His speech as usual was punctuated with long pauses between thoughts: "Some of you I recognize, and some of you are in this film. And then there are all these other people who I've never seen before . . ." Susan Sontag was sitting next to me. "That's called *audience*," she remarked under her breath. Smith then quoted in paraphrase the final paragraph of Claude Levi-Strauss's *The Origins of Table Manners*, that when man's time on earth comes to an end, as inevitably it must, it will be through a failure to recognize himself as one amongst many species.

During his lifetime I often wondered if Harry's artworks would survive him, not only because of the precariousness of his existence, but because he seemed so completely out of step with prevailing aesthetics. In 1983 I had the first intimation this might not be so. Viewing Francesco Clemente's first exhibition in New York, suddenly, here was painting that was about metaphor, illuminated poetry, Eastern philosophy, the Western occult traditions; some of the works had actually been made at the Theosophical Society in Madras, where C. W. Leadbeater wrote many of his classic books. I visited the show with Harry, who was likewise taken with the work.

A year later, after I'd met Clemente, I brought Harry by the studio. It was quite late at night, and Harry's eyesight was not good in any case. As I introduced Harry, he gallantly strode across the studio to greet Francesco with hand outstretched, in the process walking across a large unstretched painted canvas that was lying on the floor. Francesco was

calm and bemused, and mentioned that one of his children had already done so earlier that day. After we left the studio Harry remarked to me about the vast quantity of art supplies Francesco had in the studio—more that he'd ever seen in one place in his life. I later mentioned this to Francesco, who put together a large box of paints and materials for me to bring to Harry. Harry was delighted with the gift, not only for the materials (which he desperately needed), but because they came from Francesco Clemente, something he took great pleasure in telling others. People often enjoy recalling stories of Harry's outrageous behavior (and there are many of them), but it was this sort of humility that I always found most characteristic of him.

<center>❦</center>

"All ethnic music is Irish," Harry once remarked as we listened to a recording of African pygmy music. It was typical Smith—epigrammatic, facetious, and true in some odd sense. I always thought the imaginative convolutions of Celtic art and music were a good model for how he defined the aesthetic experience. Aside from the hundreds of obscene limericks Harry had memorized, his fondness for the Celtic tradition was most evident in his nostalgia for the creative heyday of Theosophy during the Irish Literary Renaissance of the 1890s, and in his love of the work of William Butler Yeats. Perhaps the most important poet of the twentieth century to have forged a new sensibility from the union of art and the occult, there is no question that Yeats could have never achieved the revolutionary potency of his poetic images were it not for the visions revealed to him by his occult practice.

Much of Yeats's fascination with the symbols of the occult (especially the tarot) lay in the complex layering of the image-components and the knotted Celtic intricacies of those meanings. As Richard Ellmann observed of Yeats, "The first fascination of symbolism was that it did not altogether disclose the secrets upon which its use depended."[1] Symbolism is the secret life of images, and from ancient times occult practice has been preoccupied with the prognosticate power of the

image (it's not possible to make an *image* without *mage*). For Smith the notion of the artist as magician stemmed from the artist's ability to create images viable enough to have a life of their own. Smith disliked the cult of personality surrounding the artist and even avoided calling himself an artist. In the 1950s he favored the word "delineator," implying linear precision and discernment. Later "animator" served best, in its dictionary definition of one who imparts life to inanimate objects.

There is no question that a great deal of mythologizing has grown up around Smith in the past decade. A cult figure in his own lifetime, the cult of personality that now surrounds him both celebrates and obscures. Duchamp once noted that when a work of art leaves the studio, the artist must relinquish their hold on how the work will be seen and interpreted; and, moreover, all of those different interpretations will eventually constitute a work's meaning. (This latter point was also Levi Strauss's definition of myth.) I have seen Harry Smith's work make an unbelievable journey from the hermetic to the public. It is ironic that the concerns that so effectively marginalized Smith as a visual artist during his lifetime are now the very subjects that make his aesthetic so prescient, and his work so appealing. The wide range of interests pursued, collections formed, and media utilized all make Smith an ideal mirror for our present moment, as we attempt to make sense of the glut of information and juxtaposition of cultures, and more crucially the threat to creativity itself, from technology.

Smith himself was not above self-mythologizing and outright deceit, being a man of many facets and multiple personae. One might even say that Harry Smith was his greatest invention. But as much as I appreciate the fantasy and humor behind his invented identities, Harry was a very real person who made very real works. I remember one evening sitting in his room at the Breslin Hotel. It was snowing outside, and he had been collecting snowflakes out the bathroom window on a swatch of black velvet and examining them under a magnifying glass. We smoked

pot and he had a Woody Guthrie record on the stereo. Harry had a Dover book where you detached the pages and folded tabs and glued together a beautiful model of Chartres Cathedral. As we worked on the model silently, I was overcome by a feeling of serenity and contentedness such as I'd never experienced. "Why can't life be like this always?" I thought. "Why do people decide they have to grow up, and stop having fun, and stop educating themselves?" I have always tried to preserve that moment.

RAYMOND FOYE is a writer and publisher based in New York. He curated the first show of Harry Smith's visual art in 2001, and recently edited *Harry Smith Cosmographies: The Naropa Lectures 1988–1990*. An earlier version of his text in this volume was published under the title "The Alchemical Image" in the James Cohan Gallery exhibition catalog *The Heavenly Tree Grows Downward*.

2

Harry Stays with Henry for a While

M. Henry Jones

I was working at Globus Brothers Photo Studio at Twenty-Fourth Street and Sixth Avenue in the mid-eighties. One day I was casting a lens with Roger de Montebello for his Integral Photography project when I heard that I had a guest upstairs—our lab was in the basement. I went up and was pleasantly surprised to find Harry Smith standing in the vestibule of the studio. I had spent a lot of time with him in the late seventies at the Chelsea and at the Breslin Hotel bringing him food and assisting him with his vast array of projects.

Now Harry had a student-sort-of person behind him and another to his right, each supporting an arm, and he had a plastic cast on each leg. They said, "We were told that if we brought Harry here, you would take him." My "boss-boss" Ronnie Globus, who had slid behind them, hand-motioned that this should be a no-go and to wrap it up—throat cut and finger wind. I had to work a few more hours, so I asked the two guys if they could find something to do with him and bring him back around six in the evening. They asked if they could leave him there with me then and just go and be free after that. I said, "Sure, but don't lose him in the next few hours. I want him to come back." I hadn't seen him in a long time.

24 Harry Stays with Henry for a While

The last time I had seen him, Harry was getting into an elevator in Cooper Square. He said he was leaving for Cooperstown. I had asked him what he planned to do there. He said he would be staying with friends, and that he would be doing a lot of writing for *Nature* magazine about myxomycetes and other simple plant forms that he would raise there. I didn't see Harry after that for at least a year. Later he told me that word got around that he was growing psychedelic mushrooms. The sheriff asked his friends to get him to destroy his setup. His hosts reluctantly asked him to get rid of the slime mold that was by then trying to escape the four aquariums he had it in. Harry said that he put it in the Cooperstown sewer, and that it broke his heart that he had to abandon it that way. It was probably still living there. Now he was here in the Globus vestibule with two broken legs.

The two guys went off with Harry, and I headed back down to the basement to finish up some interim steps with Roger on the "Fly's Eye" lens so I could continue by myself. I certainly wouldn't be done by six. Next thing I knew, they were back. I put my arm around Harry and the two young men asked if they could leave. I said sure and they ghosted. Ronnie Globus asked me what my plan was, as I usually stayed until eight o'clock to wrap up. I said I would put Harry in a chair where I could keep an eye on him and make sure he didn't wander around.

I took Harry downstairs, and he pulled an Aboriginal didgeridoo cassette out of his pocket. We put it in the deck and that was the soundtrack for the evening. It reminded me of hanging out with him at the Chelsea. He asked me what projects we were working on. Down there we had the handheld 4 × 5–inch camera with a fixed-focus lens. This one could be turned into a panoramic roll-film camera. We also had the Globoscope that they had developed that spun around a central axis. My job right then was making lens arrays by pouring clear polyurethane resin into glass-sided molds that we had been developing over the past few months. Harry was completely fascinated by all this invention. He wanted to see the machine shop, which I told him was off-limits. He wanted to see Roger's lab, too, but I told him that was top

secret and it made him want to see it even more. Ultimately, I managed to placate him by letting him watch me pour a lens array. While we waited for the lens to dry enough to take it out of the mold, we looked at Harold Edgerton's *Moments of Vision* stroboscopic photography book together. It was my favorite at the time. Finally, the lens hardened, and I could leave.

When we got out to the street, I asked Harry to show me how well he could walk. Once I got a good sense of it, I realized he couldn't really walk at all, so I hailed a cab, and he was very apologetic at the expense. We were both pretty low rent. I asked him whether the move to Cooperstown had anything to do with breaking his legs. He said that a cab here in the city had backed over him and broken both his legs and he was left screaming in the street, but no one would stop. I offered to let him stay with me for a few days, as I was concerned that I would never see him again.

We went to my place on East Ninth Street. I had to carry him up the stoop to the landing and retrieved his crutches. Once the outside door closed behind us, I knew it would work out. When I opened my door, SnakeMonkey was in full tilt. Harry was a little surprised that we had full-on cel animation going on there. I said to him, "Welcome to SnakeMonkey. This is our twenty-four-hour animation studio." We were working on the *Apple, Heart, Daisy* project. Someone too young to recognize him asked, "Who is this?" I explained, "This is Harry Smith. He's an old friend of mine. He'll be spending a few days here." We were using the bed as a drying rack for cels, so I got Harry a chair. He asked if he could smoke, and someone got him a cigarette. The next thing I knew, he had conked out in the chair. It was around eleven and we stacked up the cels and moved him to the bed. Everyone was asking about Harry and commenting that he looked really old. I said that he wasn't as old as he looked. "Forget about Harry," I said. "I'm so happy to have him here." It wasn't many days before everybody caught on to all the things he had done over the years. Tom Marsan wanted to know all about the *Anthology of American Folk Music*, and that led the way.

I started to review the work from the day, and everyone wanted to make sure they had done the right thing. Some of the lightboxes were makeshift, made out of cardboard and gaffer's tape. Each had Oxberry animation pegs, which at the time were the holy grail for a young animator. By fitting into uniform holes on the top edge of every paper or cel, they carried the registration from the pencil-test drawings to the final cels shot under the camera on the animation stand. Pegs were also instrumental in doing the flipping so that someone could learn the animation techniques. It was a little tricky because sometimes you could work for an afternoon, and when someone could really flip the stack on the pegs better than you, you could see a lot of things you missed and improvements you could make. So the first thing everyone wanted me to do was to flip their work. I wasn't much good at drawing, but I was a good flipper. I flipped a couple of stacks, and it was looking really good. Then I asked the most important question around SnakeMonkey: "Does anyone here have any blood?" Blood was the name we gave to coffee. They had saved me a cup and it was pretty righteous. I sat down for the first time in about fifteen hours.

We talked about how to take care of Harry. At one point, he woke up. It was about two in the morning and he was alarmed that we were still working. He said that this wasn't healthy. I explained to him that this was the only way we could get the animation for the *Apple, Heart, Daisy* project done, since most of us had day jobs. Obviously, I let Harry stay over that night, and also made it clear that he could stay as long as he wanted. We made him a little bed from sheets and bedrolls, so he would have his own area. It ended up that during the day, when I would go to Globus, he would stay on my platform bed and visit with people that I sent by and be up there all evening. Late at night, when SnakeMonkey finally shut down, he would sleep in the floor bed while I got a few hours of power sleep on the platform.

Most days there was no way to reach me at Globus because they wouldn't let me take calls, but at least half the East Village had keys to my apartment. There was a steady stream of animators passing through

all day and night, and that gave Harry a familiar environment. They would come through and work on cels and keep him company and let in his visitors. People would take breaks and sit on the bed and talk with Harry about his esoteric interests. Tom Marsan was particularly curious about how Harry came up with the *Anthology* liner notes. Susan Tremblay was working on a giant pink and white pinwheel drawing for the *Apple, Heart, Daisy* animation, and Harry was very taken with the process. He was a little down about his broken legs, but we would get him a Bud 40 to keep him happy. He had a ton of company and kept everyone entertained with stories of his exploits. He was also answer-man for everyone. This was back in the days when you had to go to the library to find out anything.

It was spring and early summer, and when I would get home from Globus I would do a fireman's-carry down the stairs, and we would sit on milk crates on the stoop. I called it my vacation time when I would rest there with Harry, as I was a super workaholic. As a running joke, he would threaten to get a court injunction to keep me from working around the clock. My answer was to go around the corner and get more coffee from the Odessa. Once we got set up on the stoop, I'd start to hear, "Is that Harry Smith? Is that Harry Smith?" and all kinds of people would line up to talk to him. Harry enjoyed holding court. Pretty soon the line would be around the block. Sometimes I would carry him over to Tompkins Square Park to get some sun and then people would *really* line up to talk to him.

One time, Elinor Blake was working on an animation project involving an animated surfer rat for a Music Express TV show that a friend of mine was pitching. She had come by with a few girlfriends. When Harry overheard that they were going to a record store, he wanted to go, and I said OK as long as someone stayed with him. Elinor was impressed that he created such a scene in the record store. From there they took him to the Underground bar next door. When Elinor came back with him, she said, "Everybody in New York knows your friend Harry!" She didn't realize what a music celebrity he was because

of his Folkways *Anthology*. Harry gave her a copy of the whole set he had cadged somewhere and that made Tom Marsan really jealous.

Harry had gotten a little better and could get around, so we gave him a set of keys. One time he went out alone and ran into Gregory Corso. I came home from working at Globus and I found them facing each other nose to nose in my little red folding chairs, smoking, and debating some esoteric point about Mary Magdalene washing Jesus's feet that I didn't understand. It was fascinating to see this interaction with jabbing cigarettes as they made points in their argument and drank beer. When I came in, I didn't realize who this visitor was. After Harry introduced us, and when I admitted my ignorance, Harry said that Gregory would have to get me up to speed. Corso growled, "I don't hold class for free." After a while, he said that he had to go. They gave each other a hug, and Gregory said, "I can't imagine what it's like to have your name on a cough drop." Harry came back with a juvenile jibe of his own. It was always great to see him kidding around with one of his contemporaries.

Harry wanted me to bring him a photo from the Roger de Montebello Integral Photography project, but I really couldn't do that as we had an agreement at Globus that it was a closed shop. Gradually, Harry convinced me to sneak out an 8 × 10–inch Ektachrome film sheet that we had made with the 2,644 images on it. We met at a lunchroom at Twenty-Third Street and Madison and I showed him the photo for a second and then started to roll it up to put it back in my coat. He snatched it back and said, "This is what I've been waiting for." He was amazed at the density of the honeycomb. Harry sat with me in the booth and studied it from every direction until I pried it out of his hands so we could get some food. After he badgered me for more weeks, I brought him a complete picture with the film and polymer lens array sandwiched together that I had smuggled out. It showed my girlfriend Marilyn, who had been working at Globus for a bit, with a stuffed "watch the birdie" prop that Ronnie had made. This complete piece caused a lot of excitement and I had to hide it from Harry because I was afraid he might break it.

One day, I came home, and Harry had Robert Frank there. I must have gone through *The Americans* two hundred times, and here was Robert right in front of me. When he finally spoke up, he said, "Harry dragged me off the street to look at this photo and wouldn't let me leave until I saw it, but he didn't know where it was. He's been talking about it all afternoon." I took it down off the top of a cabinet and held it up to the light. Robert said, "This photo has had quite a buildup, so let's get a look." I gave it to him, and he turned it around and around and rubbed the honeycomb of lenses and flipped it over to examine the opal-glass back, trying to figure it out. Finally, he asked how it worked, and I explained how the 3-D effect was created, and he said it was definitely worth the wait. I was trying to be cool and hide that I just about wanted to jump out of my skin with him there looking at my project. Harry kept saying, "I told you it would be worth the wait." The best part was seeing Robert and Harry badgering each other as old friends. Most of the people Harry would interface with around me were adoring younger fans. Years later, in 2017, I made Fly's Eye 3-D portraits of Robert and of June Leaf.

Manuel DeLanda and I were in a film show at The World one night in early July and we went back to SnakeMonkey at five in the morning so Manuel could see Harry and look at Roger's lens. In the dark, Manuel almost put some things he was carrying for me on top of Harry in the floor bed. When I stopped him and he saw the tiny figure in the sleeping bags he said, "Is that all that's left of Harry?" I said, "There's more there than you might think." Harry woke up and appeared to reassemble himself out of the bedding and when he got straightened out, he immediately took on his role as master of ceremonies. We all talked about loop animation for a while, and how cool Roger's 3-D lens array was.

One morning not long after that, when I woke up, I rolled off the bed to give Harry a shake so I could move him back up to his usual spot on the platform. I was stunned to see his eyes wide open, and I thought he had died. I started pounding on his chest, crying, "Don't die here

Harry," over and over. I saw his pupils receding, getting smaller and smaller and further and further away; his face seemed to shrink deep into the wooden floor. I finally saw a flicker and then a little flame and he came back to life and asked why I was pounding on him. I said, "I thought you were dead!" He made light of it all.

While I was still processing what had just happened, in walked Elinor Blake, ready for work. She was surprised to see that I hadn't already left for Globus. I just told her Harry wasn't feeling so great. He always enjoyed watching Elinor paint cels and chatting with her, so I set him in a chair near her. Then I bolted over to Anthology, desperate to ask Jonas what I should do. Once I was there, I asked Jonas if I could use his desk phone to call back home. Elinor said that Harry had just launched forward off the chair and hit his head on the floor and was bleeding. Jonas sent the Anthology librarian, Natalia, to run back over with me and see what needed to be done. Lexicon had arrived to work in the meantime. Natalia, Elinor, and I carried Harry to Lex's car, and she drove us all to the Beth Israel emergency room.

We spilled out of the Dart and got Harry into the line for the waiting-room intake. He said, "I'm embarrassed all these girls are seeing me in this condition when I'm only sixty." Natalia got him checked in and I went to work across town. He ended up getting some stitches and was admitted for observation, but no more harm was done by the fall. I went to see him at Beth Israel mornings on the way to work, and I would run over from the West Side to check on him at lunchtime and stop by on the way home from Globus.

Some days into his stay I saw him in the morning, and he asked me to help him pick out "a meal that will never be eaten." When I went back at lunch, I was told he had jumped ship and escaped from the hospital. I was upset that we hadn't made more of a plan for him. It never occurred to me that he would just take off like that. I made the circle of all his Beat friends, and no one could figure out where he had disappeared to.

A week after Harry skipped out of Beth Israel, I was working on

Apple, Heart, Daisy when I got a call from someone from the Odessa phone booth, saying he was there. I ran downstairs and around the corner, but by the time I got there Harry was gone. People said he had just left without saying where he was going. This time, I felt like my treasure of the Sierra Madre had blown away in the wind, and I didn't try to find him. I knew I wouldn't see him for a while.

I didn't see Harry again until maybe a year later. I ran into him by accident at an event at St. Mark's Church. When I saw him, I got down on my hands and knees and wrapped my arms around him. After that reunion, I only saw Harry a few more times before he went out to Naropa, pretty much for good. I've always been glad that those college kids heard that I would take him in. Harry had always moved around a lot, trying everyone's patience, and then moving again. I'll never forget that time when I got to take a turn as his host.

M. HENRY JONES, who was born in 1957, spent his early childhood in Gulf Coast oil-industry trailer parks in Louisiana and East Texas. His family graduated to a yard and hand-built trailer addition before moving to a tiny farm town on Lake Ontario, near his father's engineering work in the chemical hive surrounding Niagara Falls. Henry began model animation in eighth grade after seeing a Zagreb animation reel. He watched the pivotal PBS *Film Odyssey* series of 1971–72 with his school film club and rode his ten-speed thirty-three miles to spend weekends in the then film hotbed of SUNY Buffalo. He spent three summers as construction assistant to Earth Art creators at Artpark on the Niagara River.

M. Henry arrived in New York City in 1975 as a film student at the School of Visual Arts. In his first years in the East Village, he was a central figure at Club 57 and he created the animated rock videos *Soul City* and *Go-Go Girl*, immediately before MTV's start in 1981. He also shot *Brand New Cadillac*, which was finally edited in 2006. During his freshman year at SVA he began to spend time with Harry Smith at the Chelsea Hotel and in 1983 he was hired to be technical assistant to Roger de Montebello, to perfect a form of 3-D photography.

From 1993 to 2006 M. Henry built and toured *Harry Smith: A Re-Creation*, a tribute in which he realized Harry's dreams for the elaborate projection of his animated films. In 2007 Henry directed a final rock video, *Bangin' in my Head*, with animation of drawings by his son Atticus. Following these major projects, he devoted himself to the development of SnakeMonkey Fly's Eye 3-D until his untimely death in 2022 at the age of sixty-five, from cancer discovered too late.

3

Harry Smith and the Indians
Teaching Film Direction in the Sixties

Marc Berger

Harry Smith was always, first and foremost, an anthropologist. Whatever endeavor he delved deeply into, whether it was filmmaking or painting, recording or cataloging ethnic music, studying string figures or collecting Ukrainian hand-painted eggs, making friends or dissing hapless victims, Franz Boas unfailingly remained Harry's spirit guide. The most sacrosanct of his prized possessions—and he certainly assembled and dissipated considerable amounts of both artifacts and his own artwork over his lifetime—were, indubitably, his anthropological books, especially the ones written in the native language of whatever tribe happened to be providing the subject matter, ideally with an interlinear English translation. Therefore, when telling a tale of Mr. Smith's grand exploits or listening to stories of his horrendous mishaps, should you desire to grok what actually transpired in that particular situation, you must always be aware of Dr. Boas's constant psychic presence.

Choosing his friends from the streets of Greenwich Village—"Desolation Row" as I prefer to call it—there was invariably an indigenous aspect to Smith's interpersonal relationships, as there obviously was with his American Indian contacts. There was Gluey Louie, who

would climb buildings with his bare hands and booted feet while sky high on airplane glue; Pedro, who traversed the netherworlds of heroin and morphine; Herbert Huncke, who understood and navigated the labyrinth of streets in New York City like no one else; Francesca, whose ravishing, Esmeralda-like beauty enabled her to live with the rich, but who chose to remain with the poor; and Ritchie, whose stoned-out countenance and sensitive awareness makes him the subject of one exemplary episode in the sixties world of Harry Smith.

Harry and I had hitherto traveled to the Florida Everglades, collecting Seminole Indian patchwork, which was to be used in a motion picture, eerily similar to some of his early hand-painted animated celluloid creations. Back on Desolation Row in the Hotel Earle, the staff was asked to bring card tables into the room and to cover them with sheets. Harry then meticulously arranged the colorful, geometric cloth strips in patterns he devised from the movie in his mind's eye. Ultimately, very late in the night or early in the morning and much to my surprise, Ritchie appeared. He was, as Harry knew he would be when he beckoned him, under the heavy influence of opioids, and while Ritchie ambulated extremely slowly, Harry asked him to peruse the displayed Indigenous art exhibit and comment on it. Never in my life have I witnessed someone move in such living slow motion as did Ritchie on that night, around those four card tables, but at the time I just didn't comprehend the significance of what was transpiring. Only years later did I come to realize that Harry was employing his young friend to opine on the "proper" arrangement of the art of those Seminole ladies from deep in the swamp. Harry believed in the inherent "truthfulness" and purity of altered states of consciousness, and he often articulated what particular drug he, himself, had been on when making this or that motion picture. Surely, our companion was in one of those states of mind when observing the Seminole art and was perfectly qualified to attest to the "correctness" of the way the patchwork was laid out.

And that is, in part, how the anthropologist, painter, and filmmaker, Harry Everett Smith, empowered those female Seminole art-

ists of the Everglade swamps of southern Florida to create their own "Indian" movie. We actually shot the film later at the Hotel Adelphia, in Philadelphia, Pennsylvania, on matte black cardboard animation equipment, conceived and handcrafted by the very same Harry.

MARC BERGER grew up in Compton, California, and the members of N.W.A.—the godfathers of gangsta rap—later went to the same high school. Attending the University of California at Berkeley, Marc studied anthropology and joined the Free Speech Movement. In the mid-sixties, he went to Washington Square Park to continue his anthropological studies of hippies on "Desolation Row." There he met Harry Smith and worked for him on the Seminole Indian film "#15: Untitled Animation of Seminole Patchwork (1965–1966)" in Florida, Philadelphia, and New York City. One of his jobs while working for Harry was to decipher obscure string figures in Harry's book collection. He became a world authority on string figures and practiced this important lost artform every day, learning hundreds of these intricate masterpieces, which had been performed by primitive people all over the planet, until so-called civilization arrived.

Harry Smith:
The Alchemy of Caprice

Scott Feero

THE MAGICKAL CHILDE

I warned Herman if he spelled child with an "e" he was going to have trouble with the police . . .

<div align="right">HARRY SMITH</div>

The Halloween party I attended with Harry at the Magickal Childe,* an occult book and paraphernalia store, was certainly the freak show it promised to be. Entering the store, Harry warned me not to drink or eat anything, saying ominously that I would surely be poisoned. I recall being bored to tears as Harry made the rounds chatting up the habitués of the West Nineteenth Street sorcerer's haunt. Most people in attendance were dressed up in their vision of wizard, Wiccan, warlock, witch, or some demon-inspired entity. Herman Slater, the store's owner, and self-proclaimed black magician, needed no costume: he

*A store infamous for conducting plethoric rituals in the night and occasionally being raided by the police.

looked like someone who ate babies. In fact, probably half the people in attendance wore some form of their costumes as daily dress. Among the wide smirch of tattoos on display, this was the first time I'd seen faces and baldpates permanently inked with inverted pentagrams and other marks of The Beast. This was 1980, and even the most brazen biker's body decor paled in comparison with some of these self-professed spellbinders.

This massing of openly avowed necromancers freaked me out—I mean they were all so earnest in their desire to appear menacing and powerful. Around this time, I witnessed an argument between two self-professed magicians, each accusing the other of being a black magician. As far as I was concerned, they were both correct. Later, I supposed the point of Harry dragging me to the party was to desensitize my aversion to all things occult. The bookstore takes its name from Crowley's sex-magic operations to create an avatar-like evolved child.* Early on in our association, there were several topics having to do with the occult and magic that Harry returned to again and again that made me blanch. With my purely rational worldview, he had some fun trying to get through to me, saying things such as, "What anyone means by magic is always up for debate . . ." but then spinning my head as he went on to describe the special study he'd made of John Dee and Edward Kelley's Enochian tablets used for communicating with various angels. Then he'd show me his series of exquisite paintings that he called Enochian Tablets. Over and again, he returned to John Dee's magical activities, and it often left me cross-eyed—until, while passing together through the Strand Bookstore one day, he pointed to a copy of Dee's *The Mathematicall Praeface* (1570), recommending I buy it.

Thumbing through the book, it didn't take long to realize that John Dee practiced two types of magic: the ceremonial magic of summoning spirits, and the natural magic derived from the study of astronomy,

*After Crowley's 1916 sex-magic operations with Jeanne Robert Foster, and the failure to conceive a perfected child, Crowley ultimately declared the self-initiated Charles Stansfeld Jones to be his long sought after *Magickal Childe*.

mathematics, physics, hydrology, chemistry, biology, medicine, and so on. English historian Frances Yates said that much of what was considered magic during the Renaissance was the most advanced mathematics of the day, and as case in point, she said John Dee was accused of sorcery for being able to determine the height of a steeple with trigonometry. In Dee's day, white or natural magic was practiced in the light of day, while the ceremonial magic used in the invocation of spirits was practiced in the dark of night, hence *black magic*.

Although Harry talked a bit about the workings of ceremonial magic—in the main, through shamanism and rituals as practiced among various Indigenous peoples—most of the subjects he covered fit under natural magic. Reaching far back into Egyptian and Greek times, he demonstrated that scientific thinking was not merely a product of the Scientific Revolution, but a mode of thought used by philosophers since time immemorial. And contrary to common opinion, he said both magical thinking and rational thought have always been of a pair, and likely coevolved as a component of human consciousness. However, at the time of that party (in late 1980), I had not quite caught on that Harry was trying to underscore just how common it was for both modes of thought to function simultaneously in even the most rational minds. That all minds are to some degree clouded by a range of irrational beliefs, and by about age thirty our *personal myth*—what we assert makes us sane—is set.

Over the centuries the church had censored many important ideas that were deemed a threat to their authority, and to my thinking the church was entirely responsible for this largely deluded gathering of Halloween revelers milling about me. Watching Harry work the crowd, it soon became apparent he knew quite a few of these Satanists. Over time, after meeting a few of these wizards and witches, I gathered that most of them were just your average, workaday Joe and Jane, who were at the end of the day just a bunch of religiously minded neurotics struggling to maintain an identity they were comfortable with. Always open to all kinds of seekers, especially those looking

beyond mainstream religion, Harry tried to guide many of them to a better understanding of what they might accomplish, at the same time warning them off certain pitfalls they might face with their adopted approach. Which, for all the effort Harry put into it, seemed to be an insuperable calling.

After about an hour Harry said it was time to leave, but once out on the sidewalk he complained he had to pee. I shrugged, saying I'd wait while he went back in to use the bathroom. Harry shrilled, "Are you insane . . . ? You've seen the kind of people in there. I won't go back in." Somewhat mortified, I crossed glances with several people out on the sidewalk as Harry stepped up to the storefront, unzipped, and making a spectacle of himself began painting the brick facade. It seemed to take forever, but at long last he finished and zipped. Harry reeled about, crying out, "Look! My pee has outlined a diagram of the Pyramid of Cheops." As a group, heads turned, and there it was, rivulets of urine outlining a pyramid on the sidewalk.

Heading back to the Breslin Harry said, "Everyone drinks one or two molecules of Cleopatra's pee everyday . . ." At the time I'd thought such pearls of wisdom were original to Harry, but time and again, they only went to show how widely read the man was. I don't know Harry's exact source for this curious idea, other than it related to the cycles of freshwater hydrology. Some twenty years later, I believe in *Scientific American*, I chanced across a similar reference to "Cleopatra's pee," stating that some few molecules from the same small amount of available fresh water has passed through every person that has since lived. By this reckoning, the study of hydrology is the study of the occult.

The statement about Cleopatra's pee was of course framed for its shock value—just another example of Harry sharing his vast curiosity to stimulate others. In any case, I ultimately did look into it, and I view this as just one more example of the "Harry effect" on myself. When I asked Harry why he bothered to pursue so much of the minutiae of the world, he answered matter-of-factly, "It keeps me out of trouble." That, and to feed his insatiable curiosity.

THEY WERE THEOSOPHISTS

My parents were very strange people. . . . They lived in separate houses on opposite ends of the block, and communicated through a system of bells.

<div style="text-align: right">HARRY SMITH</div>

With his mother a college-educated schoolteacher, and his father a degree holder in fisheries and marine science from the University of Washington, Harry said, "I was raised by highly educated parents." But when he added that "they were Theosophists,"* he floated what came to be one of the most widely accepted myths about his upbringing. Getting down to details, he painted his parents as clean-living, tolerant, liberal types who loved to sing—just not together. In a sort of battle of the ballads, his mother preferred those from Ireland, while his father preferred those sung by cowboys. According to Harry they were Episcopalians, but the family did not attend church until after moving to Anacortes when he was eight. Harry said after Sunday brunch he was required to sit with his parents and listen to a weekly radio sermon, with an ensuing discussion "to make sure I'd been paying attention." Contrary to a few bloggers' speculations, his father was not a drunk. As Harry put it, "My parents were teetotalers. . . . The women in my family were suffragettes and prohibitionists, and all that stuff." He went on to say his mother had an enlightened view of race, religion, women's rights, and the rights of man (obviously excluding man's right to imbibe). He went on to say his mother was an admirer of Annie Besant, a British socialist and woman's rights activist who later in life took over as president of the Theosophical Society. The point of claiming his parents were

*In 1927 Camp Indralaya was opened by the Theosophical Society on Orcas Island, roughly fourteen miles off the coast of Anacortes, in Washington state. Local historian Bret Lunsford uncovered no record of the Smiths ever attending the family summer retreat. Learning of the camp's existence on the island where his grandparents lived was likely a young Harry's first exposure to the term.

Theosophists can be seen in the Theosophical Society's mission statement, or its "three Objects" (which stand as a ready synopsis of the Harry Smith belief system):

1. To form a nucleus of the universal brotherhood of humanity without distinction of race, creed, sex, caste, or color.
2. To encourage the study of comparative religion, philosophy, and science.
3. To investigate the unexplained laws of nature and the powers latent in man.

Giving truth to the lie, the sole condition of admission to the Theosophical Society was sympathy with this list of objectives. He said his parents—but in the main his mother—early on instilled a deep respect for all peoples, which left him free of all the usual biases and prejudices, notably those so widely held against those of African, Asian, and Native American descent.

For some background, in 1875, after forays into the Spiritualist movement, Helena P. Blavatsky ("Madame Blavatsky") and Henry Olcott founded the Theosophical Society in New York City, which essentially combined Buddhist, Hindu, and Western mystical beliefs. The pair was inspired by the Transcendentalists, a group of Unitarians who were spurred to reexamine Christian beliefs by early translations of the Upanishads, the sacred Hindu texts. At the time of the Society's founding there was a growing corpus of more accurate translations of Vedic and Buddhist texts overseen by F. Max Müller, a person much admired by Harry, and whose face was given a star turn in *Heaven and Earth Magic*.*

In a 1988 interview with Dawn-Michelle Baude, Harry put it this way, "I would say that the books lying around the house were

*In *Heaven and Earth Magic* (or, *No. 12*) the disembodied head of Müller shoots "True Knowledge" rays out of its eye at the heroine.

basically theosophical."[1] But when pointedly asked if his parents were Theosophists Harry equivocated, saying, "To a degree. They were very eclectic in their religious activities. For example, I went to a great number of different Sunday schools."[2] All of which is hardly an affirmation of any affiliation.

By the 1960s, when Harry began referring to Theosophy in interviews, few had heard of it—as was the case with myself in 1980. So it was dizzying as Harry delineated the tenets he admired in the movement, while at the same time roundly ridiculing many of the main players. With Blavatsky's *The Secret Doctrine* (1888) in hand, he talked of her belief that science and technology were occluding the spiritual. That she believed a higher wisdom could be attained through mystical insight and direct communication with transcendent beings, and that the personal uncovering of ancient hidden wisdom offered a path to enlightenment without the agency of church or priest. He went on to quote Blavatsky as saying, "An intelligent evolution of mankind was overseen by a group of Hidden Masters," and that "humanity's evolution on earth is part of the overall cosmic evolution." Harry concluded mockingly, "I don't see a lot of that happening around here."

Ultimately disqualifying for Harry were Blavatsky's racist sentiments about the superiority of the Aryan race over the Indigenous peoples of the world; she wrote in *The Secret Doctrine*: "The sacred spark is missing in them and it is they (the aborigines) who are the only inferior races on the globe, now happily—owing to the wise adjustment of nature which ever works in that direction—fast dying out."[3] Harry told me of Blavatsky contracting influenza in 1891, after which she had herself woven into a basket where she chain-smoked cigarettes until her last breath.

Needless to say, I didn't come away thinking much of the Theosophical Society, not realizing until a bit later that Harry was ever mixing the wheat with the chaff in whatever he talked about. His main point in bringing up the Theosophists, as he did so many times, was to promote the idea that the search for enlightenment was a per-

sonal responsibility, and not found through any one creed, but in the study of not only ancient wisdom texts, but in, well, everything. With Theosophy, Blavatsky and Olcott laid the foundation for the rise of the New Thought movement, and a wider interest in Buddhism. The term *theosophy* actually precedes the Theosophical Society's adoption of it by centuries, so with me, this was just Harry's first foray into the Christian theosophy of freethinkers Giordano Bruno (1548–1600) and Jakob Böhme (1575–1624), respective authors of *The Art of Memory* (1582) and *177 Theosophic Questions* (1624). Each maintained that knowledge of God could be achieved through spiritual ecstasy, intuition, and individual revelation. One of Harry's larger points was that each man daringly promoted the study of the Kabbalah, which was influential both in their own attempts and in later scientific attempts to diagram the cosmos. Arrested in Rome, Bruno was burned at the stake in 1600, while with a scandalized Lutheran clergy closing in on him, Böhme escaped retribution via sudden death in 1624. As a proponent of *prisca theologia** and practitioner of free thought, had Harry Smith lived in those times—and most decidedly not the type to recant anything—he too may well have been burned at the stake.

SCOTT FEERO is the author of *Dressing Stone: A Post-Postmodern Picaresque*. His most recent endeavor, from which this chapter is an excerpt, is a chronicle of his close encounter with the mind and work of the peerless promethean Harry Smith. Both memoir and biography, the work is centered on the vast range of subjects and topics Smith expounded on between 1980 and 1983 when the author was a frequent visitor to room 714 in the Breslin Hotel. Feero attended Massachusetts College of Art and was the recipient of the Massachusetts Cultural Council fellowship in filmmaking.

*Coined by Marsilio Ficino in the fifteenth century, the term *prisca theologia* (ancient theology) refers to the lineage of ancient philosophers beginning with Hermes Trismegistus and continuing beyond the Neoplatonists. In practice it freed Christians to consider all sources of wisdom outside scripture, and thus was heretical.

5

Intention, Vision, and Action
My Time with Harry Smith

Paola Igliori

Harry Smith was a master of the highest level in detecting the inner language of things, the secret language of creation. Like Harvey Bialey said in my film, *American Magus*,[1] a companion to the book I edited on Harry (*Harry Smith: American Magus*, originally published by Inanout Press in 1996 and reissued by Semiotext(e) in 2022):

> Everything connected with Harry; all his life he had the uncanny ability to make connections between things that were seemingly disparate, between forces, terrestrial dynamics, geomagnetic interactions, polarizations that made culture, that made music, that made art . . . that made everything that is timeless. . . . Harry's work is a crystal mountain to be mined for all times; Harry is a hub like da Vinci is a hub: if he had only painted, if he had only studied one of the thousands subjects he had studied or collected one of the hundreds of collections he had collected or influenced one of the hundreds of artists and scholars he influenced, if he only made films, he would in each one of those areas be *great*, but he did *all* of it and more. . . . It didn't matter where he was, wherever he was he made it gigantic.

Wherever Harry went he would find the world's treasures under his feet. When you were with Harry you would see and taste things nobody ever had before. You could discover something new at every moment in his presence. In my film, while Harvey is saying that Harry "truly was an occult master in the highest and truest form," we see on the screen the cutout from Harry's film *Misterioso* (that I organically and almost randomly had picked for Harvey Bialey's words) that naturally synchronizes first with the image of a snowflake (which is unique like a fingerprint) and then with the image of the world suddenly manifesting in the hands of the magician! Microcosm and macrocosm are mirrored through synchronicity in action.

M. Henry Jones says in his film, *Mirror Animations*, that Harry plotted sixty-four frames of film at a time, working with tiny triangles and squares of scotch tape placed directly onto the film, and adding onto the film layers of colors with a nasal spray. All this was done while Harry listened to Thelonious Monk's music, which he synchronized with the film. Then years later he used a Beatles soundtrack to show that any song works in the same way. Previously, he had synchronized the sound with the color in his "jazz paintings." When I think of Harry, I recall Baudelaire's line: *"Les couleurs et les sons se répondent!"*[2]

Harry had a vast collection of string figures and the table of concordances he created from them are used by anthropologists to trace precontact migration patterns. For example, the Inuit string figures are very similar to the Navajo (Diné) string figures, even though the Navajo only migrated southwest 1,200 years ago. In my film *American Magus*, alchemist Khem Caigan speaks about the unity of Harry's various collections, including the string figures:

> Be it string figures, Seminole patchworks, Ukrainian Easter eggs, all his collections—system flow charts—they are all different languages. Languages don't just reflect a concept of reality, but they create it for people. . . . In physics, in quantum mechanics, there is a ground state, a vacuum, and there are all these particles, particle

fluctuations boiling out of this vacuum, now they know there are multiple vacuums. . . . It is like there are all these universes jamming together with different speeches. Kind of like quantum semiotics!

Harry sought the true unity in all manifestations. In my film, Kabbalist Lionel Ziprin says:

> Then he [Harry] looked at all the magic squares and the significations of the different units with the mathematical permutations inside the divisions and the planets in a mathematics that still makes sense to no one but medieval and Renaissance magicians who were serious philosophers and me because in Jewish Kabbalah mathematics plays a large role: if a word adds up (with the 27 letters) to 163 and 300 pages later there is another word that adds up to 163 you see the correlation! Harry was not only a Hermetic scholar but a magician who in his practice saw the correspondences; he was able to get at their inner language, to see the patterns, the unity of all multifaced things.

Harry's gift to us is to remind us constantly that we are infinite (finite only in our fears, our *amours*, our conventions). I'm always surprised when I remember the extent to which the dictum is true: "where attention goes energy flows." My infinite gratefulness to him, to the inexhaustible power of connection, intention, vision, and action.

PAOLA IGLIORI—writer, publisher, filmmaker, and poet—was born in Rome, Italy, and for many years has run her organic farm and cultural center Villa Lina, in Ronciglione, in Etruscan Tuscia, near Rome. She first moved to New York in 1980 with her late husband, artist Sandro Chia, and in 1991 she became the publisher of Inanout Press. In 1996 she published *American Magus: Harry Smith, a Modern Alchemist*. Her first film project *American Magus*, a feature-length documentary on Harry Smith, premiered at Anthology Film Archives in New York in 2001 and at the Rotterdam Film Festival in 2002.

6

The First Surrealist in New York City

Srijita Banerjee

The experimental animator Jordan Belson first met Harry Smith through a chance encounter as he was walked past Smith's small apartment at Berkeley. Peering in through the window, Belson saw what could only be described as a tiny museum of sorts "with dramatically lit artwork, books, a cot, a kachina doll, and a large desk."[1] Those familiar with the collection of random, odd objects spanning Smith's life work (Harry Smith was a known collector of paper planes, Ukrainian Easter eggs, Seminole textiles, and 78 rpm records, among other things) can probably visualize the absurdity and irrational juxtaposition in this scene. The randomness of the objects placed together has a strong semblance to the collections built by the Surrealists a few decades ago in France. The scene inside his apartment was probably most reminiscent of the desk of Surrealist leader André Breton, which contained a collection of infamous objects collected by the Surrealist from Parisian flea markets that when prepared for auction in 2002 consisted of books, manuscripts, records of Surrealist "games," modern art and sculptures, and photographs and Indigenous art, including masks from Oceania. The impact of sub-Saharan and Oceanic art, and "primitivism," on Surrealism was both a product of its time and

a direct response to French colonization. Surrealists were known to have accumulated objects of both high and low value, especially from the Pacific Islands or the Pacific Northwest, that had directly or indirectly influenced Surrealist art. "Primitivism" is a strain of influence that can be traced across Harry Smith's work, often helping to connect what was a very disparate body of work.

Unlike the Surrealists who encountered these objects and the culture of the sub-Sahara only indirectly through the objects that trickled into the Parisian flea markets and art galleries, Smith's encounter with Indigenous culture was much less mediated. He grew up in Coast Salish country, the homelands of the Samish, Swinomish and Lummi tribes, where his mother was raised before him, and his father worked for Pacific American Fisheries, Inc. From very early on, Smith was interested in Indigenous culture but unlike children of his generation, his interest in the culture was underpinned by an understanding of the contemporary anthropological discourse. As a young boy, Smith spent time at the Swinomish reservations, and he was allowed to witness ceremonies and use technologies that were never permitted before. Smith was the first person to record the Lummi and make watercolors of specific events and rituals that had never been recorded. One of the driving forces behind this extensive work of collecting and recording culture was Smith's desire to preserve the culture; based on an oral tradition that relied on word-of-mouth transference and an aversion to being recorded, the Lummi culture was in essence ephemeral and transient. Smith was interested in holding on to as much of it as possible, making paintings and documents of important information, and collecting objects. Ironically, much of the work from this period was lost and never survived the ravages of time. Its influence on Smith's later work, as we will see, persisted.

Even in its anti-colonial critique, Surrealism's interest in so-called primitive art was critiqued for its Eurocentric approach. In his anthropological interests, Smith was aware of his own position as the "outsider" observing and recording from the fringes. This was a moment when

Smith developed his ideas on anthropology and the study of specific cultures. His work directly questioned the idea of the "primitive" within a logocentric field. But even as Surrealism's main interest lay in the access to a supposed primitive "unconscious" state of the mind, to transcend the rigors of rational reality, the manifestation of the primitive in Smith's artistic repertoire was toward an exploration of the occult. While not an alchemist in the traditional sense nor overtly religious, specific symbols and patterns from his early ethnographic work repeatedly appear in his non-objective art and films. The motivation behind the recurrence of these well-recognized patterns or symbols—whether it was his earlier interest in preserving the ephemeral or a desire to explore the occult or an interest in transcending reality fueled by his exposure to the French Surrealists—is significant in understanding the later non-objective work.

Mandala patterns and Tree of Life representations are recurrent in Smith's artistic oeuvre. Very intricate representations of zodiac signs in the mandala pattern form a series of his paintings. The *Tree of Life* painting from 1954 is an example of the detailed work replete with occult symbolism that is recurrent in Smith's art, including his non-objective artwork. Some may consider the paintings to be side projects to his collecting practice, often fueled by the need to financially support his purchase of records among other things, but that did not take away from their intricate nature. Whether it was the work with mandalas or his later jazz-paintings, these were extremely labor-intensive processes, much like the painting on filmstrips. No element was a casual imprint, placed thoughtlessly—whether a mark of the specific note in a jazz recital or the interlocking beats of respiration, each element in these intricate drawings had a purpose and was in order. The fundamental characteristics of the collector shone forth in all his other endeavors—the building of a system through order and classification from individual fragments was a principal force behind his work in search of the occult, much like the Surrealist predilection for building absurd collections.

New York was a city that saw an influx of Surrealists from Europe at the end of the Second World War. Among them were Max Ernst and André Breton, who were known to haunt antique stores around the city. Often supported by funding from Peggy Guggenheim, who also financed Smith for a while, the Surrealists contributed greatly to the modern art scene in the United States, fueled by their interests in the objects they discovered in these antique shops. Smith's interest in the objects that interested and influenced the Surrealists went much beyond serendipity in antique stores—his childhood work in anthropology research made him one of the very few people who had witnessed the ritualistic function of these objects in the cultures of their origin. This anthropological background, infused with the influence of European Surrealism in New York around this time, had a distinct influence on his paintings.

Smith's paintings that depict human forms through geometric representations are reminiscent of the work of Paul Klee and Max Ernst. The marvelous picked out of the mundane, a distinct aspect of Surrealist paintings, is tinged with occult influences in Smith's works. His *Self Portrait as the Devil* (1953) as well as an untitled painting depicting unrecognizable entities on and surrounding a throne in a mandala-esque pattern both bring together his interest in the occult and in geometries, patterns, and systems to reflect upon the ordinary in a strange and marvelous manner, bringing to the fore what was out of the world and beyond the real within everyday reality. When Smith began painting on films, having been exposed to the works of other non-objective filmmakers through the Art in Cinema series at the San Francisco Museum of Art, especially Oskar Fischinger, these influences followed him into his filmmaking. The Surrealist tendencies are most apparent in his film *Heaven and Earth Magic* (1957).

Heaven and Earth Magic relied on the Surrealist process of automating the production of art in a bid to explore one's unconscious. Smith spent a lot of time cutting out and collecting images from catalogs— the various shapes and figures we see in the film were all obtained in

this way. Once collected, all possible combinations with the images collected were explored. For example, with a hammer, vase, woman, and a dog, multiple possibilities were available—hammer hits dog, woman hits dog, dog jumps into vase, and so on. The process was made to be as close to automation as possible. While on the one hand, by automizing the process as much as possible, Smith relinquished significant control over the ordering of images, the ordering plays a very important role in sequences that otherwise lack any causal-effect relationship that viewers may grasp at. The cutout catalog figures depict the heroine's toothache caused by the loss of a valuable watermelon, with space for interpretation (the subsequent dentistry and transport to heaven). Much of this narrative is depicted through visual symbols and metaphors—for example, the valuable watermelon is introduced as a photograph that comes out of a pharaoh's tomb. Lots of things happen around it—such as an egg hatching, the cat coming out of a different tomb to turn into a tiger, a monkey taking the watermelon out of the photograph and running away with the invaluable fruit, and the photograph growing a pair of naked legs to walk out of the frame. Nothing in the scheme of events suggests the causal-effect relation in the sequence of the narrative—except in the ordering of the catalog cutouts as the distressed woman is introduced by the homunculus over the next few scenes and placed on a dentist's chair for inspection. Connections are also made between the visual and the auditory—an interest Smith pursued since his early abstraction works. Often meaning is determined solely through associations. For example, in the sequence where an indiscernible object comes out of the egg accompanied by the sound of a baby crying and gets thrown around by the skeleton, one automatically makes the association with the sound to assume that the object is a baby, wrapped up in a bundle. As the sound is discontinued, the viewer realizes there is no other foundation for this assumption—and indeed, the indiscernible baby-object soon changes into the now familiar figure of the watermelon.

The film, understood as a piece of Surrealist art, possesses a

dreamlike quality. Occurrences within the film are not guided by any causal relationships or rational connections but rather seem to flow from one to the next seamlessly. Constantly appealing to kinesthetic faculties, the film engages multiple senses simultaneously. Much like his other cinematic work, it can best be studied as a culmination of the influences and forces shaping Smith's work in painting, music, and collecting in New York—one of the early examples of Surrealism that is truly North American.

SRIJITA BANERJEE is a PhD candidate at the Cinema Studies Institute at the University of Toronto. Her dissertation, "A Cinema of Collection," focuses on the collection practices of avant-garde filmmakers and experimental animators such as Chris Marker, Jean Vigo, Jodie Mack, and Harry Smith. Her work on Harry Smith has been published by Animation Studies 2.0 and forthcoming publications include a chapter on Harry Smith for the *Bloomsbury Encyclopedia of Animation* and on Jodie Mack for *Feminist Media Histories*.

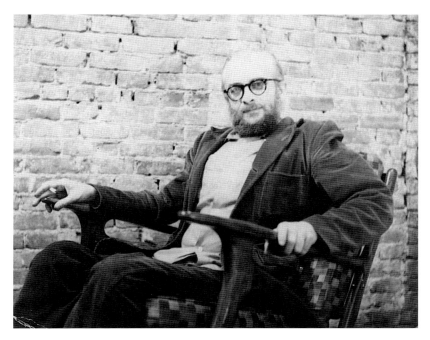

Plate 1. Harry Smith, June, 1969.
Unknown photographer, collection Raymond Foye

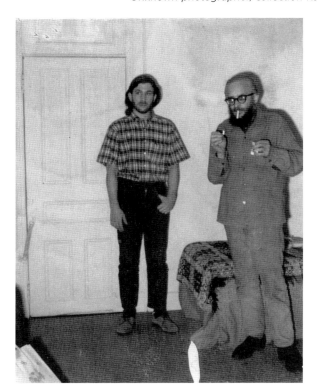

Plate 2. Harry Smith and Marc Berger, 1960s.

*Courtesy of the
Lionel Ziprin Archive*

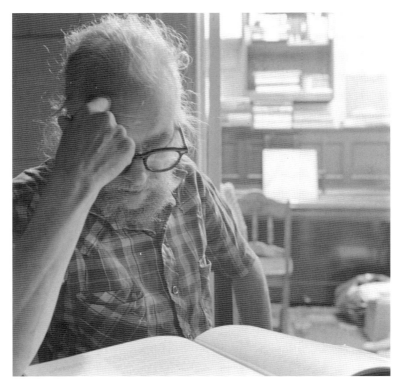

Plate 3. Harry Smith reading, Allen Ginsberg's apartment, February 22nd, 1985.

Allen Ginsberg © Allen Ginsberg Estate

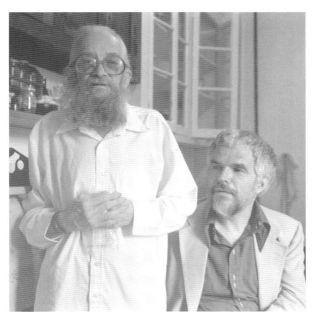

Plate 4. Harry Smith with Stan Brakhage, Allen Ginsberg's apartment, July 9th, 1988.

Allen Ginsberg © Allen Ginsberg Estate

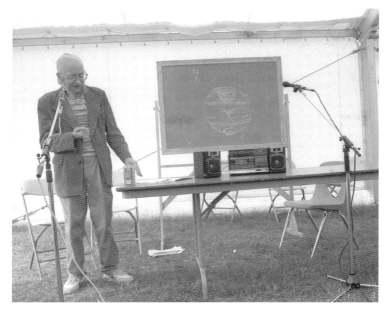

Plate 5. Harry Smith during one of his lectures to the community at Naropa, July 1990.

Photo by Peter Cole

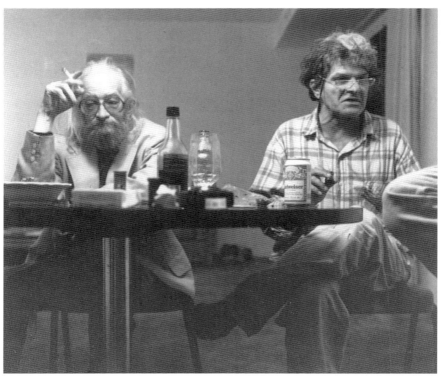

Plate 6. Harry Smith with Gregory Corso, at the Varsity Townhouses, Boulder, July 23rd, 1988.

Allen Ginsberg © Allen Ginsberg Estate

Plate 7. Giorgio Della Terza, Marianne Faithfull, Hal Willner, and Harry Smith, July 22nd, 1989.

Allen Ginsberg © Allen Ginsberg Estate

Plate 8. Harry Smith with Anne Waldman, July 20th, 1990.

Allen Ginsberg © Allen Ginsberg Estate

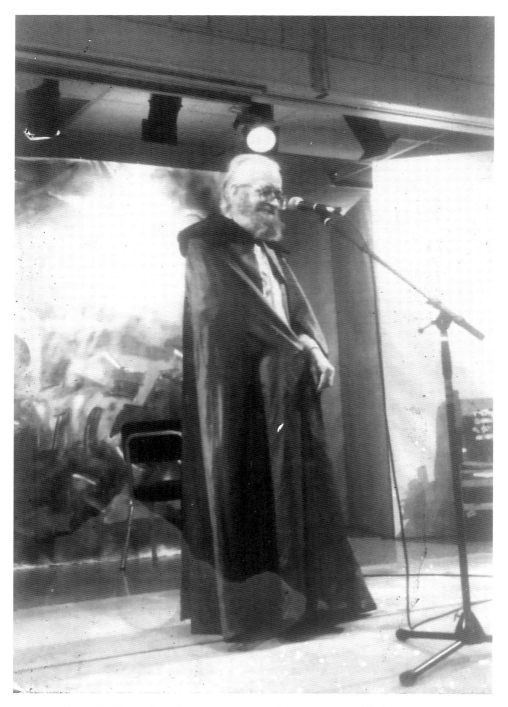

Plate 9. Harry Smith as narrator in Marianne Faithfull's Naropa production of Kurt Weill's *The Seven Deadly Sins*, July 20, 1990.
Photo by Liza Matthews, courtesy of Beth Borrus

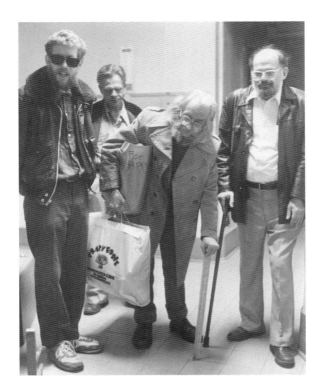

Plate 10. Alan Brooks, Julius Orlovksy, Allen Ginsberg, and Harry Smith, Ginsberg's apartment. November 25, 1987 (photographer unknown).
Courtesy Allen Ginsberg Estate

Plate 11. Harry Smith with Robert Frank, March 29th, 1987.
Allen Ginsberg © Allen Ginsberg Estate

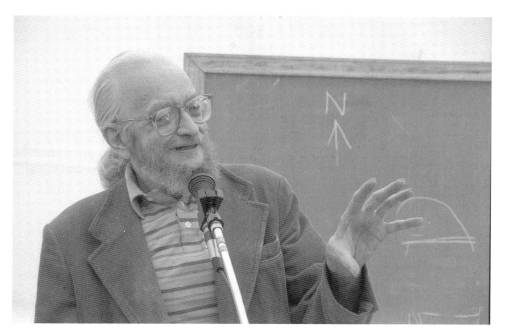

Plate 12. Harry Smith during the Naropa Institute summer writing program, July 1990.

Photo by Peter Cole

Plate 13. Harry Smith, Linda Twigg, and Clayton Patterson at the Chelsea Hotel, 1988.

Photo by Clayton Patterson

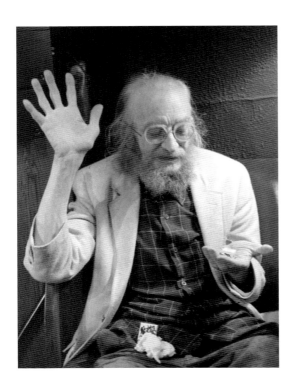

Plate 14. Harry Smith with dice at the Chelsea Hotel, 1988.

Photo by Clayton Patterson

Plate 15. Harry Smith revealing the dice at the Chelsea Hotel, 1988.

Photo by Clayton Patterson

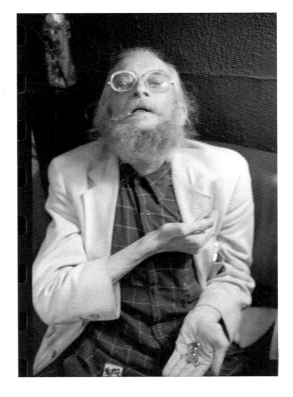

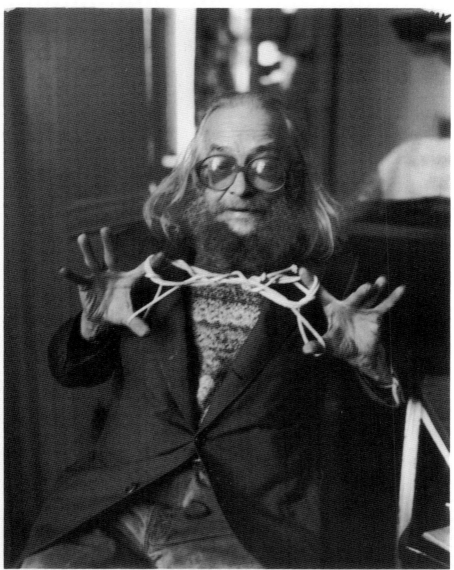

Plate 16. Harry Smith with String Figure, NYC, March 21st, 1988.

Allen Ginsberg © Allen Ginsberg Estate

Plate 17. Harry Smith with Peggy Biderman, circa 1972.
Unknown photographer, collection Raymond Foye

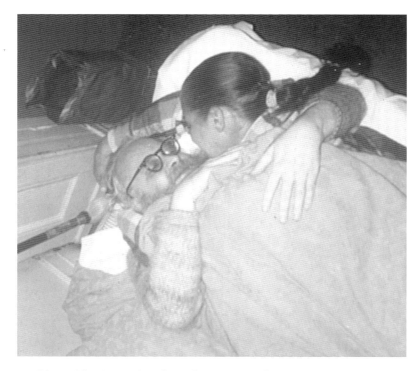

Plate 18. Harry Smith with Peggy Biderman, circa 1972.
Unknown photographer, collection Raymond Foye

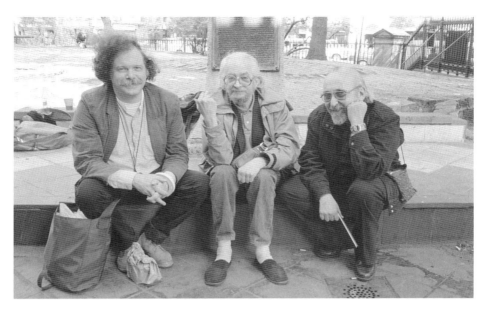

Plate 19. Harry Smith, Ed Sanders, and Jerome Rothenberg at the Poetry Project at St. Mark's Church, May 9th, 1987.

Allen Ginsberg © Allen Ginsberg Estate

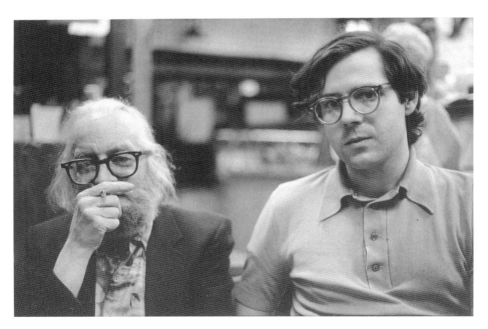

Plate 20. Harry Smith with M. Henry Jones, Kiev Restaurant, NYC, May 13th, 1986.

Allen Ginsberg © Allen Ginsberg Estate

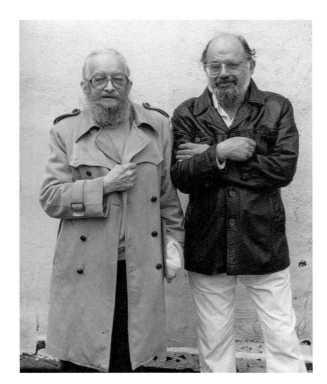

Plate 21. Harry Smith and Allen Ginsberg in the East Village, circa 1990–1991.

Photo by Sid Kaplan

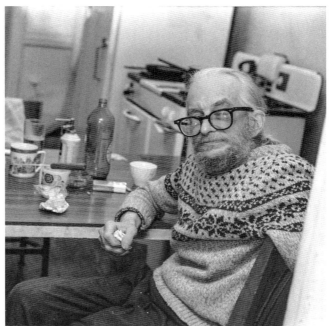

Plate 22. Harry Smith, Allen Ginsberg's apartment, 1985.

Photo by Scott Feero

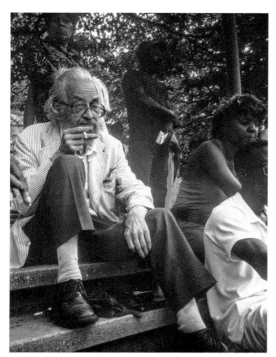

Plate 23. Harry Smith making a field recording of music at Roberto Clemente Park, 1987.

Photo by Scott Feero

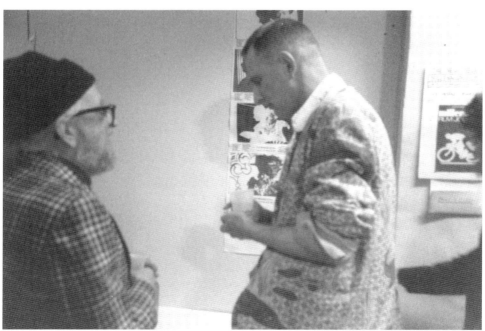

Plate 24. Harry Smith and Jack Smith at Millenium Film Workshop, East 4th Street, NYC, circa 1983. At a screening of Smith's *Normal Love.*

Photo by Raymond Foye

Plate 25. Harry Smith and Jack Smith at Millenium Film Workshop, East 4th Street, NYC, circa 1983. At a screening of Smith's *Normal Love*.

Photo by Raymond Foye

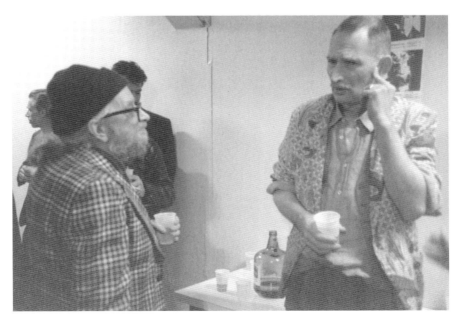

Plate 26. Harry Smith and Jack Smith at Millenium Film Workshop, East 4th Street, NYC, circa 1983. At a screening of Smith's *Normal Love*.

Photo by Raymond Foye

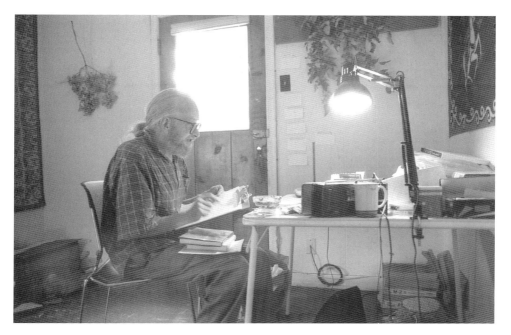

Plate 27. Harry Smith in his cottage on the Naropa campus, July 1990.

Photo by Peter Cole

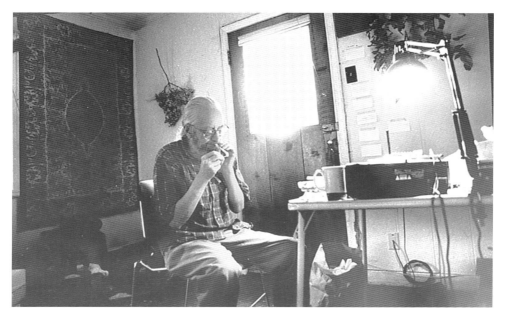

Plate 28. Harry Smith lighting up in his cottage on the Naropa campus, 1989.

Photo by Peter Cole

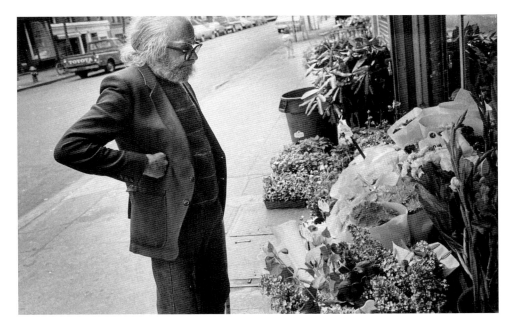

Plate 29. Harry, Easter, 1992.

Photo by Brian Graham

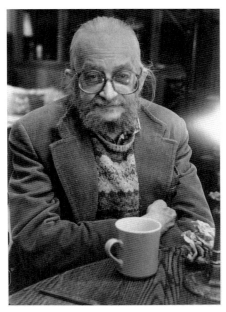

Plate 30. Harry Smith,
February 23rd, 1990.

Allen Ginsberg © Allen Ginsberg Estate

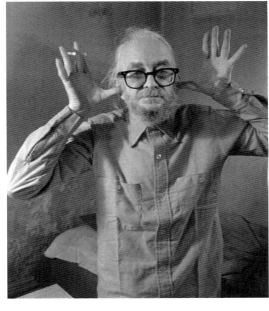

Plate 31. Harry at the Breslin Hotel,
January 19th, 1985.

Allen Ginsberg © Allen Ginsberg Estate

Harry Smith on the Holy City
From Boulder to Kathmandu

Darrin Daniel

Harry Smith left this mortal coil in 1991. Since his passing there has been a slow but steady trickle of understanding about the artist and polymath, as well as his early life in the Northwest. While finishing the book *Think of the Self Speaking: Harry Smith Selected Interviews*, as editor of Cityful Press, I was living in Seattle and close to where Harry spent many of his formative years in Bellingham, north of Seattle. After some research I found remnants and references to Harry's early work with Native American singers in the Anacortes/Bellingham Museum. The Burke Museum had some artifacts as well as some of Harry's writings and drawings. I was only able to take notes and look at the many pieces he left behind before moving to Berkeley as a young man. I read about Harry in the high school paper, the *Bellingham High Beacon*, in a story published on December 5, 1942: "He studies anthropology, the science of mankind in the Indian division. Harry's hobby covers the habits, languages, dress, and customs of the Indians of northwestern Washington. Among his collections of Indian curios, which are on display at the University of Washington Museum in Seattle, are photographic records of the different Indian rites and ceremonies taken

on the Lummi reservation."[1] In an interview with John Cohen, Harry said, "Before I got interested in record collecting, I got interested in the Indians."[2]

Recent writings, such as *Sounding for Harry Smith* by Bret Lunsford, have explored Harry's Northwest past, and much of it gives us a better understanding of Harry's life and early ambitions in ethnography and musicology. Even as a young man, Harry gave us a very clear idea of what would be on his radar as an artist, filmmaker, and scholar of so many things, from Native American peyote music to paper airplane collections. So much of what Harry did as an artist and ethnographer has permeated and impacted a generation or two of artists and creative people. It's been over thirty years since his death and we're still learning details about his life and work.

My meeting and looking after Harry for a brief period while I was a student at Naropa University changed my life. Of all the teachers I had while studying writing and poetics under Susan Edwards and Anne Waldman, Harry was by far the largest influence for me as an aspiring poet, anthropologist, and religious studies undergraduate. The years 1989 to 1990 would prove pivotal to me as I began spending more time at his apartment on campus, talking to him mostly about his past in the Northwest. He would discuss his mother and talk of other subjects concerning Bellingham. Since I had grown up in the Northwest, I could identify with him about the environment. A few of us students were lucky to be allowed to hang out and look after Harry, following Allen Ginsberg's move back to New York City. What a gift Allen had given us, along with the Grateful Dead's ten-thousand-dollar grant to assist in the care of Harry. We were fortunate enough to attend the lectures he gave while he was there; many of us weren't aware of just how special Harry was and the precious experience many of us had in Boulder.

Harry had inspired me to focus on music and culture prior to my last semester at Naropa. I was to spend a semester studying in

Kathmandu to fulfill my minor in religious studies. I was focusing on Tibetan Buddhist culture. Early on, Harry had hinted at the cosmography (the origin of the universe, man, the earth, and the heavens) of the many cultures within Nepal (with over 125 distinct ethnic groups), and this would prove an interesting challenge. This led to a new emphasis in my final paper and the decision to study the many different cosmography legends and myths of Nepal. I began asking those from different backgrounds their stories about the origination of the earth and then began compiling the similarities and differences between five distinct ethnic groups. None of this exploration would have happened if I had not met Harry. He had given me an entire world to enter and in which to immerse myself. Between Buddhist, Hindi, Newari, Sherpa, and other cultural mythologies, I eventually stumbled upon a subset of historical, literary, and artistic storylines that began to untangle some of the more sophisticated threads concerning various mythological traditions.

During the summer of 1989, I asked Harry to draw four border art pieces for a book of poetry I had finished. To my great surprise, Harry agreed and gave them to me for the book. There is one drawing along the border of the cover and two other drawings inside the chapbook. I remember asking Harry to sign my book and he signed the cover and dated it *7/29/90* and then drew a second drawing around the border of a poem I think he and I really liked entitled "Amulets":

AMULETS

I'm jell clarity of a dusty windowpane

sunbeam streams through it

a yellow dog

with one ear up

one down

new born child

blood and fluid cries with friends

on his death bed

> long blade of wheat
> bobs in august gusts of dry wind
> delicate stone hard in the sun
> polished by mud, ocean—
> a witness
> an eye
> heal wounds
> of what the winds have brought me[3]

I remember giving a copy of my book of poetry to Harry and Allen Ginsberg. I remember Allen asking me, "Harry gave these drawings for you to reprint?" I said, "Yes he did, and I am so happy to have them on my first book of poems." He acknowledged this and immediately walked over to Harry's apartment and had him sign a copy of the book. I am sure Allen also asked Harry why the hell he was giving his art to these young poets in training. But this showed how generous Harry could be to a young poet.

Harry had asked me to bring back a musical instrument from Nepal when I was studying in Kathmandu, something one might be able to find on the street. I did find a four-stringed, wood-carved, fiddle-like instrument. After my studies finished, I had trucked back this instrument, right around the time of the ground invasion of the Gulf War. This would have been at the beginning of 1991 and the plan was to mail the fiddle to him now that he had gone back to New York from Boulder. Sadly, Harry passed before I was ever able to get the fiddle shipped to him. It is my reminder of our brief friendship and is something that I will cherish forever.

A unique bond developed between Harry and myself since we were both from the Northwest, and I think that's why Harry allowed me to use his images. Perhaps I reminded him of his family that he left in the late forties, never to return. We both had memories we were trying to retrieve, and I know I am indebted to everything that I was able to learn from Harry during those years at Naropa.

DARRIN DANIEL is the founder of Cityful Press and a graduate of Naropa University. He first met Harry Smith in 1988 at the summer writing program and later assisted in helping Harry with errands and looking after him when Allen Ginsberg brought him to Naropa. Daniel is the publisher of *Think of the Self Speaking: Harry Smith Selected Interviews* as well as Grateful Dead lyricist Robert Hunter's *Infinity Minus Eleven*.

Hanging out with Harry Smith at Naropa
A Collection of Fictional Anecdotes

Rob Pacheco

All memory is fiction.
— HARRY SMITH

WHEN ROB MET HARRY

I first met Harry at Allen Ginsberg's apartment at Varsity Towers in Boulder during a party circa summer 1988. Harry, as well as Allen, were in Boulder that summer participating in the Naropa Institute's Jack Kerouac School of Disembodied Poetry. I was invited to the party by my friend Rani Singh who was Allen's personal assistant for the summer. Of course, as a wannabe poet, I knew who Allen Ginsberg was, but I had no idea who Harry Smith was. Rani told me a little about him, his importance in filmmaking and his famous *Anthology of American Folk Music*. She really wanted me to meet Harry.

At the time I was holding down a few jobs, meat cutting at the natural foods grocery store Alfalfa's, managing an apartment complex, and beekeeping for Dr. Michael Breed at University of Colorado Boulder.

As often happens at parties, when, through the get-to-know-you chit-chat, folks find out you're a beekeeper, you spend a good part of the evening answering questions about honeybees. So I ended up standing in a corner across the room from Harry, surrounded by a few folks, discoursing on honeybees, drinking beer and hitting on the pipe or joint that kept coming round. People are really fascinated with honeybees and are especially interested to hear that queen bees are bred by beekeepers and in some cases, genetic lines are kept tight by artificial insemination. I ended up talking fairly in depth on how queens are bred and raised, including how to ejaculate a drone, collect the semen, and impregnate the virgin queen. I also remember talking to someone that night—it could have been the poet Gary Snyder—about the Boulder Creek watershed, a place I had become intimate with through field time and naturalist studies. Both my bee discussion, and much later on, my Boulder Creek discussion, would play out in classic Harry moments.

Rani pointed Harry out to me. He was across the room, sitting in a corner. I remember my first impression of him: "He looks like an elderly homeless version of Pig-Pen" (the *Peanuts* character, not the guy from the Grateful Dead). But instead of a cloud of dust hovering about, a cloud of smoke emanated from his being. He sat there throughout the party for several hours in his chair, a pair of headphones stretched across greasy, stringy, gray, long hair tied back in a ponytail. On one hand—I recall it was his left hand—he wore an old black dress sock as a sound-dampening glove hovering over a Sony directional microphone perched on a tiny sound-dampening mattress also made of old socks. The mic was attached to a state-of-the-art Sony DAT machine. Harry appeared to be recording the whole get-together. On the other hand was either a substantial spliff or a cigarette, source of the ever-present haze around him. He was wearing a pair of glasses similar to Mr. Magoo's except Harry's were filthy and sitting askew. He wore a found-in-the-Goodwill-discard-pile, two-sizes-too-big grayish sport coat over a yellowing white linen dress shirt. Both the coat and the shirt were decorated with an assortment of splotches, stains, and globs of

food substances that didn't make it down his throat. And he either had very poor posture or something was seriously wrong with his spinal cord. Remarkably, he cast a captivating charm and an aura that proclaimed, "Here sits a most interesting man."

As the night wound down and the party cleared out, Rani brought me over to meet Harry. He was still recording so he spoke very briefly to me. I remember exactly what he said, "You have an interesting perspective. Come visit me. And bring some grass." I did just that a few days later.

THE SHAMAN'S SHACK—HARRY'S BUNGALOW ON THE NAROPA CAMPUS

A couple days after meeting Harry, Rani took me to Harry's place at Naropa. They had set him up in one of the little "bungalows" that dotted the campus as the shaman-in-residence. It was a tiny house with the front door opening to a room that was no more than twelve feet square. The kitchen was on the back wall with a small counter with sink, a set of drawers, two overhead cabinets, stove, and fridge. Through the kitchen was a small bedroom and one of those tight bathrooms where it's possible to brush your teeth and spit in the sink while taking a shit. There were a handful of Naropa acolytes sitting around the living room sharing a pipe. Harry's home furnishings were sparse and elemental. The couch was a chunk of cottonwood log scavenged from nearby Boulder Creek. Two small boulders served as chairs and, against the back wall under a window, stood a small table with two chairs. On top of the refrigerator sat a bottle of milk transmuting into kefir. (Despite his reputation, kefir fermentation was the only semblance of any alchemist powers I witnessed in my many hours spent with him over the years.)

Harry, like his guests, was stoned to the bone. With his Mr. Magoo glasses riding dangerously close to the end of his nose, he looked up at us with red eyes and let out an aged cackle of sorts and then welcomed us: "Good, you've come." Except it came out as "Gooood, you've coooome." He then lifted his arm and with a sweeping gesture commanded every-

one else to leave. I felt embarrassed and a little bad for them. "Leave some grass," he added as the students gathered to go.

Once the room cleared, he offered us tea or water. I remember his cup inventory was limited and not too clean. He stood up and shook my hand and for the first time I took stock of his stature. He might have hit five feet if he wasn't bent at the thoracic. He was wearing the same clothes as at the party, and honestly, I don't think he ever changed his clothes in the time I knew him. I know he must have but I never registered it. His pants, like the rest of his outfit, were two or three sizes too big and held in place somewhere between his belly button and nipples with a tightly cinched belt which left no imagination as to the emaciated physique under all those voluminous clothes. He looked up and gave the cutest smile, which surprised me in two ways. First, it was just so unexpected and sincere that it instantly made me fond of him. Second, it revealed that his dental health perfectly matched his hygiene and grooming. It wasn't a pretty sight.

"I've got something for you. Follow me." We entered a tiny bedroom devoid of any furniture except a single, thin, worn, and dirty futon folded in half on the floor, and a few vertical stacks of books. Harry kept his books stacked flat in neat balanced piles reminiscent of a hoodoo rock formation. At this time there were just a few stacks and none of them too high. Each time I visited from then on, it seemed the stacks increased in number and height until the room was so populated with books it required careful maneuvering to get around without knocking a pile over. And if one went down, it would be a dominoesque disaster of books. Yet even after the room filled up with dozens upon dozens of books, he could always go directly to the one he wanted. Retrieving books became a regular duty during my visits as it was much easier for me to pick up a few strata to get to the desired book.

Once in the bedroom, he asked me to lift off a half-dozen books from a stack so he could retrieve a book. It was Bernd Heinrich's *Bumblebee Economics*, a classic of natural history writing, I later learned. I put the books back on the stack and we returned to the living room.

Rani had something to do and left, leaving Harry and me alone for the first time. Harry opened the book, flipped through the pages to a specific place, and handed it to me. As I started to read the page, Harry lit one of the roaches left by the students and proceeded to walk me through the text. It was in a chapter about bee competition; the chosen paragraphs were specifically about non-native European honeybees and the deleterious impact they have on bumblebee populations. Harry and I had never spoken about bees, but he did record the entire bee conversation I had with the partygoers a few nights before. I was reading along as he spoke and took the roach he passed. He was able to recite verbatim from the text. And then he told me to turn to page so-and-so and read how the bumblebees were responsible for the rise of the British Empire. He loved that and let out a cackle of laughter punctuated with an "Egad!" I wondered if he really had memorized parts of the book and just brought it up to me because he knew I was interested in bees, and if so, how much of the book he did retain—or whether he was just pulling some parlor trick to impress me. Even if it was the latter, he still had *Bumblebee Economics* in his bedroom in the first place. I soon learned that Harry's mind and ability to recall both written and verbal communication was no parlor trick. I ended up spending several hours with Harry that day and finally left for my closing shift at Alfalfa's meat department, stoned, bewildered, and excited.

ADMONITION FROM STAN BRAKHAGE

Stan Brakhage, the renowned filmmaker and University of Colorado professor, was a regular customer at the Alfalfa's meat counter. After I'd been visiting Harry for a few weeks, Stan came in and I helped him. As an ignoramus, I asked, "Do you know who Harry Smith is?" He looked up sharply at me over the counter, "Of course! He's the greatest filmmaker who ever lived!" (I'm not sure if that was the exact quote, but it was made clear Brakhage held him in the highest esteem.) "Oh," I replied. "I've been hanging out with him lately." "Well, do whatever you can for him," Stan

said. That encounter went a long way in guiding my tolerances of Harry's idiosyncrasies and appreciating the time I spent with him.

MOTHS AND PINNIPEDS

One afternoon in late summer I accompanied Harry to Stagecoach Books on Pearl so he could purchase a book. This had become a regular date of ours. I'd like to think that he really enjoyed my company, but I think that mostly he just wasn't comfortable walking the streets alone and needed someone to carry the acquisition back for him. This particular errand turned into a Harry adventure that played itself out into the next morning.

The book he wanted was an academic tome of the world's pinnipeds. It was a hardbound brick of a book, each chapter authored by various experts, dealing with different aspects of pinniped natural history, ecology, biology, and distribution. (I never asked, but I was always curious from whom he scrounged the dollars whenever we went for a purchase. He never asked me for money, but I saw him solicit others more than a few times.) They had the book on hold for him. I'm not sure how long they held it for him before he "saved" up enough to buy it, but the clerk was very happy he was there to retrieve it. I took the book and put it in my backpack, and we left to return to Naropa.

By the time we neared the east end of Pearl Street Mall Harry needed a rest. It was one of those enjoyable, late summer, front range gloamings—crisp, cool, clear, and quiet. Harry sat down on a bench, and I leaned against my bike, both of us silent. (One of the things I enjoyed about being with Harry was the comfort of not talking. He and I could have long moments of quiet between us. I think he also appreciated this.) I reclined just to the east of Harry and was staring into the west with the last sun of the day backlighting the scene for me. Amidst the movement of pedestrians, a fluttering down the block caught my eye. It was some sort of butterfly or moth flitting just above the heads of the mallgoers. It was headed our way. I kept my gaze on

it and, as it got closer, I recognized it by its bat-like flight as some sort of sphinx moth. Harry was oblivious to it. It came directly at us and before I could say a word, it landed on the lapel of Harry's decrepit sport coat like a camouflaged carnation. It was probably attracted to the fermenting scent wafted about by food particles on his clothing. Without any surprise, Harry looked down, took his glasses off and said, "That's nice." I said, "Oh, look, it's a bat moth." Harry replied with a trace of exasperation, "Good god, it's a polyphemus! It's a silk moth, not a bat moth." Turned out he was right, of course. It was an *Antheraea polyphemus*, a common moth in Boulder gardens. "How do you know that?" I asked. "Because I'm Polyphemus," Harry mischievously smiled back. "Who the hell is Polyphemus?" I asked. "He's the son of Poseidon; he was a giant and his name means full of song and legend," Harry said. I wrote that down in my notebook. The moth stayed put until Harry gave it a gentle nudge and a little wave goodbye as it erratically flew away. (Later, at the library, I looked up Polyphemus and the silk moth and confirmed that Harry wasn't bullshitting me. And even later, I made the connection of Harry as a polyphemus—he certainly was one who abounded with song and legend.)

By the time I dropped him off at the shaman's shack, it was dark, probably close to nine o'clock. I rode home to my place at Sixth and Marine. The next day I had to be at work at ten, so I stopped by Harry's before my shift to check in on him. He was in a good mood, animated and glad to see me. I sat down at the table where the pinniped book sat. "Can I look through the book, Harry?" Harry was very particular about his books. He especially was concerned about wear and tear on the spine and binding. "Yes, but leave it on the table, don't hold it in your lap." He continued with an instruction to turn to a specific place in the book by saying something like, "Turn to page 987, look at the third paragraph from the top in the left column. It says we share similar ectoparasites with walruses. We have the same eyelash mites as them—well, almost." He then led me around various sections of the book, highlighting interesting facts about pinnipeds. Harry had possession of this thousand-

plus page academic monograph for less than twelve hours, most of those hours overnight, yet he was able, from across the room, to bounce me around the book on a guided adventure through the world of seals, sea lions, and walruses. He had an especially humorous take on the earless seals not actually being earless, which I regret not writing down.

HARRY, RANI, AND THE BOTTOMLESS CUP OF ENSURE

After Allen left Boulder Rani seemed to become Harry's "executive assistant." I don't know if this was an official or unofficial appointment, but Harry and Rani had a relationship dynamic that wobbled between that of an old married couple, father and caretaker, or priest and acolyte. Rani constantly ran errands for Harry, delivered essentials, ran interference with interlopers as directed by Harry or by her own intuition, and monitored his health and well-being. It was obvious Harry was fond of Rani, but he could be mean and cruel. Harry seemed to tolerate a fair bit of mothering from Rani. One day I helped Rani deliver a fresh supply of Ensure to Harry. This seemed to be his primary sustenance. I had never dined with Harry and that morning I was baptized into the "in-the-mouth-out-the-nose-back-in-the-glass" feeding ritual. Harry had several physical anomalies. Along with his hunchback, apparently, he also had a restricted esophagus and obviously some other plumbing complications having to do with the throat, sinus, and palate. Whatever was going on required Harry to have only liquids and in small amounts. He would suck up the Ensure (or other emulsified vittles such as finely ground tenderloin) with a straw and after a bit the substance would begin to drain out his nose, which he would let drip back into his glass and continue until most ended up down the throat. I'm sure Rani had witnessed this before, but I was fascinated. We all three sat silent as Harry slowly sucked and re-sucked. At one point it was stated that Harry suffered from labyrinthitis, described as a condition of open pockets between the palate and sinus cavities. Looking it up, labyrinthitis is an inner ear infection. I'm not sure

what Harry's issues were, or whether they were congenital or a result of his years of self-abuse.

THE GRATEFUL DEAD GRANT

News spread that Harry had received a ten-thousand-dollar grant from the Grateful Dead. Jerry Garcia purportedly was using Harry's *Anthology of American Folk Music* in a college course he was teaching and heard of Harry's need. Harry claimed he'd never heard their music and wasn't sure he should accept the cash if they weren't any good. With no shortage of Deadheads hovering around Naropa, soon cassette tapes of Dead shows were being proffered to Harry. I asked Harry if after listening he thought the Dead were worthy of giving him the money. "With a little improvement of the vocal harmonies," he replied.

HARRY SMITH REFERENCE PAPERS

Harry kept some sort of reference system on letter-sized unlined sheets of paper. They were usually inside the front cover of the books. The pages were filled with numbers arranged in rows and columns. He let me peruse these a bit. I asked him about them, and he claimed they were reference sheets but gave no further information. Down the right was a row of numbers that I think represented topics of the reference subject; the top row would be a list of numbers representing other sources of the subject that he had read at some point in the past; then the rows were filled in with corresponding page numbers of the topics in the books. I couldn't make any sense of it really, maybe because I was usually stoned while in the shack, or maybe because it was all gibberish, or, more likely, maybe because it was a system only Harry's mind could decipher. Maybe the reference book numbers were ISBN or Library of Congress Control Numbers; maybe the topics were Dewey Decimal system numbers? There were no periods or commas in the numbers, if I remember correctly. He was very particular about them. If it was a valid

cross-referencing system, it meant he could recall not only the books he had read in the past but also the page numbers of specific topics and sections that aligned with what he was reading in the present. Another marvelous mystery of Harry Smith.

HARRY'S ACCESS TO DATA

Conversations with Harry were like stumbling through a maze. It was impossible to stay on a linear course of thought and you never knew what was coming around each corner. If you asked him a question, he would start off on some tangent that seemingly had nothing to do with what you asked. He would go on and on, moving from one thing to another, and sometimes you would get an answer. At times it came after a few minutes of meandering that tied it all together. Sometimes so much time would elapse I would forget I even asked the question and then there it came with no segue. More than a few times, I would come for a visit, walk in, and he would start right in on some question or conversation from days ago as if we had just started the discussion. Though it wasn't necessarily readily available at every moment, Harry's recall and breadth and depth of knowledge was spellbinding when it came.

A VERY SINGULAR MIND

Harry never once talked to me or mentioned in my presence anything about his past, his life, art, or personal anecdotes. I understand he covered some of his work in his lectures at Naropa, none of which I was able to attend. But as far as regular old chitchat, story swapping, and reminiscing, there was none between the two of us.

BLUEGRASS IN NEDERLAND

Early on, while Harry was still in his nearly twenty-four seven recording mode, I borrowed a car and took Harry and a few others up to the

Train Car Bar in Nederland to hear some bluegrass. We sat at a table at the very back of the narrow car and Harry set up his Sony DAT and directional mic. The stage was at the other end of the car and there were several tables between us and the band. The place was packed and loud. Harry sat, in his light blue suit and his stained button-down shirt, incessantly smoking, with his black sock on one hand and headphones over his gray ponytailed hair. At one point he let me listen. The directional microphone was able to cut out most of the crowd noise and get a clean sound of the band. I moved the microphone a bit and could eavesdrop on the conversation at the table right in front of the band. After the show, we were all out back smoking a joint with the band, and my friend Benny, who was in the band, asked Harry how he liked it. Harry said he liked it, but "you left out the best verse of Old John Henry." Harry then proceeded to sing in the most lovely of fragile and sweet old man voices the missing verse, which none of the bluegrass boys had ever heard. The band loved it.

BUDDHIST ICONOGRAPHY

One cold winter afternoon Harry wanted to go to the Pearl Street Mall. We slowly made our way from Naropa. Walking with Harry was like walking a dog. He stopped all the time to look at something that caught his attention or to take a break. His destination was an art gallery next to Old Chicago. As soon as we entered the store, the lady behind the counter came around the counter in alarm. The sight and smell of Harry, an aged homeless bum for all she knew, accompanied by a young man with no apparent evidence of economic wherewithal and obvious lack of regular deodorant use, was something she was going to shoo out of her store swiftly. "Can I help you?" brought forth an exclamation from Harry, "God, I hope so." The gallery had several Buddhist tapestries with various iconography. Some of them looked very expensive and well-preserved. Harry made some astute comments about them which caught the proprietor off-guard. Then he pointed to a tattered

looking thing hanging up high in the back and proceeded to lecture the lady as to the rarity of the images and their arrangement in the work. He asked her how much it was, and she said something like, "Well, I'll have to take a look." "Whatever it is, I'll take it," he said. At this point I walked out, and Harry and the woman carried on for some time. She followed him out the door chatting, obviously spell-bound by the shaman. I asked him if he was going to get it? "Egad! No!" and that was the last I heard about the tapestry.

PAPER AIRPLANES

I came to learn another area of Harry's expertise was paper airplanes. Apparently, he had been collecting them for years. During my time with Harry, I witnessed him find paper airplanes on three different occasions. I'd never before or ever since just randomly come across a derelict paper airplane! The first time was on a walk downtown. On walnut street we walked by a house that had a swinging chair on the porch. Harry stopped, took the cigarette out of his mouth, and told me to go get the airplane. "What?" "There on the chair." I looked over and there was a paper airplane on the seat. Normally, I'm not much of a pilferer, but Stan Brakhage's admonition came back to me. What harm can stealing someone's paper airplane for Harry cause? I took a gander to discern if anyone was around, ran up the walk, leaned over the rail, and snagged the plane. I gave it to Harry and hoped we would move on before the cops showed up, but he stood there holding the plane, then unfolded it, studied the folds, folded it back, handed it to me, and told me to put it back. No further discussion. Another time we came back to his place after being out and there was a plane sitting on his stoop. "Oh," he said, "these fly really well." I picked it up and gave it a toss and indeed it flew like a bird. Upon retrieval, the sharp nose of the plane had creased on impact. Harry told me to leave it outside. I set it back down on the stoop. The last aeronautic encounter happened at his place and was the only time I can remember Harry getting mad at me.

It was a snowy day in Boulder. As usual, Harry had the temperature in the room up to what felt like ninety degrees. As I started getting out of my coat and boots and opening windows, I noticed a paper airplane on top of the fridge. It was quite a complex thing, unlike any paper airplane I'd ever seen. Still not appreciating Harry's long-term relationship with paper airplanes, I picked it up and gave it a flick of the wrist. The plane went straight then hooked left and went into his bedroom. Harry made some cackle of disapproval. By the time I got into the bedroom, one of the half-dozen or so kittens that had taken over Harry's place attacked the plane and in a moment clawed, bit, and shredded the plane so that it was no longer air-worthy. Harry was pissed and let me know. Luckily, I had some grass on me, so he let me stay. It was the only time I came close to being ejected from the premises, as I'd witnessed happen to so many others over the months. Later I learned about his collection, which rumor held was housed at the Smithsonian Air & Space Museum, and realized, perhaps, that I had inadvertently ruined a potential addition to the collection.

SPIDERS, SCORPIONS, CENTIPEDES, AND MITES

One late afternoon Harry and I were at Stagecoach Books. As usual I was perusing the natural history section. A copy of Golden Books' *Spiders and their Kin* was on a shelf and in my budget. I love that little book. Still a useful guide; to this day I have copies at home and at my office library. I pulled it off the shelf and was holding it when Harry came over. He asked what I had, and I showed him. "Oh, you need J. L. Cloudsley-Thompson's *Spiders, Scorpions, Centipedes and Mites*; it's still the best workup of woodlice." Then immediately Harry exclaimed in that astonished expression of his that made you feel like some incredible cosmic event had just miraculously unfolded before your very eyes, "Aagh, there's a copy on the top shelf!" Sure enough, I pulled it down. The full title was *Spiders, Scorpions, Centipedes and*

Mites: The Ecology and Natural History of Woodlice, 'Myriapods' and Arachnids. Harry took it from me, looked at the spine, opened it up, said, "Ah, good, first edition, here," and handed it back. I don't remember what the price was, but I really couldn't afford it at the time. The little Golden Book, no problem. Under Harry's influence, I went down and wrote a check anyway. I still have that book. It was one that made the cut when I packed up boxes of books to move to Hawaii with me.

HARRY AND PETER ROWAN

On one occasion I told Harry I wouldn't be around the coming weekend because I was going up to Fort Collins for the Bluegrass Festival. I mentioned Peter Rowan was playing and Harry said he wanted to go. I don't remember anything about that trip, how we got there, who we were with, how long we stayed; I only remember the scene with Peter Rowan. I think the show was at a school and we learned Peter was in a room off the gym getting ready to go on. There was a heavy industrial door with a pane of wire-reinforced glass running vertically up the top half. I looked in and saw Peter with a handful of musicians around him. Harry came to the door and looked in. I was now watching over the top of Harry's head. Suddenly, Peter looked over at us, noticed Harry, and waved us in. Hot damn, I'm getting in the room with Peter Rowan! We went in and Peter nodded and smiled at Harry, then continued his run-through with the band. Turns out they were a pickup band of local pickers and Peter was running through each song briefly and giving directions. He had to work with the banjo player a bit to get him to settle and quiet his picking down. He dismissed the band and turned his attention to Harry. After just a short bit of pleasantries Peter said, "Harry, remember this one?" and lifted his guitar up high with the body along his head as he does and started strumming and singing. I can't remember the song, but I do remember very clearly Harry started tapping his foot along with the beat. I'll never

forget Harry tapping away with those oversized old hand-me-down shoes of his. Peter did a few more snippets of songs and then he had to go. I was and still am a fan of Peter Rowan and I was thrilled. Harry looked at me smiling and said, "Thank you, that was very nice," as if I was the one who played for him. I wish I could remember more of that day.

BIRD CALLS

Being a birder I could identify most of the bird vocalizations around Boulder. Harry seemed to both like that and tease me a bit in his way about it. We'd be on a walk or sitting in his place and a distinct call or song would go off and he'd ask something like, "What's that little tweety bird?" I'd say something like "American robin," then he'd go, "Correct." It was a little game of Harry humor; I didn't think he really knew if I was right or not. One day at his place, I came in and to clear out the ever-present stank of his room opened all the windows, which Harry whined about. Suddenly, a raucous high-pitched chittering from a flock of birds came from right outside his flat. Before I could react, Harry said, "How nice, cedar waxwings." Indeed, a feeding frenzy of cedar waxwings had descended on bushes filled with berries outside.

HARRY'S GIFT

One morning Harry was very agitated and wired as he would be sometimes. I think it had something to do with all the pills he popped. He'd answered the door by cracking it open, "Oh, it's you. Come in." As I sat looking through some book on the table, he tinkered around the kitchen while shooing the cats. Other than the first words when I came in, we weren't talking. He was doing his thing, and I was doing mine. Somebody came to the door, and he wouldn't let them in. After closing the door, he went into the bedroom and came back out and said, "Here, keep it, it'll be worth something someday," and handed me a handwrit-

ten envelope addressed to *Harry Smith % Naropa*. The return address, also handwritten, was from Allen Ginsberg. I still have it.

ROB PACHECO was born and raised amidst the wetlands and farmland of the Butte Sink in Northern California. In high school Rob began working as a commercial beekeeper, and later worked for beekeeping operations across the United States, northern Canada, and Central America. Accepting a beekeeping position in Hawaii in 1991, Rob soon met his wife Cindy and together they founded Hawaii Forest & Trail in 1993. One of the first land-based ecotour operations in the islands, Hawaii Forest & Trail has garnered national and international recognition. A lifelong student of nature and a trained interpretive naturalist, Rob has spent three and a half decades sharing his passion for nature with people of all ages and walks of life, from business titans, rock-and-roll icons, celebrities, and ex-presidents to local families, kids, educational groups, and tourists.

9

The Women in Harry Smith's Early World

Bret Lunsford

Often portrayed as a lonely, misunderstood outsider, the historical record shows that creative communities enveloped Harry Everett Smith's early years. He was nurtured by feminists—in deed, if not declaration—and encouraged artistically and supported intellectually in the realms of culture overseen by members of the Anacortes Woman's Club and other organizations. What began in his mother's lap continued through primary education by "refined revolutionaries" at Bellingham Normal's progressive campus school. At age nine, Harry's work was transplanted, beginning ten years of art classes in the Anacortes Hotel. Under his godmother's wing at the Anacortes Public Library, he was lent books that opened portals into art, music, anthropology, and psychology. He was free to follow his muse, creating his own museum from nature studies and artifacts found along Salish Sea shores. In this way Harry developed a lifelong passion for reversing cultural erasure. Yet the people who raised him have been

*This essay contains some excerpts from the author's book *Sounding for Harry Smith: Early Pacific Northwest Influences* and from his Substack column *Resounding—Harry Smith in NW Washington*.

largely erased from the stories we like to tell of an alienated artistic genius.

Mary Louise Hammond Smith was born in Iowa and moved with her parents to Washington's San Juan Islands while still a child in the 1890s. She went to art school in Bellingham before becoming a teacher, primarily of Native Alaskan children, working at day schools in remote villages from Afognak to Nome and the Yukon.

Harry Everett Smith often spoke of his mother and first collaborator: "They were excellent parents that I had, but they were a peculiar type." Mary Louise Smith was president of the Christ Church Episcopal Guild from 1934 to 1937, focusing on church decoration and fundraising. If the Smiths were involved in church work as a front for their occult activities, history shows they played their small-town WASP roles very convincingly. Harry's schoolmates remember Mary as friendly, offering milk and cookies if they visited at Harry's home. Harry's early learning he credits to his mother: "She gradually taught me to read . . . so naturally by the time I got into kindergarten I was already reading newspapers every day."[1]

When he began his audio recording odyssey as a teenager, hers was the first voice he documented. Mary sang him Irish folk songs, enrolled Harry in years of art classes, and engaged with him in Coast Salish tribal cultural studies from a young age. Moses Asch said he "picked up his interest in Indians from his mother, who taught school among them in her maiden days."*

Not only did the pair travel to the nearby Swinomish and Lummi reservations to attend tribal events, together at the Anacortes Masonic Hall they presented on these studies, as documented in a 1942 newspaper announcement headlined "Woman's Club Will Hold Meetings: The

*The Anacortes American printed Mary's obituary shortly after her death on October 23, 1949: "Mrs. Smith was Mary Louise Hammond before her marriage, and was a pioneer teacher in Alaska, teaching at Kodiak, St. Michaels, and Eagle on the Yukon." Records of these positions appear in news accounts between 1908–1912. Because there is no record of statements by Harry or documentation of Mary teaching or working at the Lummi or Swinomish reservations, the author has concluded she did not.[2]

subject of the meeting will be 'Northwest Indians.' Talks and displays of Indian relics and work will be given during the luncheon. Speakers will be Mrs. Robert J. Smith and son Harry Smith who have made an extensive study upon this subject."

Most of what we know about Mary comes from stories told by Harry, and the words of her good friend, Henrietta Blaisdell, who described Mary as "so full of sharp wit and great interest in life. She kept everyone on their toes and laughing." Many of Harry's friends would describe him in the same way.

Mary did meddle with Harry. Her only known written words survive in a private letter to her son's best friend, Bill Holm, sent in 1943: "I wanted to have a Chinese friend translate the text for me but H. didn't want me to. So—I abstracted the posters & put in some waste paper thinking I'd get them back before he discovered my perfidy. It didn't work out that way! He mailed the fake & I did not dare tell him; he'd sure shoot me and not wait till sunrise either! P.S. I didn't get a translation after all! Some mix up -!"

Before even reading between the lines, the fact of the letter indicates an intense involvement of Mary in Harry's life. It shows how she lovingly hovered and collaborated, sometimes secretly, on cultural research and social networking. She had a Chinese friend, and presumably other connections. She trusted Bill Holm with her awareness that Harry was volatile and needed help despite this. The simple note demonstrates a sense of humor about life with Harry.

Henrietta Blaisdell, a.k.a. One Bubble (as her headstone in the Guemes cemetery reads), was a fascinating figure in Anacortes and the surrounding islands. Before *Sounding for Harry Smith* became a book, I imagined One Bubble as a subject. It was an idea that grew to equal parts inspiration and intimidation once I learned of her connection to Harry's family.

Bubble said, "I'm an original person and like to study life and one can't be original and proper, you know." As noted by Jane Jacobs in *A School Teacher in Old Alaska*: "To be openly proper and conventional,

and also openly daring, is a way of being that was seldom available to women in the past. Some who did pull off this trick, without being either aristocratic or rich, were Americans on the frontier."[3]

"My grandmother," Henrietta said, "taught me how to think. She got me my first canoe. She would let me go out alone and camp on the little islands. I would sit there happily, listening to the owls and thinking how different I was from the other girls with their Eastern Star mothers who constantly told them to cross their ankles and be little ladies."[4]

Bubble documented and embellished her life and living places in many forms: quilts and photo albums, themed community events, driftwood sculptures, and painted canoes. No surface or person in her orbit wanted for her creative touch. As I flipped through the pages of Bubble's free spirit scrapbooks, I was not surprised to find mention of her in the obituary for Harry's father. Or to find rare photographs of Harry's mom and dad. Henrietta's scrapbooks help fill some of the blanks about who Harry Smith was. She cared enough to clip and glue the 1943 article from *American Magazine*, featuring Harry, into her illustrated memoir, writing: "Harry's Mom & Dad came to live with me. I sort of adopted them. We built her a cabin on the beach, and she loved it so much. Mary Lou, his mother, died of cancer—happy here only to live on—leaving us all so heartbroken to lose her."

Who was One Bubble to Harry Smith? Her brief time at college in Bellingham overlapped with the Smith family's relocation to Fairhaven in 1924—and it is easy to imagine her as one of Harry's sitters, teaching him the Charleston. One Bubble followed her own path from the start. Hers was a self-sufficient life, and she enjoyed the wealth of artistic living, even during the Great Depression. Why not paint a canoe with dragons, or monkeys on the tool shed, or throw Chinese lantern parties to brighten the winter? She made her home near the Potlatch Beach of the old Samish village, on the west shore of Guemes Island. She was comfortable outside of convention, and so a magnetic trailblazer for the odd.

Living by the seaside, away from the norm, the house and grounds of Henrietta's place were an outsider-art exhibit that became a local

attraction on word-of-mouth maps. My own early encounters with One Bubble, as she insisted we refer to her in the 1980s, seem in retrospect kind of like a cosmic baton pass. Our friends were just the latest generation of visitors to her living "museum" with daily shows and workshops on how to stir things up.

Naturally, she was a customer at the used book / stained glass / photo shop I worked at and later owned, called The Business. I can still see her parking indelicately out front, unlicensed due to failing vision, yet undeterred. Wood fire smoking from the chimney of the camper on her pickup. I remember the day she brought in stacks of old negatives to our black-and-white darkroom; they blew us away. This octogenarian country flapper developed some weird film.

In 1990, before I was aware of her Smith family connection or its significance, I visited Bubble at her house to record an oral history, and she explained her family history: "I am the only one that turned into an artist, to their great disgust. And they paid me money and did everything to keep me from being one, which was a crime. . . . To me it was just something to do for fun. I just made something and gave it away instantly." In another telling, Henrietta's grandmother recognized her talents and would have sent her to any art school in the country, Bubble recalled: "I almost could have been a professional artist, but I wanted the freedom of the wilderness."

If Harry Smith moves naturally into beat, hippie, punk, and who knows what other creative social experiments, his family friend, Henrietta, was on a similar path ahead of him. Harry couldn't have picked a more adventurous muse, one whose artistic worldview perhaps influenced his own. Bubble had a strength of will that protected her vision, another trait in common with Harry. No doubt she enjoyed the attention of her local fame, but never really pursued a bigger stardom—never journeyed to Hollywood or Manhattan for a dream of celebrity.

Luella Hurd Howard's history resembles that of Harry's maternal grandma, Esther Hammond, who also came to northwestern Washington to teach at remote schools in the 1890s. Luella worked

as head librarian in Anacortes for thirty years, the last eight overlapping Harry's time in town. She was active in the Masonic Order of the Eastern Star and at Christ's Episcopal Church: she was godmother to Harry when he was baptized there at age twelve. The *Anacortes American* notes that Harry and his parents attended birthdays and other events at Luella's home soon after they moved to Anacortes, beginning in 1933. The friendship endured for years—when Harry was sixteen the "Local & Society" newspaper column of November 2, 1939, featured another story about creative collaboration between he and his mom: "Mrs. E. Luella Howard entertained Sunday afternoon and evening at her home on Tenth street. Refreshments were served, and the honor guest received many lovely gifts as remembrances from her many friends. Harry Smith and his mother, Mrs. Robert Smith, entertained with an amusing and clever puppet show."

When we wonder how Harry acquired the book titles and academic connections to feed his voracious intellect, Luella Howard is the obvious conduit. Howard didn't just work at the library, she invented it, as the *Anacortes American* reported in 1908:

> As a result of the energy, public spirit and liberality of the lumber and shingle men of the city and the enterprise of the ladies who have taken the project up with vigor and enthusiasm, Anacortes will soon have a free public library big enough and rich enough in literary treasures to challenge the pride and ambition of the community. All this came about through a chance remark of Mrs. Henry C. Howard to George E. Vincent a couple of weeks ago. "I wish we had a public library where one would be sure to find at least the standard works of literature," she said. "Why not establish such an institution?" said Vincent, and as there was no one present inclined to echo "why not?" with a dubious inflection, the idea acquired the breath of life.

Within three years the Carnegie Library was built and dedicated, and notable University of Washington history professor, Edmond

Meany, was chosen to make the principal address. The *American* article noted "the magnificent way in which he displayed his acquaintance with Indian lore, there being no better posted (*White*) man on the Pacific coast today on the subject than is Prof. Meany. At the close of his discourse Mr. Meany brought forth a large sized Indian hamper filled with curios, representing the works of art of various Indian tribes, describing the character, history and mode of manufacture of each article as he went along."

So begins the story of how Harry's library bookshelves were filled. In a regular monthly library report, readers learn that "the local library was put on the government mailing list, so will in future receive all books sent free to libraries." Apart from that: two hundred government reports were received. Other books donated included *Indian Legends and Other Poems* donated by Prof. E. S. Meany.

"Luella Howard not alone made them a good librarian, but she also played a big role in molding the reading habits and character of many of Anacortes' leading citizens of today," wrote her nephew, Glen Glover, in his "Old Anacortes" column in 1971. "Each and every one sang her praises and told me how she had influenced their lives in encouraging them to read good literature and get all the education they could."

If books are like grandparents, Harry's relationship to Anacortes's founding librarian, Luella Hurd Howard, needs to be considered as an influence on his life as a reader. Henrietta Blaisdell, the underground archivist, had this to say about Luella in her annotated scrapbook: "Our dear Mrs. Howard = who always took us kids' 'part'—gave us good advice + understood us. She believed in us."

Sophie Walsh wrote of the beloved librarian in her 1927 *Anacortes American* column, "Trials and Hardships of Anacortes Pioneers": "'Well, how are you, Lou?' The answer is always the same, 'Busy.' Being a teacher (everyone called her school ma'am) away back in 1890 wasn't such a very easy job. It never is as far as that is concerned. But there were always friends who would offer their services to the school ma'am. Red, white, black or yellow it was always the same to her—and to them. One smile

out of Miss Hurd's kindly eyes and you were a friend for life. There were as many Indian children as whites most of the time and they were just as good pupils; some of them she remembers with special pleasure—teaching school at Sutter school, near Sauk, were no whites at all."

In a conversation with Dawn-Michelle Baude, included in *Think of the Self Speaking*, Harry Smith recalled of the household library in his childhood, "I would say that the books lying around the house were basically Theosophical." But when asked "So your parents were Theosophists?" Harry answered: "To a degree. They were very eclectic in their religious activities." Not always an open book with his childhood recollections, Harry enjoyed spicing up his past with mentions of occult figures and practices, leaving out his Episcopal roots and baptismal godparents. He knew the magic of myth. The razzle dazzle of name-dropping Aleister Crowley and Anastasia spared Harry's actual influencers attention they would have modestly dodged.

"Such are the lives of our pioneers, who always preface their remarks by saying 'there's nothing to tell about me.' Lives of simple grandeur; people who are so busy being 'just folks,' that they don't know what valuable citizens they are," Sophie Walsh observed in her "Pioneer" column on Luella. "One message Mrs. Howard wishes me to give you: 'Tell them wherever I went I never found any Gopher Prairie.' To those who haven't read Sinclair Lewis' *Main Street*, we offer an explanation. At Gopher Prairie the heroine tried to uplift the community and failed. Howard says people have always been ready with friendship and help."

Louise Williams was a painter, lithographer, block printer, and teacher who studied with Randall Davey and Walter Sargent before moving to Washington in the 1920s. She played a pivotal role in the cultural life of Anacortes, and in Harry Smith's life. When asked if he studied painting, Harry replied: "Naturally I studied painting. Do you suppose I got to be the world's greatest psychopathic painter without studying painting?" Harry elaborated: "They had somebody named Louise Williams set up to be the head of this . . . and she sort of gave free art lessons to a great number of people." Soon after the Smith

family moved to Anacortes in 1932, they provided studio space to Mrs. Williams in their cannery home. "Her studio was in a sailmaker's loft in the attic of the old P.A.F. dock. There she observed the cannery workers, also Indian women as they sailed here from Neah Bay to gather a particular type of reed among the piling."[5]

Harry began ten years of art study, with lessons a few times a week, following Louise Williams's studio move from the cannery attic to the top floor of the nearby Anacortes Hotel. Imagine the conversations she and Harry had over and about art during ten years of mentoring. An extensive article explained Louise's approach to art and instruction:

> In order to take the young artist's eye away from the photographic reproduction of what he sees, Mrs. Williams has her students work on original designs illustrating the principles of transition, balance, and so on. She says that it is noticeable that the work of students in this part of the country is more vivid and bold in color and outline than she has ever before encountered. Artists observing the students' work at the fair also commented on this and ventured the opinion that the unlimited environment of northern people, the open water, clear skies and towering mountains had given them a freer, bolder attitude toward what they see.[6]

Louise Williams caused a stir upon arrival that continued throughout the summers of 1933 and 1934. Her art appeared in the new Seattle Art Museum, "at which there were several outstanding pieces of art work on display. The Women Artists of Washington also had a most attractive display there. Mrs. Williams has some of her recent art work on display in this collection."[7]

In the fall of 1934, news appeared that "Mrs. Williams is in charge of the art classes conducted under WERA [the Washington Emergency Relief Administration, begun in April 1934] activities in Mount Vernon, Burlington and Anacortes and the exhibit also includes work of pupils in these classes." Louise Williams had studied widely

and become an irrepressible educator, undaunted while supporting her family by her art. "And the curious thing was that Anacortes then was essentially a blue-collar community," pondered Harry's neighbor and fellow art student, Phyllis Luvera: "Why did we have all these opportunities? And why did the community support these programs? I don't know the answer." This intriguing question underlies a consideration of Harry Smith's childhood in Anacortes. How much of Harry's multifaceted genius arrived with him from an alien pre-life, and how much came from his enculturation in Anacortes and Bellingham, his hometowns?[8]

An awareness existed of Indigenous art among midcentury Puget Sound artists, but these tended to be extractions of visual designs, in pursuit of their own artistic visions more than attempting to understand what the Coast Salish culture meant to its native participants.

Here is where the teenage ethnographer went deeper. His work to record and transcribe the musical patterns of dance ceremonies at Swinomish and Lummi reservations changed his methodology and his mindset, and his approach to his creative life. The name of Louise Williams may not be known, even in Anacortes, but her teachings reached a wider world, filtered through Harry Smith. The way he approached his work with local tribes, so studiously and respectfully, was likely influenced by his years of art study.

"Feminist Movement" may be an overstatement of Harry's hometown subculture. Yet the list could and did go on and on of Harry's female influencers, friends, and collaborators, from his neighbors at the Anacortes Hotel, Betty and Jean Lowman, to *Anacortes Daily Mercury* publisher, Margaret McNary, to composer and musician Verna Wells, to author and anthropologist Erna Gunther, who visited Harry's Apex cannery museum and invited him to join with her college students at Swinomish ceremonies, and who introduced him to another teenage ethnographer, Bill Holm.

Ed Sanders noted that Harry "got along well with women." This was normal for Harry throughout his life, and noteworthy as a departure from the often male-centric beat and hippie scenes. Harry practiced

an uncommon fairness toward women, reportedly without sexist condescension or transactions—even while he might be mercilessly puncturing the male egos in the room.[9]

By nature, and by the nurture of frontier women educators, artists, and writers, Harry Smith explored the treasure of his own imagination. Refined revolutionaries encouraged Harry's innovation at his earliest introduction to school. It was an unexpected pleasure to learn about the natural feminism surrounding Harry—likely undeclared, though the word was certainly in the lexicon of Left Coast post-suffragettes. How can one read about Mary Louise's Alaskan teaching career, Betty Lowman's boundary pushing and canoe paddling, Henrietta's approach to art and romance, Louise Williams's work as a painter and teacher, Luella Howard's godmotherly book sharing, Jean Lowman's nurturing of young musicians and gorillas . . . and not see it add up to something wonderful?

BRET LUNSFORD grew up in Anacortes, Washington, and lives there still, working as the director of the Anacortes Museum. He has written books on local history, including *Croatian Fishing Families of Anacortes* and *Sounding for Harry Smith: Early Pacific Northwest Influences*, both published by Fidalgo Island's creative collective, Knw-Yr-Own. Bret is a founding member of the bands Beat Happening and D+. He is a graduate of the Evergreen State College and a member of the American Croatian Club of Anacortes.

10

Harry Smith's Alchemy and Magic

Charles Stein

⸙ 1 ⸙

Harry Smith has been affectionately referred to as a polymath and a magus, two species of identity not presently believed to be possible for a twentieth-century intelligence. Magic is precisely what the sophisticate disavows. And anyone may study many things, but the term "polymath" connotes a degree of omniscience not available to the human intellect since some time in the seventeenth century. I wish to suggest that the use of these terms is nevertheless oddly apt when applied to Harry Smith. For if Harry's work is assimilable as art and his knowledge commendable for its unconventional breadth, an uncomfortable implication may well be that rumors of the death of authentic magic have been grossly exaggerated, and that the ontological import of Harry's studies may lend a meaning to "omniscience" not contradicted by the impossibility of any one person's mastering the too-many fields of knowledge proliferating across our time.

⸙ 2 ⸙

Modern magic and magic for the coming times may be less a procedure for effecting miraculous changes in material conditions than an

armamentarium for effecting transformations in our sense of what is real. The art of magic would be an originary ontological or onto-poietic practice. Like art itself it would color and to some extent enforce *new being*: new modes of cognition, new frameworks for experiencing existence.

The magus would thus be omniscient in his domain. His competence would be to encompass within the closure of his thaumaturgic circle a figure of the whole. Consider Harry Smith's legendary exhaustive collections—his Easter eggs, his string figures, his paper airplanes, his Seminole blankets. Each, he hints in these lectures, serves as an index for a world. Singly and together, they limn something like a systematic magical cosmology.

The world has seen many systems of magical practice; but the modern magus comes into his own when he receives and assembles a system based on his own experience and knowledge. Harry Smith's work—and these lectures are themselves an aspect of that work—shows evidence that Harry toiled through and from, explicitly or implicitly, such a system.

Systems of magic are essentially syncretic scaffolds, gathering images, concepts, practices, and various other materials from heterogeneous disciplines and ontic realms. Like mathematics, they offer a scene for recombinant performances, allowing unheard-of connections and insights to emerge both within themselves and within the daily lives of persons whose consciousness is informed by them. The magus is thus a polymath by calling and by the nature of his practice.

3

Did Harry Smith actually "believe" in magic? René Descartes transferred the desire for certainty from the Christian's need to be certain of salvation to the secular intellect's wish for a reliable representation of the world. If salvation is consequent upon faith but faith is nothing but belief in and affirmation of a set of doctrinal propositions, certainty is a matter of ultimate concern. But in magic and alchemy, salvation is onto-poietic. The state of one's soul is reflected in the objective qualities

manifest in one's work; that is, in what one makes or makes to happen. The art of the alchemist thus shares a nature with how some artists make art. One does not begin with belief and does not concern oneself with certainty at all, though belief itself may be a factor in practical magical or artistic work: the magician might adopt belief as a tactic within the circle of his operation as the working artist accepts the terms of his subject and his craft. Beyond that, as Ezra Pound somewhere remarked, "Belief is a cramp of the mind."[1]

4

If one ventures into the world of popular occultism, one of course finds an atmosphere of clichéd imagery, embarrassingly horrendous poetry, and common ideas in outré costumes, not to mention self-deception and outright charlatanism. But nested in such untoward environs, beneath the pretense of ontological alterity, one can find ontological alterity indeed; for the occult really does provide an exit strategy from what is commonly taken to be real, and perhaps surprisingly, often a sprightly play of ontologically speculative invention. Madness, viciousness, puerility, and the pretense of spiritual authority—certainly; but also genuine liberation from cognitive conditioning, from historically limited systems of credulity, and access to the very wellsprings of how it is that we come to provide for ourselves pictures of what is real.

5

The extant texts of alchemy constitute a grand library of magical symbols, procedures, and practices. *The Naropa Lectures** allude here

*Harry Smith delivered a series of Lectures at the Jack Kerouac School of Disembodied Poetics at Naropa University (Boulder, Colorodo) from 1988–1990. During these lectures Harry would provide photocopies of handouts and play recordings, such as those of Thelonius Monk, all the while displaying his collector's obsession with categorization and comparison. He would talk on a range of subjects which included tarot,

and there to alchemy, but in a certain way they themselves resemble alchemical writings. Alchemical texts typically gather apothegms, formulas, recipes, and instructions from other spagyric compositions and link them to their own remarks. Their tone can be both magisterial and splenetic, in the latter case comprising sentences sometimes boastful, acerbic, and lodged against other alchemists whom the writer deems ignorant or otherwise inauthentic—sentences often difficult to integrate with the purported intent of the text.

Such language sports a syntax that suggests a connectivity between utterances that it does not necessarily deliver. Syntax, like the patter and passes of a stage magician, can in this way be a kind of misdirection. Apparently heterogeneous material is actually being scattered and arranged in a mosaic-like distribution, *para*-tactically, not *syn*-tactically at all. The connection between the images, assertions, conceptions, recipes, and animadversions is given by their juxtapositions, their patterns, and by resonances between them, not by the grammatical and logical syntax that fails to resolve them.

Full of discontinuities, ellipses, truncated utterances, incomplete allusions, and self-deprecating or trivial remarks, Harry's lectures assemble materials in an apparently random, fragmented, desultory manner; and yet they hint at an intentional arrangement, an orchestration of something not quite brought to bear, a congeries of meanings to be gathered, discovered, participated in, not a system of theses to be docketed, intellectually, away.

Alchemical texts are notoriously obscure and for a variety of reasons: to hide trade secrets; to mask heresy; to conceal, in the words of Harry's friend, the poet Gerrit Lansing, "real infractions beneath benign aggression"; or to preserve an indeterminacy or openness that is native to their true intent. They come with a certain darkness hanging from their roots and sources, sheltering matter properly belonging to twilight and dead

(*cont. from p. 87*) Haitian Vodou, and the indigenous folklore worlds of spirits and demons. These lectures were transcribed and published as *Cosmographies: The Naropa Lectures 1988–1990*, edited by Raymond Foye.

night from the precipitate judgments of noonday intellect. To gather what it is they have to offer, one must come into alignment with the work so that what is surreptitiously and darkly allowed to be there can surreptitiously and darkly emerge into view.

6

On the one hand, one would be a fool to think that reading a book about magical initiation is sufficient to constitute initiation. On the other hand, there are books where *the text itself is the secret*, and there are situations of seemingly casual discourse that are essentially such "books." Texts can wind their import down twisted paths of verbal subterfuge such that to experience the course of their proceedings and the intensity and inner resonances of their content is to be brought to an experience on one's own terrain of what the author would lead one on to. One cannot be led from darkness to light or lead the darkness itself into the light if the darkness is trivially illumined before the fact.

To make things more difficult, the obscurity itself may be hidden by seemingly innocent reminiscences, references to familiar topics, or the appearance of distractedness on the part of the speaker. Distractedness itself can be a form of misdirection—even when the speaker actually *is* distracted!

7

For the Christian, the devil and his disciples are "apes of God," inserting their wickedness and obscurity into luminous realms of theological intellect and spiritual practice; but magic has no need of aping anything: it has its own imagery and theology, and from its point of view the great religions as well as their nemeses—scientistic and atheistic philosophies—are themselves truncated magical systems, each limited by its particular iconographical, ideational, and narratological obsessions and inflated by sociopolitical ambitions and machinations.

Magic, in its most advanced practitioners, has the advantage of finding access to the deepest affirmation of Being without falling thrall to any ontological obsession whatsoever. I would maintain that the seemingly credulous assertions of magic theory are there to function as misdirection; that it is possible to be committed to Being precisely by remaining aloof from particular ontologies. Indeed, as thralldom is magic's provenance, the capacity to manage thralldom is its very business, though of course it is only the adept at the highest grade of initiation who even conceives of such a thing.

8

There is a fair amount of both hyperbole and understatement in *The Naropa Lectures*, as well as downright sarcasm; but not all sarcastic discourse has the same purport or charge. Preening, cynicism, alienation, defensiveness, attitudes hostile to all and sundry. But there is something more at work here, even where this catalog of neuroses may accurately identify the necrotic material out of which and on the basis of which the magical work is conducted. Sarcasm is not only sarcasm, but it is sarcasm *too*, wielded to ward off those whose hunger for thaumaturgy is not sufficient to tolerate what can be a punishing approach to the work.

9

The ceremonial magic of Europe and the Near East existed in association with Hermeticism, and, in its fullest discipline, as alchemy—alchemy neither as the vulgar quest for artificially generating gold nor the quaint prehistory of modern chemistry, but as a system of practices and intuitions intimate with the realm of matter before obsession with matter itself came to determine the two "materialisms" that dominate the present historical epoch: the reduction of nature to mathematical physics and the quantification of value by money.

Alchemy itself, of course, did deal with number, though in a man-

ner that does not *reduce* substances to their quantifiable characteristics but rather found in number itself a realm of essential qualities. The difference between the number mysticism of the Pythagorean aspect of Hermeticism or the Kabbalah and the deployment of number in modern science is an ontological difference. The very being of number is different in each case. Harry's concentration on number in his collecting and in his art is steeped in the subtleties of this distinction.

10

Alchemy's concern was the transmutation of substance and the encouragement of the "perfection" of natural processes. Its operations proceeded in discrete phases, the first of which involved the breaking down of putrescent matter into its constituent bases (a process known as *blackening* or *nigredo*); its constructive complement was the discovery and application of the philosopher's stone, an entity that shares an occult nature with everything and whose perfected virtue may, in principle, turn anything into a thing of incomparable worth. (Compare the artist's power to imbue his "medium" with aesthetic value.)

In alchemy, substance is ensconced in a value heterarchy whose most exalted and most degraded rungs are intertwined and all but identified. *The philosopher's stone is found in excrement. The way up and the way down are the same. That which is above is as that which is below and that which is below is as that which is above, for the operation of the One Thing.* The nigredo founded and pervaded the alchemical "opus" and lent to it its antinomian and pantheistic patina.

11

Alchemy, and the system of magical practices for which it provides structures, lessons, procedures, and imagery, is in a sense an ontology, but carries within the strange and untoward manner of its discourse a certain wary cynicism, a doglike impatience and lack of forbearance

regarding any fixed portrayal of what is so, because it sees the moribund at the heart of the vital, the lowliest in the most exalted, the highest in the low.

The magician's secret may lie in this: that he is concerned with that which exists just beyond any ontology—any fixed set of notions that claim to represent what is real. References to innumerable worldviews or pictures of reality are possible and in fact occur in *The Naropa Lectures* and in Harry's work in general. But even as Harry assembles such pictures of reality into an eclectic syncretism, he at the same time offers them up to be broken down. Broken down, but not dismissed or treated ironically. It is as if in their very dissolution the secret of an underwriting or underlying magical and creative ambience and activity was being brought to bear, and, for the proper audience, brought to light.

12

For the advanced practitioner of what we (along with Éliphas Lévi) might refer to as *haute magie*, all forms of ontological determinacy must suffer dissolution. The magician's manipulation of matter is at once literal, symbolic, and a mask. Material transformation, along with riddling syntactic constructions and the failure to suppress a certain cognitive scatter, might be discerned as just so many modes of misdirection, as I remarked above, even as they inspire wonder and suggest a reality within and yet beyond what seems to occur. For the practitioner of high magic really does share a certain tactic of attention with prestidigitation and popular legerdemain, in that both manipulate the play of appearances. But for the "high" magician, this concern goes to the very depths of the nature of apparency itself and its intimate entanglement with Being. That concern is tricky, full of sleights of mind on the one hand and wariness on the other. Now you see it, now you don't; now you follow the gist of the discussion, now you are lost in a jumble of who knows what species of discourse. Meanwhile, the very fabric of reality has been pulled out from under you. But it is not primarily

as performance for *you* or for *us* in general that this confusion-casting is primarily intended, for its public display reflects an operation the magus performs within, upon, and for himself. It is on this ground of the self-dissolution and reconfiguration of his deepest sense of what is real that the significance of the operation lies. This internal aspect of things is kept most secret and yet potentially has effects that impact upon history. Harry did not, in spite of everything, wear his magic on his sleeve. And yet, in an unheard-of sense, historical and cultural reality are played out through the individual magician's ontological workings. Magic and history are reciprocals, not antitheticals, for things might just be quite as Gerrit Lansing writes: "[T]he sense of history as well as of subjective past & future is magically determined, just as the magic appropriate to an age is historically determined."[2] If, as I maintain, magic is the site of onto-poietic originarity, well then . . . just so.

13

To work upon the historical *mise-en-scène*, the magician's work must be subversive, disruptive. *The Naropa Lectures* treat intellectually familiar subjects and ethnographic research but in unfamiliar ways. Harry, for instance, uses Freudian notions in their most disruptive register rather than for their quasi-scientific or therapeutic import, and he introduces tribal practices that can be extraordinarily disturbing. See in particular his presentation of the "howling dog" rite in the first lecture on cosmology.

At practically every point in his lectures Harry is concerned to unsettle (or reveal the unsettled nature of) conventionally "settled" things. For Harry, the ethnographic approach to reality encourages the relativization and disruption of conventionally held views of what is real and the displaying of patterns and possibilities conventionally unnoticed, disregarded, or denied. Consider this list of topics culled almost at random from the lectures: epileptic auras; ecological reasons for human sacrifice; cannibalism; the tonal pitches of car horns at different epochs of modernity; Paleolithic plate-tectonic collisions; floods and

"The Flood"; voodoo possession; untoward information about ethnogastronomy; the untoward implications of certain scientific findings; contact with the dead; life at the edge of hazard, chance, danger, and indeed *over* the edge, for the sake of energies accessible only by means of such adventures; an invocation of the very principles of truth he is undermining and at the same time exhibiting a conscientious concern for lost and repressed realities and the truth-realms embodied in suppressed and vanquished peoples; ritual wounding; scarification; ritual role reversals; boundary crossings; cruelty and self-cruelty; obscenity, ritual and otherwise; extreme physical states (hunger, sleep deprivation, ecstatic dance, hallucinogens, concentration); instances of extreme order (ceremonial, categorical, taxonomical); the uncanny nature of children's games; the termination of the human species; demonology; Native American smoke signals; whistles as signals in city slums; tribal warfare as tribal games; initiation through horror; the power of sticks . . .

14

There are people whose work concretizes a lifelong series of concerns, each facet of which undergoes *intensification* rather than *development*. The intellect of such a person *circumambulates* its interests. Each time it returns to a given point, it finds it on another ring of a spiral with an increase in intensity and sophistication, a bringing to bear of all the other points crossed since the last time round. Such circumambulation generates a field that in fact is the inner principle of the work, the background realm from which and to which it has inner reference, though it is not reference, precisely; rather, it is that from which the work draws its integument, its integrity. This field is also evident in much besides the work as such: daily life, casual conversation, and, most pertinently, informal, partially prepared public talks, lectures, and presentations. *The Naropa Lectures* circumambulate their topics, create a field not just for the appreciation but for the actual operation of Harry Smith's work.

15

To encounter Harry Smith with any sustained attention is to have that attention compromised by the evidence for and indeed the presence of disarray, disorder, chaos; and this is likely to happen in a manner that by its very nature exceeds any salutary interpretation of it by alchemical or other psychological, ontological, or cosmological categories. For the category of chaos is itself the paradoxical excess or erasure of all categories, and it is in continuity with and as if arising from such chaos that Harry Smith's concentration, creativity, and magic is performed. At one moment one sees the brilliance and pertinence of Harry's disarray to the multifaceted forms and patterns ubiquitous in his creative work; in the next, chaos is chaos indeed—a frantic or entropic buzz or miasma that threatens and often does undo the creativity it also fosters.

16

Harry Smith's biography is a story of ferocious concentration and tragicomic losses—lost or destroyed films, artworks, libraries, collections. In identifying the disarray that appears as well in these lectures with something like the alchemical nigredo or *putrefaction*, one does not mean to dispel its disturbing and even ruinous character. For its disturbance is of its essence. One must endure the hazard to enjoy the bounty. The disarray is internal to both form and substance. It provides the inalienable agitation behind the schemes of order and is in part the subject of the work. Everywhere there is the antithetical coincidence of extreme concentration and abject chaos; the coincidence of rigorous method and inevitable (and not merely *studied*) going astray.

17

Material chaos and mystical union share the impossibility of realizing their nature in intuitable form or cognizable category. For the

Platonists, matter was a formless receptacle that *takes on* form. Matter, in the premodern West, was formless, indescribable, ineffable. On the other hand, the One, the Good, the Ultimate Principle—was beyond all form, being its origin and source. It too was formless, indescribable, ineffable. For this reason, matter, for the alchemist, not only served as a symbol for the Ultimate; it provided a path to its realization. But for the modern alchemist, chaos/matter might also be a mask of transcendence, a false path, a descent into that from which there might be no rebound or return. And yet if one cannot hazard the exit from rational order, determinate identity, recognizable form and image, one cannot gain access to that which in its very being exceeds reason, identity, form. There is an abyss that must be countenanced, set forth upon, and crossed. The Neoplatonists struggled mightily to distinguish the aformal character of chaotic matter from the aformal character of the ultimate principle, Plotinus being particularly anxious to deny their identity. The alchemists, however, embraced and affirmed it. For them, the relation between matter and the ultimate is a heterarchy, not a hierarchy. The way down leads to the pinnacle, as the ouroboric serpent bites its own tail. The way up and the way down are one and the same.

18. *HEAVEN AND EARTH MAGIC*

The presentation of the first of *The Naropa Lectures* included a screening of Harry Smith's feature-length film work, *Heaven and Earth Magic*. The many allusions to Hermeticism and alchemy in the film have often been commented upon. What makes the work profoundly alchemical, however, is not only its allusions, its thematics, or its method of production, but its overall tone: a certain uncanny aura arising from a startling and well-nigh indecipherable layering of symbolism, allegory, irony, black humor, sublimity, Artaudian cruelty, and sarcasm. The film does not so much promulgate, describe, refer to, or even demonstrate alchemy's ontology; it manifests it, imposes it, enforces it; makes it sim-

ply be there. And what it ontologizes is a magical cosmos, a vision of the magical character of action and will.

A little man, which Harry tells us is lifted from a manual of therapeutic postures and gestures written by Judge Schreber's father, is set to symbolize what one might call the function of the magical will: that factor in the cosmos and in the person that acts—magically, willfully.

Ceremonial magic deploys just such a set of postures and gestures to organize intention and project it into the sequestrated arena (the "magic circle") wherein a magical operation is to be performed. One might compare these actions to different but related postures given by Aleister Crowley in his various expositions of "modern" ceremonial magic(k), or for that matter, the asanas in yoga or the movements and positions in Chinese systems of Qigong. In all of these, an intent is set by interrupting, altering, and enhancing the repertoire of human postures and motility. If there is a semiotics of human gesture, magical gestures and postures interfere with it, replacing conventional forms with others devised to countervail the body's enthralled-ness to them, and at the same time supplying practitioners with capacities to reorganize their somatic energies.

Furthermore, in *Heaven and Earth Magic*, equipment devised for specific uses, while remaining equipment, is set to untoward functions. The visible link between action as cause and motion as effect is abolished. There is what appears to be causal sequencing, but the push-pull mechanism of causality is not there. The little figure sets about his work in a businesslike fashion, but the business he is about is the dismantling and reconfiguration of a world. The operant principle is direct action mediated only by hidden patterns and correspondences intuitively descried and, once formally articulated, rigorously obeyed.

Intelligence and its connection to willfulness is rendered as a magical function through the imagistic performance of his postures and gestures. The will acts directly upon its object, the gestures and postures being simply the images by which that directness can be effected/depicted. Image mediates will to effect, but the formation of the image

(and here the act of making the film itself is secreted into the image that the film carries) is at once the performance of the thing to be done. The image is performed within the gesture. Though the act of filmmaking is conducted with the most exacting and exhausting material labor (the record of Harry's composing his films frame by frame is legendary), still, there is a sense in which the entire film is performed as a single act of will. The legend of creation and the image in the work comprise a science of anti-mediation. They mimic and parody causality. They mock technology. They provide an epitome or interpretation of action itself. The mystery of the will is its simplicity, its indifference to means and mechanisms. Physiology displays the nervous pathways by which an impulse in the motor cortex impels, say, a manual action; but for the actor, no such process is in evidence. One simply moves one's hand. Harry (both alchemical *artifex* and his analog, the filmmaker) compels his medium by an assiduous attendance upon his material means; but that attendance is magical, not technical. Or the technical itself is broken down and reassembled as magic.

It surely has seemed for some time that magic as such has been supplanted by technology; and insofar as magic is concerned with producing material effects, this seems true enough. But magic now is at its deepest level ontological or onto-poietic, as I have been insisting, not material. It challenges and wages war with precisely the technological essence of being and action. It performs its working upon our sense of what is real. Art in that way has a magical function when it takes up its responsibility to act ontologically.

Technology comes clearly into view in the twentieth century as its mechanical, nineteenth-century form is eclipsed by digital media. Whereas the mechanical gadget displays the sequence of occurrences that constitute a causal chain by which an intended effect is produced, digital equipment renders the entire causal chain invisible. From algorithm to output (whether on the computer screen or in the equipment that the computer directs) the effects arise without reference in our experience to causality at all. One inputs or activates the proper

program and expects its result. The magical actions in Harry's film, however, are neither mechanical nor digital, precisely because they are entirely intrinsic to the events that they produce. The image of them in Harry's film subverts the mechanical, using instruments for untoward and impossible purposes or at scales that belie the causal mechanisms to which they are in their proper context applied, and without at all anticipating digital technology or the reduction of mechanism and phenomenon to "information." *Heaven and Earth Magic* predates the "digital" revolution by decades and runs a course that is oblique to it. It delivers the gestures of ceremonial magic as images for the will itself, for the very nature of the human act as something unmediated, originary, of ontological primacy. In doing so the transmutation that the film effects is carried out upon the notion of technology itself—dispossessing its ontological claim. Will is essentially magical. Its mediations are illusory. One simply acts.

Possibly because magic and its alchemical language are before everything else ontologically subversive, the social performances of its operatives tend to be untoward, sarcastic, ironical. But the irony is situational. There is no simple way of communicating with the public sense of what is real that is not in appearance subversive, sadistic, absurdist, or blatantly irrational. But at the same time the essence of the irrational is itself subverted by appeals, at difficult-to-anticipate moments, in Harry's lectures, to reason itself, as is borne witness to by his apparent championing of ethnographic discipline, his own respect for the norms of scholarship, his interest in a whole library of scientific concerns.

19

In December of 1964 I had just finished the production of my one-issue magazine, *AION: A Journal of Traditionary Science*, with pieces by Robert Duncan, Gerrit Lansing, Robert Kelly, Aleister Crowley, the Greek alchemist Zosimos, and myself. On the particular afternoon on which I was bringing copies to Ed Sanders' Peace Eye Bookstore in

Manhattan's East Village, Sanders, Allen Ginsberg, Harry Smith, and perhaps others I do not recall had convened a meeting of the Society for the Legalization of Marijuana—LeMar—in the back of the store. I knew Harry's film work but had never met the man. He was interested that I was publishing Crowley and that I was planning a trip to Europe the following summer. Harry directed me to the British Museum where I might examine the original manuscripts of John Dee, which in fact I did. The physical presence of these manuscripts is itself sigilistic. It summons and registers the daimonic energies its texts both write about and conjure, as if something like the angels that dictated the Enochian Calls to Edward Kelley had possessed Dee's hand and projected their specific energies into the shapes and articulate gestures of his strange cursive: disturbing, electrifying, black ink markings, redolent of operations performed by the premier magician of the Elizabethan Age.

But the spiritual and physical presence of Harry Smith in Sanders's shop was as memorable as the manuscripts he led me to and for similar antithetical qualities: the spontaneous and apparently unwonted generosity of his spirit, but also this: in the center of his forehead, where the iconic "third eye" of the Buddhist or Hindu Tantric images might be configured, was a gray-black circuloid scab, about the diameter of a fat cigar, as if he had scarred or scarified himself with a burning ember, either materially to open or violently to extinguish the higher being associated with that trans-physiological organ.

❧ 20 ❧

It is insufficient to remark that Harry Smith's work contains "allusions" and "references" to a welter of subjects, among which are magical systems and anthropological knowledge of an arcane sort. The magical systems are present in ways that are considerably more intimate and complexly interwoven with his work and manner of working than the idea of "allusion" suggests. Were one to allude to the presence of magic in twentieth century, and indeed twenty-first-century art, one would

have to allude to Harry. In this regard, I would recommend investigating the work of Harvey Bialy, a poet, visual artist, molecular biologist, and founding scientific editor of the journal *Nature Biotechnology*, was close to Harry in his last years as a friend and disciple. His website is itself a conjuring of Smithian interests—scientific, magical, musical, and so on. Bialy's own visuals, to which I have contributed prose-poem accompaniments, are in some sense channelings of Harry's posthumous intentionality.

21

In the lectures, the package of handouts is not simply alluded to by Harry's remarks. One lecture is almost entirely dedicated to introducing them. They are themselves a welter, a tortuous territory in which one wanders, for one's edification and at one's peril. What peril? Harry says toward the end of his last lecture that he does not think he can get everyone "interested" in this welter of material, but that "the ones who *get* interested in it are the ones who are *already* interested in it." The package beckons to its own and excludes from initiation the ones who are not in fact or destined to be its initiates.

22

Harry Smith's magical practice involved the fact that he was, as has often been commented upon, an inveterate collector. As Harry points out (as with many of his most significant utterances, parenthetically), the observation of exhaustive series of phenomena of a given type provides access to a world not limited to those phenomena. Harry's collections, I would hazard, served him as if they themselves were cosmologies or magical systems. They were cognitive receptacles that served to interact with that which they did not include in such a way that phenomena otherwise unnoticed might come to the fore. One learns a magical system or creates one not in order to close off phenomena by reducing

them to a system of categories, but to catch on the fly orders hidden in the adjacent and the adventitious and as an instrument for further perception. Whatever comes one's way will be magnetized by the field character of the system one is wielding. Meaning appears through chance simultaneities and contiguities of heterogeneous realities evinced in the contact between realms. Again, one encourages the adventitious not to valorize the random as such, but for the cognitive abrasions and sparks that arise through contact and simultaneity, or to invite incursive principles of order and entities of an exogenous sort: spirits, demons, images, information, metaphors, metonyms. But then the systematic is valorized for a symmetrical reason: not because it represents an image of the order of the real, but because, together with the adventitious, it yields events of curious portent. Thus obsession and disarray, in addition to being complementary symptoms, are poles of a generative field.

CHARLES STEIN's work comprises a complexly integrated field of poems, prose reflections, translations, drawings, photographs, lectures, conversations, and performances. Born in 1944 in New York City, he is the author of thirteen books of poetry including *There Where You Do Not Think To Be Thinking*, *Views From Tornado Island Book 12*, a new verse translation of *The Odyssey*, *From Mimir's Head*, *The Hat Rack Tree*, and *Black Light Cats White Shadows*. His prose writings include a vision of the Eleusinian Mysteries, *Persephone Unveiled*, a critical study of poet Charles Olson's use of the writing of C. G. Jung, *The Secret of the Black Chrysanthemum*, a collaborative study with George Quasha of the work of Gary Hill, *An Art of Limina: Gary Hill's Works and Writings*, and a translation of seven ancient texts relating to the figure of Hermes Trismegistus, *The Light of Hermes Trismegistus*. He holds a PhD in literature from the University of Connecticut at Storrs and lives with guitarist, choral director, and research historian Megan Hastie in Barrytown, New York. His work can be sampled at his website, charlessteinpoet.com. A version of this essay was published previously in *Harry Smith Cosmographies: The Naropa Lectures 1988–1990*.

11

Harry Smith
Cosmic Collage

Maggie Corrigan

Harry Smith once described himself as "a collagist, as much as anything else."[1] American mystic, anthropologist, musicologist, and filmmaker, Smith found his hand in a variety of spiritual and artistic pursuits. Like a kind of manic bird, he amassed a holy shrine of art that included music, photographs, typewriters, art supplies, mystical objects, and other odd material ephemera. Smith was concerned with the mystical connotations of the universe and the possibility of artistic expression amid chaos. He would explore the process of juxtaposition and push the boundaries of an artform, informed by his esoteric philosophies.

One of Harry Smith's first encounters with man's attempt to commune with the forces of the universe occurred when he observed the Native Pacific Northwest tribe, the Lummi. Later, as an anthropological researcher at the University of Washington, Smith became one of the leading authorities in Native American music and customs, making frequent trips to visit the Lummi. As an anthropologist and musicologist, he sought to preserve the Indigenous customs and traditions, especially music. His dedication to activism on behalf of Indigenous people is well documented. His interest in amassing and creating historical

recordings stretched well beyond the Pacific Northwest. Smith's massive collection of American folk records was curated into perhaps his most famous work, the *Anthology of American Folk Music*, released by Folkways Records in 1952.

The original cover of the *Anthology* included a drawing by Elizabethan alchemist Robert Fludd entitled "The Celestial Monochord" in which a series of hierarchical spheres are connected and being tuned by the hand of God. The original cover illustrates Smith's propensity to connect audiovisual recording with nature, alchemy, and the occult. It is a reference to the alchemic belief in the order of the universe. Furthermore, the anthology is organized according to "Ballads," "Songs," and "Social Music," which all correspond to an elemental power. For example, "Ballads" has a green cover representing water, "Songs" has a blue cover representing air, and "Social Music" has a red cover representing fire. The organization of the *Anthology* illustrated and cemented Smith's alchemic vision of the relation between music and nature.

Smith's interest in alchemy went further than the *Anthology of American Folk Music*. Both Smith's parents were Theosophists with pantheistic tendencies, which involves the belief in an imminent God who is identical with nature. His interest in Hermetic philosophy and the mystical science of alchemy, which he saw as a shadow tradition in Western culture, was an extension of this pantheistic sensibility.

Two concepts from alchemy were important to Smith's thought and work. The first has to do with a philosophy of correspondences, or repeated patterns at different levels of existence. Alchemists believe there is no difference between spirit and matter, or mind and body; they are simply different states of the same basic material arranged on different levels of being. These levels are usually represented by spheres in a hierarchy starting with gross physical matter all the way up to the purest forms of God, as Robert Fludd demonstrated with his illustration of this process. This is closely related to the second concept fundamental to Smith's work, transmutation. This is the belief that matter

from lower levels—if their patterns are properly understood—can be transmuted to higher, purer levels by proper rearrangement.[2]

Given his interest in alchemy, Smith was interested in the magical properties of bringing two seemingly unrelated elements together and proving their interconnectedness. He began experimenting with the music in his films, believing he could take any piece of music and use it as a soundtrack for his cutout animated films, which he made by sourcing nineteenth- and twentieth-century illustrations and print media, including Sears catalogs, until the rhythm and the images would begin to synchronize. He called this discovery "automatic-synchronization." Each new piece of musical accompaniment to his films unleashed new possibilities, and each of the images was to be seen in a different light upon each viewing. In *Cosmic Scholar,* John Szwed writes: "His [Harry's] experience with different forms of music often led him to choose soundtracks by means of chance, well before John Cage's *Music of Changes* or William S. Burroughs's cut-ups made chance a byword in the arts."[3]

Smith believed the universe was already "cut-up" and put together into random intersections of being. These juxtapositions create patterns and, therefore, he would submit these juxtapositions to laborious creative processes in an attempt to understand and recognize them. In trying to comprehend these patterns of existence, he had the power to rearrange them into his own composite reality. This was the significance of the collage. Ultimately, for Smith, the power to compile and construct our own reality rested with the individual. In other words, you have the choice of what to put where, and this power affords you a limitless number of combinations and possibilities. The poet Patricia Pruitt, a former Naropa student, wrote in her journal on March 8, 1989: "Rani and I hung out with Harry this evening. He wanted us to hear a new tape in which he blended a Burroughs talk with construction noises and other out-of-distance conversation on his tape set. Rani left after the tape; I stayed, just talking with him, as usual. . . . I asked him about his painted films, only one of which I had seen. 'Batiked films,'

he corrected. 'But I didn't make them. God made them. I was just his medium.'"*

The implications of the cut-up method become particularly fascinating when examined in the context of alchemy. Smith experimented with the cut-up method in various ways that served to express something about the nature of his individual concept of reality and the universal connections. When understood in light of these processes of transmutation, Smith's approach to collages becomes inherently about the order of the universe.

According to Smith, since reality is simply made up of the placement of objects, the choice of what to place where in the cosmic collage becomes of dire consequence. If one understands the patterns between objects (or of the universe as a whole), then one has the power to rearrange them and potentially transmute them to a higher power closer to the purer forms of existence. A student of Harry Smith's was quoted in Stephen Fredman's essay in *Harry Smith: The Avant-Garde and the American Vernacular*:

> Harry was always in the process. The one thing he said to me that I particularly remember was the most important thing about reality is the relationship of objects. [He] said what makes everything real is the fact that things are ordered in the present status. In other words, things are set beside themselves and that is what makes reality. Reality is made up of just the placement of objects. This process could apply to art as well as life because in this conception of reality, everything is sacred. Everything has the potential to be transmuted.[4]

Smith also used the cut-up method to compose the structure of his most famous experimental film, *Heaven and Earth Magic* or *Film No. 12*. Taking file cards and splicing them into random order, Smith compiled a loose narrative structure for the images to take place, often oscillating

*Email from Christopher Sawyer Lauçanno, August 20, 2023.

between different projectors with various filters and frames. Of course, nothing about the cut-up method is truly random. Smith expressed to his colleagues that he felt there was some "hidden hand" guiding his process and that the laws of automatic synchronization were at work here as well. He felt that the connections he was making were more than a coincidence of perception and that there was a more profound process of exploration at work.[5]

Smith's interest in collage and amassing material objects reveals itself to be much more than a side hobby. On the contrary, Smith saw collaging as an integral part of his creative process, a cultural practice that would become a central part of his other artistic work. He assembled symbols and pieces of culture to produce larger meanings that drew from Native American spirituality and alchemy. Among the things he amassed were musical instruments, recording and projection equipment, ritualistic objects, books, records, canisters of film, typewriters, tarot cards, paint brushes, pages of holy texts carefully folded into paper airplanes, and even a small collection of animal bones. For Smith, collecting was a form of self-creation and a means by which to inform and construct his own identity. Like a humble scribe intent on recording the ebb and flow of time, the focus of Smith's work was never to insert himself into the art, but to allow the process of unsolicited juxtaposition to surprise him and guide him toward a higher form of existence.

MAGGIE CORRIGAN, also known as Marguerite Corrigan, hails from the same Pacific Northwestern coastal region that Harry Everett Smith came from ninety years before. Never one to ignore the psychic geography of a good hometown hero, she studied his work in her undergraduate film program with the help of a wonderful professor who facilitated a demonstration of his technique, Mathew Holtmeir, whom the author would like to thank and acknowledge. She is a local writer and film reviewer from Seattle, Washington.

The Tree with Roots
Why Harry Smith's Anthology *Is Such a Big Deal*

Mike McGonigal

In 1952, a compilation record unlike any before was released on Moses Asch's Folkways label. The eighty-four songs on the *Anthology of American Folk Music* not only pointed to the myriad bizarre and transcendent possibilities of American vernacular sound, they also helped to lead the way to deep changes in our society, and in the habits of obsessive record collectors.

The record showed that folk music was much more than Woody Guthrie, the Weavers, and Pete Seeger. Bob Dylan studied all the songs on the *Anthology*, as did Jerry Garcia, Joan Baez, Peter Stampfel, John Fahey, Elvis Costello, Ry Cooder, Bruce Springsteen, Nanci Griffith, and David Grisman. And, like any "sacred text" (as Fahey calls it; Stampfel refers to it as "the Touchstone, the Grail, the Real Deal, the Nitty Gritty, Ground Zero"[1]), the *Anthology of American Folk Music* has had different, divine meanings for each devotee.

Assembled by Harry Smith, the *Anthology* is an unerring sampler of raw hillbilly singing, unearthly gospel, inspired proto-country, deepest blues, unaffected murder ballads, and body-quaking Cajun dance

sounds. The 262 minutes of the collection are composed of 78 rpm recordings, "made between 1927," as Smith himself wrote, "when electronic recording made possible accurate music reproduction, and 1932, when the Depression halted folk music sales."[2] (The 78s were transferred to the then brand-new 33⅓ LP format.) The tunes were recorded in makeshift studios onto disc-cutting machines for successful record companies of the day, among them Columbia, RCA, Brunswick, and Victor. None of these were field recordings. The performers coax undiluted magic out of the banjo, jug, autoharp, fiddle, kazoo, flute, harmonica, guitar, hand claps, foot stomps, accordion, and human voice.

Smith, twenty-nine years old at the time of the *Anthology*'s release, was a mystically inclined fellow with a passion for collecting records, studying anthropological and scientific texts, checking out what Native Americans did during their most secret rituals, examining patchwork quilts made by old ladies, and gathering paper airplanes found on the street. He'd already made the first hand-painted films in this country, beautiful abstract shorts that took years apiece to complete. He made paintings, too. He'd been the subject of a two-person show at the Louvre in 1951, with Marcel Duchamp. Over the course of his life, he was the recipient of two Guggenheim grants.

Smith did a whole lot else—I haven't even mentioned the huge amount of rotting hand-painted Easter eggs he later collected and stuffed into his small Chelsea apartment. Toward the end of his life, this relatively obscure character did receive recognition from his peers. He was consecrated as a bishop in the Gnostic sect he belonged to, the Ordo Templi Orientis. In the eighties he was invited to join the American Academy of Arts and Sciences and was employed for several years by the Naropa Institute in Boulder, Colorado as a "shaman-in-residence" for their summer programs. However, the expansive, interdisciplinary mind-fuck that was Smith's life project is just now starting to be understood and celebrated. "It's all the same thing," Smith responded when asked how the *Anthology of American Folk Music* related to his other work.[3]

Smith first began to collect records while living in Oregon, initially coming across interesting discs by chance. He put together most of the recordings that were used in the *Anthology* while living in San Francisco in the late forties. According to disc-obsessed peer Phil Elwood—music critic at the *San Francisco Examiner* for the last fifty years and a professional historian and influential disc jockey—the Bay Area was a mecca for record freaks. The Yerba Buena record shop served as the primary meeting place for the area's musical cognoscenti. Smith would only purchase records in the most pristine condition, as he had plans for the discs beyond his own enjoyment of them. At the time when Smith was looking for these rare 78s of rural Southern music, other record collectors were not tuned in to this kind of music. They focused instead on early jazz and blues music.

John Cohen—himself a talented and inquisitive musician, filmmaker, and art professor—interviewed Harry in 1968 in Smith's Chelsea Hotel room. A lengthy document, respected folk fanzine *Sing Out!*, ran it in two separate issues in 1969. It's been reprinted in full in Paola Igliori's 1996 book *Harry Smith: American Magus*.

"Before the *Anthology*, there had been a tendency in which records were lumped into blues catalogs or hillbilly catalogs, and everybody was having blindfold tests to prove they could tell which was which. That's why there's no such indications of that sort [color/racial] in the albums," Smith told Cohen. "I wanted to see how well certain jazz critics did on the blindfold test. They all did horribly. It took years before anybody discovered that Mississippi John Hurt wasn't a hillbilly."[4]

"I felt social changes would result from the *Anthology*," Smith explained to Cohen. "I'd been reading Plato's *Republic*. He's jabbering on about music, how you have to be careful about changing the music because it might upset or destroy the government. Everybody gets out of step. You may undermine the Empire State Building without knowing it."[5]

Songs like Clarence Tom Ashley's "The Coo Coo Bird" and Dock Boggs's "Sugar Baby"—both sung with banjo accompaniment—were marketed in the twenties as "hill-country" music and "old-time music" (a

group called the Hill Billies had scored several hits, but the term wasn't used by the record companies for fear of alienating the Southern buying public). It was already old stuff seventy years ago; the marketing folks of the time played this up. As Smith wrote in the liner notes, "Only through recordings is it possible to learn of those developments that have been so characteristic of American music, but which are unknowable through written transcriptions alone. . . . Records of the kind found in the present set played a large part in stimulating these historic changes by making easily accessible to each other the rhythmically and verbally specialized music of groups living in mutual social and cultural isolation."[6]

The songs seem to have been selected because they were very human. Very real. They have such great qualities of sound, but in ways that one might not call technically perfect. The *Anthology* can be something of an addiction.

Fourth and fifth *Anthologies* were planned but never happened—Smith supposedly sold the original discs to Lincoln Center before they could have been properly assembled. With Smith dead six years now,* people have begun to explore and dissect the meaning of his work; the *Anthology* has thus far received the bulk of the attention. In *When We Were Good: The Folk Revival*, folklore/roots music scholar Robert Cantwell, now a professor at UNC at Chapel Hill, devotes an obsessively detailed, fifty-page chapter to the *Anthology*. He praises the arcane, nonracial organization of the set, connects the *Anthology* to esoteric religious practices, and elaborates on the origins of the musical forms found within.

In 1991, the last year of his life, Smith was awarded a Lifetime Achievement Grammy. Smith expressed gratitude for living to see popular culture profoundly altered by American folk music. Longtime supporter Allen Ginsberg reflected, "It said that he'd lived long enough to see the philosophy of the homeless and the Negro and the minorities and the impoverished—of which he was one, starving in the Bowery—alter the consciousness of America."[7]

*An earlier version of this piece was written in 1997. Smith passed away in 1991.

While I'm personally a bit too cynical to share that viewpoint, I'm glad Smith got his award. The *Anthology of American Folk Music* is the root cellar of both country and rock. Long may it reek.

MIKE MCGONIGAL lives in Detroit, Michigan, where he edits the quarterly publication *Maggot Brain*. His weekly radio program, "Buked and Scorned the Gospel Radio Hour," airs on XRAY.FM in Portland, Oregon, and CJAM in Windsor, Canada. He is author of the forthcoming *Walk Around Heaven All Day: A Sinner's Guide to Gospel Music*. An earlier version of the essay in this volume was written in 1997, and originally appeared in the alt-weeklies *New York Press* and Knoxville's *Metro Pulse* on the occasion of Smithsonian Folkways' deluxe CD box set reissue of the *Anthology of American Folk Music*.

13

Remembering Harry Smith
A Conversation with Steven Taylor, Harry's Friend and Colleague at Naropa

Interview Conducted at Naropa University by Ariella Ruth during the Summer of 2011

ARIELLA RUTH: You've been involved with the Naropa community, the Kerouac School, and the Summer Writing Program for many years. I want to talk about Harry Smith and his *Anthology of American Folk Music*. How did Harry arrive at Naropa? What would you say was his role in the writing program at that time?

STEVEN TAYLOR: I'm not sure of the dates, but I think his first summer at Naropa was '87 or '88. Previous to that, Harry had been coming around to Allen Ginsberg's place on East Twelfth Street in the East Village. He would come by once or twice a week for a while, then vanish for a time, but he'd generally come when he had a check to cash because he didn't have a bank account. Somebody would give Harry a check and he'd bring it over and Allen's secretary, Bob Rosenthal, would cash it for him.

Allen had known Harry for decades. They first met at a Thelonious Monk concert. Harry was sitting up close to the piano, and

he was making abstract drawings. Allen said, "What're you doing?" And Harry said, "Transcribing the music." They became friends.

In the late seventies, early eighties I was living at Ginsberg's on and off. There was a small room off the kitchen, with space for a single futon and a piano. I would often write and sleep there. Also, he had an extra apartment next door where I sometimes stayed.

There was always a lot of activity at Allen's place. In the back bedroom office, there would be Bob Rosenthal and maybe three or four people working on various projects—the photographs, the bibliographies, the correspondence. It wasn't just a matter of Allen promoting his career; it was about using his income to hire the local poets and artists, to make that a tax write-off, to fund poets rather than war. Bob said Allen was a cottage industry. He was.

So everyone would be very busy. But I made a point of getting to know Harry. I'd make him tea and talk to him. Anyway, he was coming around, and Allen was worried about him. Harry was staying at a flophouse on the Bowery. He had a little cubicle in there with a bed. Allen got worried and went looking for him and found that he had been in bed with the flu and had not been eating. Harry's habit was to get up in the morning and go to a diner on the Bowery to eat. But because he was ill, he didn't have the strength to get up, so he was starving to death in bed. Allen put Harry in a taxi and brought him back to the apartment and situated him in that little room. He wound up staying there for quite a long time.

Harry's teeth were so bad that he couldn't chew very well, so we would bring him soy milk, soups, mashed potatoes. Slowly he got his strength back. It was during this period that I really started to know him, to the extent that anyone could.

Every July, Allen, Peter Orlovsky, and I would head to Naropa for the Summer Writing Program. I remember standing in the kitchen in New York in June, and Allen saying, "What are we going to do with Harry?" It was clear that he wasn't strong enough to take care of himself, and soon we would all leave for Colorado.

And we both at the same time said, "Let's take him with us!"

We brought him to Naropa. He stayed in the Varsity Townhouse with Allen at first, and later we installed him in a cottage. Some of these houses on campus at the time, including the house where the writing department is now, were staff residences, and one happened to be vacant. We put Harry in there. If you look out the window here you can see the little porch where people sit and smoke cigarettes now, the student smoking area. That was Harry's kitchen stoop. These people are smoking in a magical place, and they don't know it. There was a bedroom at the other end, which is now where the recording studio booth is, fittingly.

There was a student here at the time, Rani Singh, who was helping out with organizing and catering and she was, as Allen and Anne Waldman would say, "solid," reliable. She was asked to take care of Harry. Rani checked in on him every day and made sure he had his Salem 100 cigarettes and ice cream bars. So there he was.

The first summer, the faculty of the University of Colorado film department up on the hill, who knew of Harry's film work, arranged a program. Don Yanacito organized it, a kind of Harry Smith mini festival, a showing of his films in the art department on the CU campus. They showed his *Early Abstractions* and *Heaven and Earth Magic*.

Heaven and Earth Magic (released 1957) was made of paper cutouts from old Sears catalogs: a guy in a civil war outfit, a lady with a long dress, various hardware, glassware, leather goods, and so on. Harry cut out these catalog illustrations of people and costumes and implements and used them for stop motion, frame-by-frame animation. The lady goes to a dentist, sits in the Sears mail-order dentist chair, takes laughing gas, and has a psychedelic experience. It was all very primitive in terms of medium and method, but brilliant in conception and execution. Harry did the soundtrack himself, mewing like a kitten and so on. When they showed it at CU, Harry made me leave with him. "Too damn long," he said. Walked out on his own movie.

The *Early Abstractions* were a series of films he made between 1946 and 1957. Some are multiple exposures photographing a lamp or lighting fixture and swaying the camera so that the light dances back and forth in multilayered complexity. Other sequences are made by painting on the film with ink, using a rubber stopper from an ink bottle to make a perfect circle in red, masking out parts of the frame with adhesive tape, and then adding colors to the taped-off areas so that the image mutates. He used a toothbrush as a primitive airbrush; he would put ink on the toothbrush and scrape the bristles to splatter color on the film. You have to imagine a guy doing this with these simple tools, frame after frame on film stock. In recent years, various media technicians have imitated these techniques using sophisticated technology, but they have not remotely approached what Harry did with a toothbrush and a reel of acetate, leaning over a table in a crappy hotel room for ten years.

Harry told me that he had designed the *Abstractions* to go with the best available popular music of the day and that the soundtrack was to be periodically updated to reflect the music of the moment. He also said that the films' rhythms were based on the ratio 72:13, which, he said, was the ratio of heartbeat to respiration when your mind is alert but restful. A graduate student, Sue Salinger, later told me the significance of those numbers in kabbalistic numerology. Harry would have known that. It has to do with loving kindness as the creative force in the universe.

Sue said 72:13 is "a famous gematria for loving kindness, which serves as a formula on how to bridge heaven and earth" (*Heaven and Earth Magic*). She also says that in Psalm 72, verse 13, the path of loving kindness is laid out. In her Naropa MFA thesis, she described this in some detail. It has to do with the source of all existence breathing being into being, and that the world is continually recreated in the relation between one being and another, actually in the speech or breath that passes between me and you. I'm not qualified to speak of this. I should study Torah for forty years and then come back to it.

Harry seemed to believe that the best music also expressed this ratio, which would mean that the music he selected for his films would reflect that. So I escorted Harry up to CU for the showing of the *Abstractions*. Don, the CU film professor, asked him to say a few words, so I helped Harry up to the podium, and he gave what I later learned was his stock line for such occasions, about how making films made him gray. Then he raised his right arm in the air and looked up toward the projection booth and yelled, "Turn it up!" The trailer counted down ten seconds on the screen and Beatles music came blasting out of the speakers to accompany what looked like a rapidly mutating Kandinsky canvas. I was blown away.

Apparently, when he last updated the soundtrack, the best available music of the day was the Beatles' second or third album, so he stole that audio and printed it on his sound stripe. Does that mean that the Beatles' early work was an expression of loving kindness breathing being into being? I'll buy that. At one point, he wanted my band to do the soundtrack, maybe because of licensing issues. The publishers of the video version put some experimental contemporary music on the video, but he said you should turn that audio off and experiment with other music. He showed it to us with Enrico Caruso tracks, and with tracks from his *Anthology of American Folk Music*. He said that if the music was good, there would be remarkable coincidences about a third of the time.

Ariella: Was he showing his films and giving talks at the Summer Writing Program?

Steven: We showed his work at Naropa at various times. He had made a movie incorporating American Indian dancing that he had shot in Oklahoma superimposed with footage at home in New York and overlaid with a recording of Kurt Weill's music for *Mahagonny*. It was Harry's magnum opus. The performance or actual projection of the thing was originally designed to take place on pool tables mounted on a wall, with multiple projectors and glass slides illustrating Tibetan demons appearing as a frame to the action. We had

only a single 16 mm projector from the library, the classroom wall, and the Weill soundtrack, but it was extraordinary.

We had him do a lecture in the tent every summer. Most of the summer events at that time took place in a big tent pitched on the lawn. After he died, we started the annual "Harry Smith Lecture in Strange Anthropology," which Peter Lamborn Wilson carried on for some years.

For one of his early lectures, Harry prepared a handout—a calendar for the students, one for the boys (printed on blue paper) and one for the girls (in pink). He did a calendar cosmology for the male and female aspects. It was all of this knowledge of folk symbolism mixed up with anthropology and Theosophy. I'm sure they have copies in a box in the Naropa archive. He gave a lecture based on the calendar. It would kind of ramble, but it was also brilliant. You can get a sense of his style from archive.org. There's a Harry Smith lecture there, from 1989, I think.

ARIELLA: That's right, I saw that one on the internet.

STEVEN: He was recording a lot. As I said earlier in the week (in the Song Works class), he recorded July the Fourth from predawn until after midnight. He had a recording of the night breeze, then bird song, sunrise, then rain, birds stop singing, rain stops, air conditioners come on, traffic picks up. He would record out of his window at the townhouse. When we came to take him to the picnic, he recorded the drive to campus, and he recorded the festivities, the chatter, then the fireworks, then the people leaving, cars driving away, and finally the crickets at midnight. Somewhere in the Smithsonian there's a recording of a complete Fourth of July in 1980s America.

He recorded other things, too. Early on, at the start of maybe his first summer at Naropa, I took my partner at the time, Lee Ann Brown, and her sister, Beth, to see Harry. We all went over to Allen's apartment in the townhouses, and after some conversation, I stepped out to do an errand. When I came back, the living room was

empty. I waited quite a while. Harry had taken the Brown sisters upstairs to his room. There he recorded them singing every hymn, ballad, and Girl Scout song they knew. This was his genius. Now, in the Smithsonian archive, there is a recording of two young women from the Piedmont of North Carolina singing in unison, in near-identical voices, the songs known to Presbyterian girls in that region in the late twentieth century. It's a minor national treasure.

He was a folklorist, a self-trained folklorist. So when you would speak to him he was really interested in what you had to say. He could be cranky, but if he liked you, if you were open and genuinely interested and not after anything, he was very charming and he was good at getting you to talk, or sing. He didn't talk about himself much. I think his reticence had to do with being homeless and dependent on the kindness of others.

Eventually, when he got situated, somehow, I don't know if Rani did it or Anne or Ginsberg set it up, but the Grateful Dead had a foundation, and they gave Harry ten thousand dollars a year. At the time, with housing provided by Naropa or Ginsberg or whoever was paying the rent, he could get by on ten thousand a year, so then he was finally OK. Jerry Garcia would have known about Harry because of the *Anthology*. Jerry was basically a folkie with a giant amp. He knew the lineage, so the Dead supported Harry.

What to say about Harry's role at Naropa? In the summer everybody knew who he was, and he was well known around the Summer Writing Program. He was often hanging out on his stoop, and he would talk to anyone. He would do his annual summer lecture and be at the Fourth of July with his headphones and mic, and he would be around, and his door was often open. People invited him to their classes to speak and show movies, and he obliged. He liked young people, I think, because of the curiosity, the friendliness, particularly around here. He was very sensitive to people's intentions. He would run away from anyone who had a weird vibe. He'd literally scurry off.

Mary Faithfull got Harry to perform. She used to come to

the Summer Writing Program and teach a workshop that would generate a kind of opera or play, where each student would provide a vignette. Marianne was renowned as a Shakespearean actress, which isn't widely known. Critics called her the best Ophelia of her generation. She really knew what she was doing. So at Naropa, she would generate these plays. One year, she asked Harry to be the narrator of the student play. And at the event, he improvised commentary in rhymed couplets.

When they first asked him to be in the show, he said, "I need a costume. If you get me some money, I'll make a costume." So they got him a hundred dollars and he went to the art supply store and bought long cardboard tubes, the kind that paper towels come wrapped around, and he bought many cans of gold and silver spray paint. He went into his little house, and he built this elaborate crown. There's a photograph of him that used to be in the print shop, wearing this costume. It's not there now. I don't know what happened to it. Whoever took that down desecrated a shrine. Maybe it's archived. You should get a hold of that.

ARIELLA: I think that's one of the photos that Andrew [Schelling] mentioned getting a hold of for this issue of *Bombay Gin*.

STEVEN: That was at Marianne Faithfull's opera. I went over to talk to him one night. He had finished building his headdress, and I went in, and his beard was covered with gold and silver spray paint. He had an inflated paper bag in his hand, and he said, "Don't let anyone tell you this shit rots your brains!" He was stoned out of his mind on solvents.

We knew that he had a significant, scholarly library that covered the range of his interests from Plains Indian sign language to Ukrainian egg design, to Seminole textiles, various symbol systems, string figures, all kinds of things that he had interest in as a folklorist mystic. He would take you into these rare bookstores, and he would say, "Do you have a hundred dollars? I *must* have this book." And people would buy books for him. So he had all these books on the alchemy of music and all these things he was interested in.

The books were in storage somewhere because he had been living in hotel rooms and then a men's shelter. Allen said to me, "We talked to the Naropa librarians. You ask Harry. Tell him, if he will bequeath his books to the school, we'll give him a room where he can get his books up on the shelves and he can do scholarly work."

So I was coming across campus with Harry and I pitched this, and he said, "I couldn't possibly leave my books to Naropa. I've been looking at the local Arapahoe legends and there's going to be a tremendous flood." Just as he said this, there was a clap of thunder and an absolute downpour. He ran, cackling madly, across the parking lot to his house.

Funny things happened around Harry. If you wanted to be superstitious just for fun, you could have a lot of fun with him. There were superstitious people who were really afraid of him, who avoided him. Certain artists around town would cross the street to get away from him.

He liked me. I had decided early on to win him over because when I first met him it was an unfortunate meeting, a disaster. He was drunk, this was maybe '77 or '78, and we were in a restaurant garden and this rat came running toward us, and my girlfriend Maria freaks out, "Do something!" So I pick up a pebble from the yard and fling it at the rat to scare it off, and it hit the thing square between the eyes, dead. Harry went ballistic. "How dare you strike a fellow sentient being!" I felt awful about it. Then we're standing outside talking, and this runaway car comes hurtling toward the sidewalk, straight for Maria, and I shoved her out of the way and smack into Harry. He freaked, started swinging and kicking at Maria and calling me a violent motherfucker. So I determined that I had to work at winning his trust. And I did, and we became good friends, but it took time. It took time and a lot of care.

I didn't know about his visual artwork when we first met. Then we came to Naropa and I went up to his room in the Varsity Townhouse. There was a desk, and on the desk there was a piece of

typing paper and on the paper there was a big letter from the Greek alphabet. It was so beautifully made, I thought a machine must have made that, it's so perfect. It was just one continuous outline. He never lifted the pen from the page. Absolutely elegant. He came in the room, and I said, "Where did you get that?" He said, "*Get* it? I made it!" He opened the drawer, and he had a whole stack of them, the whole alphabet, beautiful calligraphy. That was amazing.

So he was here, doing summer lectures. Rani was here, and a lot of the students did get to know him.

ARIELLA: Did he teach during the year as well?

STEVEN: I don't really know; I think he just lived here. During the regular academic year, he probably wasn't so known and appreciated, but curious young people might wonder who he was and say hello and then get sucked into the vortex of Harry Smith. Before you knew it, you'd be sitting at his table answering questions about where you come from. He would ask you about yourself, interview you as an ethnographic subject. People were very fond of him. He was small and bent over. He weighed less than ninety pounds, wore a blue and white seersucker suit all the time, and had long grey hair and a beard. People were curious about him.

The community basically adopted him. Some people knew who he was, and some people didn't. His furniture came from something that Trungpa Rinpoche had made. Trungpa Rinpoche was very much involved in visual art and space arrangement. There's a whole art or science of the use of space that they teach here that came from Rinpoche. Trungpa had made some kind of an installation arrangement of rocks and logs. If you went into his kitchen, you'd sit on a log or a big rock. He had a freezer full of things he'd collected, like a dead squirrel he found and various specimens of lichen. Anything that you could collect, anything that would be of scientific or folkloric interest, he would collect it. He was quite serious about it.

ARIELLA: Could you tell the story that you told to our Song Works class the other day about his paper airplane collection?

STEVEN: He would walk around New York and, as one does periodically, spot a paper airplane on the sidewalk. He would pick it up and carefully fold it flat and write on the wing when and where he found it and tuck it in his jacket pocket. He accumulated quite a collection over the years. It's a form of folk art, it's passed down, an oral transmission, and there are many, many variations on many designs. He made this collection of paper airplanes which is now at the Smithsonian. That teaches you something about collecting; if you collect enough of something, sooner or later it gets pretty interesting, which is how he made his living, I understand, as a younger man. He'd go into a junk store, and he'd find something, an old 78 record that he knew was rare and important. Over the years he'd collect a whole library of these things. He would assemble a set of everything that Blind Lemon Jefferson recorded, or whatever it was. Then, if he needed money, he could sell them as a set for much more than he paid for the individual items.

ARIELLA: Speaking of his collection of music, which ultimately turned into the *Anthology of American Folk Music*, historically, how would you summarize the cultural impact of the *Anthology*? The other day you mentioned something about the state of American music, popular music at the time that the *Anthology* was made, and that so much of what was put onto this collection was orally transmitted, that this wasn't widely known. These recordings weren't popular, and then this collection came out. In your opinion, especially as a musician, how do you see the impact of this collection?

STEVEN: It wasn't that the music wasn't popular. It's more that most people didn't know about this music. It's hard for us to imagine that now, perhaps, because we've had the revival of folk music and blues. When Harry passed away in 1991, there was a memorial gathering at St. Marks's Church in the Bowery. Dave Van Ronk was there. He was an important player in the early sixties folk music scene in Greenwich Village. He mentored Bob Dylan and the younger

artists. Dave was at Harry's memorial, and he said, "In 1952, I thought American music meant Frank Sinatra and Doris Day."

Because of the Great Depression and the rise of radio, all the little record labels, or little divisions of larger record labels that were recording these peculiar musics, went bust. During the Depression, a radio was cheaper than a phonograph. And if you bought the phonograph, which was more expensive, you also had to buy records. If you bought the radio, you didn't have to buy anything else, the music was free. But with the radio, you were dependent on what the broadcasters were putting out. What the big broadcasters were putting out was the mainstream, commercial popular music of the day, and the mass market, including the record business, went that way. When big band jazz was the pop vehicle, 1930s, that was cool, but it didn't last for various reasons including the demise of the bus tour circuit, due to war rationing of materials, post-war suburbanization, and because the kids stopped digging it, because you couldn't dance to it after a certain point. Partly it was that the bands' competition between themselves increasingly focused on featuring star singers, which had not been the case in the thirties. By the mid-forties, *Variety* magazine was saying the big bands were as dead as the banjo. That's why Dave said that by the early fifties, American music was Frank Sinatra and Doris Day, because as far as the mass audience was concerned, it had become the crooners, and the corporate monopoly music business, whereas the original recording industry had started much more diverse.

The first folk music recording that Harry talks about was made by Ralph Peer from Okeh Records, after the Great War. You can read this in the *Anthology* liner notes. Peer was traveling around with portable equipment and an Atlanta shopkeeper asked him to make a record of someone called Fiddlin' John Carson. So Ralph made a recording of Carson and he just thought it was awful. But the drugstore guy kept selling out and reordering the records. They ended up selling thousands of them. They kept coming back and saying they needed to print more.

So then Peer got interested and he started going around recording other folk musicians. And that was the beginning of it. There were these little labels that would record certain things, like if you were in Kansas City, you might realize that there's a market for jug band music. So there would be little companies that would put out records catering to various communities. Baptist preachers howling a sermon, Sacred Harp singers warbling about salvation, Cajun guys moaning over a squeeze box, all sorts of styles, many of which are represented on the *Anthology*.

And of course there were the so-called race records, which were little independent labels, or special divisions of larger labels, recording black musicians. There was that market. But at first, the market for the consumption of music was largely segmented, actually segregated, until jazz started to cross over into the mainstream at about the time that recording took off as a mass market phenomenon, but the real crossover took decades. You had white artists, Gershwin, billed as "The King of Jazz!" Goodman, "The King of Swing." Well, what about Armstrong and Basie? It took a decade or two before rapid, large-scale crossover gained steam, and it happened largely because of the youth market. But even then, after rock broke big, the segregated mass market persisted a long, long time. As Amiri Baraka says, if Elvis is the King, who is James Brown? God?

Harry purposefully didn't segregate the *Anthology*. He categorized the music by broad terms like "social music" and "songs." People who hear the record couldn't tell what race some of the singers were. Harry did that on purpose. Another significant thing about the *Anthology*, and part of what makes the music so powerful, is that it represented the last generation that had learned to play music largely via oral transmission. After that, everyone was learning to play from the radio and records. So it was pre-homogenization. It has the power of the family line. It's like tribal music, people learning from their elders rather than the media.

Harry knew about folk and blues recordings from childhood.

Somehow a record of a black artist, a country blues man, found its way to Harry's hometown, Bellingham, Washington. It had been mistakenly shipped to the record store and he got a hold of it as a kid and he was like, "What is this? Where can I get more of this?" With his natural curiosity he just started to collect this stuff. Then during World War II, he was working in the war production, working on bombers, so he had money, and he got his hands on large quantities of records that had been warehoused and were going to be melted down for shellac for the war effort. So he had this massive collection, which he eventually wanted to sell to Moses Asch at Folkway Records, as was his habit. When he had money, he would collect, and when he was broke, he would sell. Moe told him he didn't want to buy the collection, but he could publish part of it. Harry agreed to publish part of it if he could pick the selections, sequence them, and write the liner notes, which he did. And that's the *Anthology of American Folk Music*, which came out in 1952 on six LP discs with eighty-four tunes.

ARIELLA: Harry didn't want to hang on to his collection?

STEVEN: I believe he wanted the money.

ARIELLA: So he had been collecting these records ever since he was a kid?

STEVEN: Apparently. Whenever he got a hold of something that he was interested in he'd start to collect it and study it.

As a young man in college in Seattle, he took a weekend trip to San Francisco, and he met Woody Guthrie, smoked pot, and decided to stay there. He became involved in the jazz scene, living over a club and listening and painting the music. He also made films and then projected them onto live jazz musicians. You might say he invented the light show.

There was a conference sponsored by Smithsonian Folkways in Washington, D.C., in 1997, where all these folklorists and music people, critics, and scholars all got together to talk about the *Anthology of American Folk Music*. There were some older guys there who had

come up in the folk scene in Cambridge, Massachusetts, had been Harvard kids who had picked up on this stuff. They passed it all around as tapes. The booklet that came with the *Anthology* you could buy separately for a dollar. This fellow was saying it was expensive for a college student to buy a big box set of albums, but you and your friends could pool your money, buy the set, and then make tapes for everybody, and everybody buys their own copy of the book for a dollar, and that's how the stuff got spread around.

ARIELLA: How is it that Harry Smith collected these records for so long, yet this collection was so revolutionary when it came out? There must have been people who were aware of certain bands or singers, or had an album here or there, but was it just that this one person had this comprehensive collection that made it so innovative?

STEVEN: Scholars were aware of it. Pete Seeger was aware of the tradition of union songs and folk songs, and he was putting it out in the forties. But you have to remember that Peter and Mike Seeger were the sons of a music scholar, a very important ethnomusicologist, Charles Seeger. Pete was a Harvard dropout. These were middle-class people, which is largely what happened with the revival. There was also the red scare blacklist and the McCarthy hearings. The year the *Anthology* came out, Seeger couldn't get airplay. And the *Anthology* was in part a reaction to that blacklist on the part of a socially conscious, middle-class, Jewish, lefty record company owner, Moe Asch. It was defiant, like, "You want to talk about America? I'll show you America." It was partly, or even largely, an intellectual thing.

The revival had a middle-class impetus. Bob Dylan pretended he was a carnival kid from New Mexico or whatever, but he was really the son of a Midwest businessman, a store owner, and he learned about folk music at university, because that's where the movement was spread. The revival took off in college towns. These were not factory workers digging this stuff. Joan Baez's father was the MIT physicist who invented the x-ray microscope. These folkies weren't

exactly folks, they were middle-class enthusiasts. It was these people, like Dylan and Joan Baez, who took it to the mass audience.

Folk music *had* affected the mainstream earlier with Pete Seeger and the Weavers, beginning in '48, but that was relatively polished and sanitized, so they could get away with it, until they were blacklisted. At one point they were playing in tuxedos. To me, a lot of that first wave of revivalists had this forced presentation. Some of it was almost operatic, and some had a kind of Boston aristocracy diction, with sharp consonants and so on. DonT wanT to go dowN no moRE, privileged Yankees doing songs about coal mining. The edge came back into it with Dylan in the sixties, because he wasn't in a tux. He had the whole routine down, the country accent, the battered railway cap, the purposefully "bad" singing.

So there were important early revivalists, like Pete. Then after the Anthology came out, Pete's brother, Mike, had a band with John Cohen, from '58 on, the New Lost City Ramblers, and they started putting this stuff out and they got a name for themselves. The public was ready for it. And you had the Clancy Brothers getting recognition from '61 on. When they came over, you had forty-five million Irish Americans who thought Irish music meant "Mother Machree." The real stuff wasn't widely known. But then TV variety shows picked up on it. Record companies picked up on it. It's very romantic, very seductive. Folk music is patriotic, it's recovering the lost heritage of the people. It took off. It was like a mania, like a virus. Dylan started out wanting to be like Little Richard, he started out a rock and roll musician. But at college he sold his electric guitar to get an acoustic guitar. You go to college, and the coolest people are all folkies, and the music is fantastic. You hear Leadbelly hollering about where his black girl slept last night, and it's electrifying. What is this stuff? You have to have more. You catch the virus. I've got to have the newly unearthed tune, let me hear it! They would pass these songs around and do each other's versions of the tunes.

ARIELLA: And do you think that was a result of the impact of the *Anthology*?

STEVEN: Probably. Or that body of music. It was a whole chain or complex of events. Maybe the whole thing came from Harry, as a college kid, smoking pot with Woody Guthrie in the back of a van. He never looked back. Pretty soon he's making psychedelic paintings of Monk solos.

ARIELLA: There's an early photo of Harry Smith that shows him as a teenager recording Native American songs at a reservation in the Seattle area. I know you talked about this briefly in our class this week, and you said he became really interested in Native American languages growing up in that area of the country. Do you know if he continued to pursue studies in Native traditions and why in his *Anthology* he didn't include any Indian songs or drumming?

STEVEN: That's a really interesting question. I don't know. Except that the *Anthology* was all pirated commercial recordings. These were not field recordings. He was rereleasing stuff that had been marketed commercially between the World Wars. Native songs were probably not of interest to Columbia Records at the time.

ARIELLA: When you knew him later in his life, when he was here at Naropa or in New York City, were Native American cultures still of interest to him?

STEVEN: Oh sure. He put out the Kiowa Peyote Meeting record in 1973. When you start recording Native American song, there are certain ethical considerations. You can read the liner notes and look at how the album cover was set up. Harry was very respectful, very careful in his method of presentation. He said he hoped the record would serve practitioners of the peyote religion who couldn't make it to the ceremony. But that was a particular series of events that he experienced personally with these Kiowa guys in Oklahoma. I don't think he was interested in mass marketing Native music.

ARIELLA: Everything that ended up on the *Anthology*, that was all studio recorded?

Steven: It was studio recorded or it was professionally recorded in a room with the best equipment available. It was a commercial enterprise. It wasn't folklorists. It wasn't Alan Lomax going around recording in jail cells. It was people who were trying to sell records.

Ariella: Do you think he kept it to the commercial recordings because there was such a contrast between the commercial stuff and then going to some sort of gathering and just bringing a recorder and recording songs?

Steven: Yeah, he didn't make any of the recordings on the *Anthology*, although he did record people. He recorded the Kiowa singers, and he recorded the Carter Family at some point. But the *Anthology* was all record company product. My guess is that what he wanted to do was a cross section of what was commercially available in the United States as folk music in a particular five-year period. It's the period between electronic recording coming in and the Depression shutting down the labels. So it was 1927 to 1932, something like that. I think he was just doing a cross section of American popular music, or folk music, just before big media took over.

Ariella: Do you think that he did make field recordings at some point for his own collection?

Steven: I know he made recordings of people, and I know he made recordings of other people's record collections. He made concert recordings in New York in the eighties. And he recorded my band, False Prophets, in downtown clubs. He was particularly interested in rehearsals and auditions of new players. He used to blast one recording he'd made when we auditioned a drummer. It was the first thing Ben Daughtry ever played with us and it was fantastic. Here's this kid from Kentucky trying out for the New York band so he can go to Europe and be a punk rock star for a month, and Harry caught that. It was fresh and kicked serious ass. Harry used to blast it on his stereo in the cottage, and people would come over from the classrooms next door to complain.

When I went to Brown, I had the most extraordinary experience around Harry's private tapes. I went to do an ethnomusicology degree. In my application—you know you write a little essay—I said that Harry Smith turned me onto the idea that what I was doing was something that was worthy of scholarship. It never occurred to me that the music I was practicing was something that scholars or social scientists would be interested in. Harry turned me onto the idea that they might, because he was recording me.

Harry's Smith's name rang a bell with my main teacher, Jeff Titon, who's an ethnomusicologist, blues scholar, and folklorist who runs the ethno program at Brown. He knew of Harry. So I get to Brown and I'm in a coffee shop and a woman who was in the program with me came in and we were talking—what are you doing? I'm doing Cambodian music, or whatever. And she said, "They gave me a job working in the archive." And I said, "What's that?" She said, "The music archive." I said, "I didn't know we had a music archive." She says, "Yeah, come on, I'll show you." So she takes me to the basement of the music library, and there was a big steel door, like a bank vault. She opens the door and I look in. The first thing I see is Harry Smith. Shelves of boxes of seven-inch reels with Harry's writing on the side. Somehow Brown had gotten a hold of some of Harry Smith's recordings. Jeff thought the tapes had been given to the Brown archive by a New York City DJ who knew Harry and had somehow gotten a hold of the tapes. I still don't know what's on them and they're down there in the library at Brown University. I don't know if anybody's touched them. That struck me, like he was following me around. He was dead for a year by that point. Of all things, to run into Harry Smith tapes in the basement of my music building was very strange.

ARIELLA: Were people in your program, besides your professor, familiar with Harry?

STEVEN: Not a clue.

ARIELLA: Really? I'm sure maybe they are now.

Steven: American folk music specialists know about the Folkways records. That's why Jeff knew. But everyone else I was there with was doing African work, Asian studies, Polish mountain music, Irish bagpipes. It's a matter of specialization.

You know, Harry was secretive. He never set out to promote himself as a big celebrity or a hot academic. Millions of people know about Eric Clapton, but how many know about Richard Rabbit Brown? It's like that. Forget about the folklorist who issued the stuff.

And when he lost everything, he went downhill. He lost all of his artwork. His landlord dumpstered his life's work because he didn't pay the rent. He went to Oklahoma to photograph Native dancers and hang out with the Indians and record the peyote songs and he got really wrapped up. He went to Indian country and got really into it and he forgot to pay his rent. He was making movies and recording stuff and hanging out with people, studying. His landlord put all of his belongings in the dumpster. He lost everything. When he came back to New York he kind of fell apart, or so the story goes. He drank a lot and had a bad time of it for a while. Then when I met him, about '77, he was starting to pull out of the drink. By the time we brought him to Naropa in the '80s, he was basically on coffee, codeine, and marijuana.

Ariella: Steady diet. So, losing the apartment in New York, that all happened before you and Allen brought him out here?

Steven: That's right. When I met him, he had been at the Breslin Hotel and then he lost that because they were going to remodel the hotel. It was a cheap residential hotel. Then he wound up living at Allen's for about a year. Then he went back and was living in a flophouse, and then got sick and went back to Allen's. There were a couple of periods of time when he lived at Allen's. Allen was like that; he was incredibly generous.

So finally, about 1989 or 1990, after Harry had been in Boulder for a couple of years, he would practically go back to New York for

various things. I traveled with him on one occasion. Finally, his teeth were so bad that there was fear that it was going to kill him. If your upper teeth get badly infected, you can get a brain infection and die. As part of the program of taking care of Harry, there were doctors and dentists. The dentist said he would have to do it in the hospital, it was too complicated. Then Allen said, and he may have been exaggerating, "Nobody wants to touch this, it's too risky." He's so full of rot nobody wants to risk it. So the idea then was to send him back to New York to get his teeth pulled in a New York hospital.

He went back to New York and checked into the Chelsea Hotel and just never took care of it. In the end, the ulcer got him. He had a bad stomach ulcer. But he took so much codeine that he couldn't feel his other symptoms. Eventually he started to hemorrhage. Rani was with him, and she told me about it. She wanted to call an ambulance and he refused to let her make the call. So she said, "If I go get the car will you let me drive you to the hospital?" And he said OK. By the time she got back, he was on his way out. He was singing, "I'm dying, I'm dying." He died in the ambulance.

Allen asked me to photograph his room in the Chelsea Hotel, and they had someone do the same thing here at Naropa. There's video footage of all his belongings, here and there. I went to the Chelsea, and I could barely get in the room. It wasn't messy, but there were piles of books everywhere, you could just open the door and there were a few feet of floor space. There was a little bedside table with his marijuana and his aspirin. On his bed there were cassette cases, these padded cases that hold a dozen cassettes, with all his recordings that he'd made, neatly labeled. He slept curled around this stuff. I went in and slowly photographed the spine of every book and around the room, all the belongings, all the various books and records and things. On top of one of the piles of books there was a certificate. It was very beautifully printed, really elegant, very colorful. It is said that he had been inducted into some sort

of Catholic society, but I figured he just joined so he could get the certificate. It was such a curious thing, so beautifully made. It had a date on it, one of the last things he collected. There were some Easter eggs in a drawer. I photographed the stuff and then I left. We had the memorial service at St. Mark's, and everybody came out. That was when I saw the range of his acquaintances, people who could talk about the various branches of his knowledge.

ARIELLA: Where are the photographs now, the ones you took of his belongings?

STEVEN: It was videotape, 8 mm, probably in the Ginsberg archive at Stanford. Since Allen commissioned the same routine in his Naropa rooms, that tape is probably in the Ginsberg archive, too.

Harry had these ambient recordings that he would make. He would be at Allen's place, and he would hang a microphone out the front window onto Twelfth Street, and he'd hang another microphone out the back alley where blue jays lived. He would make this very high-level stereo recording of an hour of street noise and alley noise. When he played it back, it became a conscious listening experience, like music.

He called his ambient recordings "movies for blind people." Once we did a presentation at Naropa where we played the ambient recordings through the big PA system in the tent, as if it were a concert. It was very absorbing. It was music. I told him so. I remember walking across the lawn with him here, and I said, "Harry, you're actually a great composer." He said, "I know, but don't tell anybody." I thought he did John Cage one better. Where Cage had made a live piece of ambient sound, Harry actually made recorded pieces of ambient sound. They could be listened to over and over again. He made quite a lot of those.

ARIELLA: Some of those, you said, are at the Smithsonian?

STEVEN: Yeah, they all went to the Smithsonian. I'll tell you a funny story about the Smithsonian that Rani told me. After Harry died, Rani was trying to figure out where all of his belongings were, to try

to somehow collect it into an archive. Things were here and there. He left things in people's houses because he was homeless, it was all over the place. She tried to track whatever paintings remained, she wanted to find out if collectors had bought his work and had it hanging in their dining rooms somewhere.

She knew that he had sent a bunch of boxes to the Smithsonian. So she went there and talked to one of the curators and asked what was in the boxes, and he said, "I don't know. He didn't send a packing list. We stored it but we haven't opened it." So she opens a box and on top of the box is the videotape cassette. She puts it in a machine and it's a video of Harry packing the box. "I acquired this in 1954. This is a Seminole blanket," like that. He made a videotape of himself packing each box.

ARIELLA: So there's the packing list right there. Is there a place where you can find the rest that's not in the Smithsonian?

STEVEN: The Anthology Film Archive has a bunch of his films and maybe some of the visual art. That's Jonas Mekas's place. That's in good hands. The thing that Rani was worried about with the Smithsonian was she wanted everything in one place. In a place like that, they'll do the aerospace collection over here, they'll do the Native American collection over there, the Ukrainian collection over there. Her dream is to get it all in one gallery somewhere. I don't know where she's at with that. She wound up working at the Getty Museum in Los Angeles, that's where she is now.

ARIELLA: Could you tell me that story again, the one you told in class, about how Harry could tell what county you're from by hearing you sing a verse from "Barbara Allen"?

STEVEN: I think it's in the box set notes, in the reissue of the *Anthology*. It's Luc Sante. Luc is a writer, he lived in Allen's building. He says that he had been dating somebody, a new girlfriend, and there was a party for Harry, or Harry was at a party. Luc went with his girlfriend to the party. Harry claimed that if you could sing a verse from "Barbara Allen," he could tell you what county you were

born in. She said, "OK," and she sang it. Harry said, "Mecklenburg County, North Carolina." And she said, "Yes, you're right."

ARIELLA: Had he done extensive traveling to be able to pick up on that sort of thing?

STEVEN: Yeah, he traveled, and he read a lot. He studied all the time. He was always experimenting or studying. That's all he did. Study, make art, collect.

He was constantly surprising me. He had a disco collection. I had very particular taste in music, and I just thought disco was the worst thing that ever happened. He was fascinated by it. He collected it!

There's a YouTube video of Harry getting his Grammy award. He says at the Grammy's, right before he died, "I'm glad to say that my dreams came true—that I saw America changed through music." He seems to have had a hand in that transformation.

ARIELLA RUTH is the author of the chapbook *REMNANTS* and was a finalist for the Two Sylvias Press 2017 Full-Length Poetry Manuscript Prize. She has a poem engraved on a sandstone monolith in downtown Boulder, Colorado, as part of the West Pearl Poetry Project. She holds an MFA in Writing and Poetics from Naropa University's Jack Kerouac School of Disembodied Poetics and works at the Harvard University Graduate School of Design.

STEVEN TAYLOR is a poet, musician, songwriter, and ethnomusicologist, and one of Allen Ginsberg's primary collaborators from 1976 to 1996. Taylor has published two books of poems and a musical ethnography, *False Prophet: Field Notes from the Punk Underground*. He is a member of the seminal underground rock band The Fugs, and serves on the faculty at the Jack Kerouac School of Disembodied Poetics at Naropa University. He lives in Brooklyn.

14

At Naropa with Harry Smith (1989–1991)

Tom Banger

In January 1989, when I lived in Colorado and was coordinating the North American wing of Thee Temple ov Psychick Youth (TOPY), the experimental theological organization founded by Genesis P-Orridge, my friend William Breeze called me up and said, "There's somebody I think you should meet. He's recently moved to Boulder to lecture at the Naropa Institute, and he doesn't know many people around Boulder. I think you'd benefit from knowing him." I asked who it was, and he said Harry Smith. I knew of Harry Smith because Bill had spoken of him before. Bill was one of the founders of Mystic Fire Video and had given me a video copy of the Harry Smith films. I had watched them, but frankly didn't understand them at all. They were visually stunning but extremely abstract. The *Early Abstractions* felt like animations of Kandinsky paintings, while his *Heaven and Earth Magic* resembled moving Max Ernst collages. I was familiar with the seminal 1952 *Anthology of American Folk Music* and knew Harry had compiled and released it, but I had not yet read his remarkable liner notes. He had also recorded Kiowa peyote ceremonies. I knew from Bill that Harry was a Gnostic bishop with longtime ties to the Ordo Templi Orientis (OTO),

and generally a very well-read and erudite man. Bill gave me Harry's number and I called him immediately.

I'm not sure what sort of person I expected to answer the phone, most likely a sixty-something beatnik. Harry picked up the phone after maybe five rings and shouted, "Hello, hello, hello?" I said, "Is this Harry? Hello, hello!" back at increasing volume, only to hear another "hello" in apparent reply. If I remember correctly, he hung up on me. I called back. "You're going to have to talk louder than you were!" he shouted. "Sorry if I'm shouting, but I'm kind of deaf." I practically shouted who I was, and that Bill Breeze had asked me to call him, and he shouted back, "Oh Bill, yes. What's your connection, how do you know Bill?" I told him that I ran an organization called Thee Temple ov Psychick Youth, and Harry said, "That sounds like a cult. What does your cult do?" I explained to him that our group was experimenting with sexual magic and the art of creating change through sexuality and willpower. He said, "Well, how do you do that?" I explained to him the Ritual ov Thee Three Liquids where at 23:23 hours on the 23rd of every month you visualize something you desire and you bring yourself to orgasm and then you send the fluids, along with blood and hair, to the Temple. He said, "I don't know if I'm qualified for membership because I don't think I can produce sexual fluids these days. Will you accept phlegm? I have plenty of that!" I told him I didn't see why not.

I should have known what I was in for then, but I persisted and I'm glad I did. I was based in Denver and tended to avoid Boulder, land of hippies and college students. However, my friend Ted managed a printshop on College Avenue. Every Saturday, he had the shop to himself. If I gave him a hundred bucks and brought my own paper, he'd give me the run of the place while it was open. The only condition was that no customers could show up with jobs that required the use of one of the copiers. Ted's shop had a Xerox 9600, the latest, most state-of-the-art copier available. You could literally throw in a couple dozen pages, press a couple buttons, and it would spit out multiple collated, stapled copies in a matter of minutes. I'd show up at the shop at eight sharp on

occasional Sunday mornings with a case of paper and just start printing stuff: booklets, flyers, cassette and video covers. When we needed to put out a newsletter Ted would print it on one of the A.B. Dick offset presses. Every day I showed up, we'd do thousands of dollars' worth of work for virtually nothing. I'm forever grateful to Ted for enabling the history of occulture and DIY magick—and for giving me an excuse to spend time with Harry.

The next time I went to Boulder I thought, "I'll go see Harry," and called him to see if he was home. "Of course, I'm here—I can't go anywhere unless someone drives me!" he shouted.

I pulled into the dirt parking lot in front of a tiny one-story house with red paneling. The front door was open, the house sealed only by a flimsy screen door. Not wanting to be too obtrusive, or break the screen door, I tentatively knocked on the door. No answer. I knocked louder and louder, still no answer. I was sure he was there and expecting me, so I persevered, shouting "hello, hello" and knocking louder and louder until I was practically kicking the door. Finally, a wizened, bearded, hunchbacked man opened the door. He probably had a cigarette in his hand—Harry smoked tobacco nonstop, and fortunately, I did, too. I learned later that Harry was only sixty-five when we met, but he seemed infinitely older, both in appearance and bearing. His wavy hair was almost completely white with occasional dark streaks and ran almost to his shoulders. His beard was long, almost rabbinical—it and his mustache were stained a brownish yellow. He was wearing worn brown trousers and a wool V-neck sweater over a button-down shirt. He wore a huge pair of thick-lensed glasses, the bridge repaired with tape. (He commented once that he wore the widest-framed glasses possible so that he would have a larger field of vision when he was reading. When he wore normal glasses, the frames would limit his ability to scan text.) "About time you got here," he said. "I've been waiting for you forever!" "I've been knocking on the door for some time now," I responded. Harry let me in the door and proceeded to suck me into his world for something like six or seven hours.

This was repeated every time I saw him over the next ten months or so.

I asked Harry what had brought him to Boulder. "Here I am in Boulder, the Holy City," he said. "Allen Ginsberg got me a job here as the shaman-in-residence. I'm not sure what that means, but it helps pay for some of the books. Allen lets me live in his house here at the Naropa Institute when he's out of town, which fortunately seems to be most of the time." The house was tiny; the front door opened into a small living room and a bedroom or two. The place smelled of stale tobacco and marijuana smoke and didn't appear to have been swept or dusted since before Harry arrived. The floor was covered with cat hair, dried leaves, and twigs. Near the front door, the Colorado wind had blown this detritus into spiral patterns. When I offered to sweep the floor, he angrily told me that he left the leaves there intentionally because there was beauty, and possibly a message from the wind, in the patterns it had created. I didn't ask again, and I watched the patterns evolve over my visits.

The kitchen needed some work. There were dozens of boxes of gruel piled on the table and counters. The name of the product escapes me—perhaps Ralston Complete. It claimed to provide 100 percent of the recommended daily allowance of protein, carbohydrates, vitamins and minerals in a single serving. It didn't seem very appetizing—the three different "flavors" came in yellow, red, and green boxes. The sink was full of unwashed bowls, and I'd often wash up teacups or water glasses for our libations. I don't remember Harry ever offering me anything to eat or drink, but he would ask me to make some tea or pour some water for him and myself. Sometimes, after four or five hours of nonstop listening punctuated by speech, I'd ask for a glass of water to soothe my parched throat, and Harry would tell me to help myself. He'd usually take a glass when I offered him one. There wasn't any ice in the freezer and the water was straight out of the tap, but this was Boulder, not Boston, so the water came out cool and tasted sweet and fresh. I remember using Lipton tea bags to make tea. Harry, like me, took his with milk and sugar—and a Salem Light cigarette, of course.

Harry spoke in a slow slurred drawl. He was absent-minded at first sight—he was absolutely impossible with practical matters such as schedules, repairs, or housecleaning. But mention films, books, history, music, zoology, ethnography, anything in any of the millions of books he seemed to have read, and he would suddenly spring to life. He'd hop from topic to topic and digress constantly with parenthetic notes and observations on whatever topic he happened to be speaking about. He'd start talking about one thing, digress to another, seemingly unrelated topic, then ask, "Where was I?" I'd usually still be mentally catching up with his digression; Harry would snort in disgust at my inability to follow, and dive straight back in. By the time Harry was done with his exegesis, it was obvious that the two apparently unrelated topics were absolutely related, in fact codependent. You can watch Harry connect disparate and seemingly unrelated topics in what appear to be ramblings during his Naropa Lectures.

However, Harry's tendency to ramble probably wasn't always intentional, nor all due to age—after all, he was only in his late sixties at this time. Although I don't remember Harry drinking during our time together, he did not eschew prescription drugs or weed. One afternoon while we were smoking weed around the kitchen table he laid out a mandala of the couple dozen tablets or capsules he was taking. "Four Valiums—for the Elements, seven Stelazines—one for each layer of my subtle body . . ." and on and on. I don't remember all of them, but he named half a dozen prescription products, and each of them had a mystical attribution. Harry seemed to be able to find the mystical in everything around him, and to imbue everything he did, no matter how mundane, with spiritual significance.

In my youthful naivete, I thought Harry was a lot more self-sufficient than he probably was. An attractive woman of South Asian descent dropped by during one of my early visits. "Hello Harry! Is everything okay?" she asked. "Yes, Rani, I'm fine," replied Harry, somewhat crossly, it seemed to me. "Who's your guest?" she asked. Harry introduced me, then introduced her as Rani Singh, his "minder." I now

realize what a chore it must have been to keep Harry alive and somewhat healthy, plus preventing him from wandering off or squandering all his money on rare books. In retrospect, she had the very challenging task of keeping Harry on the straight and narrow. At the time, however, Harry and I both saw her as an obstacle to all things fun—midnight conversations, book runs, pills, weed. She probably saw me as a terrible influence on Harry, and she was absolutely right. He and I treated Rani much as Jack Nicholson and his asylum friends treated the Big Nurse in *One Flew over the Cuckoo's Nest* and we did our utmost to dodge her stern gaze and commonsense admonitions whenever possible. After Harry's death, Rani became the director of the Harry Smith Archives. She's done an incredible job of preserving and promoting Harry's collections and artistic legacy.

Harry had two long-haired cats, one black and the other tawny, if memory serves me. They tended to curl up next to the front door and it was their hair that was scattered in clumps throughout the house. I asked him what their names were, and he sounded almost offended when he replied that it was demeaning to cats' spirits to name them and thus categorize them and try to determine their destinies. The two of us would sit around the coffee table (which was naturally also covered with books) while we talked and watch the cats arrange themselves into patterns. It was almost like watching TV; Harry would provide commentary on the positions they assumed and compare them to yogic asanas. He believed that the patterns they formed with their bodies were significant and that they were forming yantras with their bodies. Interestingly, they did appear to almost always be in symmetric positions and form yantras or yin/yang-like figures. Sometimes they would lie back-to-back, paw to paw or curled up together belly to back, their tails curled around themselves, adding to the impression of symmetry or perfect circularity. Harry treated these cat asanas as an oracle of sorts and thought their poses reflected the current psychic ambience. Harry seemed to always find messages in seemingly random phenomena, be it sound, cat asanas, cloud formations, or the placement of leaves, and the

signals he parsed often seemed to fit—sometimes even define—the feeling of that particular moment.

I was mesmerized by Harry's collections. According to him, "only" a fraction of his collections made it to Boulder; nonetheless, the hallways and bedrooms of the small house were packed wall to wall and floor to ceiling with his stuff—mostly books. Lacking bookshelves, Harry stacked them horizontally to save space. Some of the stacks were three or four feet high and teetered precariously. This horizontal arrangement forced you to move all the books on top of a specific title before you were able to extract it. Despite the general disorder of the house, Harry was fastidious about his books. There didn't seem to be any order to the way the books were arranged, but Harry knew exactly where each one was and would pounce to the proper location to retrieve a specific book. He hovered over me the first few times I tried to pull a book out of a stack to make sure I handled them properly and didn't dent the covers or ruffle the pages. I've never known anyone with such a reverence for the printed word.

I offered to build some bookshelves for him so he could store the books vertically, but he said he couldn't afford—*I* couldn't afford—to build proper bookshelves. I suggested using cinderblocks and one-by-ten lumber, but he said that wouldn't hold the books and would damage and discolor them. I decided against suggesting using salvaged plastic milk crates as shelving. These were the days before the ubiquitous IKEA Billy shelf. Harry insisted that the only "proper" way to build bookshelves was to use the open steel shelves that you bolt together, which were solid and would last forever. The enamel coating on the surfaces of the shelves would ensure the books didn't stick to them and prevent the shelves from staining the covers. He also felt it made it easy to pull books out without them catching on a rough surface. I knew better than to argue with Harry about anything, but especially the care and storage of libraries!

Harry's books were about everything: alchemy, Aleister Crowley, history, ethnography of every conceivable tribe and group, dictionaries,

grammars, and linguistics for every human language you can imagine. Books on chemistry, music, psychology, geography, natural science, biology, art.

Harry had a particular affinity for children's books and had an exhaustive collection of pop-up books. He loved them and would open them up, page through them, and critique the way that they had been designed. He preferred ones with illustrations that popped up into three dimensions; those with mere tabs received poor ratings. To Harry's mind, they weren't "proper" pop-up books. Besides being particular, Harry could also be very literal—if you were going to call something a "pop-up book," then it ought to actually pop up, not pull out!

Harry also had a large collection of "Choose Your Own Adventure" books whose pages were split three or four ways horizontally so you could flip the pages in different ways and get a different permutation of the story based on which section of the page you turned. His interest in these alternative stories reflected his fascination with randomness and permutations. These books captivated me because I was interested in William S. Burroughs's cut-up method and was exploring the notion that randomness could be a way of triggering so-called magical phenomena. I mentioned Burroughs to him once in the context of randomness and cut-ups, but he was a bit evasive because, apparently, despite them both being close friends of Allen Ginsberg, Harry and Burroughs had never hit it off.

"It's a terrible addiction, an affliction, my attachment to books," Harry told me. "I can't help buying them." Bibliomania is well-documented, he said. He told me there was even a pope who was so attached to his books that, unable to leave his precious library behind, traveled across Europe in the middle of a major war with a caravan of wagons filled with books. Once we happened across a photograph of the Flatiron Building in New York, and Harry told me that a famous occultist named Count Walewski had lived there. The Count was notorious for his massive collection of occult books. When he died, rather than report his death to the authorities, half the New York magical

community went into the apartment and gingerly stepped over the Count's corpse as they snuck books out of his apartment. According to Harry, Count Walewski was quite ripe (and his library significantly depleted) by the time his death was finally reported.

Harry would pull random books out of a pile, hand them to me, and then begin riffing on them while I thumbed through the pages. Sometimes he would produce a book to support a point he was making. He always knew the exact page and paragraph that contained the phrase he was looking for and would read it while underlining the sentences with a gnarled index finger. During one visit, I mentioned that I was going to the mountains to forage some wild wormwood to sell to people to make absinthe (which was illegal to sell in that unenlightened time). I mentioned I had heard or read that absinthe may have influenced the visual and color distortions of Impressionist artists. Harry immediately produced a book entitled *The World Through Blunted Sight*, in which author Patrick Trevor-Roper suggested that visual impairments like nearsightedness or color blindness may have caused the distinctive visual impressions of artists like El Greco, Monet, and others. If Harry didn't already know a little about any random topic, he had a book in his bungalow that could answer the question.

We were both fascinated by pre-Columbian culture. This was the time when Linda Schele's groundbreaking, almost intuitive, work was allowing the Mayan hieroglyphs to finally be partially decoded, revealing game-changing new insights into their history and ritual practice. Schele had entered the field as an amateur—she was an art teacher who was fascinated by the glyphs. Her interpretations—which turned out to be correct—were lambasted by the "experts" of the time. An untrained outsider himself, I think Harry identified with her and certainly admired her phenomenal work. At the time, I was teaching myself the Mayan glyphs, primarily as an artistic practice but also on a linguistic level. Harry told me that the only way to master the glyphs was to learn the language. He was right as usual, and I soon abandoned the project due to lack of linguistic resources in Denver.

I had recently spent some time at the Ute Mountain Reservation and told Harry about my experiences there. I wondered if Ute lands were not in fact Aztlan, the original homeland of the Mexica people who we generally lump under the blanket term "Aztecs." Harry thought it could be possible, because both nations spoke languages in the Athapascan linguistic group, also known as Uto-Aztecan. Legend has it that the Mexica had migrated to the area around Lake Texcoco from the north—why not southern Colorado, especially given the shared linguistic roots?

Harry grasped the historical and cultural importance of language. He told me that preserving language fragments was perhaps the only way to reconstruct entire cultures. If a culture could maintain its language, it could preserve its stories, myths, and cultural practices. Once the language was lost, the stories would be forgotten, and an entire culture and way of life would most likely be lost. Harry's great contribution to human culture was his mania to capture and preserve stories in their original language—from Kiowa peyote songs and stories about quilting and textiles to Hebrew chants. We spoke a lot about how the interplay of words and ideas can influence assumptions, affinities, and biases. As Alfred Korzybski noted, our behavior and thought are strongly influenced by the way our language is constructed. While Korzybski advocated for transforming our behavior by changing the structure of our native language, my impression is that Harry believed you could achieve similar results by studying other languages.

Despite spending most of his life in poverty, there was a patrician side to Harry that would surface from time to time. You could tell that he came from a "good family" and had been raised with old-world manners and retained some of the values he had been taught. He told me during one of our conversations that his parents were Theosophists and he grew up on the coast in a remote part of Washington state. I recall him telling me his mother and father were among the first professors of Native American languages and their home was frequently visited by representatives from various northwestern tribes bringing objects and

articles of clothing. He spoke of headdresses and drums, longhouses and totem poles, and I thought how exciting it must have been for a young boy to come in contact with such exotic people and incredible treasures. I asked him what had happened to all those irreplaceable artifacts, and he said that, like so much of his art, writings, and collections, some of them had burnt up or been stolen, but that most of it simply disappeared over the years. Although I later learned that Harry tended to "mythologize" his past, most parts of this story (with the exception of his parents' professions) align with what Harry's biographers accept as the truth.

Harry and I spent a lot of time talking about magic and mysticism. Harry had studied the Enochian system of magic, which includes colorful tablets with grids of letters. The magician would trace out patterns to "spell" the names of god and the various angels plus the words for incantations. We came up with an idea for substituting the numbers on dice with letters and coloring them based on the Enochian color scheme. We would then roll them to derive the names of spirits. Although Harry and I never followed up on this idea together, I have used this method on my own with interesting results.

Harry possessed an acerbic wit and would snap at you in a second. He immediately and mercilessly pounced on any statement that he disagreed with, or thought was incorrect, with brutal, unassailable logic. He was incredibly kind to underdogs, whether cats, cockroaches, or humans, but was relentlessly cruel to rich and entitled people. Heaven help anyone who put on airs around Harry. He spoke with compassion and authority on all types of marginal or marginalized cultures: Indigenous, urban or rural people, people of all colors, drug cultures, filmmakers, writers, poets, musicians, alchemists and magicians, academics. Harry could entertain and enlighten any listener with anecdotes and tales about all the major players in every one of those cultures.

Time vanished when you were around Harry. Our sessions tended to last from mid-afternoon well into the night, and at some point, I'd get hungry. Sometimes I'd beg off and grab some food on the way out,

but usually I just toughed it out. One evening when I was especially hungry, I started hinting at food and hunger. Harry didn't seem to catch the hint, so I finally asked him if he was hungry. "Of course I'm hungry! I've been hungry for ten years! I don't have any fucking teeth!"

His teeth were indeed rotting out—he told me his periodontal disease was so advanced that abscesses were forming in his skull and beginning to threaten his brain. He was going to have to have most of his teeth extracted and then undergo a horrific surgery that would remove much of his jaw and portions of his skull to excise the infection and prevent it from recurring. He was scheduled to return to New York in the winter of 1990 to undergo the surgery and he was terrified of it. He didn't trust doctors in the first place, and he wasn't sure he would survive the operation. When he went, Harry managed to avoid having the surgery, despite urgings by his friends and minders both in Boulder and New York.

Harry had a complicated relationship with booksellers. I made the mistake of taking him to a Boulder bookstore a couple of times, and I thought we'd never leave. He would peruse every book on every shelf. He seemed to know more about the booksellers' stock than they did and had memorized the location of every book in every store he'd visited. He found a rare edition on both of our visits to the bookstore in question. At first, he told the bookseller that it was underpriced, but nonetheless dickered over the price until the dealer brought it even lower. Books brought out an unexpected shrewdness in Harry, and he drove a hard bargain.

Harry told me he had left most of his library with someone for safekeeping and suspected someone had pilfered some of his books. He blamed the person for not protecting his collection. On one of our trips to the bookstore in Boulder, he opened a rare ethnographic book and insisted it had come from his collection because of some scratches on the binding and other markings that were nearly impossible to see. Harry demanded to know how the bookseller had gotten it. The proprietor claimed he couldn't recall who had sold it to him, but Harry

insisted that the book had arrived very recently because he remembered every nonfiction book in the shop. He was also sure that it was one of the books he had entrusted to his friend for safekeeping. Harry was so adamant about it and, given his photographic memory and obsessive attention to detail, he was able to wheedle and bully the owner until they either gave him the book or sold it to him for a fraction of the asking price.

Besides his books, the two collections Harry allowed me to see were his cards and his audio tapes. He also had a shelf filled with brown cardboard boxes that I thought were full of books or cards. "Don't touch those!" shouted Harry as I reached for them one afternoon. "They're very fragile." "What's in them?" I asked. "Painted eggs," he replied. "They can't be opened here." I didn't have the temerity to ask him why he kept something he couldn't open. I later inferred that this was his famous collection of Ukrainian Easter eggs. I didn't dare to touch them, nor to broach the subject again, so the Easter egg collection remained a mystery to me until after his death. Harry was very fussy about his collections.

Harry had an enormous collection of cards. If memory serves, the cards were packed sideways into stacks of shoeboxes so you could read the name of each deck on the side of the package. He must have had a couple hundred of them—scores of tarot decks: Crowley's Thoth deck, dozens of Marseilles decks, the Enochian Tarot, the Golden Dawn Tarot, obscure German and French decks. His collection wasn't limited to fortune-telling and playing cards, though; he also had collector decks like an R. Crumb collection of portraits and biographies of old-time country musicians, and a guide to plants of North America. He had alternate printings of some of the decks. He had dozens of ordinary playing cards, some from casinos, standard decks like the Bee and Aviator decks, as well as themed decks such as a deck from Sea World with fish on the faces. There were also numerous children's game decks—Old Maid, War, Crazy Eights, Go Fish. Harry was a completist. Once Harry decided to collect something, he collected *everything*. He also learned everything there was to know about it.

The deck I remember best was a Mickey Mouse deck. It featured Goofy as the joker, Minnie as the queen, and possibly Donald Duck as the jack. Mickey was the king, and Harry remarked that this was one of the few novelty decks he'd seen that depicted the king of hearts correctly because Mickey had the sword behind his head. "Right, a suicide king," I said. At first, I didn't think he heard me. "The suicide king! The sword is in his head and the heart from the suit is his blood." "No," said Harry, "can't you see, he's holding the sword *behind* his head." "It's frequently used as a wild card in poker," I explained. "Haven't you ever played poker?" Harry was indignant. "*Poker?* Of course not—I wouldn't *dream* of playing poker!"

Harry seemed to be knowledgeable about everything. One time the subject of ravens came up and he told me that crows and ravens are genetically the same but grow into whatever they become based on diet. I looked up this factoid on the internet many years later, and this could be the only thing he may have been wrong about. But he told me with such offhand authority that I didn't challenge his assertion then and even though Wikipedia says otherwise, to this day I have a hard time believing he got it wrong.

I remember Harry always wearing worn corduroy trousers or slacks, but one visit, I was surprised to see him in a pair of relatively new-looking Levi's. I remarked that I'd never seen him wearing jeans, and he told me that he used to always wear dungarees, as I recall him calling them, but they had gotten too expensive at some point, so he had switched to slacks. Some kind soul at Naropa had bought him a pair of Levis, and I think Harry was wearing them every time I saw him after that.

Harry seemed to know *everyone*. He'd frequently drop names like Maybelle Carter, Jerry Garcia, Dizzy Gillespie, Lou Reed, or Patti Smith, but not to impress, merely as part of a story he was telling. He was also generous with his contacts. One visit, I asked him if he had any ideas for a place in Los Angeles I could couch surf. He suggested Bridget Fonda's place and gave me her phone number. He said she was very nice and would certainly welcome me if I told her I was a friend

of Harry. I think he knew her through her mother. I'd just seen her in Franc Roddam's segment of *Aria* and was utterly infatuated with her and too intimidated to cold call a budding starlet to ask for a place to crash. Although I never had the guts to call Miss Fonda, I still have her number in my phone book.

Even in the late eighties, Harry was an obsessive collector of sound, perhaps more properly a sonic hunter-gatherer. He'd stick a mic out the window in the morning and record the day's ambient sounds—cars going by, birdsong, the wind. He said he was capturing the voices of angels, the music of the spheres. He also made ambient room recordings, recorded all his answering machine messages and phone calls, and captured at least a portion of his in-person conversations. When Harry returned from his 1990 trip to New York, he was euphoric about having received a significant grant from the Grateful Dead for him to do field recordings. Harry had already purchased a state-of-the-art portable tape recorder and begun producing higher quality recordings than he was able to capture on the Walkman he'd been using before. He played a couple of the tapes he had made during his trip.

One recording he brought back was of him, Allen Ginsberg, and Harley Flanagan from the punk band Cro-Mags in a taxicab. Harry, who seemed to be on the spiritual cusp between Thelema and Buddhism, was berating Harley about his involvement with the Hare Krishna movement. He said he didn't understand why Harley believed in what Harry saw as a simplistic religion—a degraded version of the ancient and legitimate Hindu spiritual system. Although Harry seemed to become increasingly agitated, Harley seemed to mostly ignore him while occasionally shouting "Hare Krishna, Hare Rama, Ki Jai" back at him.

I was curious why an elderly, scholarly man such as Harry (or a peace-loving gay poet like Ginsberg) would be in a cab with Harley, who had a reputation as one of the most violent skinheads in the entire US punk scene. When I asked him about it, Harry drawled in response: "I knew Harley when he was a baby. You see, Rosebud and I originally thought Harley was my son. That was the early sixties, Rosebud and

I were fucking just about anyone those days, and she had a long relationship with Glen 'Tex' Flanagan, a Hell's Angel who later went to prison. So initially, we thought he was mine, but when his voice started to change, he sounded just like Tex, so we changed his name to Harley Flanagan. He's also the only person who's ever beaten me in a staring contest." I couldn't resist the challenge and had to try him. He stared me down, silent, stern-faced and unblinking for more than half an hour until I had had enough and pretended I had to use the bathroom.

We listened to a tape of Ed Sanders of the Fugs (who also wrote *The Family*, one of my favorite books on the Manson cult) singing his version of Woody Guthrie's "This Land Is Your Land."

> This Land is their land
> This Land ain't my land,
> From California to the New York tiredland
> From the sawdust forest
> To the Gulf Stream derricks
> This land was stole from you and me

Harry also played a recording he'd made of a Butthole Surfers show. While it seemed in character for Harry to listen to reimagined folk tunes, I didn't expect him to be interested in the distorted punk mayhem that Gibby Haynes and company produced—that sounded more like my cup of tea than Harry's. When I asked him about it, Harry told me that punk is folk music, too, with its own style and vernacular. In fact, he said, although he thought that more visceral, less-produced music like punk was more "pure," he saw all popular music—jazz, rap, techno, heavy metal, and on down the list—as "folk music." I had never thought of it that way, and never would have had Harry not framed it that way. This may be the most profound thing I ever learned from Harry, as it completely transformed the way I listen to and judge music. I've concluded that Harry just loved music—any music, provided it was produced from the heart by and for working people.

And although I'm not *positive* he recorded me, I'm pretty sure I'm on more than one of his tapes. This is all a roundabout way of telling you how I came to produce the syllabus for Harry's final Naropa lecture.

As I remember, Harry called me during the summer of 1990. I was out of town most of June, so it must have been very late June or early July. He asked me if I would help him run a number of copies of the "textbook" for his upcoming lecture. He must have been in a hurry to run them off. I was excited to see the textbook, because I had never seen Harry's writing. I was frankly a bit disappointed when he handed me a stack of what appeared to be random articles on Native American culture from various historical, ethnographic, and anthropological journals, along with a Rube Goldberg cartoon. The odd pages were hand-numbered in the upper right-hand corner. I can't remember if he accompanied me to Ted's printshop or if I merely picked the master document up and went to the shop alone. In any case, there were over a hundred pages to copy, which was close to the maximum number of pages the copier could handle, so I split them as close to fifty per load as I could without having to split an article. Since the copies were two-sided, I had to add in a blank sheet of paper to copy the last page properly. I don't know why, but I threw a couple of extra sheets in the end.

The volumes would have turned out ugly and difficult to page through had they been stapled, so with Harry's consent I decided to go with comb binding. Initially Harry was insistent that they be spiral-bound, but the printshop only had comb binding supplies. I don't recall whether Harry initially wanted the notes in one or two volumes, or whether it was because the printshop only had enough small binding combs to bind all the copies. Harry and I agreed that the two volumes should be bound in different color card stock, and we settled on pink and sky blue. "Pink for girls, blue for boys," quipped Harry. We ran out of pink card stock at some point and had to switch to red.

I stopped by Harry's place in November 1990, months after his July lecture, and shortly before he left for New York to ostensibly have his

teeth fixed, and he presented me with two sets of the lecture notes. I asked him to inscribe them, and he did me one better by not only signing them, but by adding artwork. Although I didn't know it then, the time we were able to spend together was drawing to a close and this made a remarkable memento of a remarkable association.

The last time I saw Harry was probably in early February 1991. He had recently hung a tapestry that featured several Black men seated and standing around a table. Some wore military uniforms, others had high African hats. I asked him what it was, and Harry said it was the 1919 Pan-African Congress, and he named all the men in the picture: Marcus Garvey, Haile Selassie, W. E. B. DuBois, and many others I can't remember. I was surprised that Harry not only cared enough about Pan-Africanism to hang the tapestry, but also could identify all the leaders of the movement. He told me that Africa was still under the yoke of colonialists and racists and eventually had to break free.

We sat down and began talking about everything and nothing in particular, and then he dropped the bomb. "I'll be leaving for New York again," he told me. "It seems I'm being awarded a Grammy. A lifetime achievement award!" I congratulated him on his finally being recognized for the work he'd done, but he downplayed it. "I did the work they're honoring me for a long, long time ago. And now they're going to make a big deal about it. I've been starving to death all these years and they still aren't going to give me any money." I can't remember what all we talked about. But we must have talked on and on into the night, me asking questions, making observations, and Harry talking on and on in his precise, erudite, rambling drawl. When I had to pull myself away, either to eat, sleep, or both, I wished him a safe trip, assuming we'd meet again. We never did—Harry opted to remain in New York and left this world nine short months after our final conversation.

I'm finally gathering my memories of Harry more than thirty years after the fact, and although parts of our time together are embossed in my memory, they are imperfect, and our most interesting conversations are lost in time. I wish I'd kept a better diary back then and captured

more of our conversations in writing, or perhaps on tape. Harry was a brilliant, funny, complex, cantankerous, and at times, exasperating man; in my youth, I thought our friendship and conversations would last forever. I am grateful to have had the privilege of learning at the feet of a master.

Tom Banger, formerly known as Tom Headbanger, has by turns been a punk promoter, audio engineer, author, lecturer, Thee Temple ov Psychick Youth organizer, and IT professional. He recently retired from a fifteen-year US government cybersecurity career and keeps busy by writing, drawing, and growing beautiful things in his greenhouse. His Facebook and Instagram implants answer to @tombanger.

15

Automatic Synchronization
Music and Image in the Films of Harry Smith

David Chapman

Harry Smith has a secure place in the histories of experimental film and animation.

From the 1940s to the 1960s, Smith produced a series of complex abstract animated films that used a number of direct film techniques, such as hand painting, batik, and stencils. He also animated drawn and photographic images gleaned from a wide range of books and magazines. These films have received acclaim and attention for their visual dynamism and the development of animation techniques, but the relationship of Smith's films to the music that accompanied them is less often discussed, even if raising important questions about sound/image interaction and how audiences experience music and film when combined together. Smith's extended explorations of his films in combination with a variety of music in different screening contexts were also directly influential, or at least prescient, of a number of later developments in audiovisual media presentation.

Music was a central part of Smith's life and work. He received various honors for his musicological research. His *Anthology of American*

Folk Music, originally released in 1952 on the Folkways label as a six-album compilation, is regarded as a significant catalyst for the folk revival in the United States in the 1950s and 1960s and is still highly regarded today.*

Music was a key element in both the creation of Smith's films and how music might be used for creating a continuously mutable framework for their reception. Smith dubbed a key method that he advanced throughout his filmmaking career as "automatic synchronization," which he proposed for the particular utilization of music to accompany his early, ostensibly silent, films (the collection released in 1965 under the title *Early Abstractions*). At its most basic level, "automatic synchronization" consisted of taking a piece of music, playing it alongside any of his films and the rhythms of the images, and allowing the music to "automatically" synchronize. Although ostensibly the use of "automatic" here refers to the idea that music will "always" sync up with the imagery in his films, I will argue that the term also refers to the idea of "automation" as used by the surrealists: that chance procedures can bypass the controlling ego of the artist to connect with more elemental processes.

EARLY ABSTRACTIONS

The development and practice of "automatic synchronization" opens up consideration of a wide range of subsequent audiovisual practices but has proved controversial for some film critics and scholars with regard to its overall importance within Smith's film oeuvre. One sceptic is film writer Fred Camper, who describes a seminar he attended in 1972 where Smith explained his concept of "automatic synchronization."

*Smith's musicological work also included recordings of Kiowa peyote meeting songs and a proposed fifteen-LP set of rabbinical chants and prayers from Rabbi Nuftali Zvi Margolies Abulafia. The Kiowa recordings were released on Folkways, as was one record of the rabbi's material. The rabbi's grandson, the poet and mystic Lionel Ziprin (a friend of Smith's), struggled to get the complete set released, and his family are still trying to fulfill this aim.

After Smith invited everyone present to first smoke marijuana, in order to establish a suitable ambience, the seminar began:

> At one point he (Smith) explained automatic synchronization, and, preparing to show one of his films to demonstrate it, he pointed at me, as I was sitting on the floor near a stack of records, and said, "Hey, you, pick a record, any record." Without looking (it's to my eternal regret that I didn't look) I passed the first record on the stack up to him. He looked at it and said, "You idiot, not *that* record." I handed another record up to him, and he looked at it, and said, "You moron, not *that* record!" Finally, the third record was acceptable, and he played it while showing a film he was working on. I remained, and still remain, unconvinced of the virtue of this procedure.[1]

Apart from giving a sense of Smith's sometime curmudgeonly demeanor, this anecdote suggests that the procedure did involve some element of selection. However, for Camper and others this method was rendered highly problematic when Smith authorized the release of his *Early Abstractions* with a soundtrack drawn from *Meet the Beatles!*, the Beatles' first album, as released in the United States in 1964 on Capitol Records. Camper outlines his misgivings on this particular combination:

> The rhythms of the imagery are incredibly complex, polyphonic really, and the sound tends to slave certain rhythms to it, while effacing or obliterating others. It makes films that are very profound seem like happy visual accompaniment to the songs.[2]

It should also be said that this particular combination of music and image is not helped by the accompanying lyrical content. Any lyric inevitably creates an additional semantic level to the music that further skews audience engagement with the visual material. At this time the Beatles' lyrics worked the romantic vein of most contemporary pop music. Songs such as "Please, Please Me" and "I Want to Hold Your

Hand" contained lyrics that seemingly run counter to Smith's abstract and complex imagery. There is an increased incongruity noticeable with the introduction of figurative elements with occult significance in *Film No. 10*, combined here with the slower and more overtly romantic song "Till There Was You." The apparent overall randomness of the exercise is compounded by the fact that, after initial syncing of start points, the tracks just run over the films: their individual distinctiveness becomes subsumed beneath the linear trajectory of the Beatles' record.

So, why did Smith make this choice? P. Adams Sitney (1979) suggests that this seemingly casual choice of music was a deliberate gesture intended to obscure the considerable achievements of Smith's animation work by merely updating the soundtrack. Smith was capable of being self-destructive as well as careless in relation to his work. Many pieces were destroyed or went missing over the years. The most authoritative account on the choice of *Meet the Beatles!* comes from Smith's "spiritual wife" Rosebud Feliu-Pettet. She relates that Smith used this particular music due to her insistence. As a dedicated fan of the Beatles, she reasoned with Smith, "'It's got to be the Beatles. You're the highest art form that exists in this animated technique. And the Beatles are, of course, the greatest music in the world. So you belong together.' So we tried it and it worked perfectly; so perfectly that the music was used forever after."[3] This apparent indifference on the musical element belies the fact of Smith's wide knowledge of music. To take a more generous reading of Smith's choice, this was also a time of an increasing momentum in pop music, both as a genre and vivid manifestation of a new, youth-oriented consumer culture. Powerfully exemplified by the Beatles, this culture was being actively engaged with and harnessed by artists, most explicitly, of course, in pop art. Smith's direct engagement with contemporary music included producing the first album of the satirical folk-rock band The Fugs in 1965.[*]

[*] A reel-to-reel of their music apparently accompanied some screenings of *Early Abstractions* before the production of the optical print with the *Meet the Beatles!* soundtrack.

Whatever the real intentions or factors behind the choice of *Meet the Beatles!* to accompany the release of *Early Abstractions*, there are many recollections that indicate that Smith felt his films should be screened with contemporary music whenever possible. The screenings utilized a wide range of music, both live and recorded—in particular bebop jazz records and non-Western music, the more fluid and complex cross-rhythms of which were perhaps better suited to the intricate visual rhythms of Smith's films.

EMERGENCE OF A PRACTICE

As with many other things in Harry Smith's life, there are contradictory stories of his intentions in relation to the use of music soundtracks and the development of "automatic synchronization." As he relates in an interview with Mary Hill in *Film Culture*:

> Those films were all made as silent films. They were basically derived from the heartbeat and the respiration which are, roughly . . . 72 times . . . a minute, and you expire about 13 times a minute. You see, those are important Cabalistic numbers—13 is half of 26—so I had taken those two basic rhythms . . . and interlocked them in certain ways.[4]

This, however, is a later recollection. In an earlier interview with Sitney in 1965, Smith indicated that he had an epiphany on the potentialities of sound and image connectivity whilst painting to a Dizzy Gillespie record. For a time, Smith produced paintings that were representations, often note for note, of jazz tracks such as Gillespie's "Manteca."*

As Smith recalls, "I had a really great illumination the first time I heard Dizzy Gillespie play. I had gone there very high and literally saw all kinds of color flashes. It was at that point that I realized music

*The painting based on Dizzy Gillespie's "Manteca" can be seen at the beginning of Smith's *Film No. 4*.

could be put to my films."[5] Sitney states that Smith claimed to have cut down *Film No. 2* from over thirty minutes to synchronize the film with Gillespie's track "Gaucho Guero."*

William Moritz (2001) recounts a slightly different story: "Harry told me that he was jazz-crazy at that time, particularly for Dizzy Gillespie and Thelonious Monk, and insisted that he had synchronized the first three painted films to jazz performances by Dizzy Gillespie: Guarachi Guaro, Algo Bueno and Manteca."[6] Moritz also states that fellow filmmaker Hy Hirsh had recorded live performances of Gillespie's band performing these three pieces and had given the tapes to Smith.† Smith then painstakingly synchronized the images to these recorded tapes.

However, he could not afford the cost of transferring the tape to an optical soundtrack, nor of producing sound release prints. Allen Ginsberg relates that when he first met Smith, in the Five Spot Café, a jazz club, in 1959, Smith was noting Monk's playing to see whether he was on, behind, or in front of the beat. While this was connected to Smith's interest in numbers and esoteric systems, it was done specifically to analyze Monk's tempo changes for synchronizing his films.‡

Smith also related to Sitney that his interest in music stemmed from his practice of devising systems for notating dances he saw at Native American meetings in Puget Sound, where he spent a good deal of time as a teenager. This interest in the patterns and diagrams produced through this method led to a deeper attentiveness to the music itself. So, visualization of music, its patterns and rhythms, was an early fascination

*Neither the original longer version of *Film No. 2* nor a synchronized print appear to have survived.
†Moritz played Smith a bootleg LP of Gillespie's music entitled *Dizzy Gillespie Live in Sweden*. Smith insisted they were the same performances as the tapes given him by Hy Hirsch in the late 1940s. Moritz suggests these same live performances were later released, rather confusingly, as the CD entitled *Gillespie Live in Paris*.
‡This might be referring to preparation work done for *Film No. 11*, a reworking of *Film No. 10* synched to Thelonious Monk's *Misterioso*. Although the dates of Ginsberg's meeting and the presumed production of *No. 11* (ca. 1957) may be slightly at odds, the production dates for Smith's films are not always precise.[7]

developed further when he started to see colored shapes when listening to music while high. In other words, Smith's understanding of rhythm is clearly both visual and sonic. He seemed to move between these two understandings, further underscored by a notion of rhythm on a cosmic level. In a series of correspondences with artist and curator Hilla Rebay, Smith indicated his thinking around some of his early films.* In a lengthy letter of June 17, 1950, he explained to Rebay that *Film No. 2: Message from the Sun* is an

> investigation of the rhythmic organization of mans [sic] mind. Just as the atom is a small model of the solar system, in that both consist of a central force with circling points around it, the mind of man, is miniature of a greater mind. . . . This film is like the diary of the earths [sic] path around the sun during the two years I worked on it.†

The letter goes on to explain the film's construction and meaning in great detail and also enthuse about the "new kind of music" being developed by the jazz musicians who were at that time having regular "jam sessions" improvising to his projected films. Significantly, toward the end of the letter, Smith added, "[t]he rhythm of my films will automatically synchronize with any music having the same general speed. They are best silent, however." This indicates that Smith was already promulgating his concept of "automatic synchronization" as early as 1950.

On May 12, 1950, as part of the Art in Cinema program at the San Francisco Museum of Art, there was a screening announced as the premiere of four hand-painted films by Harry Smith. They were titled *Strange Dream, Message from the Sun, Interwoven,* and *Circular Tensions*.‡

*In her role as director of the Museum of Non-Objective Painting (forerunner to the Guggenheim Museum), Hilla Ribay provided Smith with a grant in 1950 to support his visual art and film work.
†From the Harry Smith Archives.
‡The Harry Smith Archive takes these titles to refer to *Films No. 1, 2, 3,* and *5,* although the Archive also suggests that the titles sometimes shifted in relation to the films.

The program noted that each one of the hundreds of painted film frames were to be considered a separate work of art. Bereft of sound prints, on this occasion the films were accompanied by a live jazz band.* In a letter to Arthur Knight, Art and Cinema organizer Frank Stauffacher wrote that he considered the show to be a highlight of the May series and that "the event made notice and even a picture in *Downbeat Magazine*."[8] The events program describes the screening as:

> Five Instruments with an Optical Solo. The film by Harry Smith will serve as the sixth instrument in a be-bop jam session to consist of an expert group in person, on the piano, cornet, valve-trombone, bass and drums. This is the first presentation anywhere of a performance in which the optical images will be tried, not as visualization of the music, but as a basis for its departure.[9]

We do not know whether this was the "first presentation anywhere" of this particular approach, but it was definitely an early manifestation of the mixing of film and improvised music as a singular event. A little over a year later, at the same venue, Smith presented four of his 3-D films. This time they were projected with, "a synchronized soundtrack of Balinese, Hopi and Yoruba music, and also accompanied by modern instrumentalists and a vocalist improvising directly from the visual stimuli."[10] Smith appears to have "synchronized" the music by playing tapes or records simultaneously with the films, as there are no records of optical prints produced using these accompaniments. The museum screening was also witnessed by Jonas Mekas, who stated that Smith would also vary the projection speeds for the films during these presentations. Mekas further suggests that Smith never really settled on a tempo for his films or the music that went with them. Similar experiments occurred at screenings with live music at various San Francisco

*Bill Moritz (2001) lists the musicians: Atlee Chapman on trombone and bass trumpet, Henry Noyd on trumpet, Kermit Scott on tenor sax, Robert Warren on bass, Warren Thompson on drums, and Stanly Willis on piano.

jazz joints, such as Jimbo's Bop City, that Smith writes so enthusiastically about to Hilla Rebay.

In the light of these differing accounts, from both Smith himself and others, it is clear that Smith was continually revising his understanding of his films in relation to both music and other conceptions of rhythm. Or that, in line with the complexity of his thought processes and Hermetic philosophy, all these possibilities could be held together at the same time without contradiction. For Smith, these were interlocking conceptions which, while apparently disparate, are all part of a wider cosmic connectivity and rhythmic pulse, both of and beyond the material world: the rhythm of music, the beating heart, the operation of the lungs, the sparking of cerebral synapses, and the revolutions of the Earth. We are here taken back to Robert Fludd's drawing of God tuning the celestial monochord that adorns the cover of the *Anthology of American Folk Music*: the Pythagorean notion that the mathematics of music is analogous to the mathematics underpinning the functioning of the universe.

THE "HIDDEN HAND"

Whether it was creative intentionality or financial circumstances (or both) that led to his early films being silent, these events indicate that Smith was clearly open about the musical accompaniment he would sanction for screenings and that the concept of "automatic synchronization" was in play from as early as 1950. Smith chose to explore the potential of this process to the end of his life, as evidenced in the classes he taught at the Naropa Institute between 1988 and 1991. As Rani Singh recalls:

> In Harry's alchemy class of 1989 we collected many different types of music, from Enrico Caruso to The Butthole Surfers to Monk and Mingus and played them to *Early Abstractions* over and over again. Each time it seemed the music was made to correspond directly, note for note with each frame: and that was just the point.[11]

There are recordings of some of these lectures where Smith can be heard rummaging through boxes of records, playing sections, finding material he approves of to play with his films, commenting, and looking afresh at his films as they are given new nuances and inflections with each new combination of music.* Given Smith's deep interest in Hermetic philosophies and alchemy, he was perhaps attracted to the seemingly "magical" properties of bringing the two elements together; each new musical accompaniment was a catalyst for the images to be rendered afresh. Through his friendship with Ginsberg, Smith knew about William Burroughs's reworking of the Surrealists' "exquisite corpse" method to develop the "cut-up technique." Smith himself explored a similar process of "automation," using the random drawing of file cards under various generic headings, to produce the narrative order for the images in *Film No. 12: Heaven and Earth Magic* (ca. 1957–62), an activity he likened to the divination method of sortilege. He indicated to Sitney that he considered the possibility that there may be some "hidden hand" leading this process. Smith's knowledge of "automation," in this sense, might provide a wider definition of his use of the term "automatic synchronization": that the chance synchronizations he observed were more than just a quirk of perception.

There were notable antecedents. The Surrealists' exploration of "automatic" drawing and writing and the collaborative creativity of the "exquisite corpse" were developed as means to overcome the controlling, rationalizing self and to open up chance occurrences and unlikely juxtapositions that might reveal the workings of the subconscious mind. The "Brain Drawings," which Smith made around the same time as his paintings to jazz music, were described by Jonas Mekas, as "automatic drawings, allowing the mind a certain freedom—for the mind to move without too much interference from the subconscious."[12] The methods of Jean Cocteau perhaps come closest to Smith's approach to film music.

*These recordings can be accessed at the Harry Smith Archive website, harrysmitharchives.com.

For his first film *Le Sang d'un poète* (1930), Cocteau commissioned composer Georges Auric to provide the score for various sequences of the film. Cocteau then reorganized the music by placing it with different sequences to the ones Auric had worked with during composition. As Cocteau stated, "[I] shifted the musical sequences, which were too close to the images, in order to obtain accidental synchronization."[13]*

Alongside the Surrealists, there was the influence of John Cage, who, motivated by his studies of Taoism and Zen Buddhism, began in the 1950s to use "indeterminacy" in his compositional work. This was a methodology designed to bypass the structuring ego of the artist and open up chance occurrences in the compositional method. His teaching at the New School for Social Research in New York City from 1957 to 1959 led these approaches to influence art practices beyond music, and some of his students became active in the Fluxus group and the art "happening," which placed chance and serendipity as important elements to open up new approaches to creativity.† In other words, the artistic milieu Smith was working in during this period was invested in opening up work to the possibilities of chance.

BEYOND THE HIDDEN HAND

The idea of a "hidden hand" is clearly of importance to Smith as an impetus for "automatic synchronization," but how can we best analyze what is being revealed in this process and understand it in relation to wider insights into audiovisual practice? Concepts proposed by Michel Chion (1994) offer productive insight. Chion describes an exercise he

*I explore Cocteau's notion of "accidental synchronization" in more depth in my 2009 article "Chance Encounters: Serendipity and the Use of Music in the Films of Jean Cocteau and Harry Smith," in *The Soundtrack*.

†Fluxus members George Brecht and Dick Higgins were students, as was Allan Kaprow, a significant force in the development of the art "happening." As Ed Saunders indicates in a video interview posted on the Harry Smith Archives, there was a lot of interaction between these different art scenes in certain New York bars and at Sanders's Peace Eye Bookstore, which Smith frequented.

dubs the "forced marriage," which consists of playing a selection of music alongside a visual sequence. He argues that this process illustrates a range of phenomena in relation to sound-image association: "By observing the kinds of music the image 'resists' and the kind of music cues it yields to, we begin to see the image in all its potential signification and expression."[14] Chion also speaks of a "transsensorial model," with which "there is no sensory given that is demarcated and isolated from the outset. Rather, the senses are channels, highways more than territories or domains."[15] He goes on to relate this to rhythm:

> When a rhythmic phenomenon reaches us via a given sensory path, this path, eye or ear, is perhaps nothing more than the channel through which rhythm reaches us. Once it has entered the ear or eye, the phenomenon strikes us in some region of the brain connected to the motor functions, and it is solely at this level that it is decoded as rhythm.[16]

Given its rhythmic visual complexity, Smith's work can conceivably find purchase with any number of rhythmic or melodic points from any given music. The description of Smith's contribution to the Art in Cinema performance as an "optical solo," while an evocative idea, suggests this idea of synesthesia. The idea of the "transsensorial model" is a less loaded term than that of synesthesia, which is often mentioned in the context of Smith's films, with its connotations of a genetically inherited "gift" or a consequence of medical conditions or narcotic experimentation.

Another useful perspective might be derived from the ecological theories of perception. Developed primarily by James Gibson (1966 and 1979), mainly in relation to visual perception, the ecological model considers human perception to be, in essence, exploratory, proactively pursuing stimulation in order to understand the environment and its changes and potentials. The perceptual system "self-tunes" to increase its absorption of information from the environment and to optimize

its "resonance" with it. Gibson condenses this process to the idea that "a system 'hunts' until it achieves clarity."[17] This "hunting after clarity" from sensory stimulation, coupled with the cultural knowledge that filmic presentation of sound and vision "invites" connectivity, is another way of considering this process of "automatic synchronization."

I would argue that the seemingly "automatic synchronization" of abstract and complex rhythmic imagery with music cannot be considered "automatic" in absolute terms; rather the automation should be understood in terms of degrees. If Smith's work is compared with that of his near contemporaries and fellow exponents of direct film, Len Lye and Norman McLaren, it becomes evident that Lye and McLaren's work is predicated on an extremely close synchronization between the music and the kinetics of the marks, forms, and colors that comprise the image.* By contrast, in *Early Abstractions* Smith's use of music can be experienced as synchronized, but this is a *soft* synchronization, in the sense that the painstaking frame-by-frame attention at work in Lye and McLaren's films is absent, if not rejected or resisted, in Smith's. It is in this sense that Smith's "soft" synchronization is "exploratory," as well as allowing audiences more space to form their own points of contact between sound events and visual events.

If Fred Camper's critical observations of "automatic synchronization" are compared to the positive acceptance by Rani Singh and Rosebud Feliu-Pettet, then questions of personal musical taste and a willingness to engage with a concept that is allowed to function as a form of "alchemy" are also allowed to seep into the equation. This is less relevant to Lye and McLaren's work, where the sound and image are more clearly structured as a unity, directing the audience's attention to the virtuosity and playfulness of the music-image synchronization rather than to the appropriateness of the music. This is also pertinent to the close synchronization employed for Smith's *Film No. 11*. A more

*This includes films such as *Swinging the Lambeth Walk* (Lye, 1939) and *Begone Dull Care* (McLaren, 1949), to name but two.

interesting case again is, perhaps, *Film No. 12: Heaven and Earth Magic*, as the images are synced here with a tightly edited montage of sound effects. These are sometimes associative, matching the actions, things, or organisms depicted onscreen, and sometimes they are more oblique, or deliberately at odds with the image presented. A hammer hitting a cow's back is synced with the sound of smashing glass, or a train noise accompanies a walking house and parade of farmyard animals. The effect is at times humorous, at others more unsettling. The use of repetition of sounds at different points in the film acts in a way similar to automatic synchronization, in that it makes apparent the fluctuating effect of image and sound through various different juxtapositions. These shifting points of purchase enhance the surrealist effect of the sound/image combinations, but also start to undermine the representational nature of the sounds themselves, as they take on a myriad of rhythmic and expressive functions in relation to the animated images. What also emerges is the complexity of Smith's sound editing, which creates an engaging piece of *musique concrète* in its own right.

LEGACY

If Harry Smith's experiments are, in many ways, of their time, can they be regarded as more than of just historical interest? Are there additional, longer-term influences discernible? While these practices tend to be presented as part of the trajectory of an individual artist, the focus on particular conceptualizations or methodologies should not obscure longer-term histories nor the creative genealogies from which these practices emerge. Smith's work needs to be placed in the context of an American avant-garde film culture that was intently interested in both the materiality of film and the exploration of psychological and sensory affect, as exemplified by Stan Brakhage's "light works" and the "flicker films" of Tony Conrad and Paul Sharits. This cinematic ground was interwoven with a counterculture interested in esoteric philosophies and altered states, and with a similar interest in the exploration

of audiovisual as a means to challenge sensory perception or to enhance chemical-induced reveries. In a catalog of his films produced for the Film-Makers Cooperative, Smith includes notes on what particular intoxicants he was taking when producing each film. In his letters to Rebay he also indicated he used sleep deprivation as a means to open a gateway to dreamworlds and spiritual states. A trajectory can be mapped from the early 1950s to the late 1960s that includes, among other work, Smith's experiments in jazz joints and the Art Cinema, Jordan Belson and Henry Jacob's multimedia "Vortex Concerts" (1957–59), Andy Warhol's "Exploding Plastic Inevitable," and Ken Kesey's West Coast "Acid Tests"—new cultural forms and experiences open to notions of the "random," or at least of the loosely structured combinations and interactions of music, images, dance, and light, thereby opening up new forms of audience engagement and experiences. As Sitney mentions, if Smith's Hermeticism could sometimes make him seem aloof from the theoretical debates of fellow filmmakers, he was much more aware of these wider explorations than he sometime admitted and was fully cognizant of the practices of his contemporaries, many of whom were friends and associates.

The creation of multimedia and multisensory experiences became the hallmark of psychedelic events and concerts. In both his practice and through personal associations, Harry Smith can be seen as a direct precursor of these cultural practices. Along with live music and film screenings, he created "proto-light-shows"—multiple-projector screenings that he refilmed from the screen during performance.[18] In the early 1960s Smith presented his films at the Film-Makers Cooperative in New York. There he created special screens for projection of his films, which he then augmented with additional projected images and colored filters. As Ginsberg recalls, the early light shows at the Fillmore in San Francisco were created using some of Smith's equipment, abandoned when he moved to the East Coast, including the process of mixing oil and colors on a mirror, which was then projected to create "liquid flowing, moving psychedelic images."[19]

Harry Smith's experiments must be put in the context of a centuries-long search for forms exploring the idea of synesthesia and the seemingly intimate connection between light, color, and music. As documented by Barbara Kiensherf (2005), this body of theoretical experimentation and attempts to create "color music" in a performance context had been investigated for a number of centuries through a variety of inventions (such as color organs and pyrophones) with varying degrees of success. This endeavor was largely taken up the 1920s and 1930s by filmmakers such as Viking Eggeling, Hans Richter, and Oscar Fischinger, the latter having collaborated with color slide projectionist Alexander László in the 1920s and developed his own Lumigraph color organ in the 1940s. Indeed, Fischinger is particularly important in the American context, having had a direct influence on figures as diverse as Walt Disney, the Whitney Brothers, and Harry Smith himself. Smith visited Fischinger and paid respect to him with his *Film No. 5*, the occasional title of which is *Circular Tensions (Homage to Oscar Fischinger)* (ca. 1950).

In this longer and wider context, the pioneering work of Smith can still be seen as relevant. Combining music and image based on the operation of chance and forms of automatic synchronization has been a consistent element in various media forms up until the present, particularly in popular music culture. The emergence of the VJ in 1980s and 1990s—mixing eclectic selections of video material as a visual backdrop at concerts or in a club—is also continuing this approach. There is still a fascination in adding new music to Smith's films and continuing the exploration of automatic synchronization. Musicians such as Philip Glass and DJ Spooky (Paul D. Miller) have performed live sets to Smith's films, and a search of the internet offers numerous new combinations of music for the films.

I want to conclude by taking up Paul Virilio's suggestion that to invent a specific technology is to invent the relevant accident:

> To invent the train is to *invent the derailment*. . . . if the accident reveals the substance, it is indeed the "accidens"—what happens—

which is a kind of analysis, a techno-analysis for what "substat"—lies beneath—all knowledge [original emphasis].[20]

Even if, or perhaps, precisely because, Smith's experiments were only partially understood, and had to be viewed through the lens of his multiple preoccupations, they can be productively rethought as "accidens"— they were attempts to open up knowledge and a better understanding of the sound film and of the ability of music and image to operate on each other to create meaning and modulate affectivity. From here the important question is: What is the "substat" of Smith's experiments; which unexplored cinematic, theoretical, and historical trajectories lie beneath Smith's pursuit of "automatic synchronization"?

DAVID CHAPMAN is a filmmaker, sound artist, and researcher based in London. Through film and audio installations he investigates the sonic mediation of the natural world, historic buildings, and the durational aspects of place. David's practice includes *Watermark* (2012, York Guildhall), *Octo: Sotto Voce* (2009, York Minster), and *Resounding Falkland* (2010, Falkland Estate, Scotland), a series of works made in collaboration with Louise K. Wilson. Other site-responsive projects are the video series *Observances* (2005, Café Gallery, London), the audiovisual installations *Hark* (2005, Gunpowder Park, UK), and *Hark 2* (2007, Matrix East, London), made with photographer David Cottridge. More recent work explores historical and cultural issues. These include *Meanings of Failed Action: Insurrection 1946* (2017)—a multimedia installation produced in collaboration with Vivan Sundaram, Ashish Rajadhyaksha, and Valentina Vitali (2017, Mumbai 2017; 2018, New Delhi) that focuses on a politically charged moment of South Asian history, and the documentary video installation *Art as Problematic Waste* (2019), codirected with Finnish artist Aimo Hyvärinen (2019, UK/Finland), which explores the overproduction and decommissioning of art. David was awarded a PhD for research on sound, place, and perception and writes on film sound and sound art. He teaches film and sound at the University of East London; his website is davidchapman.info.

16

Backstage of a Glyph
The Structure of Harry Smith's Mahagonny

Rose Marcus

Each film has its own language, and in the case of Harry Smith's *Mahagonny* (*Film No. 18*, 1970–1980), the film presents a hybrid language in extremis. *Mahagonny* floods and hammers the audience with hundreds of scenes, each constellated between four separate film reels. Smith projected the reels simultaneously on four 16-mm projectors; he situated each projector so that onscreen the films appeared as a unified two-by-two grid of interlocking imagery.

The dense quilt of hundreds of scenes—of New York City, handmade animations, and intimate portraits—revolves across the four reels for two hours and twenty-one minutes. The grid of imagery provides a sweeping experience that overloads the viewer with multiple actualities. The scenes shift minute by minute, creating a rhythmic, saturated set of relations within the grid. Examples include: Chelsea Hotel denizens in capes enacting movements suggesting ritual; disembodied hands scraping and smoothing out designs into colored sand, sensually pouring paint, and constructing string figures; and mirrored projections of Central Park and Times Square. Smith overexposed some scenes, and staged and sped up others, all while interlacing them with blank black

pauses and the experimental animations. In the following pages, we will dive into Smith's planning and organization of *Mahagonny* and analyze it in detail in order to uncover the structural and metaphysical roots of the entirety.

On top of this fluttering pattern of scenes, Smith loudly played the soundtrack of the 1956 Columbia recording of the Brecht-Weill opera, *Rise and Fall of the City of Mahagonny* (1930). Smith created the four-reel work in tandem with the cabaret-style opera score and German-language libretto, fixing the film's length to the exact length of the opera. The film creates a visual experience that is lush and lyrical, at times pairing surprisingly well with its chosen anachronistic soundtrack recording of the Brecht-Weill opera with its accompanying jarring, raucous, cabaret-style score. Smith exquisitely controlled the scene relationships and transitions in connection to one another and the scenes in the libretto; the quadrants of imagery convey control. Yet the overall effect is poetic and flowing, without being overwrought. The film is abstract, has no narrative arc, and many scenes repeat. The use of repetition makes the experience of watching the film blur into memory even during the watching. But the film is not opaque; it is born of the patent reality of the city, embracing both its dire straits and abundant frivolity.

For *Mahagonny*, Smith designed the most complex film organization strategy of his film production. He created the film structure from more than thirteen hundred sequences producing four distinct types of film imagery: Portrait, Animation, Scene, and Nature. He devised a lengthy palindrome to organize the scene types using the first letter of each: P for Portrait, A for Animation, S for Scene, and N for Nature.[1] The palindrome hinged on Nature and reads:

PASAPASNAPASAPANSAPASAPNPASAPASNAPASAPANSAPASAP.[2]

Smith planned the whole in detailed charts and scrolls; at least 120 of the former and one of the latter are nearly ten feet long, and these scrolls mapped out hundreds of the four image categories in relation to their timing and placement within the film and the opera score.[3]

By structuring the sequences within the film as a palindrome, a mirrored symmetrical structure, Smith created a planning structure that reflects what appears on the screen: mirrored images, repetition, and patterns. In other words, the palindrome is not legible through the film, yet the grid provides mirroring, making the palindrome device visually implicit on the screen. Not included in the palindrome are the blank black frames whose visual pauses comprise about one-sixth of the whole film. In his notes and interviews, Smith does not explain these breaks, but aesthetically they provide a welcome refrain from the rotation onscreen. Smith's palindrome system drives the film like a machine, like an algorithm, alluding to the repeated rhythms and melodies in the original opera.

A title card introduces the film. In silence, the film begins with large bold white text over a black background and reads: "being a mathematical analysis of Marcel Duchamp's 'La Mariée mis à nu par ses célibataires, même' expressed in terms of Kurt Weill's score for 'Aufstieg und Fall der Stadt Mahagonny' with contrapuntal images (not necessarily in order) derived from Brecht's libretto for the latter work." The two foreign language works mentioned in the title translate as *The Bride Stripped Bare By Her Bachelors, Even* (1915–1923) referring to the sculpture by Marcel Duchamp and *The Rise and Fall of the City of Mahagonny*, referring to the original 1930 *Mahagonny* opera. The title card, usually meant to orient the viewer, instead disorients, with an introductory rhetorical flourish in which five languages are present: English, French, German, mathematical, and operatic. English, French, and German are literal languages; mathematical and operatic are structural languages. Within this framework, "contrapuntal images" can be treated as Smith's sixth conceptual language. Contrapuntal, as defined in music, is two or more independent melodic lines; in Smith's film, I propose that images operate as one melody and the score another. "Not necessarily in order," as Smith also stated in the title card, however, contradicts his use of contrapuntal by avoiding said logic of the latter. Through the strategy of multiplicity, the title card thus reflects the film

itself. The grid of images provides multiple coexisting visual "melodies" throughout the film so that viewers may understand passages in relation to one another. In addition, by referencing two seemingly unrelated interwar artworks, along with multiple languages, and further, by withholding English translation, Smith prevents comprehension and exposes the viewer to a wide array of associations. The viewer, primed to look for clues and orientation, instead meets a confusing array of references. *Mahagonny* presents multiple narratives visually, aurally, and textually through the title card, to inflect meaning and to buoy Smith's symbolic language, through contrast, translation, and connection.

Close analysis of the first four scenes introduces the reader to the style and tempo of the film as well as the conceptual richness of each scene, setting the stage for the hundreds that follow. The film commences as the opera soundtrack begins with a brooding orchestral march featuring jerky horns and strings. In the first scene, an expansive city skyline appears, silhouetted by the last bit of daylight. The silhouetted city, viewed through an out-of-focus chain-link fence, seems to melt into the lower half of the screen, which remains black. The point of view remains fixed, with a skyscraper at center, as the crimson sunset slowly fades to amethyst. In the background, traffic races far below the skyscraper; pairs of car headlights move in time with each other, yet in opposite directions, perfectly mirrored. These oddly simultaneous traffic movements induce the viewer to examine the scene closely. Initially appearing as one building in the foreground of a unified nightscape, the central skyscraper image is actually derived from two separate projectors. Smith took footage of half of a skyscraper, framed so that the vertical edge of the frame crops the central axis of the building. He then copied this footage and flipped one of the copies horizontally creating the illusion of one central skyscraper at center, with the lower two quadrants left blank.

The illusionary trick, present only in this first scene, initiates the viewer to Smith's deft exploitation of the film medium while also taking advantage of the symmetry inherent in architecture and gridded

streetscapes. Further, Smith establishes the illusion that the grid of images looks as if it is derived from only one projector and one reel. As the sunset recedes, the sky grows dark and the diminishing light vignettes around the frame. The darkening of the perimeters of both images ends the illusion of a single skyscraper in the middle. Each frame separates and the dual images dissemble from false cohesion. As the sun sets, the images resemble a set of glowing orbs or anthropomorphized eyes, thereby suggesting the lit city was a unified landscape, like a mask, an illusion.

As the introductory opera overture slows, the second scene replaces the cityscape with several liquor bottles placed in a line on their side atop a red and green surface. The camera pans overhead so that the bottles appear as if on a conveyer belt; Smith uses the panning operation to create another illusion. Also arranged as a mirrored symmetry, the traveling bottles, resting on their sides, move inward toward the central vertical seam and melt into one another at the center, while the lower two quadrants remain empty. The hypnotic flow of bottles renders them into an effortless pattern. Unlike the stationary skyscraper, the movement in this scene encourages the viewer to get lost in the seam where objects dissolve into one another. The seam calls attention to both the edges of the images and the scroll-like quality of film. The bottles also represent the central theme of hedonism in Brecht's original opera, and the conveyor belt rhythm alludes to mechanization similar to the procedures depicted in Duchamp's *The Large Glass*.

As the first recitative begins, in the opera three fugitives converse in German about their destination; meanwhile onscreen, the third scene shows a woman in a brown dress, hanging her head, hair draped over her face, and repeatedly crouching, standing, and falling with an expanse of red brick wall as background. Again, Smith copies the sequence and mirrors the pair across the top two quadrants of the grid, with the lower two quadrants remaining blank. Rather than a unified image or flowing pattern, this scene simply contains the woman, moving up and down, repeated in each frame. In his notes, Smith labeled

this scene "Rosebud Falling and Rising on Roof." In labeling the scene in this way, Smith directly refers to and inverts the complete title of the opera, *The Rise and Fall of the City of Mahagonny*.[4] Both the scene title and the movement of the woman show how the opera score is neither background nor mere juxtaposition to the film but intrinsic to the choreography and scene formulation.

The fourth scene, a vertical upward pan, repeated in the top quadrants of the grid, shows a collection of stacked objects: a record player, statue, and lampshade with tassels. In his notes, Smith titled this scene "Pan of Robert's 'construct' ceiling to phonograph."[5] This "construct" refers to a sculptural arrangement by the artist Robert Mapplethorpe comprised of found and domestic objects. The slow pan reveals a work that appears to be both temporary, as it is stacked, and partially functional, as it includes both record player and lamp. By capturing another artist's work of art, similar to reusing the original opera as soundtrack, Smith posits questions about the importance of including outside art practices within his own and deftly points out the thin line between documentation and appropriation. Smith emphasizes the importance of the environment by including both the floor and the ceiling in his pan, thereby framing the art object. In the first few minutes of the film, these initial four scenes present formal density and initiate the viewer to the mesmerizing, mirrored reels. Smith therefore uses these initial scenes to communicate appropriation, illusion, documentation, and narrative as interrelated as the concepts that govern the film.

From here, the scene transitions continue to shift in a relatively consistent tempo, most about one minute long, with some varying from seconds to over two minutes, often loosely cued by shifts in the music.[6] After the initial four scenes, the bottom two quadrants, formerly blank, begin to contain images. Throughout the remainder of the film, blank screens intermittently interlace with the grid of four images, offering breaks from the density of information. The grid allows Smith to adhere staged scenes to simple, uncomplicated, candid captures of frantic traffic, suited men eating, and passersby staring at restaurant menus

posted to storefronts. Individuals perform for the screen, sometimes mirrored in two quadrants while butting up against quotidian shots of the city in the other two quadrants. Smith avoids monotony: the viewer is absorbed by a constant rhythm of changing scenes, grid arrangements, and varied scene types. Smith's interventions express his control of the material: he speeds up and slows down some scenes, overexposes others, and orients the camera at a diagonal in others. He layers images, blurring their individual relevance so as to render disparate imagery equivalent. Images meld into patterns fanning out like a deck of cards framed by the narrative highs and lows of the opera.

Mahagonny exemplifies a fundamental through line of Smith's fifty-year film practice: planning through complex structures to allow the act of making to occur within systematic parameters. Smith often referred to the structures at the foundation of his film practice. In 1965, he stated that his film designs are inspired by and work in concert with biological rhythms:

> All these works have been organized in specific patterns derived from the interlocking beats of the respiration, the heart and the EEG Alpha component and should be observed together in order, or not at all, for they are valuable works, works that will live forever—they made me gray.[7]

Such a structure may at first seem unrelated to *Mahagonny*; however, due to the formal qualities resulting from the image sequencing and mirroring, *Mahagonny* does build on "patterns" such as the liquor bottles flowing into one another and the woman rising and falling repeatedly. Further, all four film reels are seen "together in order, or not at all," because the grid arrangement mandates the constant confluence of images. "Interlocking" also occurs throughout the entire film. The four quadrants never change all at once; every new scene overlaps with an ongoing scene. This interlocking allows the image from the previous set to take on new meaning with the context of its newly paired images.

Creating an organizational system and linking the scene changes in this way, Smith deftly allows for the malleability of meaning in each image.

Though Portrait, Scene, Nature, and Animation categories herein have been discussed as distinct, Smith designed these categories to operate in conjunction with one another on the screen, creating a varied, uninterrupted, and ever-unfolding film. Smith accomplished this sense of continuity not only by ordering the images according to the palindrome but also varying the orientation of the imagery on the grid. By using the palindrome, Smith ensures each scene category revolves within the grid. For example, Nature sequences never pair with other Nature sequences. For the duration of the film, all categories mix on the screen. Smith also oriented the images in three different ways on the grid; as mentioned, these three different orientations loosely align with each of the three acts of the opera. Concurrent with the first act of the opera, the four reels mirror along the grid's vertical axis. Moving objects melt into or are born out of the central vertical seam. During the second act, mirroring abates, and all four reels projected are different. Each frame within the grid is a distinct world, and the contrast beckons to the broad natural expanse of everyday urban existence. During the final act, several previously shown scenes replay, and repetition again occurs, but along the grid's horizontal axis. The imagery repeats at top and bottom, either the vertical pair on the left or the vertical on the right, and these two passages often fall out of sync, and the scenes are one or two seconds apart so that the viewer can rewatch the action from seconds before. The three orientations operate to introduce variation into the film and also align with the content of the opera.

The palindrome and the grid orientations reveal a methodology in which the planning, content, and design meld into one another. Similarly, the celluloid film material itself may have inspired the various visual orientations within the grid. On a piece of film, the functional sprocket holes run along the edge of the filmstrip and the optical sound encoding appears as jagged white lines along the right edge. These technical notations create an ornamental frame for the images

at center. The framing, which helps to move and encode the film with sound, if viewed formally, appears as abstract patterns. Reminiscent of some passages in *Mahagonny*, which combine abstract animations with live scenes within the grid, the incorporation of non-objective imagery alongside photographic imagery echoes the physical layout on a piece of film. Since film by nature is transparent, if someone holding a strip of film were to merely flip the material, each frame could easily be viewed from the opposite side. Opposite sides of the film replicate Smith's presentation of imagery through horizontal mirroring, which dominates the beginning of *Mahagonny*. Further, a short section of a strip of film contains nearly identical images since the standard frame rate captures twenty-four frames per second. The grid orientation—wherein images repeat on top and bottom quadrants of the grid and appear just out-of-sync—mimes a section of stacked images on a filmstrip. As a visual object, the characteristics of celluloid film offer much of what *Mahagonny* displays within the screen: repetition of images, mirroring, patterns, off-sync sequences, and non-objective visual information. In this way, Smith used the qualities and technical aspects of film reels to design the film, so that operations—copying, flipping, editing, and designing—behind a narrative film become visible. As a result, the necessary intimate relationship with the material becomes, essentially, his subject.

In 1965, delivering a lecture to a group of film students about the nature of film in general, Smith stated that each film frame, what he called "photographs of actualities," should be understood as a glyph: "You shouldn't be looking at this as a continuity. Film frames are hieroglyphs, even when they look like actuality. You should think of the individual film frame, always, as a glyph, and then you'll understand what cinema is about."[8] More than a decade after this statement, Smith revealed the nature of film as essential to the form of *Mahagonny*. This connection deepens the understanding of the grid structure as a methodology. This methodology siphons each frame through a quadrant of relationships, expressing the individual nature of each as well as

a totality in relation to others. In doing so, like a glyph, each sequence in *Mahagonny* carries multivalent meanings depending upon the context, the repetition, and the content of the image. Just as glyphs unify image with language, *Mahagonny* marries form, celluloid film, and meaning, images together with images, to convey new symbolic meaning. Smith acts as both composer and conductor, inventing an intricate system to organize and enact the display of thousands of glyphs.

Rose Marcus is a visual artist, writer, and doula in New York City. She received a BFA from Pratt Institute and a master's in art history from Hunter College. As a visual artist, Marcus has exhibited her work in galleries and institutions internationally for over a decade. Marcus's work has been reviewed in *The New Yorker*, *The New York Times*, *Art in America*, *Artforum*, *Cura*, *Architectural Digest*, *Mousse Magazine*, *Cultured Mag*, *Vogue*, and *Foundations Magazine*. She wrote her thesis on Harry Smith's magnum opus film *Mahagonny* and acted as curatorial consultant for the 2023 exhibition at the Whitney Museum of American Art on Harry Smith.

17

Visionary Charlatan
Harry Smith's Way-Out Science of Thought Forms

Ed Hamilton

Just as you feel when you look on the river and sky, so I felt,
Just as any of you is one of a living crowd, I was one of a crowd

Just as you are refresh'd by the gladness of the river and the bright flow, I was refresh'd
. . .

WALT WHITMAN[1]

At the end of his life, the wild polymath Harry Smith, best known as an experimental filmmaker and folk music anthologist, lived in Room 328 of New York's Chelsea Hotel. He died in the room in 1991, approximately four years before I moved into the hotel. The rectangular room, at the end of a crooked corridor with two bends, was—on a generous estimate—approximately one hundred square feet, with one closet, a tiny sink, and a single window overlooking the courtyard behind the hotel. I know the room well because I lived in Room 332, on the same corridor, though

my view was of the fire escape and the roof of the synagogue next door. In 1995, the year I moved in, a man with sparse gray hair named Robert Isaacs was living in Smith's room, paying the rent (which he thought exorbitant) by working as a ticket taker at the movie theater down the block. One evening as we were drinking beer in his room, a fat black cat curled up. As it watched us from the bed, Robert told me a story:

> I've been an atheist from an early age, maybe even before I started school. I grew up in a small town in Iraq, where we had all kinds of religion: various sects of Christians, Muslims, and Jews. There may have even been a few animists—old-time pagans—though I'm pretty sure they didn't tolerate Hindus. I was a Jew—well, I still am, though I don't believe in the religion. Maybe I should say I was "from a Jewish family." Anyway, there were all these clerics everywhere—priests, rabbis, imams, whatever—walking the streets wherever you looked, totally ubiquitous. If you threw a rock you'd hit one. They all wore these wild, colorful costumes, these elaborate, billowing robes, and crazy, ornate hats, and every one of them had a long, flowing beard. I was most impressed by those beards, which made the men seem very wise and otherworldly. I listened to what they said, too. They preached in the streets and my father had always encouraged my brothers and me to be intellectually curious. They told some pretty good stories, they knew how to entertain, and for a while I was very interested, you might even say entranced, by one or two of the best ones who told stories of the supernatural, stories that, I realize now, were designed to appeal to the young. But it didn't take me long to realize what the endgame was: they were all con men, charlatans, whatever their creed, and what they wanted was your money. One thing I learned early on—and remember, I was only six or seven years old—was that while these impressive, imposing, learned men all wore different hats, they all had the same beard! I remember thinking it *exactly* that way: while they wear different hats, they all have the same beard.

Harry Smith's beard was Theosophy. Despite claims of an ancient origin, modern Theosophy was founded in or around 1875 by Helena Blavatsky and a handful of her followers. This esoteric philosophy, said to be based on Buddhism, posits "the fundamental identity of all souls with the Universal Over-soul," and claims that "Souls travel through the cycle of incarnation according to Karmic Law."[2] Theosophy is a type of pantheism in which God, nature, and human beings are essentially identical. Its theories lay at the heart of the Spiritualism of the late nineteenth and early twentieth centuries, and later, of the New Age philosophy that developed in the sixties and seventies. Significantly, its name comes from the Greek words for God and knowledge, *theos* and *sofia*, and, unlike most religions, Theosophy endorses "the study of comparative religion, philosophy, and science," encouraging its practitioners to "investigate unexplained laws of Nature and the powers latent in human beings."[3] Devotees poured over the ancient texts, performed a lot of séances, and, like Smith, engaged in scientific and pseudoscientific research and experimentation designed to reveal the hidden truths of the universe. And while a lot of its claims may seem pretty far-out to those of us schooled in one or another of the patriarchal, Bible-based faiths that dominate Western society these days, it's important to keep in mind that Theosophy was the religion of Smith's parents, and so, for Harry, was as American as apple pie.

Smith famously wore a lot of hats—artist, filmmaker, anthologist, collector, and so on—but one of the earliest and most fundamental was his scientist hat, which encompassed anthropology, ethnology, and a type of "psychologism"—for want of a better word—in which he sought to explain people's inner motives by reference to external entities such as universals. As Harry says, "I'm trying to found new sciences, to entirely overhaul anthropology and turn it into something else."[4] While his Theosophical views are essential to his thought, it was science, as Smith understood it, that grounded him early on, and continued to guide him throughout his life, undergirding and supporting his endeavors in all fields. According to Smith's biographer, John Szwed, Smith told

him later in life that he considered himself primarily an anthropologist. Harry had studied the subject for a couple of semesters in college. Smith was constantly engaged in compiling data through his collecting and recording endeavors, often using various forms of art as a platform for "experiments" designed to "prove"—or at least in some sense support—the truths of Theosophy, and, in particular, to demonstrate the existence of what its devotees call "thought forms." That's where the psychologism comes into play.

Noticing his son's intellectual precocity, Smith's father provided the young boy with a workshop and a collection of blacksmithing tools, encouraging the budding scientist in the pursuit of an early form of science, jokingly telling the boy to turn lead into gold.* But it wasn't long before Harry became bored with the primitive blacksmithing technology and asked for the latest new thing: a record player! Actually, the phonograph had only been around for a few years, and Harry was an early adopter of this technology, which he quickly put to excellent use in his first real scientific researches. There's a famous photograph of Harry at nineteen, recording a religious ceremony of the Lummi Indians on a primitive-looking phonograph that he had jerry-rigged to run on a car battery. Harry was a true prodigy engaging in mature scientific fieldwork at an age when most of us were just playing Little League baseball and worrying about pimples. Harry's childhood scientific pursuits included recording and transcribing the songs and ceremonies, and photographing and notating the dances, of Indigenous tribes; he also donated collections of cultural artifacts, assembled in his teen years among the Lummi and Swinomish peoples, to the Washington State Museum.[5]

*I've read several versions of this tale, most recently in: Sherill Tippins's *Inside the Dream Palace: The Life and Times of New York's Legendary Chelsea Hotel* (p. 173). Szwed's biography *Cosmic Scholar: The Life and Times of Harry Smith* also contains a version (p. 24), as well as a story about how Harry's father owned by the cannery company as a museum to display his extensive collection of biological specimens (p. 27). The original tale is in P. Adams Sitney's 1965 "Harry Smith Interview" in *Film Culture*.

The story Robert told me is obviously a parable of sorts, although I don't believe he thought of it that way. For him it was simply his experience, although an early, formative experience that was important enough to stick to him in a singular, visceral way. Like many good parables, it's rather ambiguous, and open to more than one interpretation: for instance, are the "hats" the differing creeds that conceal the underlying, essentially mercenary "beard"—or motive—of all clerics? Or are the differing hats merely stylistic flairs worn to obscure the essential nonsense (and essential sameness of the nonsense) at the core of all religion? Robert's tale is about why he became an *atheist*, after all— and it was not just to hold on to his money. And perhaps, after all, the delicious ambiguity of the parable is part of its stickiness, part of what makes it memorable: the simplistic parable of childhood thus becomes engaging for the adult mind, making it more likely to be mulled over and remembered. But was the parable of Robert's own construction? It seems unlikely. While I had never heard this particular parable before, I tend to believe that somebody, perhaps Robert's father or an older brother, must've told it to him, or some version of it, and it formed a perfect template for a youthful experience that may have otherwise been difficult to understand. It's a shorthand, a heuristic, for the impressionable child and then the trusting adult, to avoid being taken in by novel (and perhaps very devious) religious cons. I also think it's an almost perfect expression of what Smith and his Theosophist buddies call a "thought form." Significantly, the parable has both a verbal and a visual component: two distinct ways of expressing a single concept. It accomplishes what Harry was getting at when he tried to paint the content of whatever message a jazz tune, such as Charlie Parker's "Koko," might be said to express.

So what, exactly, is a thought form? R. B. Elder, in a fascinating and erudite study that is in large part the inspiration for the present essay, begins the arduous process of shaving Harry's Theosophical beard. In arguing that the notion of "thought forms" is what unites all of Harry's varied pursuits, he tells us that, for the second-generation Theosophists

Annie Besant and Charles Leadbeater, "thought forms, which they also call 'artificial elementals' . . . are visible forms, usually a nebula of colors, produced by human thoughts and emotions. Thoughts . . . resemble vibrating energies, and these vibrations can become colors or sounds. . . . Thought forms . . . are made up of astral matter and live out their existences as ensouled beings on the astral plane."[6] Wow. While it's easy enough to get carried away here and fly off on a wild journey into parts unfathomable, if you take away the better part of the mystical window dressing, you find that a thought form is simply a disembodied "idea" (like a Platonic form or ideal) that can be expressed in multiple ways in the physical world. For Plato, a form or concept like "justice" has many, maybe a potentially infinite number, of particular instantiations: there can be particular sentences handed down in courtrooms; there can also be vendettas. And even a form like "chair" can instantiate in the world as a wooden chair, a metal chair, a chair with cushions, and so on. A thought form, in other words—minus the anthropomorphism and color theory—is just a type of universal: it exists in pure form in some kind of (more or less well- or ill-defined) conceptual world. (Numbers are another example of this sort of universal, hence Theosophy is sometimes labeled Neo-Pythagoreanism.) Smith's project, as I see it, was to employ the methods of science to simplify and pin down examples of thought forms and to show how they are transmitted. At the same time, like any good charlatan out to make a buck, he stroked his long beard of Theosophy as he dove headlong into the art world—where he found it easier to gain acceptance and financial backing—putting on a magic show, obscuring and complicating his theories even as he was simultaneously laboring to enlighten and simplify them with science.

Theosophists are idealists, and, as such, monists (rather than dualists): there's only one kind of substance, the spiritual, which naturally exists on the astral plane, though it can, and does, instantiate itself in this world. However, while this view may sound pretty way-out-there, the good thing about monism is that, in practical, "scientific" terms, idealism works as well as materialism, because there's no bar to investi-

gating it with the tools and methods of science. (In the dualist view, by contrast, there are two realms, and seldom if ever the twain shall meet. Typically, as in most forms of Christianity, there are spiritual mysteries accessible only to God and other spiritual beings, and there's no using science to look into them; you just have to have faith and wait for some kind of revelation.) Theosophists conceive of the one substance as a kind of energy, like electricity or electromagnetism. All of which reminds me of an old episode of *The Outer Limits* in which a radio DJ, investigating the universe with his radio tower in his time off, stumbles upon a signal from a distant galaxy. A stereotypical-looking alien appears on the TV screen and says something like: "I come from a world where all is pure energy." The alien is not supposed to be messing with this powerful new technology either, but then something goes wrong, and he steps right out of the radio into our world, predictably wreaking havoc. In Theosophy, thought forms (like energy-based alien beings) can "come through the radio"; they are susceptible, in other words, to empirical inquiry.

We can, with some assurance, speculate that Smith's overall, guiding hypothesis, which he sought to demonstrate by empirical means, was simply that thought forms exist, and that they can be expressed and communicated in various media. He tested this hypothesis in a number of ways, visual as well as auditory, over the course of his career. In an early, typically ambitious experiment relying on the color theory introduced by Besant and Leadbeater,[7] Harry attempted to transcribe various jazz tunes into visual form as oil paintings, hoping to demonstrate that whatever thought form underlies a particular tune can be expressed in an equally compelling, or at least equally comprehensible, visual form—hopefully at a glance, thus obviating the need to listen to the whole jazz number. The extant jazz paintings and photographs of jazz paintings are abstracts composed of colorful geometric shapes intricately interwoven among various squiggles and spirals, and are reminiscent, or perhaps even derivative, of the work of fellow Theosophist Wassily Kandinsky, who attempted something similar for classical

music. Smith's jazz paintings are impressively painstaking works, each larger canvas composed of a series of smaller panels (suggesting the frames of a film), and each panel representing a single musical note (or series of notes), that, taken together, are intended to play out visually what Charlie Parker or Dizzy Gillespie played audibly.* However, as beautiful and compelling as the paintings are artistically (and as packed with detail), one would be hard-pressed to identify the tune from the image alone, and even knowing the song doesn't help much in identifying the individual notes (though of course Smith could point them out). Smith sometimes suggests a rather Wittgensteinian theory of projection and one-to-one correspondence between the musical notes and the elements of the paintings, but whether or not, in any sense, the paintings convey the same (unspecified) message or feeling as the jazz tunes seems almost entirely subjective.†

The next, related, hat that Smith donned was that of filmmaker, and by incorporating the dimension of time into his transcription of musical notes, he seemed to at least get one step closer to his goal of demonstrating the existence of the elusive thought forms. Here, too, his process for producing the works seems almost unbelievably laborious: for the films known as the *Early Abstractions* it involved etching each individual frame of the film with bleach and then coloring them one

*See, for example, Smith's paintings of Dizzy Gillespie's "Manteca" (1948) and "Algo Bueno" (circa 1951), and Charlie Parker's "Ko Ko" (circa 1951), reprinted in Szwed's *Cosmic Scholar: The Life and Times of Harry Smith*, p. 4 and 5 of the color plates, though they can be found online, as well.

†Wittgenstein's picture theory of language states that there's a one-to-one correspondence between the facts in the world and the words of a sentence; think of a light projected through a fact and casting an image of the various facets of the fact onto a sheet of paper, thereby "writing" the sentence onto the paper. It's likely the case that Harry was trying to achieve something like this by establishing a language of jazz that he could then project onto a canvas. The problem is that it's hard to get the intuitional or emotional part to shine through—or at least to have it shine through in anything recognizable as the same thing. Wittgenstein famously abandoned the theories of the *Tractatus* when he realized that there were a lot more games to be played with language than the simple description game.

at a time, essentially hand-painting twenty-four frames for each second of the 35 mm films, and producing, thereby, a series of tiny, abstract expressionist masterpieces.* The films have a dancing quality that perhaps, even in the absence of a soundtrack, suggests a jazzy musical tune, though labeling them with the titles of jazz songs, such as Gillespie's "Guarachi Guaro" (*Film No. 3*) or "Manteca" (*Film No. 4*), or Thelonious Monk's "Misterioso" (*Film No. 10*, composed of animated collage), primes one for a "musical" experience from the get-go, producing something of a self-fulfilling prophecy. In a sense, one sees, or hears, what one is told to see and hear. To his credit, Smith abandoned the notion of a one-to-one correspondence between musical notes and pictorial elements (such as the frames of a film) early on, finding that the films worked equally well with a variety of soundtracks.

While the work for which Smith is most famous, the *Anthology of American Folk Music*, seems not to have originally been his own idea, but rather the suggestion of Folkway Records owner Moe Asch, Harry was quick to seize the opportunity to further his own studies, compiling the songs in such a way that their unusual juxtapositions suggest an almost boundless wealth of connections. The *Anthology* has been studied extensively since its release in 1952, especially in recent years as its popularity has increased, and part of that scholarship has involved the search for just such connections, which seem to jump out at the listener in an uncanny way, sometimes immediately, and at other times after repeated listening, perhaps only after the listener has become acclimated to the "old, weird" milieu from which the songs seem to eerily emanate. These connections can be more or less concrete or nebulous, but by placing the songs in the order he did, Smith may well have been trying to provoke just such "ah-hah!" moments, revelations that point the way to certain (nearly lost) ways of thinking, or thought forms, that we can wrap our minds around and come to share with our forebears.

*For a discussion of Smith's process, see the documentary *Harry Smith, American Magus*, directed by Paola Igliori (available on YouTube), at around the fifty-four-minute mark.

To take just one example of such a connection, the songs on side one of volume two, "Social Music," constitute a series of "Stomps," though only two of them, "Georgia Stomp" and "Old World Stomp," actually contain the word in their titles. These tunes, mostly instrumentals and thirteen or fourteen in number, played at roughly the same tempo and sounding weirdly, almost monotonously similar, are dance tunes, and the strangest thing about them is that they all instantly suggest the same dance, the stomp dance, consisting of one foot stomping (though obviously there would have been other movements involved, probably depending on the region) rhythmically and repeatedly. On this reading, the thought form can be called "Stomp," which is instantiated in at least two ways: aurally through the music, and physically—one might even say viscerally—through the dance. (There also is possibly a visual instantiation: the "hoedown.") When I hear one of these tunes, no matter which one, the beat seems to vibrate up through the muscles of my right leg, setting it to stomping, or at least making it hard to resist stomping. This, I believe, has less to do with the suggestion of calling the dance a stomp than simply the feeling naturally produced by the music, and so—significantly—it doesn't involve the obvious circularity of the previous two examples. If he meant to show how a thought form could be transmitted, Harry seems to have been onto something here. Note also that two of the tunes, "Old World Stomp" and "Indian War Whoop," hint at the cross-cultural lineage of the genre.

While it's indisputable that Smith was engaging in descriptive science of a high order in his work of filming, recording, and transcribing the dances and ceremonies of the Pacific Northwest Indigenous peoples, as well as in many of his subsequent activities, this is not the place to definitively establish whether or not his thought form "experiments" constitute actual science in any strict sense. There is a way in which both the proposed instances of particular thought forms, and the reality of thought forms in general, constitute presuppositions that can't be challenged, unfalsifiable and thus unverifiable, incapable of disproof and so also of proof. It's actually hard to even think of what would con-

stitute evidence against the theory. If that's the case, then perhaps on that basis Smith's theories may be judged unscientific, though I like to think of the theory of thought forms as less like the obvious pseudoscience of creationism, and rather more like Freudian psychoanalytic theory: endlessly evocative and generative—think of the concepts of the ego, the id, and repression—and penetrating the collective consciousness in such a compelling way as to be *sui generis*, almost establishing a demonstration of its own truth

In other words, whatever their ontological status, the Freudian constructs are so helpful in making sense of our lives, that they just *seem* real, and the theory *seems* right. Smith's theory of thought forms has a similar "sheen" of truth—or at least it would have if knowledge of it were more widespread.

Perhaps Harry was simply ahead of the curve, out in front of the zeitgeist. Positing theoretical concepts or entities that can't be directly observed or tested is not, in any event, outside the realm of respectable science. Consider, for instance, Noam Chomsky's hypothesis that there is a universal grammar—presumably situated in the brain and constituted of neurons, or, more likely, a web of electromagnetic signals—that underlies and supports all particular human languages. Even more instructive is Richard Dawkins's theory of memes, whereby (nonphysical, somewhat nebulous) entities called "memes"—the universals of words, phrases, ways of doing things, and even cultural artifacts and activities (such as boats and boat building)—are subject to transmission and even to a sort of nonbiological evolution. Memes behave like viruses, not quite alive and always dependent upon a host for their continued existence, but able to reproduce and spread as long as, in the case of words and phrases, somebody utters, writes, or even thinks them. The theory of memes is firmly grounded in evolutionary theory and materialism, thus gaining a sheen of academic respectability and scientific street cred, but the concept of evolution is also central to Smith's thought, and we've also seen how Theosophy, for all its weirdness and excess baggage, is a fundamentally "physical" theory. Perhaps, then, the

debate is simply over the ontological status of the proposed universals—memes or thought forms—or in other words whether, and in what sense, either of these sorts of things can actually be said to "exist." The parallels between these three theories—in particular the uncanny resemblance between thought forms and memes—are intriguing, and well worth further investigation.

So was Smith a scientist, a charlatan, both, or neither? Then, as now, and partly by his own design, this man of many hats defies categorization. Toward the end of his life, in conversation with his much younger friend, Raymond Foye, Harry seemed to express skepticism for the sort of mystical baggage that comes bound up with the traditional Theosophy package, advising his protégé that, "These are not real laws; they're imaginary laws."* Might we not then speculate that perhaps the battle-scarred old magician was shedding the patchy beard of Theosophy and coming to the belief that thought forms, rather than astral beings of some sort, are actually something more like memes, universals that express ways of doing, ways of seeing, ways of being in the world? This may be especially true as he thought, following the early Wittgenstein, that the world is made up of facts rather than things. Heidegger thought that consciousness was like a "clearing": something that you and I, as individuals, and humanity as a collective, might burst into now and again, perhaps only after a span of walking lost through the trees in a dark forest of ignorance and confusion.[8] I like to think of Harry as blazing a path through the forest by leaving behind little breadcrumbs of cultural detritus for us to find. Once in a while, if we follow the trail long enough and don't get lost in the brush, we might be blessed with a fleeting glimpse of the cool meadow, the crystal stream, and the vast, blue dome of sky above. Walking the halls of the Chelsea

*In John Szwed's new biography *Cosmic Scholar: The Life and Times of Harry Smith*, Smith is remembered as saying that he would like to have a pyramid as his monument. Well, a pyramid stands, to this day, atop the Chelsea Hotel. Harry shot part of his magnum opus, *Mahagonny*—using the music from Bertolt Brecht's opera about an anarchist community of outcasts—in the rooftop gardens surrounding this pyramid.

Hotel, like Raymond, like Robert the parable-teller, I often find myself feeling honored and privileged to be sounding the same creaking boards, navigating the same mysterious turns, and gazing down upon the same cityscape set to the jangling, discordant, jazz-like soundtrack of the New York streets that is essentially the same as when Harry stuck a microphone out the window and recorded it decades ago. Surely, too, just as when we cross the East River in the wake of Walt Whitman, we must be picking up some of the thought forms that crackled like electricity through the brains of Harry and the many other creative, visionary folk who have graced these halls for over 140 years.*

ED HAMILTON has a master's degree in philosophy. He is the author of three books: *Legends of the Chelsea Hotel*, *The Chintz Age: Tales of Love and Loss for a New New York*, and the novel *Lords of the Schoolyard*. Ed has lived in Manhattan's Chelsea Hotel since 1995.

*From Raymond Foye's "Harry Smith: The Alchemical Image," available online at raymondfoye.info. This must be qualified, however, in light of the fact that, in the same article, Smith is also quoted as denying that he's a scientist. As Smith was not known for his consistency, perhaps these statements should be taken with a grain of salt, although it is also possible that he had changed his views by this time, late in his life.

18

A Yoyo Shaped Like a Hamburger, or The World According to Harry Smith

Beth Borrus

This morning, February 8, 2022, toward the end of my home yoga practice, I was distracted by the interplay of shadows on my wall, branches moving in response to the wind outside. This, combined with the psychedelic Radiohead tune I was listening to, created a filmic experience, which I stopped to record on my phone. Then I noticed the hum of the air conditioner, my dog's snoring. This moment was brought to me by Harry Smith.

I met Harry Smith over thirty years ago and we grew to be unlikely friends. He changed the way I see and hear the world, and for that I will be ever grateful. It was 1988, and I had finally completed my BA on the ten-year plan. My marriage had ended a year earlier, after my first summer at "Camp Kerouac," and I had decided at that time to apply for the initial year of the MFA program in poetics at the Naropa Institute in Colorado. Little did I know that the one teacher who would influence me the most was the one I'd never heard of before applying.

My first encounter with Harry was up on the hill at the University of Colorado. Stan Brakhage was presenting *Early Abstractions* and *Heaven*

A Yoyo Shaped Like a Hamburger, or The World According to Harry Smith 197

and Earth Magic with Harry in attendance. His yellow-gray hair was pulled back in a ponytail, and he was wearing a light blue and white seersucker jacket, cleaner than I would ever see it again, and oversized glasses. The films were stunning, like nothing I'd ever seen before.

The next time I saw Harry, I was sitting cross-legged on the floor of the Naropa classroom where he was lecturing. Harry stood a few feet away from me, puffing on one of those little wooden pipes that were sold on the counters of local liquor stores. "This is purely for medicinal purposes," he asserted. "What is he smoking?" I whispered to the person sitting next to me. "What do you think?" was their response. As a pot afficionado of many years by then, I wasn't exactly naive, but that was the first time I heard of medicinal marijuana.

Allen Ginsberg had moved Harry out of Manhattan and into a small house on the campus, hoping to rejuvenate him in some way. The plan worked. Harry was a magnet for us students—a fascinating speaker, an experienced scenester, and an expert on numerous subjects, from traditional music to string figures to Ukrainian Easter eggs. Harry was what we aspired to be: a decadent intellectual with no visible means of support.

As we got to know Harry, Rani Singh, his official caretaker, and my closest friend at Naropa, as well as several of the other MFA students, began to hang out with Harry informally. As the cottage had no phone, we'd just show up and knock. Harry kept dead bats and squirrels in his freezer, and made his own yogurt in the fridge, which he graciously offered and which I cautiously refused. He fed the squirrels peanuts through a chest-level hole in his screen door; they'd climb up to reach the opening. Instead of furniture, Harry had a log and some stones near the heater we could sit on when he held court.

Harry usually welcomed our visits, although I remember stopping by one night on our way somewhere. When Harry answered the door, the house was full of acrid smoke. Someone who knew about such things shouted, "It's frankincense! It's toxic! Open the windows!" We ran around madly opening the windows as Harry yelled at us for so

rudely interrupting his evening. That smell stuck in the back of my throat. I forgot the incident entirely until years later, at the memorial Gnostic Mass held in Harry's memory at St. Mark's Church in the Bowery. All the luminaries present confirmed the stories Harry had told us, and only added to the legend, but at that time, I was sick as a dog, unaware that I'd been poisoned by frankincense that was burned during the ceremony. I had gone outside and vomited in the street; later that night, a bunch of my friends took ecstasy and played poker in a room we'd rented at the Chelsea Hotel, while I lay on the bed, trying to figure out what it was that had made me so sick.

Harry used to record "ambient sound" wherever he was. He determined patterns in the order in which the birds sang in the "dawn chorale." He described the waves of human voices in a restaurant reaching a crescendo and then suddenly dipping into silence, as if by common agreement among the talkers. On one memorable night, Harry had started recording while we were still en route. I'm pretty sure it was the night we took Harry to see the Butthole Surfers at the Hi-Lo Lounge on the outskirts of town. I was driving, and we stopped for gas, at which time I managed to swing the metal safety belt latch into my face, giving myself a fat lip. Harry thought that was hilarious, of course, and somewhere, this historic moment is recorded for posterity. Once we arrived at the venue, Harry, in his oversized trench coat, asked us to get permission from the band for him to record the evening. "I don't want them to think I'm from the CIA," he added.

Like Harry, I had come to Naropa and Boulder to live in the spring of 1988. The only people I knew in Colorado were the other MFA students and my coworkers at the Boulder Army Store, where I was a part-time clerk. I wasn't much for schmoozing with the faculty. Harry was the only elder I considered a friend. By now, I knew about the films because I'd seen them, but a lot of what Harry said seemed, well, preposterous, like his stories about Hank Williams and Thelonious Monk and Robert Mapplethorpe. The *Anthology of American Folk Music*. Really? "Harry," I remember blurting out in frustration, "if you really

did all these things, you'd be famous!" "I am!" he'd retorted. "You just don't know anything!" That was the meanest thing Harry ever said to me, one of the few times he raised his voice in my direction, although he could be very ornery to others.

I still needed confirmation. By this point in his life, Harry was a man of unimpressive physical appearance. Speaking to him for even only a few moments, anyone could see that they were in the presence of a genius with a talent for fictionalizing his life story. Pre-internet, our only way to confirm Harry's tales was to check the Boulder Library for the *Anthology*. It was there, for a while at least, with all its quirks and idiosyncrasies clearly identifying it as the work of our pal. My new friends and I took turns checking it out, but, before long, someone realized the value of this treasure and walked off with it.

If memory serves, I returned to San Diego briefly in mid-June to retrieve some property from my ex-husband. As I best recall, I arrived in Denver from San Diego in July 1989 and was met at the airport by my friend Rani Singh, who informed me that I would be playing the queen in Marianne Faithfull's *Seven Deadly Sins* course's culminating performance. This was a Shakespearean device, a play-within-a-play in which I merely sat on stage. I had no lines (hence my selection as queen!). Basically, I was available because, as Harry's TA, I couldn't attend Marianne's course or rehearsals. My only question was, "Who's the king?" "Harry, of course."

Naropa was a small, intimate setting and everyone was on a first-name basis. I was in awe of Marianne Faithfull for years before I ever met her, but even more so after working with her at Naropa. By now, Harry was my friend.

One of my strongest memories of Harry is when I was his TA during the Naropa Summer Writing Program. As I recall, he only had one big lecture class to present, and to set it up, I had to procure two televisions and two VCRs. At that time, in Boulder, I knew no one with a TV, but somehow, I was able to line up two in advance. The morning of the class, of course, one of the TVs was suddenly unavailable. I scrambled to find

one, succeeding at the last minute. Then, knowing the classroom was ready, I headed over to Harry's cottage to escort him to the building.

I found him there with Marianne Faithfull and Giorgio, her then husband, listening to a tape recording of Enrico Caruso that Marianne had brought over. "Harry, we have to leave soon. The class starts in minutes, and we have to set up the videos." "I can't leave *now*. I'm listening to Caruso!" "But the class starts in—" "But Caruso isn't finished!" I could see this was going to be a losing battle, so I did the only thing I could do. "Well, Marianne, you brought the recording over. I'll leave this to you. The class begins at ten. I'm going over to the room to get set up."

Which is what I did, knowing that if anyone could charm Harry into fulfilling his obligation, it was Marianne Faithfull!

Harry showed up to class in the nick of time, and we showed *Early Abstractions* on two side-by-side TVs, with a five-second delay between the two projections, so that the shapes in motion on the first TV looked like they were bouncing over to the second TV. In my memory we used *Meet the Beatles!*, Harry's preferred soundtrack for these films—although he'd told me that as his films were calibrated to the human heartbeat/breath cycles, all but one-third of any recorded music would work in sync with the imagery. That was one example of my alchemist friend turning near-disaster into triumph.

During the editing of this text, I found an audio recording of this class on the Naropa online archives (July 23, 1989). It was difficult to listen to it at first, like listening to ghosts from over thirty years ago. What I had forgotten about the day is as interesting as what I remembered. For one, Allen Ginsberg introduced Harry that day, a fact I had completely lost track of, but one which would explain my anxiety at getting Harry to the class on time. Listening to the recording, at first, all I could focus on was Harry breathing into the microphone. When he addressed the class, Harry was always charming and hilarious. "The students, so-called, were here before I was," he intones at one point, affirming at least one detail of my memory of the day.

On the recording, Harry makes a dig at me for getting one small

TV monitor and one large one. Our back-and-forth makes me laugh out loud at times (in the present, not at the time). At one point, Harry requests that I place the small TV on top of the larger one. My "if you wa-ant . . ." gets a sympathetic laugh from the class. He later requests a specific musical accompaniment to the film, stating, "That's why the assistants should always be at hand." To my retort that I can't "be in two places at once," Harry responds, "Well, that's all right, don't let it worry you."

As the class proceeds, I recognize the still-familiar voices of Marianne Faithfull and Steven Taylor. Both are present in the classroom, as Harry introduces a recording of Steven performing a string instrumental. Later, I can hear myself negotiating with Harry as we rewind and adjust different cassette recordings during a break in the class. Listening to this recording, I suddenly hear the voice of Hal Willner, offering Harry a recording of Mingus. This aural experience penetrates my mind as I try to collect these tender memories and put them into words. This unexpected and magical moment is exactly the type of encounter Harry Smith brought to me when he was alive. His influence continues to echo powerfully through my life to this day. The recording proves that this class was as memorable as I recalled it to be, a July afternoon that continues to be evocative across the years.

Less than a week later, it was time for Marianne's class to perform their original songs, a prelude to Marianne's own performance. For the two evening performances of the *Seven Deadly Sins* class production, a purple cape was rented for King Harry. He had been working for weeks on his crown, making everyone anxious that it would not be done on time. Harry had been collecting paper towels and toilet paper cores, which he then glued to a cardboard halo. Finally, this was painted in metallic colors. On the day of the performance, Harry picked wildflowers and filled his crown with them. It was spectacular. This was one of the few times I witnessed Harry's creative side, and it only solidified his reputation as a genius.

We appeared together onstage those two nights, which were two

of the best of my existence. Marianne had asked me to end the performance with an original song, effectively allowing me to open for her unforgettable performance that followed. Afterwards, Harry cast a spell on the audience with the "Flight of the Valkyries" added as a soundtrack for emphasis, admonishing them to "Scram!"

Spending time with Harry altered my subsequent interactions with the world like nothing since I'd dropped acid as a teenager. I leave you with one final exchange that exemplifies how there was never room for the mundane when dealing with Harry Smith:

"Harry, I'm riding my bike over to Safeway. Need anything? Cigarettes?"

"A yoyo shaped like a hamburger."

It took me years to find one, but I never stopped looking.

BETH BORRUS currently resides in New Jersey, where she was born. She is keeping her books in boxes, ready to move on. Over the years, she's lived in Boston, New Orleans, San Diego, Boulder, and Bahia (Brazil), and, at this writing, is leaning toward New England.

A proud dropout of Boston University, Borrus completed her undergraduate education much later at UCSD, where she had the good fortune to study with poetic luminaries such as Charles Bernstein, Fanny Howe, and Rae Armantrout. She continued her studies as part of the first MFA poetics cohort at Naropa University, where the faculty included Allen Ginsberg, Anne Waldman, and Diane Di Prima, as well as the unique and unforgettable presence of Harry Smith. Her full-length book of poetry and prose, *Fast Divorce Bankruptcy*, was published by the short-lived but fun Incommunicado Press in 1994. Since returning to New Jersey in 2006, Borrus has been an active part of the vibrant local poetry scene she first encountered in 1991. With old pals Anthony George and Tom Obrzut, Borrus is a longtime co-editor of *Arbella* magazine. A teacher for the past twenty-nine years, Borrus retired at the end of 2022 to pursue her passions—poetry, music, and the visual arts. And to catch up on her reading.

19

The Paradoxical Life of the Artist Harry Smith

John Szwed

I almost met Harry Smith, twice—once at the Five Spot in 1959, a Bowery dive where Thelonious Monk was holding court for weeks on end, the second time in the lobby of the Chelsea Hotel. But I was wary of him. I'd just begun my first year of graduate study in anthropology and was already wondering if I should be doing something else. A professor of English I admired suggested I move to Greenwich Village and study with Harry Smith. I'd never heard of Smith, and when I asked around the Village, I was told he'd put together the remarkable six-LP *Anthology of American Folk Music*, but that he was also an irascible panhandling drunk, a frequently homeless polymath of the streets and the flophouses who, when he felt like it, could discourse sagely on any subject. When I first saw him, he seemed to me a small, scraggly, old-before-his-time, almost ghostly presence who would discourage students.

At that time, no one in New York seemed to know that Smith was also a filmmaker, a painter, jazz aficionado, anthropologist, and a student of the occult. He had come from California in 1952, and it would be twelve years before it was known that he was also a filmmaker with a considerable reputation in the San Francisco Museum of Modern Art

film series, had received support from the Guggenheim, and had studied anthropology and lectured on jazz at Berkeley. Those few who knew Harry in the early years after his arrival in New York spoke of him as a recluse, paranoid and secretive. But if he had a secret, it was in not disclosing just how far-ranging his activities were, and how a completely unknown young man from out of the West came to know so many people with such divergent interests so quickly. He had been quietly making films, painting, creating more record anthologies, working in occult book shops, befriending musicians such as Thelonious Monk and Percy Heath, researching peyote uses among Native Americans, and recording Orthodox Jewish music.

Finding his way among Village musicians, artists, and the earliest of the Beats was one thing. But virtually no one knew that he had been hired to do research in extrasensory perception, radionics, and ancient magic by Arthur M. Young, engineer, astrologer, and principal inventor of the Bell 47 helicopter, and Andrija Puharich, physician, military ESP researcher, and promoter of Israeli psychic Uri Geller—or that he had discussed his research with millionairesses and parapsychology enthusiasts Ava Alice Muriel Astor, Marcella du Pont, and Joyce Borden.

How Smith became involved with these people is still a well-kept mystery. Even those few who knew him in this period said that he could disappear for a month or so, and then turn up somewhere nearby. Still, Harry might be seen at Studio 54 in its heyday, shuffling past the sullen guardians of the velvet rope despite being ill-suited (and ill-tempered) for the carefully curated crowd. Or be found in the Columbia University bookstore on the opening days of a semester, noting what professors in a dozen fields listed for required reading on their syllabi. If you were to attempt to engage him, he could be mean, impatient, and insulting, yet sometimes also helpful and quotably insightful and funny. He could intrigue by the sheer range of his knowledge, and seemingly rattle off pages of books, verbatim, whether from a history of Australian anthropology or *The Egyptian Book of the Dead*. His encyclopedic monologues might be mesmerizing in their detail and arcana, in the swerves and

careens that his narratives could take; or he could be a crushing bore, a Professor Irwin Cory–like pedant with a dry Northwestern drawl, who warned his listeners that he left his sentences unfinished, only to return to finish what he was saying in the middle of the next day's perorations. At times he played the fabulist, constructing and deconstructing himself. The trick with Smith was to read between his lines or behind them and listen to the different versions of his tales long enough that you might catch his meaning.

So it would go with Smith. His films grew longer and more technologically complex and difficult to comprehend, his research among Native Americans increasingly innovative and daring. He surfaced from time to time among the famous and the infamous—the Fugs, Andy Warhol, John Zorn, Patti Smith, Leonard Cohen, Lucien Carr, and a number of little-known Lower East Side mystics, musicians, and tattoo artists. Yet he never held a regular paying job after his twenty-fifth birthday, and was supported marginally by Peggy Guggenheim, Jonas Mekas, Peggy Mellon Hitchcock, Allen Ginsberg, Henry Geldzahler, and a handful of devoted younger followers. His was the paradoxical life of an artist almost completely outside the public's view, always on the edge of calamity, if not death, and yet influential in so many ways in both the high and low arts.

JOHN SZWED is an anthropologist, musician, and writer who has taught African-American studies, film studies, music, anthropology, and performance studies at NYU, the University of Pennsylvania, Yale, and Columbia, where he was director of the Center for Jazz Studies and is an adjunct senior research scholar. His books include *Space Is the Place: The Lives and Times of Sun Ra*, *So What: The Life of Miles Davis*, *Alan Lomax: The Man Who Recorded the World*, *Billie Holiday: The Musician and the Myth*, and *Cosmic Scholar: The Life and Times of Harry Smith*.

20

You're the One Who Signs the Checks!
When Harry Lived with Allen Ginsberg

Bob Rosenthal

Harry Smith lived with Allen in the mid-1980s. Impossible to describe. One might know Harry as the groundbreaking film animator. As the field recorder of peyote rituals. As the editor of the *Anthology of American Folk Music*. Those recordings schooled the emerging group of folk singers in the 1950s, from the Weavers to Bob Dylan. Maybe one knows the old curmudgeon living in a dumpy room at the Breslin Hotel surrounded by collections, objects. String figures. Barn keys. Easter eggs. The Breslin closes. Harry moves into Allen's dump on East Twelfth Street. He is small. Thin with white hair. Criminally neglected teeth. He is surly when drunk. I first encounter him at a film showing of *Pull My Daisy* with Robert Frank present at Millennium Films. A voice heckles the film: "Fifties Art! Fifties Art!" I am introduced to that voice after the film. Harry hears my name and exclaims: "Oh, you're the one who signs the checks!"

I like having Harry around although he is trying to one's concentration. He starts to record East Twelfth street. He has a microphone out the open window twenty-four hours a day. Often, he plays the tapes he

has already recorded. The windows are open, so the Lower East Side is both recorded and amplified. The street noise enters in real time. Time sifts through sound. If I hear a fire truck, I have no idea if it is in the present or from several days back. Harry gets proficient at discerning the urban soundscape. He hears a siren. Harry explains: "That's on Sixth Street and Avenue A." Harry's diet is limited to sugar, cigarettes, beer, milk. Allen takes many pictures of Harry. The iconic one is Harry sitting at Allen's square kitchen table pouring milk from one Ball jar into another.

Julius Orlovsky also stays on Twelfth Street. Sony Corporation gives Allen a small camcorder to keep. In exchange, Allen has to make a small movie. Let Sony have a copy. Allen shoots Harry, Julius, Peter, and himself. It is touching, sweet, sad, unvarnished. Peter forces Julius to do chin-ups. Harry walks through holding cassette tapes and muttering. Julius cooks a hamburger. He turns on Allen putting his fist to his eye and other hand flat before his head. "What are you doing?" Allen asks. "Cooking a hamburger." "No, what are you doing with your hands?" "I am doing what you are doing." Allen calls the film *Household Affairs*. Julius is the star of course.

The Committee for International Poetry hosts the Haitian poet Felix Morrisau Leroy. I walk in on Harry and Felix in deep conversation

Harry Smith grocery list, March, 1985.

speaking the West African language Twi. Harry collects objects and acquires areas of knowledge. He reads trade magazines for astronomers. Follows the arcane beliefs of Aleister Crowley. He is not much of a bather but does not smell bad either. I come into Allen's kitchen. Harry is deeply absorbed in making a painting. It is dark and highly textured. He looks up at me. Says proudly that he is painting with shit. I know he means it. The painting doesn't stink but I make him dry it out on the fire escape. I am always friendly with Harry, but I don't kiss, hug, or otherwise touch him, as I fear he might break. Harry tells me that he likes me because I never try to kiss him. I come in. He is weeping. He has just read Allen's *Kaddish*. He reads Allen for the first time!

BOB ROSENTHAL (b. 1950) is the author of *Straight Around Allen: On the Business of Being Allen Ginsberg*, in which a version of this text first appeared, and *Cleaning Up New York*. He is also the author of books of poetry, including *Morning Poems*, *Lies About the Flesh*, *Rude Awakenings*, *Viburnum*, and *Eleven Psalms*, as well as plays cowritten with Bob Holman, such as *The Cause of Gravity*, *The Whore of the Alpines*, *Bicentennial Suicide*, and *Clear the Range*. He taught at Abraham Joshua Herschel High School from 2006 to 2016 and was Allen Ginsberg's secretary from 1977 to 1997. He is presently the executor of the Allen Ginsberg Estate.

21

Harry Smith's Universal (Digital) String Figure

Henry Adam Svec

> *While [abstraction is] going on within the digital and the electronic world, the knowledge that's passed on from one person to another in the making of string figures or the making of Peruvian fabrics reveals a huge amount of digital information in people's hands.*
>
> JOHN COHEN

> *Through the digits, through the fingers.*
>
> TERRY WINTERS[1]

Harry Everett Smith is perhaps most well-known for the 1952 Folkways album that he curated, the *Anthology of American Folk Music*. These three LPs are alleged to have laid the foundation of the folk revival to come in the early 1960s, expressed by the commercial success of acts like Peter, Paul and Mary and Joan Baez, and they finally entered the mainstream in their own right via a 1997 Grammy-winning CD reissue.[2] Not a standard collection by any means, Smith's initial release was akin to an "art object" featuring provocatively Surrealist liner notes and unconventional

selections and combinations.[3] The praises of this sprawling, dense database of "old, weird America," as critic Greil Marcus has described the content, would come to be sung by artists such as Robert Frank and Bob Dylan; but when Smith first entered Moses Asch's Folkways offices in 1950, merely hoping to sell some of the records he had collected, he had already garnered a reputation within avant-garde cinema circles on the West Coast, where he had been part of a burgeoning cultural scene.[4] (And Smith would go on to produce several important experimental films throughout the 1960s and 1970s.) As many commentators have pointed out, then, there has long been at least two legendary Smiths, and listeners and viewers were not always aware of their congruity. Complicating the picture even further, more recently his work as an obsessive collector of self-made sound recordings and various objects of anthropological interest—including paper airplanes and Ukrainian Easter eggs—has come to receive (posthumous) attention, with exhibitions and collected volumes emerging related to these aesthetic practices.[5]

Smith's interest in string figures interestingly unites his distinct areas of creative output, for his related endeavors would include anthropological curation and analysis, filmmaking, as well as outright collection. Still, the weightiest articulation of this interest is perhaps the unpublished and apparently unfinished (despite its roughly one thousand pages) manuscript on the topic, which is currently housed at the Getty Research Institute. Scrawled on hotel stationary and on the backs of Chinese takeaway menus—by Smith's hand and that of his archival assistant, "Rosebud," with whom he conducted research at the New York Public Library—the text consists of numerous lists and various assemblages of string figure information. With content ranging from succinct instructions, to categorized lists (e.g. "Three-Dimensional Figures," "Moving Figures," "Figures Beginning with 'Opening A'"), to drawings, Smith is both a compiler of maps and a feeder of instructions. In fact, among the opening notes of the manuscript can be found one of the few existing hints as to the significance of the exercise from Smith's point of view:

> Of all of the strange things primitive peoples do the only one that can be quickly and easily learned by us is the art of "string figures." For unlike music, literature, or painting, there is a sort of automatic mathematical check on perfection of performance unless such and such a move is made at precisely the correct speed rhythm and tension in relation to all of the other similarly accurate ways a tangled or at the least obviously multilateral figure results. How useful it would be if we could learn Hawaiian poetry, Arnheim painting or Congolese counterpoint with the same inevitable principle present that assumes that unless each word, brush stroke or note was exactly correct the final word, the brush stroke or note would be not only ugly but impossible.[6]

Due to the sequential nature of the string figure, Smith observes, it is not possible to approximate any particular example. Whereas other media and formats can lead to mistranslations or error, the string figure can only be recreated faithfully, in other words, authentically, or not at all. Thus, at the same time that researchers in a variety of disciplinary fields were beginning to think seriously about the situatedness of language, culture, and meaning (for instance, Geert's interpretative approach), Smith ponders a cultural format through which *lossless* compression might facilitate processes of universal communication.

Indeed, Smith seems to have extrapolated from this digital, sequential characteristic an entire theory of cross-cultural competence. For he spends much of his work searching for mathematical/gestural connections among geographically distinct groupings, which function precisely because of the lossless digital quality indicated above. Thus, Smith is constantly running cross-references, probing the ways in which these distinct patterns, from distinct locales and cultures, can be manipulated to converge and join. Consider, for example, a list of notes on the figure "Little Finger":

- If the left little finger is released in "Brant and black bear" just before the "head" is constructed a "man" rather than a "bear" is formed as the final figure.

- If the left little finger is released after "Stage A" (of Shag, Mouth, Brant and Black Bear etc. A "Man [*sic*] is produced").
- In "Brant and Black Bear" if the right little finger is inserted between the "beavers" front legs and "head," a "bear" rather than a "squirrel" is produced. A "Man" can then be made by pulling the lower transverse away to the left between the "Beavers" legs.
- Just before Katillook, Eskimo [*sic*] "two Butterflies [*sic*] is like . . . 'Carrying Wood'" upside down.
- Just before Katilook Esk "Dog or Dune" is like Nov "Big Star" upside-down.
- "Little finger" can be made from "Walrus" if two other strings than usual (the ones that make "bad man") are pulled up.
- (I first noticed this on 19 Oct. 1965)[7]

Smith pays much attention to the geographic and cultural origins of the figures, as his source materials including texts by Jayne, Haddon, and Maude had done; but Smith seems unique in his fascination with the means by which one distinct, cultural artifact can be made, through the performance of the string figure artist, to transmogrify into another. The resulting text amounts to a kind of hacking or programming of the string figure corpus. Smith quests for shortcuts, for secret pathways across time, space, and identity, which might be manipulated into being through the digits.

It is worth pausing for a moment to consider more deeply Smith's lifelong fascination with various forms of magic, for mediated enchantment is the unspoken subtext of his string figure manuscript. Smith's own biography suggests that he was engaged in alchemy from an early age. As he told P. Adams Sitney, in an interview for *Film Culture* in 1965, at the height of his string collecting efforts: "Like I say, my father gave me a blacksmith shop when I was maybe twelve. He told me I should convert lead into gold. He had me build all these things, like models of the first Bell telephone, the original electric light bulb, and perform all sorts of historical experiments."[8] Rejecting any anxieties of influence

outright, Smith forges, through his narration of his childhood, new articulations of media-historical change in which paradigm shifts can be cross-wired or reanimated, and by which media history is a branching pathway of possibilities and potentialities. His sense of the power of media—art, music, paper airplanes, Seminole dresses, Depression-era 78 records—is not only a belief that he held, however, but a consistent theme of his entire body of work. As Bruce Elder observes, writing about Smith's relationship to Theosophy and Neoplatonism, a belief in the transformative power of art and ideas unites all three branches of Smith's expansive oeuvre (folk music, film, and collecting).[9] Smith's own self-mythologizing in interviews bolsters such claims:

> The type of thinking that I applied to records, I still apply to other things, like Seminole patchwork or to Ukrainian Easter eggs. The whole purpose is to have some kind of a series of things. Information such as drawing and graphic designs can be located more quickly than it can be in books. The fact that I have all the Seminole designs permits anything that falls into the canon of that technological procedure to be found there. It's like flipping quickly through. It's a way of programming the mind, like a punch card of a sort.[10]

Smith saw transformational promise in many different symbols and cultural artifacts, but the universality of the string figure, distributed as he believed it to be across the majority of global cultures, lent it particular power as a vehicle of alchemical "programming."

And yet, Smith's string figure manuscript was not to find a publisher. It remains unclear whether this was because Smith could not find a suitable press, or because he himself had abandoned the project; it also remains unclear at what stage of completion the Getty manuscript had been in, according to Smith. In any case, as an experienced collector of folkloristic and pop-cultural artifacts, Smith must have been struck by the strange task he had set out for himself. How to construct a written or printed text documenting such a clearly *performative* genre of

artifact? The problem is magnified by Harry Smith's own performance in his "Screen Test" for Andy Warhol in 1965, for which he chose an unconventional means of self-presentation. In the roughly three-minute film, Smith wrings out a succession of string figures; that is, with his hands and fingers and a long piece of string he weaves, squeezes, and stretches ephemeral but vivid representations. Is not film a more suitable medium with which to communicate such an opaque, surreal, and layered form?

Smith's fascination with string figures would thus migrate into his own late work as a filmmaker in deep and transformative ways, with string figures appearing in *Film No. 14: Late Superimpositions* (1964) and the unfinished *The Wonderful Wizard of Oz*, and perhaps most explicitly in his magnum opus, *Film No. 18: Mahagonny*, which was completed over the course of the 1970s but first exhibited in 1980. Framed by a title card as "a mathematical analysis of Marcel Duchamp's 'La Mariée mis à nu par ses célibataires, même' expressed in terms of Kurt Weill's score for Aufstieg und fall der Stadt Mahagonny' with contrapuntal images (not necessarily in order) derived from Brecht's libretto for the latter work," the elaborate structure and symbolism of the film do not allow for easy interpretation. Described by Anne Friedberg as "an encyclopedia of objects, landscapes, and portraits to be dealt in recombinant juxtapositions," *Mahagonny*'s field of view is comprised of four quadrants, which Smith had wanted to be projected onto four hanging pool tables.[11] Each quadrant depicts an array of documentary, drama, and stop-motion animated images, with the distinct quadrants coming into conversation frequently throughout the duration of the film. Thus it is among images of Patti Smith and Robert Mapplethorpe's studio, parties in the Chelsea Hotel, New York City automobile and pedestrian traffic, and an array of powdered drugs and booze bottles that sequences occur depicting collector Kathie Elbaum performing an array of string figure patterns.

The theme of entanglement—of ideas, of images, and of source materials—is very much at the foreground of this challenging text.

As Paul Arthur has pointed out, the quadrant form "underscores the function of the grid as a net or web," and an opening scene in Brecht's opera connects "Mahagonny" to "spiderweb."[12] However, I suggest that the naturalness of spiderwebs and the demonic quality of urban webs are both in sharp contrast to the human, communicative power of the string figure in Smith's vision. Because Smith frequently sets up mirrored images in opposition among the quadrants—such as, for example, traffic moving from left to right and right to left, thus disappearing in the center—the visual effect is close to the capsizing of a knot, as in a string figure transformation.* The appearance of Elbaum might even be taken as a moment of self-referential *ekphrasis* in the text, with the art of filmmaking implicitly compared to this ancient act of manipulating series (often moving) images. Smith's description of his film in a grant proposal further suggests that the universalizing power of the string figure is something that he hoped his film could harness:

> In its final form the film will be a series of scenes of varying lengths synchronized to the time of an entire song, designed to translate the opera into a universal script based on the similarities of life and aspiration in all humans. As far as I know, the attempt to make a film for all people whether they be Papuans or New Yorkers, has not been so far made. It is by far the most complex of the 20 or so films I have made in the last 30 years; and my hope is that it will not only be successful, but will introduce a new theoretical basis for films and through the use of world wide symbols help to bring all people of the Earth closer together.[13]

The string figure for Smith had been a portal, a pathway, a networked transportation system by which cultures could connect and communicate

*Although she does not connect the effect to string figures per se, Anne Friedberg has also glimpsed the woven quality of *Mahagonny*: "Color forms a matrix, a quilt, breeding kinship and symmetries between deep reds, glaring yellows, and muted pastels" (from *The Virtual Window*, p. 213).

without—or better, perhaps, below, or beyond—language;[14] and in his most ambitious film he redeploys this image of media as the essence of cinematic art.

HENRY ADAM SVEC is the author of *American Folk Music as Tactical Media*, a scholarly monograph, and *Life Is Like Canadian Football and Other Authentic Folk Songs*, a novel. His interdisciplinary work has also spanned performance, music, theatre, criticism, and game design. He was raised on a cherry farm near Blenheim, Ontario, and has lived in New Brunswick and Mississippi. He currently teaches at the University of Waterloo in Ontario, Canada. The author would like to thank research assistants Zach Pearl and Ron Leary for their work on the larger project from which this piece is taken. This text was originally published as part of a longer essay entitled "'Through the Digits, Through the Fingers': Variations on the String Figure as Imaginary Digital Medium," published in *Convergence: The International Journal of Research into New Media Technologies*. Finally, the author acknowledges that this work was supported by the Social Sciences and Humanities Research Council of Canada through an Insight Development Grant.

22

String Figures, Not Cat's Cradles

Marc Berger

Harry Smith is, most definitely, the one who turned me on to string figures and who is responsible for my initiation into this ancient cosmic form of communication, art, and storytelling. Franz Boas was, in turn, the one from whom Harry learned about string figures. Smith was known to be a mad collector and anthropological books were his dearest love; he read Boas's work from 1888*—in which were recorded Inuit string figures—and then over the years assembled a library of treatises on this intriguing and universal art form. When I came under his tutelage in the sixties and after he observed my avid interest in string figures, from studying them in his books, he asked me to attempt to decipher some hopelessly misprinted instructions for Australian Aboriginal string figures in an anthropological journal. It was tedious work, and I wasn't entirely successful, but I was able—with my acquired knowledge of string figures from Harry's books—to reconstruct the correct directions for many of these said string figures; I have no idea what happened to my endeavors, as so much of Smith's belongings were lost.

One thing I am absolutely sure of, is that cat's cradles and string

*Franz Boas's first monograph, *The Central Eskimo*, was published in 1888 and contained details of the time he spent on Baffin Island studying the Inuit people.

figures are completely different: the former are performed where civilization exists, and the latter are done where there was no civilization. In other words, when so-called civilization arrives, string figures disappeared. Harry repeatedly preached those exact same words (he is, in fact, whom I heard them from) and no one can convince me otherwise. Furthermore, the technique of performing string figures with a loop of string over the hands is absolutely dissimilar from the method by which cat's cradles are done. String figures were rendered all over the planet by Indigenous peoples, including the ancient Hawaiians, multiple North American Indian tribes, the Patomana Indians of British Guiana, Eskimos, Australian Aboriginal peoples, Maoris from New Zealand, inhabitants of the Torres Straits, Filipino tribes, Gilbertese, Papuans of New Guinea, Pigmies of central Africa, and undoubtedly many more cultures, many of which were unfortunately not recorded because anthropologists simply hadn't arrived before civilization did and caused string figures to dematerialize. There are cave paintings of the Mimi spirits in Arnhem Land, northern Australia, teaching string figures to Aboriginal peoples—who have no written language, thus elevating string figures to a position of utmost importance in their Dreamtime. Some earthlings believe that string figures were taught by extraterrestrials to humans in order to help them develop their brains to a higher level; it is a known fact that doing string figures with the right hand is connected to the left side of the brain and doing them with the left hand is connected to the right side of the brain, and both encourage the growth of neural pathways in our brains. When I practiced the more than four hundred string figures I had memorized, every single day, my brain conceived amazing and wonderful connections between totally different cultures on different sides of the planet. These magical parallels involved both the method of construction of the figure, and the interpretation of the end result. The importance of string figures cannot be overemphasized and their value to human beings is monumental.

When I was asked to speak at Harry Smith's memorial at St. Mark's Church, the first thing that entered my mind was to give a string

figure demonstration, and I concluded it with the "Mr. Ubebwe" series, from the Gilbert Islands, which depicts their creation myth. Mr. Ubebwe, to the Gilbertese, is the creator and to me, Harry's student, it seemed very fitting for the people gathered there on St. Mark's Place to honor Smith, to witness with their own eyes this Indigenous version of the creation.

For the biography of MARC BERGER see page 35.

23

Like a Talisman for the Guardian Angel
What I Learned from Studying Harry Smith's Work

Peter Valente

Harry Smith was a painter, filmmaker, anthropologist, ethnomusicologist, archivist, and alchemist. He also amassed a fantastic collections of Ukrainian painted Easter eggs, string figures, and paper airplanes. He was schooled in many cultures and used disparate but related materials in his films and in curating the *Anthology of American Folk Music* to create a unified work. But the process was not driven by the ego. Smith once said about his movies: "My movies are made by God; I am just the medium for them."[1]

I remember first listening to Harry Smith's *Anthology of American Folk Music* in the late nineties and being blown away by what I heard. Originally released on three double-LP volumes in 1952, the *Anthology* included eighty-four tracks of gospel, fiddle music, blues, and Appalachian folk songs, recorded between 1927 and 1932. This was before the age of mass market consumption. The music was about the struggle of living, about poverty and oppression, violence, young

love, and loss; but there were also gospel songs and instrumental dance music. The cover design contained an illustration from the work of sixteenth-century mystic Robert Fludd, and the color scheme that was used to distinguish each volume was based on an elemental color code drawn from the Enochian system of John Dee, a sixteenth-century occultist. Smith was serious about esoteric magic, eventually being ordained as a bishop in the Ecclesia Gnostica Catholica of the Ordo Templi Orientis founded by the occultist Aleister Crowley; for Harry Smith there was a connection between the culture of American folk music and the occult. So, it's possible the *Anthology* contains some buried old-time magic. There's certainly something extraordinary in listening to these songs about the farmer's economic hardships or those ecstatic instrumental dances, or the country hymns, love ballads, and gospel songs. The music was a gateway to this unknown and long vanished world. But if we listen closely to this music, it is actually the secret history of ourselves, a celebration of the vitality of life in all its complexity and magic.

In the early nineties I would often go to the Essential Cinema series (the showing of a collection of key experimental films of the sixties and seventies organized alphabetically according to the last name of the filmmaker) at the Maya Deren theater at Anthology Film Archives; there I saw Harry Smith's films for the first time. His *Early Abstractions* were a visual response to the great jazz artists of the 1950s such as Dizzy Gillespie, Charlie Parker, and Thelonious Monk. Smith would represent the syncopations of Parker or Gillespie using a color code in his "jazz" paintings. His films were also synced to various kinds of music, including jazz and popular music, like the Beatles or the Fugs; Smith films were meant to trigger internal sensations of sound through the intricate interplay of colors. His spiritual epic, *Heaven and Earth Magic*, seems to have been made between 1950 and 1960. In this film he used cutouts of figures and objects drawn primarily from Victorian-era catalogs, and animated them, to create a complex relationship between the images; the entire film

suggests the workings of the spiritual world in its mysterious transformations. In *Heaven and Earth Magic* Smith suggests both the earthly and the spiritual realms. The magic in this film is created through the movement between both these two realms. Magic interpenetrates and alters objects and people in the quotidian.

What remained of Smith's projects during the 1960s was the unfinished mystical animated version of *The Wizard of Oz* entitled *Film No. 13: Oz*, or *The Magic Mushroom People of Oz*. Eventually this film was edited with other material to form subsequent films. The first part of *Film No. 16: Oz: The Tin Woodman's Dream* is an extraordinary fragment of a film that never was completed. Smith took another ten years to complete his film *Mahagonny* (1980) based on Bertolt Brecht and Kurt Weil's opera *Aufstieg und Fall der Stadt Mahagonny*. In this film, Smith wanted to create a new language for film that everyone would be able to understand through the use of visual symbols, which would connect to a collective, spiritual subconscious. He used live action and animation and filmed many of the scenes in the Chelsea Hotel, where he lived at the time; the film featured his friends Allen Ginsberg, Jonas Mekas, and Patti Smith, as well as random homeless people whom he befriended.

Among my papers, I found the following note about the time I saw M. Henry Jones's projection of Smith's films on the Lower East Side:

> The other night I attended a screening of Harry Smith's *Early Abstractions*, *Mirror Animations*, and *Heaven and Earth Magic* organized by M. Henry Jones at the Clemente Soto Valley Cultural Center on Suffolk Street on the Lower East Side of Manhattan. The films were presented with multiple color superimpositions. The music was presented by SoundLab Cultural Alchemy and DJ Spooky. DJ Spooky is a popular DJ on the acid house, techno music club circuit. The multiple superimpositions were interesting to watch as they played over the films, sometimes resulting in a kind of psychedelic complexity that worked. The overall visual experience

was indeed powerful. I've read that a Beatles soundtrack had been used up to the present for *Early Abstractions*. Art House, an independent distribution company, is rereleasing Harry Smith's films on video: *Early Abstractions* with the Beatles soundtrack and a restored print of *Heaven and Earth Magic* with the original music.

It was during this event that I saw *The Tin Woodman's Dream* for the first time on a big screen. I remember there were lines around the block for the performance because DJ Spooky was mixing live in conjunction with the films and the place was filled with ganja smoke!

Harry Smith's work is about this unity born out of chaos, or nothingness. This is one of the important themes of *Heaven and Earth Magic*. This unity is brought about through an alchemical fusion of the elements: the *mysterium coniunctionis*. Sulfur, in the alchemical texts, is the prima materia of Sol and companion of Luna. It has a double nature as burning and corrosive, heating and purifying, corporal and spiritual, earthly and occult, the source of all living things and the end product of the Work. It has effects that are dualistic: it consumes and purifies. In the *Early Abstractions* you can envision this kind of alchemical process as the colors swirl, amidst constantly changing forms, connecting and disconnecting with one another; the forms appear and disappear, solidify and melt, as if in the alembic.

During the nineties I kept some journals where I meditated on Smith's work and the Kabbalah and tarot. I find in one journal this discussion about an idea important to Smith: that there is no difference between one thing and other, or rather they are both different and the same. It is an idea that leads to understanding and wisdom through the dissolution of duality. The following is from my journal:

> The Empress Tarot (direct connection to the divine, ruled by Venus) in the Kabbalah is on the path between the two Sephiroth, Binah (Intuitive Understanding, [the palace, the womb]) and Chokmah (Wisdom, [primordial point, origin]). The path that connects Binah

and Chokmah forms the base or foundation of the uppermost triad, whose pinnacle is Kether (Will, [*ayin*, nothingness]). The path is a bridge that connects both fire and water above the abyss that is represented by the "false" Sephira, Daath, or Knowledge. The Abyss and Daath belong together because the Abyss sets a limit on what can be known from below the Abyss; the Abyss is an Abyss of knowledge, and Daath is the hole we fall into when we try probe beyond.

Crossing the abyss to venture into the unknown is important in understanding what is at stake in pursuing the life of an artist like Harry Smith. The Hebrew word associated with the path above the abyss means "door." This is the door that connects the microcosm to the macrocosm and asserts the original unity of man as God in the dissolution of duality.

Furthermore, the following journal excerpt deals with the tearing of the veil of illusion to see the truth:

> The *ajna* chakra is commonly known as the "third eye" or "inner eye." Interestingly, *ayin* (ע) is the Hebrew letter for "eye" and in Aleister Crowley's Kabbalah refers to Lucifer as the light-bringer who opens the eyes of the blind and those chained by dogma and law. In Dharmic traditions, opening the third eye allows a person to see beyond what they would normally see, thus increasing clarity and intuition of all qualities including beauty.

The *Anthology of American Folk Music* is not merely a collection of songs but through Harry's organization of the tracks and his notes, the *Anthology* becomes the story of civilization itself; listening to all the songs, I find it a tale as compelling as Dante's journey through Hell (songs of murder, violence, lost love), Purgatory (the hopeful sounds in the instrumentals, the joy of community), and Paradise (the gospel songs). Smith allows us to see what we would not normally see in a collection of songs.

In another of my journals, I find the following observation about the "renovating intelligence," and the "integration of the higher self," ideas crucial to understanding Smith's work:

> Furthermore, the path from Hod (Mercury) to Chesed (Jupiter), on the Kabbalah, passes through Tiferet (the Sun) which reminds us that the awareness of splendor combined with beauty enhances expressions of love and kindness. Furthermore, the path from Hod to Tiferet contains the *ayin*, the renovating intelligence, Lucifer. Hod and Netzach are extremes of thought and emotion balanced by the presence of Yesed; this indicates the integration of the higher self because of the presence of Tiferet in the triad. The other path from Chesed to Tiferet goes along the path of the Hermit or willful intelligence. Here the *emotions* of the higher self are reconciled with the *thoughts* of the higher self.

Harry often lived like a hermit, whether ensconced in the Chelsea Hotel, or the Breslin, or Naropa, or wherever he would find himself. Extremes of thought, which led Smith to destroy his own work, were counterbalanced with a generosity as when he said he believed all "occult" knowledge should be shared.

Smith avoided a regular life and opened himself to the world of complex phenomena, thus ensuring that his mind would remain focused and not derailed by the banality of simply existing. Debbie Freeman, in her interview with Paola Igliori published in *American Magus*, says about Smith: "He felt that his art came first, and therefore everything else was secondary."[2]

Like the alchemists of old, Smith used disparate but related materials to create a unified work. I learned the importance of this way of thinking, which involves a kind of synthesis of the elements, from reading and studying him. It is not about avoiding the suffering of life, but rather, the transformation of that pain, integrating it in a fuller experience of the universe; it is to enter the space that existed when one was

a child, to see everything as new, as a potential for creative action; it is to focus not on what decays, and fades away, subject to the ravages of time, but that which is unseen, the invisible energy that we feel more than we can explain and that connects us all to each other. But the most important thing that Harry Smith's work taught me was that one is in service to the universe, not one's ego. One's mind and body are like a talisman for the Guardian Angel, our higher self; we must open ourselves to be receptacles for the indwelling of the light; the universe speaks to us, and we are aligned to its creative energy.

For the biography of PETER VALENTE see page 5.

24

Essays on Harry Smith's *Tree of Life in the Four Worlds*

James Wasserman and Khem Caigan

Harry Smith created this brilliant and unique interpretation of the Tree of Life in 1954 when he was employed at Inkweed Arts, a greeting card company owned by Lionel Ziprin. Five hundred copies were printed in the first edition. *Tree of Life in the Four Worlds* was shown at the Whitney Museum exhibit *Beat Culture and the New America 1950–1965* and appears in *Art and Symbols of the Occult* by James Wasserman, and on the cover of *American Magus Harry Smith* (the first edition, published in 1996), edited by Paola Igliori. The Tree of Life is a complex symbol representing totality. As such, we offer two short essays on the tree written by friends and students of Harry Smith.

The Kabbalah and the Tree of Life
James Wasserman

The Kabbalah may be defined as the esoteric Jewish doctrine. The Hebrew root KBL means "to receive" and refers to the passing down of

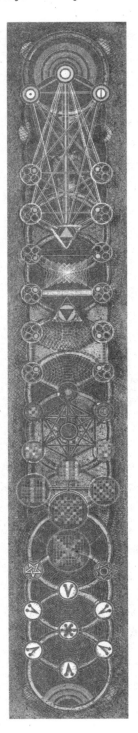

Harry Smith's *Tree of Life in the Four Worlds* (1954).
Courtesy of Harry Smith Archives, Los Angeles, California

secret knowledge through an oral transmission. It is said to have been taught by God to a select company of angels in paradise, who conveyed it directly to Adam after the fall as a means for him to reclaim his spiritual grace. It was passed on to Noah and then to Abraham, who traveled to Egypt, and shared the doctrine with Egyptian priests, who taught it to other nations. Moses was initiated in Egypt and became adept in the Kabbalah during his desert wanderings, where he was also taught directly by the angels. Moses concealed the doctrine within the first four books of the Pentateuch. The teachings remained deep within Jewish culture until the *Zohar* was published in Spain in the thirteenth century CE. The book is the record of discussions during the first century CE between Rabbi Simeon Ben Jochai and his son, conducted during the twelve years they hid in a cave after the emperor had sentenced the great rabbi to death for criticizing the Roman Empire.

The evolution of Kabbalah into a more widespread force in European esotericism took place in the Middle Ages through the works of Pico della Mirandola (1463–1494). Thus was developed the Hermetic Kabbalah, the marriage of Greek Hermeticism and Jewish Kabbalah. Pico's interest, inspired perhaps by the unpublished manuscripts of Raymond Lull (1235–1315), influenced Cornelius Agrippa (1486–1535), Robert Fludd (1574–1637), and others who influenced the Rosicrucian flowering of the sixteenth and seventeenth centuries. In the mid-nineteenth century, Éliphas Lévi popularized kabbalistic doctrines in his widely read books. In the latter part of the nineteenth century, Kabbalah was adapted as the primary symbolic language of the Hermetic Order of the Golden Dawn through two of its leaders, William Wynn Westcott and S. L. MacGregor Mathers. The resulting twentieth-century development was referred to as "bop kabbalah" by Allen Ginsberg in his epic elegy, *Howl*.

The primary symbolic groupings within the tradition are the divisions into four, ten, and twenty-two.

The Four Worlds: The primary description of the structuring of reality is patterned after the divine name IHVH. Each letter of the name is assigned to one of the four elements: fire, water, air, and earth, respectively. The four elements are the primary and most general "qualities" with which the amorphous and purely "quantitative substance" of all physicality first enters differentiated form. The letters IHVH also refer to the four planes of reality called the Four Worlds. These include *Atziluth*, the archetypal world, or world of pure idea, the root-notions and volition behind all forms; *Briah*, the creative world, in which are contained all patterns of general ideation; *Yetzirah*, the formative world, the world of thought, imagination, design, and the astral plane; and finally *Assiah*, the material world, or tangible manifestation of these finer levels.

The Thirty-Two Paths of Wisdom: The most important graphic symbol of the Kabbalah is the Tree of Life. It is a richly provocative image, the ultimate symbol of creation; all of nature is included in its schema. As a visual diagram it is composed of ten spheres, or *Sephiroth*, and twenty-two paths connecting the spheres. The ten spheres represent the numbers from one to ten, and the twenty-two paths correspond to the twenty-two letters of the Hebrew alphabet. Together they are the thirty-two paths of wisdom described in the *Sefer Yetzirah*, an early kabbalistic text attributed to Abraham. In Harry's image, the tree is shown reflected in each of the Four Worlds.

The Ten Numbers: The Kabbalah includes a numerical description of the successive emanation of our known universe from the nothingness prior to creation. The mathematical sequence begins with triple veils of the negative. The number zero is called *Ain* (nothing), the primordial void. Within *Ain* is something similar to infinite space called *Ain Soph* (without limit). *Ain Soph Aur* (the limitless light), slightly less abstract, is akin to the space-time continuum. These concepts establish the preconditions of physical manifestations.

The Twenty-Two Letters: The Hebrew alphabet is considered to be the vehicle by which God created the physical universe and indicated the means of return to divine union. In the *Sefer Yetzirah*, the twenty-two "foundation" letters are divided into three groups: the three mother letters (corresponding to the elements of fire, water, and air), seven double letters (corresponding to the planets), and twelve simple letters (attributed to the astrological signs).

The Kabbalah, as the symbol of the infinite, involves many other aspects. It includes breathing techniques, yoga-like postures that may resemble certain letter shapes, extensive meditation techniques based on a deeper penetration of the root meanings of the letters, meditations that focus on the Tree of Life or other diagrams designed to access deeper layers of consciousness, and magical practices whose purpose is to influence or alter natural events. The divine tree is as an image of the interaction between heaven and earth.

JAMES WASSERMAN played a key role in numerous seminal publications of the literary corpus of the English philosopher Aleister Crowley. Three of the most important of these included his supervision of Weiser's 1976 edition of *The Book of the Law*, in which the holograph manuscript was appended to the corrected typeset text of the OTO's 1938 publication, in conformity with the book's instructions, for the first time in a popular volume. After several years of negotiation, he successfully arranged to professionally rephotograph the Crowley/Harris tarot paintings for an improved second edition of the *Thoth Tarot* deck published in 1977, to which he contributed the booklet of instruction. In 1983, he helped to produce *The Holy Books of Thelema*, the critical collection of Crowley's inspired (class A) writings. In 2005, he and his wife Nancy launched *The Weiser Concise Guides*, a series of books on basic occultism. The series includes five topics: alchemy, yoga, herbs, astrology, and the teachings of Aleister Crowley. In June of 2012, his *In the Center of the Fire: A Memoir of the Occult 1966–1989* was published by Ibis Press.

Harry's Tree
Khem Caigan

I know a lot of you think that Athanasius Kircher is somehow to blame for this, but it's not so. Actually, it's all Rosebud's fault, but we won't go into that here.

Though Kircher may have published the first diagrams of the magic lantern in his "Great Art of Light and Shadow," others had written on the subject prior to that, including Della Porta in his "Natural Magic" & Chaucer in "The Franklin's Tale." And R. Joseph Ashkenazi talks about projecting the letters of the Tetragrammaton on a large white sheet about the universe of Aravot. Anyway, I'm supposed to write something about the Tree of Life.

In common with the other memory palaces, Harry's *Tree of Life* is a set of empty screens or frames providing places for sorting and storing of ideas and images, but unlike them it serves to extend the powers of the soul as well as those of memory. It's called a "tree" because the affinities and correspondences between objects and ideas resemble a tree extending from the heights to the depths, which links everything into one living unity. It provides a map of divine consciousness, with its ten (or more) qualities reflecting and organizing the inner life of supernal existence. While conventional mnemotechnics may aid you in reciting the contents of the *Encyclopedia Britannica* forward and backward, magickal memory serves the no-less-useful purpose of assisting in the recollection of one's true self. And while it does demand a great deal of time and effort on your part, it's really well worth it. After all its's not the car keys you've misplaced, it's the fact of your divine origin.

In practice, you separate the elements of your experience into their essential relationships and restore them to their sources on the tree. You can restore the holy spark in any thought, however extraneous it may seem, by examining it and attaching yourself to the divine essence, as it is written, "You shall attach yourself to God" (Deuteronomy 8:4).

The spark is then elevated from its husk to its appropriate Sefirot, and bound there. As it is said, even the tiniest of sparks may become a great flame.

As thoughts fall into your mind from the Sefirot, you continue in returning them to their roots, elevating them to the attributes from which they emanate and binding them there. Gradually, the levels of consciousness connect with each other, and your forgotten self arises into activity and emerges into the spiritual domain. As it is said, "If you embrace in yourself all things at once, time, place, substances, quantities, qualities, you will comprehend God." Your every word and expression bring about a unification in the supernal universes, and your thoughts come to mirror the divine countenance in the circulation of impulses and intentions. By consciously combining and uniting the divine attributes, you climb with the power of your intention from one branch to the next until you return to your source in the Ain Soph, the infinite.

It is also written, "He who strives for good shall seek the Will" (Proverbs 11:27), and having identified with this unity, the highest will clothes itself in your will, & the tree you have traversed becomes a channel for the highest light to course through your soul. And while your light is increased, you are transmitting light and nourishment to all the universes, a participant in their creation and perfection.

Souls passing through the column from one universe to another attach themselves to you and reveal themselves, and you are unified with the divine essence. All universes are then united as one, and there is great joy and delight as the bride and bridegroom meet face-to-face. It's the end of fragmentation and separation, the exile is overcome, blessing brims over from on high, and souls bloom forth on the Tree of Life.

Thus far, O best beloved, the discourse on Harry's Tree.

KHEM CAIGAN was born in Passaic, New Jersey. He was a scholar and writer and Harry Smith's assistant throughout much of the seventies and eighties.

25

Harry Taught Me How to Be a Complete Human Being
*Pesach Betzalel (Peter Fleishman)
Interviewed by Zia Ziprin (2022)*

ZIA ZIPRIN: Hello Betzalel. You have been a part of our family since before I was born. I knew you growing up as Peter White Rabbit. Now I call you Betzalel. I wish I was sitting in front of you for this interview, but I am in New York, and you are in Los Angeles. Let's start with where you and Harry met. You told me that you met him through your friend, a graduate from Goddard. What was his name?

PESACH BETZALEL: David Peterson. He introduced me to your parents.

ZIA: So, does that mean that you met Harry through Lionel and Joanne?

PESACH: Yes, but much later. I heard about Harry often. They spoke of their genius friend who made these incredible films and who had come to study esoteric Kabbalah and work with them. But I didn't get to meet him until a year or so later. He had left New York. It was after Inkweed Arts had been sold as well as after Qor Corporation. I arrived after the collapse of the Qor Corporation, this company that Lionel, Harry, and others worked on.

ZIA: Can you tell me about the Qor Corporation?

Pesach: It was a company that had developed special inks, laminations, and Mylar for industrial purposes.

Zia: I'm always interested in learning more about all their various endeavors. As you know, I wasn't even born yet. I have had to piece everything together from the archive, stories, books, or publications. Lionel has been gone for thirteen years and it's not like I can call him up and ask him, Harry, or my mother a question. There are not many people left to ask.

Pesach: It was a revolutionary time. There were new innovations in plastics being developed. For example, accessory companies had figured out some way to stick rhinestones into sunglasses and now you have sunglasses with rhinestone siding. This new development led to numerous adhesion methods being available and led to all sorts of possibilities for companies to explore and develop.

So, everybody or almost everybody had the potential for financial exploitation of this new product that they'd all been involved in, right? And then they wanted to start dividing Qor up before it was even a real business. Your father got fed up and walked away.

Zia: We have, in Lionel's archive, many of the original laminates, Mylar, and metal plates that they designed for the Qor Corporation. I don't know if you ever got to see them. I was told by Lionel that those were made to secretly heal whatever spaces they ended up in. They were esoteric kabbalistic designs. Their vision was that through Qor and big corporate companies, they would sell the Mylar and laminates for homes and businesses. Tables, floors, countertops, walls, and such would be covered in the designs, and they would cause subconscious healing and unknown protection for the viewers.

Pesach: The Nabisco logo. Angel or demon signature!

Zia: I heard that Harry loved store windows and that he would stare at them for hours. I was so surprised! I can't imagine that!

Pesach: I do know that he smashed and broke many store windows in his lifetime. He was very destructive in general. He would sometimes walk down a street and break every window on it!

Zia: I never heard that before, but I'm not surprised.

Pesach: I knew Harry broke windows, but I didn't know that he loved them. You know, it's funny how everyone has different versions of Harry, and windows, and love. I never thought about whether he loved the windows or that he might have. It's like a marriage. The great problem in a marriage, and in parenting, is that people don't know how to express their love and they wind up doing very destructive things. Whatever the creation may be, whether it's a marriage or their children, or whatever. Look at us. We are the product of these people. I'm sure they loved us, but they had a hard time expressing it.

Zia: Yes.

Pesach: Now, I have more of a clue about Harry's love for me! You see, I lived in this storefront on St. Mark's Place between First and Avenue A and I reworked the window every day. It was called Peter Fleishman's Butcher Shop. The windows were a reflection of my life and what was going on every day. Kind of like the way Lionel wrote the comic book scripts. The windows were a kind of history of the Lower East Side. Anyway, I would change the window every day. This editor for the *Village Voice*, I think his name was Edmund Wilson, visited daily and would often write about the windows. Much of Harry's film, *No. 14: Late Superimpositions*, was filmed at the butcher shop.

We did a lot of the film with masks. We would cover parts of the lens with a mask so that later we would have that film unexposed so we could expose something else on that part of the frame. That was Harry's theme from his very first film, which was the stuff that was hand painted. His method (he's such a maniac) was that he made masks with masking tape, and each one would be perforated or cut out, so that he could have all these layers of masking tape that he could peel off or adhere to the film to expose parts that hadn't yet been inked on the frame. He could cover up part of a frame. It was hand painted directly on 35 mm film. He had a 35 mm empty frame so he could see one frame at a time and work on one frame at

a time. I'm finding it hard to breathe thinking about it. Only Harry could do something like that. If there was something that needed not to be colored, he would put Vaseline on the film that had been colored already and then he could peel the mask off and have the open part exposed; but the part that he didn't want colored was covered with Vaseline so the sprayed-on ink would not adhere to the film. When he cleaned off the Vaseline then you could look at the film! Heather and I are in the movie.

Zia: Who is Heather?

Pesach: Heather Milgram. I met her through Lucien Carr, who was a friend of Harry's. Heather and I were living together with her kids after she separated from her husband. I don't remember the exact years, but I know Kennedy got blown away during the time we were together so that was 1963 and I think the film was made in 1964.

Heather and the Carrs lived next door to each other, and I was hired to babysit her children. We moved together in an apartment in Greenwich Village and love came later. I still think of her every day. I wish I could find her again. I had been living in my storefront on St. Mark's, but I would hang out with the Carrs in those days. I was like a poor artist. I was working at the Door Store; it was like a prototype for Ikea. They figured they could cut the costs if the furniture wasn't put together already. It was a place for various kinds of artists, actors, and such, who were just starting out.

Harry's connections in general were to wealthy people. I was probably the only poor person, right? I don't know how we could rate your family, but . . .

Zia: They definitely weren't wealthy!

Pesach: Your father and I would go out every day and somehow raise grocery money and rent. Your father was also writing comic book scripts then.

Zia: Yes. Did I hear that there was a comic book character named The Mariner after you? I have heard that various friends and characters of Lionel were used as inspiration for the comic books he wrote.

Pesach: Yes, my character was named Captain Duke Peters. It was from the comic book *Voyage to the Deep*.

Zia: That's amazing!

Pesach: I must have met the Carrs through Harry. Lucien Carr was the night editor at United Press International, which is no longer around. Francesca Carr was the editor of *Natural History Magazine*, the periodical published by the American Museum of Natural History. You know the story about Lucien killing the professor?

Zia: Yes, of course.

Pesach: Harry wouldn't go frequently to the Museum of Natural History, but rather next door to the National Museum of the American Indian.

Zia: I heard that you were occasionally Harry's bodyguard of sorts…

Pesach: Yes, I somehow ended up being Harry's bodyguard. I was interested in learning about filmmaking and part of my job, in exchange, was watching over him as he caused trouble everywhere he went. I was his bodyguard, and I was a good bodyguard in those days. After my father passed away, I was so angry that he died, I fought all the time, you know? When I was a kid, I wanted to hurt people, but I couldn't pick a fight with just anybody, so I became a protector for little guys. The little nasty guys like Harry who would antagonize people. Then I could defend them and feel justified in hurting people.

There was an event where Lucian and Harry needed protection; it was a joint production of the Museum of Natural History, Qantas Airlines, and the Australian American Association. They had invited an anthropologist who lived with the Aboriginal people in the outback. He had two Aboriginal wives and many children, and was the world's great authority on the Aboriginal people and Aboriginal art. He brought a whole bunch of Aboriginal carvings, ceramics, and tapestries. He was going to show this stuff, do a slide presentation, and then sell the items, and it was all for charity to the Aboriginal people.

There was an open bar that Lucian and Harry took great advantage of. After the event was over, Lucien and Harry could barely walk, and everybody had left except for a group of ex–rugby players from Australia. I had one advantage because I was the designated driver, so I wasn't drinking. Drunks can be dangerous, especially when they're over six feet tall and nearly two hundred pounds each, right? I was hanging out with Harry, trying to get him out of there. When I maneuvered him toward the stairs, Lucien was sitting at the bottom of the stairs, and already had a circle of a half a dozen of these big guys who were taunting him. The Australians were real racists against the Aboriginals. A huge argument broke out between Lucien and the Australians. They were talking about the good old days when they could go out with lances on horseback and hunt the Aboriginals like animals! Anyway, at that point, I had to throw both Harry and Lucien one over each shoulder, while at the same time punching out the five rugby players who were thugs and escape out the door. We survived.

ZIA: Incredible story!

PESACH: Harry always introduced me to his rich patrons as "one of the world's greatest artists." I had sold some of my really good early paintings for pennies. The things we do when we are young! I had learned to glaze and not everybody knew about glazing. You could make luminous stuff by putting light colors underneath and then transparencies on top. That is why I understood Harry's work and how his animation processes worked. He was doing on film what Tiffany had done a hundred years before with glass; fifteen windows that were ten layers thick. The luminosity and the depth weren't the only thing; it was incredible art. It was that there were actually layers and layers. And that's what Harry did on his animation stand. At the time, animators would have layers close together. Harry's animation stand was like twelve feet tall and so the layers were a foot apart. You would see depth in the film because it was real depth; it wasn't just some perspective and moving colors. He

was doing things that were actually ten feet away from the next image. The studio was an old Park Avenue apartment with really high ceilings so he could fit the animation equipment in there.

ZIA: I always imagined everything was done on incredibly intricate tiny little squares of film.

PESACH: There was original stuff where he painted directly on the film. What he got from that was the code for the heaven and hell film.

ZIA: You mean, *Heaven and Earth Magic*?

PESACH: Yes! Except for the people that were looking at it! It was hell! It scared the shit out of them! [laughs] When the lights would turn on after the film, people were afraid to get up in the dark. People would go running and screaming out of the theater! One of my jobs was playing songs from the *Anthology of American Folk Music* on my guitar at the film screenings. I listened to and learned many of the songs. I was telling you about the record collection, right?

ZIA: Yes, we spoke about it before.

PESACH: Harry eventually gave me the whole second part of the unpublished recordings and I had all these tapes and records. As we know those records and recordings influenced whole genres of music in the world.

I was always suspicious of Harry, you know, I don't know if he was actually a homosexual or what, but he was always hitting on me, and it freaked me out. It seemed that was part of his art, irritating people! He would do it just to watch them squirm! I have nothing against anyone, but it was just not for me. He wanted me to go to the Warhol Factory and I just couldn't do it.

So *Heaven and Earth Magic* was made on a cardboard base. Harry loved cardboard; did you know that?

ZIA: I have never heard that before. I did hear he made Joanne a cardboard replica of our family's apartment when she was working on the Oz film so she wouldn't be so homesick.

PESACH: Yeah, well he loved cardboard, and he taught me to love cardboard, because it's such great stuff. It's such a great product. They

make a much better cardboard now so that you could actually build a house with cardboard, and it wouldn't fall down. Harry made the animation stand out of cardboard. He always made it out of cardboard. He made everything out of cardboard. He gave me the whole set of solids, which I later smashed to pieces, you know?

Zia: What were solids?

Pesach: The geometric solids; he made a whole set. They were three-dimensional structures that began with a triangular pyramid on a rectangular prism until all the way up there was the biggest one which was about a diameter. It was this big geodesic creation.

Zia: And . . . you smashed them?

Pesach: I didn't take care of things, you know? I had all this precious stuff that Harry had given me, but I didn't have the means to take care of it. I needed an archive. But it was all fragile, and it was all just, you know, worn cardboard and it didn't even pack. He didn't even reinforce the joints; it just had cardboard joints that were glued together.

Zia: It was put together with spit and glue!

Pesach: Anyway, it wasn't the right thing to give them to me, except he couldn't keep them anymore. See, he gave it to me when his personal archive had nothing that wasn't flat. If it wouldn't go in the drawer, he couldn't keep it anymore. The only three-dimensional stuff he had was Seminole clothing.

Zia: I heard about the Seminole patches, but I didn't know about the clothing.

Pesach: A thing that the Seminole people did was *reverse applique* and that was their art form, and they made these incredible geometric patches with colored cloth that they cut into strips and then sewed back together. I had a shirt that was given to me by John Phillips from the Mamas & the Papas.

Zia: They lived near us in the Lower East Side, right?

Pesach: Yes, on Tenth Street.

Zia: When we drove from Seventh Street to Berkeley, we stopped and

stayed at Michelle Phillips's house in Santa Monica. I remember seeing the beach for the first time in my life.

PESACH: The shirt John gave me became my birthing shirt. I became a midwife, and I would always wear that shirt when I was helping somebody with their delivery.

ZIA: Wow, that's a beautiful story.

PESACH: I lost that shirt, among many other precious things, when I lost my storage some time ago. That was a tragic loss.

ZIA: The things we lose in our lifetime.

PESACH: I saw, during my last visit to Harry's apartment, that he had stacks of architectural drawers. I don't know exactly if they were architectural drawers, but they were full of paper and that's all he had in them, along with Seminole clothing and a maybe a few Kachina dolls. Everything had to be basically flat to fit in the drawers.

So *Heaven and Earth Magic* was a phenomena of innovation. Harry figured out instead of making a color movie, that you could make a black and white movie and color it with the color wheel. Harry was so adept at the color wheels that he would put a whole bunch of color wheels in front of each camera and . . . Harry's hands!

He could manipulate the color wheels in front of black and white film and the registration was so exact that like a guy's pants, as the guy ran across the picture, would remain blue all the way across. He covered one part of the frame, so he could keep the blue moving across the frame to keep the guy wearing the same blue pants he entered the frame with on the right until he exited the screen on the left. Other things maintained their colors as well. To keep the animations in order he would write these scripts that were like your father's comic book scripts, but he would write them for the animation, so he could remember what was going on because it was just too much going on all at once. It wasn't like you're doing a drawn animation where you have the last cel that you could read from, to make the next cel follow in order. Because it wasn't digital,

it was actual film, and so the only way you could keep track of how everything had to move was to have it all written down beforehand. Harry's brain! You know, his head was misshapen because his brain had grown so much? He had to store so much information, and a lot of it had to do with keeping track of what was happening on the animation stand. On this twelve-foot high animation stand, where there were things going on at every different level. It was, you know, just too much! He wanted to make a theater where the seats were all physicality detectors.

ZIA: So they could read the body?

PESACH: Exactly. So he could understand what's making people squirm, what's making them sweat the most, what's making their blood pressure go up.

ZIA: I heard that he had an innate way of knowing exactly how to push each person's buttons and that's exactly what he did.

PESACH: He was doing the best he could manipulating the film while animating his animation. He could see what was making the people freak out the most. There were two slide projectors and a movie projector. The image on film was a square format, instead of rectangular; and the screen was rectangular and the scenery that was projected at the same time, from the slide projectors, was all the stuff that was in the film. In the animated film, there was the female character who was the star. She was the woman who had gone to the dentist, right? The woman goes to the dentist, and she gets in the chair, and the dentist comes out. He comes with a big hypodermic syringe and speaks to the chair and of course, we're under her psychedelic trip through the chair, the pedestal, which extends and extends, going up through the seven heavens, right? And the stuff that's going on is all stuff that's in the film, but all the characters that she sees going up through all these different layers are also in the slides. Harry would discover what was bothering the people most in the film is that he'd used those slides. In fact, if people were bothered by the woman's head, he would put the woman's

head up, and if the people were bothered by the dog and the cat, or the watermelon, or whatever, that's the one you'd have to look at.

ZIA: What film was he working on when you were around him?

PESACH: *The Wizard of Oz* [*Film No. 13: Oz* or *The Magic Mushroom People of Oz*].

ZIA: So then Mom was already finished working on that with him?

PESACH: Right.

ZIA: I was just a little kid, but I remember having a vivid nightmare during the time she was working with Harry.*

I was trying to call her on the pay phone and the pay phone was melting. Strange how you never forget certain nightmares your whole life. She was gone a lot of the time working on that film. I also heard that after years of her working on *The Wizard of Oz*, Harry tore the entire project into shreds, and so she walked out and refused to speak to him for quite some time. At some point later, he carefully reglued all the thousands of little pieces of film or paper, that she had painstakingly cut out, and presented them to her as a peace offering. I think that was the end of it. I have a stock certificate made out to her from Van Wolf Productions as part of her ownership of the film. He was producing it. I doubt she ever got paid for all her work.

PESACH: By the time I got there, we didn't shoot one more frame of the *The Wizard of Oz*. I just couldn't handle it. I was so angry at

*The last time I saw Harry Smith was when I was six or seven years old. Harry was a permanent fixture among a slew of other artistic and otherworldly characters that seemed to converge every night in our basement apartment on Seventh Street, between Avenue C and D, in New York City's Lower East Side, where I lived with my parents and three siblings. Harry Smith, though, was the one who would forever haunt me. I remember taking my baby sister Dana into the closet to play every time he arrived, so as to somehow disappear from his gaze and drown out his high-pitched voice. He appeared to me to be an evil, mad professor, out of a dark fairy tale, and I was terrified of him. During a recent reading with a prominent spiritual medium, I was told that someone named Harry was "watching" over and "protecting" me. I had to laugh and had a sudden revelation that Harry Smith probably had always been watching over us and now—as a grown woman—I feel quite honored to be "protected" by this unusual guardian angel.

the lack of production. We would go and show the *The Wizard of Oz* test footage for wealthy people, and they would give us money and he would drink it all up. We didn't do any more film and that's what I was there for. I wanted to learn how to animate, but I didn't get to do it. All I got to do was hang out with Harry and watch him get drunk and smash stuff! Harry always said "God makes no mistakes" so I'm assuming it was all exactly as it was meant to be.

Zia: So you and Harry went your separate ways after the Oz fiasco?

Pesach: No. We went to Conrad Rooks. He was making some kind of documentary and he wanted Harry to do it. Rooks had his studio at Carnegie Hall. Carnegie Hall had artist studios. It wasn't just the auditorium. They also rented studio space and Rooks rented one of them and that's where we went to work on his project. I don't remember if we ever did anything. That's what freaked me out. By the way, I was told that I was the star of Harry's film *Mahagonny* and I should say something about that. All I can say is that from lights off at the Getty where it was screened and the projector cranked up, it looked like someone else got an editorial hand mixed in it; so, I just conked out until they turned off the projector and turned the lights back on. The best part was getting to meet Patty Smith, who's still just as beautiful as she was back in the sixties. But I was just so frustrated, because I was hanging out with Harry to learn how to make movies. We did it once in all those years: *No. 14: Late Superimpositions*.

Looking back, I can see now, I had to come to Chabad Chassidus to understand this was Harry's way of teaching me how to make films. This was Harry's way of teaching me how to be a complete human being.

A war baby, Pesach Betzalel Fleishman (Peter Fleishman) got into show business entertaining the troops training and recovering from their tours of duty. He scrambled around for the next half century or so looking for some

kind of communal spiritual connection, but he kept slipping through the cracks. Aryey Leib and Chana Marium (Lionel and Joan Ziprin) provided a possible venue, but their artistic angle was more attractive than the Jewish one, so when Harry seduced him into the realm of animation, he took that route for as long as we could stand it. By way of youthful folly, he skipped out on the great love of this life. He got into midwifery and once resuscitated a stillborn son. He hooked up with Kesey who shoved him over to the Hog Farm whose events attracted the Chabad boys and their phylacteries, but they miraculously passed him every time. After fifteen years of near misses, he had to practically break down the door of the Chabad House Berkeley to get in. After two more years the Rebbe welcomed him in Crown Heights. So that's twenty years ago and still, all he wants is Moshiach NOW! Peter passed away in 2024.

ZIA ZIPRIN, a native New Yorker, one of four children, was born in the Lower East Side to artist parents Joanne and Lionel Ziprin. She is a photographer, fashion designer, CEO of GLS Archive and head archivist and executor of the Ziprin Estate. Zia currently works with her daughter, Aishling Labat, directing various projects, exhibitions, and publishing works pertaining to the Ziprin family archives of literature, poetry, Jewish ancestry, and art.

26

A Short History of the Installation
Harry Smith: A Re-Creation

M. Henry Jones and Friends

For many years I wanted to realize Harry Smith's desires for the projection of his animated films. He imagined a multi-projector performance with magic lanterns, colored gels, his framing slides, and live music. When I was spending a lot of time with him in the late seventies, he would describe his early attempts to stage such a show. He wanted to break down the edge of the film with the addition of animating borders, to create a dreamlike, hypnotic state. Sometime after his death I produced *Harry Smith: A Re-Creation* to honor his ideas for the magnification of his films in performance.

 I first heard of Harry Smith from sculptor and performer Suzanne Harris. I had assisted her as part of my summer job as construction assistant and materials wrangler for artists at Artpark on the Niagara River in Lewiston, New York. After that summer, when I came to New York City in 1975, I visited her often. It was then that she asked me if the School of Visual Arts was teaching about Harry Smith. She let me know that he was the foremost experimental animator, and I needed to look him up.

 I was at Anthology Film Archives a lot that first year in New York.

They had a regular rotation of the history of avant-garde cinema, so following Suzanne's suggestion, I circled Harry's films on the schedule and saw their Harry Smith Program #1. I decided to write a paper about him for William Everson's SVA class, The History of Film. Amy Taubin told me that I could go to the Donnell Library at Fifty-Third Street to examine his films more closely.

That was the first time I used a Steenbeck. At SVA only the upperclassmen were allowed to use the Steenbeck editing machine, but Donnell had one for the general public, along with an extensive collection of films. The Steenbeck allowed me to run Harry's *Early Abstractions* reel at varying speeds in slow motion, and to examine them one frame at a time. I could tell that he had splattered frames of film with a toothbrush, and I saw strange positive/negative effects that I would later learn were batiked using Vaseline, shapes cut from masking tape, Clorox, and red Avery dots, like the ones used to show a piece was sold in galleries. I was amazed to see how much animation he could create with just a few dots and a toothbrush. I spent days looking at how he had manipulated the film stock itself frame by frame.

I had asked if it was possible to meet Harry when I saw the first program at Anthology, but no one would say where he was. After my intensive study of *Early Abstractions* at Donnell, I went to see the Harry Smith Program #2 at Anthology. This time I saw *The Tin Woodman's Dream* in 35 mm. After I experienced that, I pestered Jonas until he revealed that Harry was at the Chelsea. No one was supposed to know Harry's location and I was sworn to secrecy.

Once I found Harry and he allowed me into his remarkable room and many projects, I spent a lot of time with him at the Chelsea and Breslin hotels while I was in school and for some time after that. He told me about shows he had put on in the mid-sixties. He said he had made drawings and transferred them to glass slides to frame *Heaven and Earth Magic* on screen. He had a bunch of film and magic-lantern projectors in a giant black box, and he would be inside orchestrating the show with his animated film and the frames and handheld colored gel strips. Harry

always said he wanted to have the experience of watching his animation to be less like viewing a film while sitting inside a shoe box, staring at one end. He wanted to break the screen edge and surround the viewer.

One night in 1980 Harry and I showed *Early Abstractions* at the Hellfire Club in the Meatpacking District. We took the projector over in a cab and rigged up a makeshift screen by hanging up a bed sheet and tying it in with photo clips and bungee cords. Harry was delighted that I had brought a Bell & Howell 285 projector that could run in reverse. He asked to meet the DJ and when he came up Harry said, "What's today's hit? Play that," and it worked exactly, proving his idea that the timing of his animation, based on human breathing, heart rate, and alpha waves, was universal, and that any kind of music would sync. Harry conducted the show, signaling to me when I should run the film backward, and when it should go forward. It was an impromptu show and, given the location, it got a pretty good turnout. The hard-hat guy from the Village People was there that night and everyone was dancing to the film and music. Harry thought it was great to be part of "the scene" again.

For years after that Hellfire show I always remembered Harry's discussions with me about the unusual ways he wanted his films to be projected and experienced. In 1993, after his death, Rani Singh from the Harry Smith Archives at the Getty gave me a call and asked me if I would come into Anthology while she was in New York. She wanted me to talk to her about some color transparencies and a box of negatives that she had found and needed to identify; it looked like I was involved in making them. She was remembering that I had helped with some of the six *Film No. 18: Mahagonny* multi-projector shows held at Anthology in 1980. I met her and found that she had some color images that were Ektachrome 4 × 5 transparencies of Harry's watercolor and ink drawings that were in register to be glass-slide projection frames. I had photographed these with my Linhoff view camera with Harry at the Chelsea. They were intended for *Mahagonny,* though in the end they weren't used.

The other box was the big surprise. She had seventeen black-and-white 4 × 5 negatives of a different group of Harry's frames. These were

not for the *Mahagonny* show. I knew a couple of the images really, really, well because I had tried to find out about them for several years when I was first hanging out with Harry. I had discovered these images in the Robert Russett / Cecile Starr *Experimental Animation* book, which was my Bible then. There was a Tibetan griffin and a flower ring; the griffin had a white box in its middle in the 16 mm aspect ratio of a movie screen. The caption said that they were slides of artwork to be projected around *Heaven and Earth Magic*. I had asked Harry about them over and over, and he would say they were lost or had been thrown away. It was tricky with Harry because his answers to the same question would vary day by day as he went on one tangent after another. Finally, he said the images in Russett/Starr were from a magic lantern show he gave down by the Brooklyn Bridge in the sixties.

For my meeting with Rani, I had borrowed a copy of Russett/Starr from Cheryl Daitch. When I showed it to her, I realized instantly that her second box contained the film negatives for the magic-lantern slides that Harry thought were lost. They were his animating borders. At some point someone had made a set of film copies of the glass plates he had made. The original artwork would have been watercolor on white paper, and whoever rephotographed the slides took the trouble to be sure the registration was right for projection with dissolves around his animation. This was what Rani had. The 4 × 5–inch negatives were the missing link that Harry had misplaced. Now I could fulfill his ideas.

To realize Harry's multi-projector *Heaven and Earth Magic* show I needed to make positive glass lantern slides out of Rani's negatives. One day, a bit after the discovery at Anthology, I had arranged for her to come by SnakeMonkey. She was coming to shop with me and to pay for the box of 4 × 5 Kodalith orthographic film and the photo chemicals I needed to make transparencies from the negatives she had found. She didn't show that day for some reason, but instead one of those weird New York events happened.

P.S. 13 was across Avenue A from my studio. There were often juicy dumpsters there for clearing out stuff from the school. There was a new

one that day and while I was waiting for Rani, I went across to take a peek. It was empty except for a yellow Kodak box of unexposed orthographic film all alone, right in the middle of the dumpster. I climbed in and got it; it was the same film I was waiting on Rani for. Now I could make positive contact film-to-film of the negatives to mount in glass and use in the show we were planning. All I needed was the AB developer for ortho. I called up Mark Anger and asked if he had any and he said, "I've got pails of it. Have you got fix?" I did have the Dektol fixative and now I was all set. I made both high and low contrast copies of a lot of the negatives so that we could layer five different versions of the same drawing on the screen. By stacking all the slides with varying densities on top of each other on the screen and doing dissolves it created an ethereal and almost three-dimensional projection around the original *Heaven and Earth Magic* animation.

Since first hearing about Harry's projection ideas, whenever I came across something Harry had talked about, I would grab it. I found some of the obsolete things in midtown garbage bins by the used-camera stores. Judi Rosen remembers that "Henry said that Harry threw some of his old projectors at him down a flight of stairs when he asked too many questions." I started getting together more of the old projectors we would need from school dumpsters and flea markets and junk shops. Lary 7 was righteous when it came to seeing gold and we had our heads together a lot. I stole parts from three or four projectors to put together one that actually worked. The equipment included a 16 mm optical/sound projector to fill the midscreen, three 1950s American Optical lantern projectors, a Variac dissolve unit, and custom-made devices.

I modified two 1913 magic lantern projectors, hitched together so the images overlapped in register. I had been trying to make a 3-D projection device with them for my binocular pinhole images. Instead, I built a free-floating device I called the Interrupter to go in front of them. It was hand-cranked and had a timing belt that rotated two large disks, each with four holes over which we taped gels in different colors. The disks were side by side, parallel to the projector light, with one just

slightly in front of the other so that a hole from one disk would line up with a hole from the other in sync. As we cranked the Interrupter, we got repeated combinations of the gels layered by the machine. That added in afterimage effects for additional limited animation.

We had our first several shows at Anthology in 1993 and 1995, with the track that was on the film. In 1996 we put on a show at the Ukrainian National Home. It was a book party for Paola Igliori's *American Magus* and for that presentation she introduced me to DJ Spooky. We turned off the projector sound and let him take over. After that trial run and good word-of-mouth, we continued the free-style shows. Ralph McKay connected me with Simon Field, the programmer for the 1998 Rotterdam Film Festival. In the reception after the Rotterdam show, Tim Woods from the Walker Art Center introduced himself and took me around the room to meet everyone he knew there. From those connections and the good press we got, I was able to tour the performance all over. Later, Jim Karpowicz got us into Cleveland and Paola Igliori got her publisher to bring us to Rome.

Packing all the equipment was always a monster project. (Judi Rosen says that "Henry had built these beautiful cases for the projectors that allowed the behemoths to travel without fear of them incurring any damage.") Sometimes we drove them, but other times we had to ship them and live with the terror that they might be trashed. Finding the right bulbs for all the old projectors was an ongoing problem. In Cleveland we found a guy with a giant cabinet of projector bulbs for auto shows, with bulbs going back to the 1920s. He had the Bell & Howell quartz lamp we needed, but he wanted eighty dollars for it. I balked, but when he said, "I suggest you get the bulb and save yourself a lot of headaches," I coughed up the money. There was no eBay back then; that would make it a lot easier now.

Through all the shows, I was chief equipment wrangler, director, and one of the projectionists for every show. Judi Rosen was mostly the other projectionist and would often keep the show moving while I explained it to curious audience people. Dave Cherry worked with me

on all the promotional flyers and postcards, starting in 1998 with the Cleveland Public Theater show. Tom Five drove us with all equipment in his van several times and Robert Parker made his truck available whenever we needed it.

The film, equipment, and personnel continually changed, and this fit Harry's ideas. He never intended his films to be a static, controlled, single projection. Constant change and experimentation were the essence of his entire life, and we had the show embody those impulses. In the first show we only did *Heaven and Earth Magic*, then we added *Early Abstractions*, and then the restored 35 mm *Tin Woodman's Dream*. We had a lot of variation in the projectors and screens that different venues could handle. Not every venue could accommodate 35 mm, so we would have to drop *Tin Woodman's Dream*. The rooms and auditoriums were always different, and we played with that instead of getting frustrated. Sound and music improvisations worked to expand and change the projections even more and in the same spirit. We retained the randomness that Harry had envisioned, constantly changing the show instead of attempting to nail down a consistent performance.

Judi Rosen remembers becoming the lead projectionist for the project:

> After sorting, cleaning, and tinkering on the grab bag of projects always underway, I suddenly found myself on a lofted stage in the center of the room at the Ukrainian National Home. We had briefly practiced using some of the equipment at the studio, but really I didn't have much to go on. I supposed I fancied myself a connoisseur of the psychedelic, so I felt at home pushing the boundaries of the visual space. What I didn't realize is that I would spend the next three or four hours straight staring into the bright projected light, cycling through the glass slides and intermittent colored gels without a break or hesitation, in order to keep the live animation interacting with the film. When Henry finally returned to the platform hours had passed and it was over. I climbed down, ran outside,

and proceeded to projectile vomit on the sidewalk. The strobing lights had sickened me to the point of complete hurling nausea.

We called the portable booth that we built the Bug or Fly, since it had wings on it. The fan configuration of the equipment was required so that the projector beams wouldn't overlap. Judi Rosen had a lot of input on assembling the booth. Every place was a different shape, so alterations had to be made so that the booth would fit the location. Judi says that "prior to each show we would build a lofted space above the heads of the audience, sometimes even incorporated into the theater seats. The idea was that people would dance and move throughout the space as we performed. I designed a loft that could be built within the steep incline of theater seating. The loft had to fit four to six large projectors, the Interrupter, the boxes of the glass sides, reams of color gels, and enough room for the two of us in the center, but it had to be small enough to not encumber the room."

Charlotte Slivka remembers:

Henry never getting mad when I didn't understand something, or if I almost accidently knocked over something in the loft, never getting frustrated or stressed at me but tending toward the kinder edge of stress. He never made me feel foolish. In rolling the Interrupter I began to understand how the films and slides all worked together, like a dance that was constantly reinventing itself, working according to a unique rhythm that was always in time. Eventually, Henry had me moving the slides. There was not a lot of instruction except don't break them and he just left it up to me which ones I chose to move across the screen and when.

Johanna Spoerri remembers that in Rome:

Our show was held in the absolutely huge Basilica of Maxentius in the Roman Forum. The first challenge was that Henry had to build

a platform to raise the equipment high enough so that the projected images were above the heads of the participants and so that the size of the images was large enough to have the proper effect in the vast space. It required a twenty-five-foot screen. This was very challenging and for a few days Henry had real doubts about pulling it off. We had no translator to assist us, and at the hardware store I had to draw pictures of the required items down to the screws. Then an electric generator was needed, so a big truck arrived with that. Our five magic lanterns and three movie projectors utilized AC current and in Italy it is DC, so a conversion was required.

There were memorable accidents and variations. On the second night we were on the barge at Pier 63 in New York a tremendous squall came through and blew down the screen in the middle of the show, so we crammed everything into the Frying Pan lightship for the rest of the night. In Austin, Daniel Johnston improvised vocals to accompany the films and slides. In Rome, my five-year-old son created a sideshow by building a replica of the Roman Forum from the Styrofoam packing materials. He drew a good crowd with his demonstration of the model while we were busy setting up.

That show was part of a city-wide "White Night" celebration that pulled so much electricity that it brought the grid down completely and burned up gear from southern France to Rome. Johanna Spoerri remembers that:

> DJ Spooky spun his discs while other lights filled the upper columns of the basilica above our screen. Crowds filled the floors dancing wildly. Henry began directing the projectionists and preparing the glass slides, when suddenly everything in Rome was cast in total darkness by a power failure. Our show went on because we had the generator. More people flooded into the Forum, dancing as we continued the show. Everybody was grooving to DJ Spooky and Harry's mythic imagery when one of the projector bulbs blew, and then another bulb

blew and then another and then another, until I realized that only my projector was working. Then my bulb blew, too. Show over.

The generator and AC to DC were too much for the old equipment and we joined the blackout.

Audience participation varied a lot. Judi Rosen says that:

> Our shows were usually about four hours long. It was challenging and needed to be viewed by a very willing audience. Sometimes people would leave, sometimes they would need to puke, but mostly they loved it. Henry would get angry at the short attention spans that we would at times encounter, but for every show where we ran into conflict there would be another audience that just absolutely embraced us. One of my favorites was performing in an old stone building at Swarthmore. We woke up a bat and it started swooping down on my head and then it became part of the projections. The audience was cheering it on as it wandered in and out of the projector lights casting its shadow on the screen.

We usually drew large crowds. Big Joe Teitler remembers that at CSV:

> after the platform was moved up closer, and test projections done, Henry and I went outside into the freezing cold night to see what all the ruckus was outside. We passed Rachel at the jammed ticket counter where the fire department was saying "no more people inside!" Looking north on Rivington below the throng on the steps, the sidewalk was packed all the way around the corner—a moment of supercharged delight.

Judi Rosen says that:

> There was this guy who came to a bunch of our shows, and he loved to antagonize Henry and I. He was an intense contrarian. The

second night we performed at the Knitting Factory, it was a very buttoned-up crowd, not particularly conducive to our performance. He became really aggressive with me after the show, arguing that we had desecrated Harry's intent and we were capitalizing on his work, not knowing the history Henry had with Harry or taking into consideration that we were being as true to his vision as possible. While we were essentially doing just that, I think the commodification of the show was becoming unbearable to Henry. We did get a taste of being rock stars with the accolades the audience would rain on us at the end of the shows. The guy's argument hung on me like a lead weight. Several years had passed and we hadn't altered the experiment in any way. I decided to move on.

I was growing weary of all the packing and travel, and Judi Rosen's departure was the beginning of the end of the show. We pulled my son Atticus out of school to go to Rome during his first month of first grade, and that created an uproar with the principal and teachers, so we didn't want to do that again. Jim Karpowicz and Big Joe Teitler helped put on the big show one last time in 2006, as a double feature with Angel Orensanz's *Burning Universe & Steppes of Mars*. At that show we introduced film-strip projection of Harry's slide images onto two weather balloons. DJ Free Simon handled the audio. I did one last show at Anthology when they restored *Heaven and Earth Magic*. Since then, half the gear has been stored by Mark Brady and the other half is in the custom cases in my storage tent in Pennsylvania. Maybe some time we'll pull it all out and do it again with new music. Harry would like that.

This story was transcribed during a long series of hospital visits uptown and then outdoor sessions in the East Village and Stuy Town with my brother and his dog Tiger in the spring of 2022. I want to thank Henry's many friends, who contributed to finishing the piece with their own memories of the show. I apologize to anyone left out of the itinerary. Henry willed all of the antique and hand-built equipment for Harry Smith: A

Re-Creation to Anthology Film Archives in the hope that they will occasionally revive the show.

<div align="right">PENNY JONES</div>

HARRY SMITH RE-CREATION ITINERARY—M. HENRY JONES:

1993–96: *Harry Smith: Heaven and Earth Magic*

- Anthology Film Archives, 32 Second Ave., New York, November 26, 1993; projection by MHJ; *Heaven and Earth Magic* with Harry Smith's soundtrack.
- Anthology Film Archives, 32 Second Ave., New York, April 20, 1995; projection by MHJ; added in *Early Abstractions* with the *Meet the Beatles!* soundtrack.
- Ukrainian National Home, 140 Second Ave., New York, March 14, 1996; audio assist by DJ Spooky and DJ Filippo Chia, projection by MHJ and Judi Rosen; added in *Late Superimpositions*.

1997–2003: *Harry Smith: A Re-Creation*

- Films Charas, Charas / El Bohio, 360 East Tenth St., New York, June 13, 1997; audio assist by DJ Spooky, preparation and projection by MHJ and Judi Rosen; *Early Abstractions*, *Heaven and Earth Magic*, and premiere of the 35 mm restoration of *The Tin Woodman's Dream* funded by the Rotterdam Film Festival.
- "Revelations of Tradition: Harry Smith's *Anthology of American Folk Music* and Its Legacy," Wolf Trap, either October 24 or 25, 1997, at Wolf Trap, Vienna, Virginia, or October 25, 1997 at National Museum of American History, Smithsonian Institution, Washington, DC; [likely a limited version]
- International Film Festival Rotterdam, Lantaren/Venster 1, Gouvernestraat 133, Rotterdam, the Netherlands, February 2,

1998; audio assist by DJ Spooky, preparation and projection by MHJ and Judi Rosen.
- C[lemente] S[oto] V[élez] Cultural Festival, 107 Suffolk St., New York, February 27, 1998; audio assist by DJ Spooky, preparation and projection by MHJ, Robert Parker, and Big Joe Teitler.
- Fourth World at Cleveland Public Theater, 6415 Detroit Ave., Cleveland, Ohio, May 8 and 9, 1998; audio assist by DJ Spooky the first night, original soundtracks plus Pufftube and the Scott Davis Trio the second night, preparation and projection by MHJ, Judi Rosen, James Karpowicz, Claire Coleman, Rachel Amodeo, Charlotte Slivka, and Tom Five.
- Institute of Contemporary Arts, The Mall, St. James's, London, August 4, 1998; audio assist by Gretschen Hofner, preparation and projection by MHJ, Judi Rosen, and Rachel Amodeo.
- Angel Orensanz Foundation, 172 Norfolk St., New York, [unknown date], 1998; audio assist by [unknown], preparation and projection by MHJ, James Karpowicz, Rachel Amodeo, Charlotte Slivka, and others.
- Swarthmore College, Swarthmore, Pennsylvania, [unknown date], 1998 or 1999; audio assist by DJ Spooky, preparation and projection by MHJ, Judi Rosen, Tom Five, Charlotte Slivka, and Esther Regelson.
- The Knitting Factory, 74 Leonard St., New York, February 3, 1999; audio assist by DJ Spooky, preparation and projection by MHJ, Judi Rosen, Robert Parker, and Charlotte Slivka.
- Walker Art Center, 725 Vineland Place, Minneapolis, April 16 and 17, 1999; audio assist by DJ Spooky, preparation and projection by MHJ, Judi Rosen, and others.
- Scottish Rite Temple, 207 West Eighteenth St., Austin, Texas, November 12 and 14, 1999; audio assist by Futura and improvised vocals by Daniel Johnston, preparation and projection by MHJ, James Karpowicz, Claire Coleman, and Rachel Amodeo.
- The Knitting Factory, 74 Leonard St., New York, [unknown

date], 1999; audio assist by DJ Spooky, preparation and projection by MHJ and Judi Rosen.
- Bard College, Annandale-on-Hudson, New York, [unknown date], 1999; free-for-all party with students assisting, preparation and projection by MHJ and others; no 35 mm and film soundtracks turned on.
- The Barge at the Frying Pan lightship, Pier 63, Hudson River at Twenty-Third St., New York, June 1 and 2, 2000; audio assist by Engine Orange, preparation and projection by MHJ, Robert Parker, Mark Brady, John Eberantz, and Rachel Amodeo.
- Notte Bianca / White Night Festival, Basilica of Maxentius, Roman Forum, Rome, September 27, 2003; audio assist by DJ Spooky, preparation and projection by MHJ, Johanna Spoerri, Rachel Amodeo, Atticus Jones, and others.

2006–07:

- *Harry Smith Light & Sound Explosion*, M. Henry Jones, along with Angel Orensanz, *Burning Universe & Steppes of Mars*, Angel Orensanz Foundation, 172 Norfolk St., New York, September 14, 2006; audio assist by DJ Free Simon, preparation and projection by MHJ, Robert Parker, Big Joe Teitler, Roberta Bennett, and others; available on YouTube.
- Anthology Film Archives, 32 Second Ave., New York, March 14, 2007; preparation and projection by MHJ; premiere of restored print of *Heaven and Earth Magic* with score by Harry Smith.

Correlating Irrationalities in The Moving Maths of Harry Smith

Essay on Harry Smith's
The 96 Apparitions of 96 Alchemical Formulae (1 to 36), *with the Original Text*

Robert Podgurski

> *But we must not suppose that we know anything of the Tree a priori. We must not work towards any other type of central Truth than the nature of these symbols in themselves. The object of our work must be, in fact, to discover the nature and powers of each symbol. We must clothe the mathematical nakedness of each prime idea in a many-colored garment of correspondences with every department of thought.*
>
> ALEISTER CROWLEY, *A BRIEF ESSAY*

Since its inception the Kabbalah has never been anchored upon a single foundation. Because language is constantly evolving, and the Kabbalah relies on the alchemy of correlations between various words to deliver expanded or sublimated meanings, Kabbalah has always been fashioned

as a flexible metaphysical tool *par excellence*. This type of fluid framework is critical, because even though an experienced kabbalist may be able to relate an insight based on their meditations upon the relationship between various symbols and terms, it is still up to each and every observer to do the same. Significance is only rendered complete by the individual's innate or intuitive awareness of the task. For example, Abraham Abulafia, one of the founders of the *way of names* and the art of combinations, borrowed freely from a broad range of kabbalistic schools "whenever he found them relevant."[1] Harry Smith was guilty of the very same type of selectivity as he formed his own alchemy of words and images. And so attempting to track down Harry's *modus operandi* may prove fruitful but at the same time futile if one is seeking any hard and fast closure to this pursuit.

When approaching *The 96 Apparintions of the 96 Alchemical Formulae* we are looking at Harry Smith's alembic of images, numbers, and words as he saw them falling into place and achieving some level of synthesis and intuitive sync. Based on Harry's documented interests the following pages of this essay are geared toward exploring the mechanics of this open network at play in his dynamic approach. This exposé is in no way intended to be exhaustive. On the contrary, I have assembled this essay to tease out a number of topical strands that Harry was particularly concerned with primarily as a stimulus for further investigation. But perhaps this long-forgotten fragment of Harry's attention is best served by our own personal interaction with it. Based on Harry's deeply vested interest in the power of moving pictures the reader may invite themselves to view his *96 Apparitions* as a series of phantasmic frames to be mounted and run in the imagination's hand-cranked mutoscope. As an interiorized process we have the ability to speed up, slow down, or even replay as needed in order to digest this impassioned morsel of Harry's overall alchemical projection.

In Mss. D, *The 96 Apparitions of the 96 Alchemical Formulae (1 to 36)*, of an unpublished monograph reproduced in its entirety at the close of this essay, Harry Smith engages a numerologically bound syn-

thesis. This piece conveys a schemata but hardly a closed or conclusive one.* In many ways the manuscript reads like a modernist allegorical poem in the tradition of Andrea's *The Chemical Wedding of Christian Rosenkreutz*.† To label Harry Smith's *modus operandi* as singularity anchored within a static foundation would be to overlook its mantic and maddening dynamics. Rather, the unique nature of these formulae in this exposition are more akin to what are aptly termed *moving maths* because they are widely varied and projective as well as calculated much like the elements of his films. The only reason to put a finger on them is to acquire a feel for what is happening in Smith's field of number, image, and story; not to explain or hold them in an insular position conceptually or otherwise.

Because to hold any notion within a static frame of conceptualization runs counter to *our* art.

This possessive case utilized by the alchemists was a device meant to designate the spagyric art as distinct and unique, not to be confused with purely ordinary physical chemistry. Hence, *our* mercury, sulphur, or salt was endemic to their implementation, both material and immaterial, for the process of sublimating the soul as well as all soul-infused substances. So in order to speak of an art that by all accepted appearances is an illogical one, then utilizing everyday language to describe the alchemical process is by all accounts an attempt to use round pegs to clarify the fit of square holes. The visionary alchemist has little choice but to modify each and every peg by the art of combination for the purpose of putting them into the service of squaring away what may actually be going on in the transformational realm. There's little doubt

*"The manuscript is dated 10-15-1973. Around that time, [Harry] was living in the Chelsea Hotel and writing a lot of poems, also making them up spontaneously. It reminds me a little bit of the 'Evensongs of Ecstasy' he wrote with Jacques Stern, poems based on Tarot imagery." Email from Raymond Foye, September 6, 2022.

†*The Chemical Wedding*, often attributed to Johannes Valentine Andrea, composed in 1616, has been taken as the third manifesto of the Rosicrucians next to the *Fama* and the *Confesso*. *The Chemical Wedding* is part poem, part cipher, and part instruction into the conjunction or union of opposites within the alchemical process.

Smith was keen on clothing "the mathematical nakedness of each prime idea in a many-colored garment of correspondences" as Crowley so well described: "In the world of common sense, reason works; in the world of philosophy, it doesn't. The metaphysical deadlock is a real and not a verbal one. The inner nature of things is not rational."[2]

Fleshing out the nature of things via Smith's logic is a precarious one to follow because it is a rationale of his own devise carried on and attenuated by his fancy for the topic at hand. Therefore, it's best to keep in mind that "A thing is not necessarily A or not-A. It may be outside the universe of discourse wherein A and not-A exist."[3] Sage advice for entering into Smith's world that is on one level created through allegorical or phantasmic storytelling. Straightaway, I'm reminded of a statement from the introduction of *String Figures* that "attempting to comprehend or rationalize any of Smith's intentions is a fool's quest" we are forced to agree with only if one is using ordinary rationale.[4] However, if we are willing to assume the post of the fool, one of the loftiest tiers within the kabbalistic Tree of Life, we may be rewarded with adopting a crazed or illogical perspective. In no way will such a vantage point offer any expository account of what's taking place in Smith's *ut pictura poesis* because it is a poetic object that generates itself through the realization of its unfolding. However, such a perspective may impart a glimpse or two into Smith's enlightened and intuitive ambling. To gain any foothold here is reward enough as anyone who has spent any time studying Smith's oeuvre will attest.

Take for example, "7—bears the tail of a lion who suffers at the pranks of its victims." In this example the Arabic numeral 7 becomes the object of some magical play. Rather than an arbitrary signifier of a cardinal number, Smith's 7 is turned into a pictograph through his childlike perspective. The lion has long been symbolized as an aspect of the universal alchemical mercury, often by the colors green or red to denote its degree of transformation. But in this case the image of the number 7 becomes a mimetic one displaying a sharply bent or broken lion's tale. Perhaps Smith is intimating that those who don't know how

to manufacture or handle this lion/mercury properly distort its outcome as they in turn become victims of their mistakes.

In this manner Smith's 7 is visually a sort of string figuration that speaks of the lion's line and its manipulation. However, if one looks further, this string figure play that Smith was so fond of ceases as quickly as it starts. Up to this point the lion's form occupies the numbering story's progression emblematically.* Then in 7 it becomes a figuration resembling the very thing it expresses. Once the lion is "wed to the homonculous & revealeth secrets of the connubial embrace" in 9 it completely disappears. This is indeed a mercurial lion, that once it has served its duty in the alchemical union or wedding, it is dissolved and transmuted. With Smith's vision, though, we are at pains to understand its purpose other than the transformation of the informing imagination. Because after the consummation of this wedding, instead of visions pertaining to enlightenment and illumination, as are most common in traditional alchemical lore, Smith takes an abrupt detour with "10—is liable to be a drunkard / but one who is sullied by passion for the desert."

The remaining twenty-six passages are a chaotic amalgam of seedy hotels, herring, and other assorted bestiary, as well as tainted or tumultuous relationships. The great liberation, at least on the surface, is not apparent in its commonly portrayed manner. But there is no reason that it need be. Awareness through acquired associations can be a stern task master. Bleak theophanies may be their own reward regardless of their tenor. Smith appears to embrace the sentiment expressed by artist

*It's worth bearing in mind that "for the Renaissance magician, *numbers numbered* would have been viewed as the actual tool that facilitated the mapping process. The difference between the Neoplatonic and Humanistic concepts of *numbers numbered* and *numbers numbering* is important. Numbers numbered are those numbers or quantifications assigned by God to things. Much like the divine *signatura*, numbers numbered are impressed upon the world. Numbers numbering, on the other hand, are those quantities or numbers residing within God. Because Numbers Numbering are part of God they're the established divine proportions upon which all else is based."[5] Smith clearly is digging away at a similar number assignment but one that is wholly original and idiosyncratically inspired.

and magician Austin Osman Spare when he suggested that one must be conscious of lower bodily functions and states of existence as being commensurate to the loftiest states of awareness. It is even conceivable that this shifting of gears in the progression was a result of Smith going on a bender. After all, he openly admitted to being an alcoholic that often set him on destructive sprees. In any event, certain depths are ineluctably sounded in this adventure's expansive screening effect.

It is somewhat easy and convenient to lapse into an analogy of film with Smith's writing, but as to what influence is the overriding one is a matter of the chicken or the egg. Whether his films influenced his writing or vice versa is a moot point. The reciprocal relationship between these influences probably switched positions regularly depending on a myriad of factors. Within these *36 Apparitions* we see traces of native folklore, creation myth, alchemy, and magick; the list goes on and on. Perhaps the key term here is *apparitions*, suggesting a fleeting realm of images, spectral in their appearance and placement. Crowley, in his essay on numerological correlations, stated that: "I have in this book unified all diverse symbols of the world; and also, 'the world of shells' ie this book is full of mere dead symbols; do not mistake them for the living Truth."

Smith was no doubt aware of the role played by symbols in any myth or allegorical construct, especially his own. To the ancient Greeks the word image, or *sunthemata*, as a signatory gate to various realms and associations is a notion that would have been near and dear to Smith's heart. Algis Uzdavinys, in his study of Sufism, observes that "a certain polyphony and homophony of the script—were elaborated [in esoteric texts] permitting the memory of the ideographically revealed realities." Such a reconstruction is for the purpose of a divine reclamation within the consciousness of the visionary. Furthermore, Uzdavinys boils down the visionary's role to one "who understands the entire code of divine Speech with its written signs and symbols . . . they are the knowers; they can decipher divine signs."[6] And yet the critical thing here is that such a vision of the world of spirit interaction is implied as anything universal

or as having a broad spectrum. Instead, it may be very personal and idiosyncratic maintaining relevance only to the seer itself.

Whether or not such symbolism in Smith's *Apparitions* holds any relevance to us here and now may be arbitrary. There are no steadfast rules that apply to the life given to the gateway images of a vision. The kinetic quality of these emblems endowed by the visionary is invariably autonomous and freewheeling. Furthermore, *Apparitions* was never published and so may never have been intended for public consumption. Nevertheless, there's nothing to suggest that the suffusion of symbol and number in *Apparitions* was intended to be solely relevant to Smith alone either. Within this variable frame the vital projective force of *Apparitions* is best evaluated on a one-by-basis by each of us who are moved to do so. The beauty of such a bewildering sequence is that these *Apparitions* stand defiantly perplexing in their aporetic and enigmatical wonder, all the while always hinting at something beyond discernible boundaries.

Harry Smith was an ordained Gnostic bishop in the OTO. This hybrid Freemasonic organization that Smith was involved with was inextricably influenced by Aleister Crowley. He was extremely familiar with Crowley's writings and so I have considered Smith's work within such a context to a certain degree. The primary reason for making a guarded assessment though is due to the fact that Smith's compositions, for the most part, lack direct references to or explicit discussions of Crowley's Thelemic project, unlike those of his mentor, Charles Stansfeld Jones (aka Frater Achad).* Jones, Crowley's erstwhile magickal child,† wrote

*In fact, according to Gerrit Lansing, he and Smith studied magick together under Charles Stansfeld Jones's tutelage. This account is important because it lends credence to what had only been alleged previously concerning Achad's relationship with Harry Smith. See the introduction to *The Incoming of the Aeon of Maat*, ed. Michael Barham and Michael Staley.

†Whereas Jones may have temporarily assumed the role of Crowley's magickal child, Smith alluded to the possibility of having been one of Crowley's actual offspring. According to the poet and founder of the Fugs, Ed Sanders, Smith stated: "My mother did know Crowley. . . . She saw him running naked down the beach" (Ed Sanders, *Harry Smith's Anthology of American Folk Music*, vol. 4 (Austin, TX: Revenant Records, 2000).

several pieces that Smith's *Apparitions* bear a certain resemblance to, especially his *XXXI The Hymnes to the Star Goddess—Who Is Not*. However, Jones makes overt references to Crowley's manifesto, *The Book of the Law*, whereas Smith does nothing of the sort. In *Apparitions* the numbers of each passage actively participate the dialogue in a seamless fashion whereas nothing of the sort occurs in Jones's published work. Yet, Smith's *Apparitions* and Jones's *Hymns* both employ a similar layout and exhibit a similar structuration with columns of information following particular images associated with them. Jones's influence on Smith, for the most part, is clearly indirect and allusive.

Smith does, however, take up his mentor's yoke by incorporating a great deal of the theoretical basis for Crowley's premises within his own apparitional technique. "When the skeptic sneers, 'With all these methods one ought to be able to make everything out of nothing,' the Qabalist smiles back the sublime retort, 'With these methods One did make everything out of nothing.'"[7]

In this single passage Crowley succinctly encapsulates the conundrum and wide-open field exposed by kabbalistic numerology. Hermann Hesse himself, in *Magister Ludi*, proposed a similar venture wherein the contestant who is able to continue creating the longest chains of correlations between a concept and its permutations is the winner of the glass bead game. Smith, the inveterate collector, was obsessed with amassing collections of all sorts. And it seems that connecting the dots between all of these fields may have been the source of much amazement as well as consternation for Smith. As mentioned earlier, we know Smith was constantly abandoning projects and literally destroying their contents. One plausible reason for such *seemingly* irrational behavior may have stemmed from this very kabbalistic logic Smith enveloped himself within.

As many come to learn, one of the most unsettling things about the kabbalistic pursuit is that it's hardly a static method leading to a fixed perspective. Those looking for refuge in a solidified home-base of insights need to look elsewhere because most of what kabbalistic probes

unearth invariably require the practitioner to decipher. There is one particular sphere though that is perhaps most instrumental from which to view Smith's inventories, both created and destroyed. Hod, or glory, the eighth sphere, is governed by mercury and the Hebraic god-form of Elohim Tzabaoth. The Elohim are a masculine-plural, feminine-infused condition in a single noun, thus denoting the union of male and female in one deity. Tzabaoth is indicative of the creative demiurge. The combination of Elohim Tzabaoth is then suggestive of a very alchemically inclined force, one that consumes and produces via its creative nature. Furthermore, as Crowley illustrates, "the 'mystic numbers' are simply the sums of the numbers from 1 to their own numbers." For example: "(8) Hod = 1 + 2 + 3 + 4 + 5 + 6 + 7 + 8 = 36." Coincidentally this formulation lands on page 36 of Crowley's *Essay on Number* in *777*, not to mention the fact that there are only 36 out of the purported 96 *Apparitions* extant in Smith's manuscript. Such a coincidence, if it is one, may signify so much more were we only privy to some designation that could express the elements of synchronicity, coincidence, and serendipity as acting in concert with one another.

The Kabbalah, via Hod-based logic, is ultimately forged from an idealist approach where images, although arising from the earth plane, are first conceived on the inner levels and subsequently as concrete forms. Most philosophies are logical structures, based on premises held to be self-evident and there is little ground to be gained from logical disquisitions on them. As Gareth Knight describes, "In the last analysis, 'you pay your money and take your choice,' and the choice of the Qabalist is the idealist viewpoint."[8]

Immediately we see that Knight's assessment of the consciousness fostered in Hod is very much sympathetic to Crowley's outlook and ultimately Smith's method. The crucial contribution to this stance is Knight's insistence on *choice*. Taken to its logical conclusion such an approach points toward the very thing we see manifest in Smith's *Apparitions*. In other words, if in the course of working through various associations between numbers, images, and their cooperative generation

of meaning one discovers that the traditional ten-sphere structure of the Tree of Life is not equipped to meet the demands of the discoveries, then there may be no alternative other than to devise a modified or new version of the spheres and their patterning. The choice then becomes whether or not to start over and make something out of nothing or something out of the pieces of the precedent systems. In Smith's case we see a little of both and possibly more generating through this apparitional art.

Like any manifest formation the kabbalistic spheres all exhibit a shadow side. In the case of the spheres, these shadows or *qliphoth*—the shells—have their own titles. The qliphoth of Hod is described as "poison of God."[9] Stemming from this venomous aspect, Smith's mention that "26—resembles a barrel in its uppermost parts, and in its others / is a tomb which preserves & yet destroys" brings to light the coinciding oppositional aspect of the alchemical *summum bonum*. The elixir in this respect is a type a pharmakon or remedy that heals as it destroys. Smith has his eye on both sides of the coin in *Apparitions*, which is a risky affair. Reconciling the dark and the light simultaneously is no simple feat, especially where consciousness itself is at stake. In some ways Smith's life is a reflection of this precarious dance. What may initially appear as some reckless folly on Smith's part, in broaching the seedier side of existence in tandem with the sublimation of the alchemical quintessence, may actually be a sign of a greater wisdom, but one not without its own inherent pitfalls.

Smith's game moves as it plays out and about. Within such kabbalistic ratiocinations, as Harry Smith's longtime friend Gerrit Lansing wrote, "Logic equals Magick / (I leave it to you to find what is really meant."[10] The bones, strings, symbols, and so on that are constantly being cast in *Apparitions* rarely come to rest in any one isolated field the closer they're paid attention to. The cost of attention, in this case, is to consider how understanding actually interacts with each new element as it works its way into the fold, playing and alternately being played by the game. It is as if Smith's process were constantly one step

ahead of itself—a projection that expands on a variety of registers, defying most attempts to gain any awareness of a presence of mind for such operations in their immediacy. As such, it becomes a game of never-ending catch-up. And even if intentionally ignored or abandoned, once engaged, does such a venture ever abate?

ROBERT PODGURSKI has been writing about magic and poetry for more than thirty-five years. *The Sacred Alignments and Sigils* is the most recent manifestation of one of his lifelong project(ive)s. In that work Podgurski establishes a practical epistemology for the relationship between sigils, symbols, and ecriture as an extension of the visionary magical field. As a continuation of this operation Podgurski is launching his forthcoming work, *The Aetheric Alignments*, prospectively in the fall of 2024. This monograph will encompass the history of the aether in early Western as well as Eastern consciousness, up to and including the current era, and will also establish the implementation of theurgy and spontaneous magical practices for engaging the aetheric medium. Podgurski is the author of several works in poetry, including *Wandering On Course*, and his ongoing long poem *Intersecting Visions / Vision Intersects*. Along with poetry Podgurski has also authored fiction, including the forthcoming novel *Beyond the Lens of Time*. He holds an MA in literature from the University of Colorado at Boulder.

The 96 Apparitions of
96 Alchemical Formulae (1 to 36)

By Harry Smith

1 is in the form of a lioness is useful to those

 who would bear children out of wedlock.

2 beareth the head of a lion,

 but has the body of a pig

 and is useful to those

 who would bear a child ~~within the bonds of marriage~~ **uselessly.**

3 has the mane of a lion

 but the soft footprints of a tiny child

 seeking its parents.

4 leaves the footprints of a lioness in the sand

 & ignores the screams of its victims

5 discovers the child & other great treasures

6 resembles a man & a woman

 in intercourse

7 bears the tail of a lion

 who suffers at the pranks of its victims

8 pulls forth from the earth

 the powers of that great bird

 that rises in the East at morning Tide

9 is the lion wed to the homonculous

 & revealeth secrets of the connubial embrace

10 is liable to be a drunkard.

 but one who is sullied by passion for the desert

11 Sees sin as a mokery & is useful in mending old kettles

12 carries a banner which bears the inscription:

 Thus so far have I lived.

13 is a diligent worker, who however is unable to reach a

 climax.

14 is wafted by a still cold wind & solves the secrets
 hidden by the clouds.
15 is a poor man who has lost his parents.
16 reveals the treasure buried beneath the armory.
17 is that cloud which bears not only the thunderbolt
 but also the soft rains that fructify the stars.
18 Defeateth the hated enemy
 by drawing the breath from out of his body.
19 Sitteth in the lobby of a scroungy hotel
 & waiteth for the loved one who never appears
20 Causes the dead to rise from their Tombs.
21 Blows like the wind
 Caused by a Tiger lashing its tail.
22 Is the naked maiden who shields
 her virginity with a wreath of poppies & lilacs.
23 returns to the sky wafted by its rapturous downfall.
24 (Forgive This one O Lord
 for the word of god is insufficient
 to bear it from the earth)
25 is a salted herring useful to mother, father & child
 as nourishment
26 resembles a barrel in its uppermost parts, and in its others
 is a tomb which preserves & yet destroys
27 May thy fate deliver thee from this
 because the bearer of This number
 mistaketh the black stone for the red.
28 This personage has 3 heads
 & appears in nightmares
 as the deliverer of blessings
29 This is the one who delivers fool's gold
 to the rich
30 thirty can separate the sparrows from the hawks
31 Bears the form of a preserved fish

as was described in 25 but which existeth in no semblance

to that fish which liveth

in the salt salt sea*

$$☽ \quad ⊖$$
$$⊖ - ☽ = ♁ + ☿$$

32 has the horns of a goat,

　　the body of a snake

　　and the genitalia of a dove, & yet these characteristics

　　bear nothing but displeasure.

33 is the one who will die in / and **X**

　　stabbed by the horns of ~~32~~ **X**

34 Preserve this one and sanctify its name

　　before the Lord

*Parallel to these *36 Apparitions* and directly preceding them is Mss. C (*96 Alchemical Formulae*). In 31 here I have reproduced Smith's formula as it appeared in the manuscript. Unfortunately, it does not line up with the formula in number 31 of the *Alchemical Formulae*. To connect these two manuscripts would be an immense challenge not only due to the fact that there are only 36 out of 96 apparitions documented but because there are no explanatory notes for Smith's accompanying *Formulae*. Furthermore, there are a number of creative aspects to Smith's catalog. One immediate issue is that Smith has connected the alchemical nitre with salt, indicated by his placement of the symbol for salt and the symbol for nitre above the line "salt salt." There is precedence for the conflation of these two components in Jacob Boehme's *Signatura Rerum*, in which he describes their fusion through the term *salniter*. But how and why Smith would have conflated nitre and salt is somewhat of a mystery without further conclusive evidence. Also, as we can see in 31, Smith has developed a sort of modified glyph based on the symbol for Mercury and John Dee's *Monas Hieroglphica*. Smith included the dot in the circle of Mercury's head as did Dee in his hieroglyphic monad. However, Smith used the same horns found above the circle for his emblem's base whereas Dee used two semi-circles to depict Aries or fire in that position. It is possible that by mirroring these crescents on the top and bottom Smith was illustrating the Hermetic axiom, "As above, so below"—however, this is mere speculation on my part, worth considering to some variable extent. See Jacob Boehme, *The Signature of All Things*, ed. and trans. Clifford Bax (London, UK: J. M. Dent & Sons, Ltd.: 1969), 184.

35 This is the one Before the final preserver.
 In the earthly sense, moans for salvation
36 is the spittle which falls upon the earth
 from that pompous thundercloud,
 but lacks the power to separate
 The two from the one

28

Unlocking the Secrets of the Unseen Universe
Essays on Harry Smith's Letter to Arthur M. Young (August 30, 1960)

Kathy Goss and Elliot Wolfson, PhD

Arthur Young and Harry Smith: An Odd Encounter
Kathy Goss

Harry Smith appears as a minor character in Arthur Young's "astrological autobiography," *Nested Time*, published by Anodos Foundation in 2004. He is mentioned only once, in the context of Harry's confirmation of the torus as an example of the importance of sevens:

> Many of the myths I studied talked about seven stages of creation. I had a hard time accepting that the number seven had any special significance until early 1956 when Harry Smith (an artist and scholar who was helping me with myth) reminded me about the torus. The topology of the torus, or donut shape, requires seven hues in order

to color a map on its surface with no two adjacent areas having the same color. This was a very important confirmation for sevenness. In effect, I had been given permission from mathematics to hypothesize seven stages in the theory of process.[1]

Of course I was familiar with topology, and had known about the torus, but Harry's reminder helped everything fall into place. When I thanked Harry for his important contribution, he said, "Well, I knew I was supposed to give this to you, because of a dream I had: I was driving a car along a mountain road with my girl, and the car started to go off the road. I quickly grabbed the spare tire and saved it, instead of saving the girl." The tire, of course, is a torus.

Despite their very different positions in society, Arthur Young and Harry Smith were kindred spirits in important ways. Like Harry, Arthur was on a ceaseless quest for truth as manifested in unusual phenomena not accepted by orthodox science. Arthur's philosophical explorations began very early, during his years at Princeton, when the tragic death of his younger brother set him on a search for a "theory of time structure" that would help to explain the occurrence of unexpected events, or "discontinuities." This question would eventually lead him into metaphysics, including the advanced practice of astrology. Before undertaking his work at constructing a "comprehensive theory of the universe," Arthur wanted to test his ability to develop theories in the physical world. He searched the US Patent Office for possible inventions that had not already been patented. He settled on the helicopter.

Working from small models, Arthur came up with a novel solution to the problem of instability in vertical flight, and in 1941 took a working model to Bell Aircraft. Bell set Arthur up with an entire engineering department to design what ultimately became the Bell Model 47, the first commercially licensed helicopter in the United States.

With the successful completion of his real-world project, Arthur retired from Bell and turned increasingly to metaphysical subjects.

He became a student of May Benzenberg Mayer at her Source Teaching Society in New York, a serious student of astrology, and a frequent patron of the Gateway Bookstore. It is possible that it was there that he first encountered Harry Smith:

> I took up the study of astrology on September 24, 1948. The major influence was perhaps the fact that Jung had taken the subject seriously. Another possible influence was that during 1947 I had discovered the Gateway Bookstore, whose proprietor, Mrs. Gorham, always looked at you as though she were searching for marks of Buddhahood. Her shop contained a great variety of books on the subjects that interested me, including astrology, and among her clientele were several persons who helped me on my search.[2]

Arthur's metaphysical explorations contributed to the development of his Theory of Process, a paradigm for the evolution of consciousness. The theory broke new ground in integrating the wisdom of ancient teachings and myth with the findings of science, including the emerging field of quantum physics. It was there, at the level of quantum reality, that Arthur found evidence of pure freedom, represented by the photon, which, driven by purpose, becomes embodied through the successive stages of evolution until it is completely bound in the materiality of the molecular realm, and then, through the progressive development of conscious purpose, is able to free itself again and ascend back into the realm of light.

Arthur represents this seven-stage, four-level evolutionary process in the form of an arc, with the arrow of evolution descending through four levels, and then ascending back through the four levels on the other side of the arc. This arc, the hallmark of the Theory of Process, is depicted in Arthur's seminal works *The Reflexive Universe* and *The Geometry of Meaning*, both published in 1974.[3]

The evolutionary pattern of the arc, embodied in worldwide myths of the fall, depends upon the significance of sevens. Without the con-

The Seven Stages of Evolutionary Process.

firmation of sevenness, Arthur could not have devised the arc model. He had found ample evidence of sevens in myth, but it wasn't until Harry Smith provided the clue about the torus that Arthur put it all together—that the unalterable mechanisms of mathematics itself provide confirmation of the significance of sevenness.

When I was working with Arthur on the manuscript of *Nested Time*, attempting to fill in the details of the years when he was developing his Theory of Process, I interrogated him more than once about who Harry Smith was, and how he had happened to hire him during his early work on the theory. At that time Arthur, through his Foundation for the Study of Consciousness, was employing an assortment of expert researchers to look into specific topics—Mark Gallert on radionics, Fran Farrelly on the mysterious Acámbaro figurines, Frederick Marion on psychometry. In our editorial sessions, Arthur never mentioned that he had engaged Harry to look into the permutations of the Tetragrammaton and their astrological associations. Harry's impressive report, in his characteristic meticulous printing on gold paper, turned up in Arthur's archives, which I helped to organize after his death. I learned to recognize Harry's handwriting and his scholarly style; his documents, with their recurrent requests for further funding, always brought a smile of recognition. When I later learned of the republication of Harry's *Anthology of American Folk Music*, and then of his death, it was as if I were encountering an old friend once again and discovering more details of his remarkable life.

Arthur himself had a harder time explaining who Harry Smith was. I asked him more than once, and he was always rather vague. The best we could come up with for the manuscript of Arthur's autobiography was "artist and scholar." In one of our editorial conferences, when I queried Arthur about Harry's contribution on the torus, he described Harry as "a friend" and "quite a character."

The archives of Anodos Foundation contain ample evidence of the decades of association between Arthur Young and Harry Smith, but it was only Harry's contribution on the torus that surfaced before Arthur's death. In the latter years of Arthur's life, I doubt that any of his close associates knew the extent of the esoteric topics that Harry had explored at Arthur's behest, nor did we have any idea of how wide-ranging Harry's interests, talents, and circles of friends and acquaintances were. The two men, different as they were, undoubtedly shared the curiosity and open-mindedness that help to unlock the secrets of the unseen universe.

KATHY GOSS worked closely with Arthur Young during the final decade of his life, helping to prepare his writings for publication. She continues to assist Anodos Foundation in its mission of preserving, publishing, and applying Arthur's work. Kathy has edited and coauthored books on complementary medicine and sustainable technologies. She is a poet, musician, and author of *Darwoon Dyreez: A Fictional Memoir* and *Coping with Covid*, a humorous pictorial and poetic chronicle of the pandemic.

Harry Smith to Arthur Young: A Note on the Letter

Elliot Wolfson, PhD

The main point of Harry Smith's letter is to elucidate the correlation of the twelve permutations of the Tetragrammaton, YHWH, the ineffable and most sacred name in the Jewish tradition, and the twelve signs of the zodiac (or the twelves planets). The list that is offered as the most authoritative (found in the *Pardes Rimmonim*, composed by sixteenth-century Safedian Kabbalist Moses Cordovero, and in Heinrich Cornelius Agrippa's work, as well as in the seventeenth-century Athanasius Kircher's work) presents the first three permutations beginning with Yod, the first letter in the Tetragrammaton, the next three beginning with He, the second letter in the Tetragrammaton, the next three beginning with Vav, the third letter in the Tetragrammaton, and the last three with the final He, the fourth letter in the Tetragrammaton. The tradition about the twelve permutations of the Tetragrammaton was articulated by Kabbalists already in the thirteenth century. Smith also presented alternative lists (a total of seven) from what he erroneously called *Sefer Raphael*, referring in fact to *Sefer Raziel*, a compilation of Jewish mystical and magical texts, first published in Amsterdam in 1701 (he claims he used the Warsaw edition of 1881), and from *Kabbala Denudata*, an anthology of Jewish and Christian kabbalistic texts in Latin edited by Christian Knorr von Rosenroth, the first two volumes published in Sulzbach (1677–1678) and the last two volumes published in Frankfurt-am-Main in 1684. (British occultist and co-founder of the Golden Dawn, Samuel Liddell MacGregor Mathers, published a version in 1907 called *The Kabbalah Unveiled*.) The twelve permutations are also correlated with the twelve months of the year according to their Hebrew names as well as with the twelve simple letters of the Hebrew alphabet (according to *Sefer Yetzirah*), and the twelve tribes of ancient Israel. This is the gist of the letter, which is reproduced here in full on the following pages.

300½ EAST 75ᵗʰ STREET
NEW YORK 21, NEW YORK

Dear Mr. Young!

 When you were in this city two months ago you commissioned me to the welcome labor of searching out what data I could on the relation of that high and holy name יהוה to the twelve signs of the zodiac. I have now collated the available references concerning this matter and would say that the order ~~order~~ of permutation bearing the greatest authority is as follows:

♈ יהוה
♉ יההו
♊ יוהה
♋ הוהי
♌ הריה
♍ ההרי
♎ והיה
♏ וההי
♐ ויחה
♑ היהו
♒ היוה
♓ ההיו

(NOTE: All Hebrew words used in this paper read from right to left.)

 In my opinion the foregoing series is most certainly the correct one; an opinion

– 2 –

I hold because this order contains the largest number of parallels with the other available lists of permutations, lists which otherwise are quite divergent one from another. This order is also more consistent internally than any of the others, the first three permutations beginning with י, the second three with ה, the next three with ו, and the last three with ה, so that the name יהוה itself underlies the entire series, and in fact appears numerous times in the registers of the second, third, or fourth letters read vertically in either direction. Also, this order was employed by Moses Cordovero, Kircher, and probably Agrippa, and thus was approved by three of our greatest authorities on such matters.

None the less, as one (or more) of the other traditional orders may suggest to you some point that has eluded my analysis, I am listing them in the table on page three, and on succeeding pages are a few other items that came to hand, and which may be of some value. As you specifically stated, however, that you did not wish an extensive exposition of the zodiac in relation to יהוה, you will perhaps prefer to turn directly to the appeal for funds which begins on page seventeen.

	A SEFER RAPHAEL	B KIRCHER OEDIP I. AEG. p. 239	C AGRIPPA		D KABBALAE DENUDATAE VOL.4, pt. 4	E KABBALAE DENUDATAE VOL.1, p. 38	F KIRCHER MUSURGIA	G KIRCHER OEDIPI AEG. p. 337
1	יהוה Nisan	יהוה PSALMS 95.v 11	יהוה	♈ PALLAS	יהוה KETHER	יהוה	יהוה	חהוי ♈ NISAN
2	יההו Iyyar	יההו JEREMIAH 9:24	יההו	♉ VENUS	יההו COCHMACH	יההו	יההו	היוה ♉ IYYAR
3	יההה Siwan	יהחה EXODUS 26:20	יההה	♊ PHOEBUS	יוהה BINEH ♄	יהחה	יוהה	היהו ♊ SIWAN
4	הוהי Tammuz	הוהי JOB 33:27	הוהי	♋ MERCURY	הוהי DAATH	הוהי	הוהי	יההו ♋ TAMMUZ
5	הויה Ab	הויה DEUTER. 9	הויה	♌ JUPITER	הויה CHESED ♃	הויה	הויה	יההו ♌ AB
6	ההוי Ilul	ההוי ISAIAH 45	ההוי	♍ CERES	הוהי GEBURAH ♂	הוהי	ההוי	יההה ♍ ILUL
7	והיה Tishri	והיה DEUTER. 20	והיה	♎ VULCAN	ריהה TIPHERETH ☉	היהו	ההוי	ההוי ♎ TISHRI
8	והחי Heshwan	והחי DEUTER. 6	והחי	♏ MARS	היהי NEZACH ♀	ההוי	ההוי	חויה ♏ HESHWAN
9	יההו Kislew	יההו GENESIS 13	יההו	♐ DIANA	הוהי HOD ☿	והיה	הויה	הוהי ♐ KISLEW
10	היהו Tebet	היהו PSALMS 33.v 4	היהו	♑ VESTA	יהיה JESOD ☽	והיה	היהו	וההו ♑ TEBET
11	הירה Shebat	החהו ISAIAH 12	החוי	♒ IUNO	ריהה MULCHUTH	רההי	היוה	יההו ♒ SHEBAT
12	חהוי Adar	ההיו JEREMIAH 8	ההוי	♓ NEPTUNE	יההה MULCHUTH	יההי	והיה	יהוה ♓ ADAR

– 4 –

NOTES ON THE TABLE

 I – Vertical alignments are called "columns", horizontal alignments are called "lines" in the following discussion.

 II – The seven columns represent the sources actually used by me, but not necessarily the first printing of that particular series (see Bibliography below).

 III – The lines are numbered from one to twelve, and show the order the names are given in the works cited at the top of each column.

 IV – The names that have been tinted pink in the table are those that occur only once in that particular position in any of the columns, while the names left uncolored are those that occur most often in that position. The names tinted green are those that appear more than once, but less often than the most frequent name in that line (except in the case of lines seven

— 5 —

and eight, in each of which two names each occur twice; here the green has been added as an aid to clarity).

BIBLIOGRAPHICAL NOTES

(A) - <u>SEFER RAPHAEL</u>: I have used the Warsaw edition of 1881. The twelve names appear in a table on page 117 which aligns the four divine names revolving in the four worlds of the caballists with the twelve months; יהוה is assigned to Assiah – the visible heavens. I have added the names of the months in transliterated form below the respective permutations of יהוה. This particular correlation is found in numerous sources, most of which trace back to Moses Cordovero (b. 1522) and his work "Pardes Rimmonim" (publ. 1591). (It should be noted that the Hebrew "month" names here listed are post-exilic in date and are Babylonian words that derive from a solar calendar rather than from a lunar system such

- 6 -

as the same names are attached to in the later Rabbinic literature. They can, consequently, be assigned exact zodiacal correspondences — for which, see below under "Agrippa".)

B) KIRCHER - OEDIPI AEGYPTIACI (1653) Vol. 2, p. 239.
Kircher gives as his authority for this series the "Pardes Rimmonim", and it can be seen that it corresponds exactly to the list in the Sefer Raphael, from the same source, except for the appearance of יהו״י on both the 10th and 11th lines. The main interest of this column is the derivation of the ~~of the~~ names from certain verses in the Bible. For example, יהוה is arrived at by taking the 1st, 4th, 9th, and 14th letters of the 20th verse of Exodus 26 (which verse in its entirety reads: "And for the second side of the tabernacle, on the north side, twenty boards"). The other names are constructed in similar fashion from the chapters listed below the names.

-7-

© - AGRIPPA - DE OCCULT PHILOSOPHIA, LIBER 3. (1602 Edition used; Originally printed in 1533). This list corresponds closely to the two preceding sources and may also trace back to the "Pardes Rimmonim", but is unfortunately defaced by typographical errors; יהוה occurs in both the 3rd and 8th, and הוהי in the 4th and 9th lines. The placement of ההוי and היהו in the 12th and 6th lines respectively (which positions are the reverse of those given by the Sefer Raphael and Kircher, p.239) casts some doubt, however, on precisely what was intended, and whither the divergences are errors pure and simple, or if an actually different tradition has been drawn on. None the less, Agrippa's list is valuable, despite its' confusion, as he gives the sign of the zodiac he considers equivalent to each permutation, and these signs correspond correctly to the Hebrew month names given in the Sefer Raphael (for equivalence of ♈ to Nisan, ♉ to Iyyar, etc., see Jewish Encyclopedia, volume 2, page 249). I have

-8-

also added from Agrippa's work a list of Greek Deities he claims correspond to the respective permutations. (This list of Agrippa's has been repeated by Barrett in his "Magus" (London 1802) and in the various editions of "The Great Book of Magical Art" (Chicago, 1906 etc.))

Ⓓ - KABBALAE DENUDATAE (Frankfurt, 1684) vol.4, p.4
This list, like the rest of the material in Knorr Von Rosenroth's magnum opus, is of rather uncertain lineage, but is of interest as he aligns the eleven Sepherot of the later Caballists with the twelve permutations, an alignment that necessitates the placement of two names in Mulchuth (the Earth plane). Von Rosenroth also assigns a second יהוה to Mulchuth, thus giving a total of three names to that particular sphere. I have added to the list the planets through which each Sepherot operates in the Heavens of Assiah, according to the same authority.

-9-

(E)- KABBALAE DENUDATAE. VOLUME I, p. 38
A curious list, also from Von-Rosenroth, identical in its first five names to those series derived from Cordovero but completely divergent in the last seven lines.

(F) - KIRCHER - MUSURGIA UNIVERSALIS (1650) p. 6
This series is given by Kircher in the mathematical introduction to his chapters on the harmony of the Heavenly Choirs, and seems to constitute what he considers the "logical" order of the names.

(G)· KIRCHER-OEDIPI AEGYPTIACI. Vol. 2, p. 337
A list totally unlike others I know of. It is presented by Kircher as part of an elaborate table that also gives correspondences to the twelve "simple letters" of the Hebrew alphabet, the "operations" of the human body, months of the year, the Twelve Tribes, the "Winds", orders of Angels, the Hebrew "months", and the signs of the zodiac. I have

- 10 -

added, below the names, his data on the two last named categories. As this list differs from others, even to the point of beginning the series from a permutation other than יהוה — (a seemingly standard practice, and one that Kircher follows in his other lists)— it is probably no more than an example of his known penchant for trying to work "Art Magic" in the interests of the Austro-Hungarian empire; an avarice that corrupts so many of the volumes issued under his name. (Note that "יהוה appears twice, on both the 5th and 10th lines, and that as a consequence one name, יוהה has been left out.)

SUMMARY OF ABOVE

The following tabulation gives the number of the line on which each of the twelve permutations in the column furthest to the left (these are in the order of the Sefer Raphael) actually appears in

– 11 –

the seven lists used in this study. For convenience I have added the zodiacal correspondences to the lists wherein they occur, or where they can be derived exactly from the Hebrew "month" designations.

It can be seen that Kircher's series on page 337 of Oedipi Aegyptiaci is practically the reverse in order from the other lists, and that the most serious displacements in the Kabbalae Denudatae and Musurgia lists are in the area between ♍ and ♑.

		S. RAPHAEL	KIRCHER p.235	AGRIPPA	KAB.D.44	KAB.DEN p.12	MUSURGIA	KIRCHER p.337
1	יהוה	1 ♈	1	1 ♈	1	1	1	12 ♓
2	יהוי	2 ♉	2	2 ♉	2	2	2	11 ♒
3	יוהה	3 ♊	3	3, 8 ♏	3	3	3	
4	הוהי	4 ♋	4	4, 9 ♐	9	4	12	9 ♐
5	הויה	5 ♌	5	5 ♌	5	5	9	8 ♏
6	ההוי	6 ♍	6	12 ♓	6	9	7	1 ♈
7	יהיה	7 ♎	7		10	10	5	6 ♍
8	והיהי	8 ♏	8	7 ♎	12	11	6	5, 10 ♑
9	ויהה	9 ♐	9	9	11	12	4	4 ♋
10	היוה	10 ♑	10, 11	10 ♑	8	7	10	3 ♊
11	הידה	11 ♒		11 ♒	4	6	11	2 ♉
12	ההיי	12 ♓	12	6 ♍	7	8	8	7 ♎

-12-

In addition to the serial lists allready given, Oedipi Aegyptiaci contains two cellular arrangements of the permutations. The first of these is on page 239, and is as follows:

יההו	יההו	יהוה
הויה	הוהי	הוהי
והיה	והחי	וחיה
חיהו	היוה	חיהו

By substituting the zodiacal correspondences from the Sefer Raphael we get:

♊	♉	♈
♌	♍	♋
♐	♏	♎
♓	♒	♑

which, except for the reversal of ♌ and ♍ places the cardinal, fixed, and common signs in separate columns.

—13—

The second cellular arrangement is on page 415 of the same work, and gives the names in columns which, according to The Sefer Raphael Correspondences, would be, reading from right to left, cardinal, common, and fixed (except for the transposition of ♏ and ♐) thus:

היוה	החרי	יהוה		♒	♍	♈
הויה	חהיו	היהר	=	♌	♓	♑
והיה	והחי	והיה		♐	♏	♎
יהחו	יוהה	הרהי		♉	♊	♋

Except for this one fact, however, the exact logic that underlies this arrangement is curiously obscure, to me at least.

NOTES ON THE NAME יהוה

יהוה occurs 6,823 times in the Hebrew Bible. It is found numerous times in every book except Ecclesiastes, where it does not occur at all, and in Daniel where it appears only in chapter IX.

— 14 —

From a grammatical standpoint יהוה appears to be the third person singular imperfect of the verb היה ("to be") meaning, therefore, "He is", "He will be" or perhaps "He lives", the root idea of the word being probably "to blow", "to breathe", and hence "to live". Another explanation derives יהוה from הוה ("to fall") originally designating some object such as a stone, possibly an aerolite, which was believed to have fallen from heaven (See Jewish Encyclopedia, volume 9, pp. 160-161). With this last interpretation should be compared the famous "Black Stone" at Mecca, and the creation theory of Enoch II.

IN Exodus, chapter VI, verses 2 and 3, we are told this name was not known to the Patriarchs, and in Exodus Chapter III (especially verse 14) that it was first made known to Moses in a vision at Horeb.

History leaves us uninformed as to precisely when the twelve permutations were attached to the signs of the Zodiac. The earliest Rabbinic literature interprets

-15-

Deuteronomy, Chapter 32, verse 8, to mean that the earth consists of twelve parts corresponding to the twelve sons of Jacob, and section 24 of the Alphabet of Rabbi Akiba (3rd century) declares these zones correspond to the zodiac (see Ginzberg: "Legends of the Jews", Volume I, page 13). The Sefer Yetzereh (2nd century B.C.) assigns permutations of the tri-literal name יהו to the six sides of the Cube of Space existing in the Formative World, and as it has been argued that the lost Sefer Assiah treated the four-letter name in a similar way, I believe that we can assume the twelve arrangements of יהוה were allready in existence at the beginning of the Christian era.

Regarding the attribution of the four elements of the ancients to the four letters of יהוה, available authorities completely disagree. There is a definite tradition in several organizations, mostly recent, and mostly of pseudo-Masonic persuasion, that י is in the south and is of a fiery nature, that the first ה is westerly and of water,

- 16 -

That י is in the East and is Airy, and that the final ה is of the North and generates (or is generated by) the element Earth.

Robert Fludd in his Utriusque Cosmi Majoris scilicet et Minoris (1629 Edition, Vol. 2, pp. 198-199, and elsewhere) agrees with the above that Earth is north, Air is east, Fire is south, and Water west, but places י with Earth, the first ה with Air, ו with Fire, and the final ה with water, while Kircher in Oedipi Aegyptiaci (p. 331) assigns י to the north and Air, the first ה to the south and Fire, ו to the east and water, and final ה to the west and Earth.

The great difficulty in checking any of these correlations stems from the question of precisely which ה is final ה in any permutation other than יהוה, and I have been unable to decide which, if any, of the above correspondences of letters to Elements is the correct one. I assume, however, that your better knowledge of Astrological facts will clarify the matter in a satisfactory fashion.

- 17 -

Well, Mr. Young, I have probably presented more information than is strictly necessary for your purpose but, as stated on page two, I have prefered to be prolix rather than risk leaving out the particular bit of data that can best serve your research. I would also claim that though my approach to nature has sometimes been characterized as atheistic, I really am loath to tinker with the alleged names of God without granting them the respect traditionally due them — just in case.

As to my own work; I have shown the film to to quite a number of people since seeing you. A complete description of their sometimes curiously Hermetic reaction would require at least another seventeen pages, so for the present it will suffice to say that both one of the Television networks and a fairly large independent distributor here have evidenced real interest in capitalizing on my productions.

I now have the advice of an excellent lawyer, and it appears that many more

— 18 —

of my techniques can be legally protected than I originally assumed was the case.

At present, however, I am still not receiving an income from my film work (or anything else), and probably will not realize cash from it before the late Fall. As you had indicated during our meeting of two months ago that your generosity had not yet reached its limits, I would appeal to you at this time for any monetary contribution possible, be it for research or otherwise, in order to sustain my mundane self during its present time-consuming assault on the Moguls of financial independence.

<div style="text-align: right;">Best wishes to you and yours,

Harry E. Smith.</div>

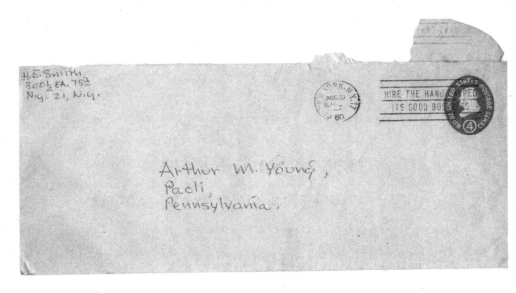

Harry Smith's letter to Arthur M. Young (August 30, 1960), including the envelope in which it was sent.
Courtesy of Joan L. Schleicher / Anodos Foundation.

ELLIOT WOLFSON received BA and MA degrees from Queens College of the City University of New York, where he pursued the study of philosophy, focusing especially on phenomenology, hermeneutics, and existentialism. He received MA and PhD degrees from Brandeis University, where he specialized in the study of the kabbalistic texts and traditions that have remained central to his scholarly work. Wolfson has written and edited over two dozen books on Judaism, philosophy, mysticism, and poetics. He was the Abraham Lieberman Professor of Hebrew and Judaic Studies at New York University, where he taught between 1987 and early 2014. A poet and painter, he is also considered to be "the leading scholarly interpreter" of the late Rabbi Menachem Mendel Schneerson, influential former leader of the Lubavitch Hasidic dynasty. Wolfson has served as the editor of the *Journal of Jewish Thought and Philosophy* since its inception in 1992.

29

Harry Smith Live
Three Interviews with Harry Smith

※ ※

Harry Smith Interviewed by Dawn-Michelle Baude (Boulder, Colorado, 1988)

DAWN-MICHELLE BAUDE: What interests me about your work is its spiritual aspect. I've read your films from that perspective, and I wanted to know what kind of occultism you were exposed to when you were growing up.

HARRY SMITH: Well, I would say that the books that were lying around the house were basically Theosophical.

DAWN-MICHELLE: So your parents were Theosophists?

HARRY: To a degree. They were very eclectic in their religious activities. For example, I went to a great number of different Sunday schools, so I got a great number of religions, although my parents did rely on the more ecstatic ones that would have rooms in the church basement where you could roll on the floor.

DAWN-MICHELLE: And froth.

HARRY: And so forth. There was a lot of chicanery to it. On the other hand, I got some idea of the pageantry—but I don't believe any of the theology of the Catholic church. I mean, that's influenced me

quite a bit. The ceremonies of the Catholic church must be beautiful, and you know, in 1300 or so it was . . .

DAWN-MICHELLE: Magical at that point.

HARRY: Yes, it was the answer to rural life. My grandfather was Catholic and had a big collection of liturgy. My grandmother was a friend of people like Annie Besant and Bishop Leadbeater [Charles Webster Leadbeater].

DAWN-MICHELLE: Bishop Leadbeater? Really?

HARRY: Yes! He sent me a magazine that I've never been able trace down more copies of called *Wee Wisdom* . . .

DAWN-MICHELLE: *Wee Wisdom*?

HARRY: A Theosophical magazine for children, I believe. Henry Miller gave me a sense of *The Secret Doctrine* by Madame Blavatsky, various things, Presbyterians, stages of Krishnamurti, who I suppose you'll get to . . . yet the form of these things seems to me to be completely chaotic. The Bishop had a cat that was the backwards reincarnation of the entire Theosophical Society.

DAWN-MICHELLE: I know! It gets very twisted, doesn't it?

HARRY: Well, Annie was gone, of course. The Bishop referred to her as being "on the threshold of divinity." She had already been people like Christ and Leonardo Da Vinci and a variety of other people. I would say that the books of Kandinsky and the paintings of Rudolph Bauer were important. Does anybody ever hear of Rudolph Bauer?

DAWN-MICHELLE: I know Kandinsky, but I don't know Bauer. Is he a Theosophist?

HARRY: I don't know, I'm sure he . . . well, he sort of out-Kandinsky'd Kandinsky, but due to his relationship to Hilla Rebay, Bauer was sort of hated, because Hilla spent a lot of money, and one of the first things they did was rent an entire floor toward the top of the Plaza Hotel, then arranged the stuff in the order it was supposed to be in. My interests in occultism at that point were more in the practical application that Kandinsky, in the two books or so, wrote

about. The axe and the square and the circle and the triangle. Now who got me interested in the modern occult movements? There were some people who had a bookstore, Billy and Mary Goines, and they'd sit at the same table at the café, The Black Cat, with Aleister Crowley and Somerset Maugham, and various things they told me would shock people, so I don't want to put in on tape.

DAWN-MICHELLE: Too bad. I was thinking of Kandinsky and Klee's palette when I was watching *Early Abstractions*, and I was wondering if the colors were symbolic of spiritual states or is that too much—you know how the Theosophists have all those charts with colors and shapes.

HARRY: Yes, there's a mythology, but there's more than thirty glorious colors of reality. Incidentally, those three paintings at the end of *Thought-Forms*, I've forgotten who the three composers are, you know, where the stuff bubbles out of the cathedral.

DAWN-MICHELLE: Mozart is one.

HARRY: And Bach is one, and the third is Scriabin. Those were, with no doubt, the first paintings that more or less were fully removed from what we might call "realistic" painting, a specialized way we have of viewing reality, which isn't very good in a lot of ways. In some book or other, there's—never mind! I've seen it myself! When you get off a railway train or whatever and arrive in a strange town, it's complete confusion. And that flat kind of painting, before Raphael, really resembles the confusion more than a perspective drawing. For example, the main street in Boulder, Colorado—a postcard doesn't really get you to a place that sells cigarettes, but it might get you to plenty of places that sell carrot juice!

DAWN-MICHELLE: But in *Early Abstractions*, the colors . . .

HARRY: The colors were based on colors that were available. They're not necessarily "occult" colors, they're just the basic colors. And after all, we are experiencing an illusion of a psychedelic nature at this very moment! We're high on something. Starches figure very heavily in the production of this particular illusion.

DAWN-MICHELLE: Oh no! When I was watching *Early Abstractions*, I kept thinking about Pythagoreanism and numerology and the Kabbalah. Were those concerns at the time you were making those films?

HARRY: No, I don't believe so. I was thinking more coercion and, to a degree, Chinese art.

DAWN-MICHELLE: Mandalas? Thangkas?

HARRY: Yes. Tibetan painting figured in my life for a long time—or the Chinese style. I insisted on dressing in Chinese attire until I had to go to school. I can remember weeping and wailing. And I had all these Chinese things laid out. I would put robes on. And I had a couple of dolls. These were pictures from *National Geographic* that later turned out to be Tibetan.

DAWN-MICHELLE: So were you getting Buddhism or Taoism when you were growing up?

HARRY: I haven't trusted writers on Taoism, until this doctor—whatever his name, Chang!—who writes a book on the Tao and sells Chang's long-life tea from a recipe of his grandfather's. He traces his genealogy back to whoever wrote *The Yellow Record* and peddles his tea in San Francisco, but his book on Taoism is sure an eye-opener. He ends up with a very careful analysis of the I Ching and says anybody who uses this for divination has just missed the point totally and entirely. Signs are to be meditated on, but never used to indicate the future. Naturally, he also goes into tai chi very carefully. He goes into animal exercises that are very close to how an American Indian thinks, so if you stretch your arms out you'll be a bird.

DAWN-MICHELLE: Or if you crouch down, you'll be a frog. In *Early Abstractions*, the music . . .

HARRY: Well, the music was changed around many, many times. They were first meant to be silent, married to two rhythms, one for the heart, and one for the respiration, so the rhythms would lock in. I think they're thirteen and seventy-two, I'd have to look it up, but

as one ages, one's anatomy—one must adjust the figures slightly. I think it's thirteen and seventy-two, and those are both important occult numbers.

DAWN-MICHELLE: Right.

HARRY: True knowledge of things like the *Zohar* and Pythagoreanism, and such like stuff, basically came either from Goines, or someone named—Lionel Ziprin's grandfather [Rabbi Naftali Zvi Margolies Abulafia]. Personally, it's through the Kabbalah. For example, the peculiar way the Kabbalah operates is—I had been given some shoes, supposedly from the head of the Rosicrucians of Belgium. When I got to New York, I put the shoes on and walked, and rang a doorbell, and it was these two people, Lionel and Joanne, who just got married, and not even their parents knew where they were, but the shoes had gone there. They brought me to see the Goines. There was a lady who used to hang around named Dorothy La Bour, and at one point she said, "Well, I think it's time to get Count Walewski." I didn't realize—you see, Dorothy was a very strange person. She traveled for many years with Gurdjieff.

DAWN-MICHELLE: Right! I knew the name.

HARRY: Oh, I've never been much interested in that [Gurdjieff], too many papers, although I've made motion pictures of the dancing, which was quite impressive. But yes, she traveled around and also, interestingly enough, was also a close friend of Nikola Tesla, who one year made experiments on . . .

DAWN-MICHELLE: Physics. Tesla's in revival right now.

HARRY: Well, he invented the alternating current that made everything possible. His major early experiments were on the top of Pike's Peak. Tesla's big because they suddenly realized that he invented everything. He slept on a windowsill and thought his existence was connected with a certain bird who came to the terrace at the Versailles Hotel, which is where he lived, and that he would die when the bird died. And sure enough.

DAWN-MICHELLE: Wow. That's a real totemic . . .

HARRY: So a lot of people turned against Tesla. Edison, is, of course, an archenemy. The alternating current can kill people much more easily than direct current, and Edison built his machinery on direct current, but he was as crazy as Tesla. On his way home from the laboratory, Edison would stop to shake hands with hundreds of people that weren't there, but he thought he saw. He was totally tone-deaf and played the organ every day for a few hours, and x-rayed a marble statue of Diana, and at the same time of his death was working on an extract of sunflower oil, that when applied to a certain part of the brain, increased its ability by three million times. That's because he thought these advancings—yes, they were advancings—were coming from little people who lived in his head. Now, of course, the existence of these homunculi, who have been demonstrated, particularly by Robert Fludd, at the Montreal Numerology Center, and . . .

DAWN-MICHELLE: What? I don't know that—what you just mentioned.

HARRY: Great. I hit something you didn't know. But I also presumed that the colors were in some way automatically built-in, like to be "red in the face" is entirely different from being "green with envy" or "having the blues." Colors are very peculiar because they are the intermediary. Most of the colors are vices, such as the color wheel and the circle of colors. Those of Schiller's and Goethe's inventions, strangely enough.

DAWN-MICHELLE: Right. Schiller and Goethe were both working on that. So when you were making *Early Abstractions*, were you thinking of what these colors do to the body or the mind? I mean, obviously you were, because when I was watching your film *Early Abstractions*, I was thinking, "There's a story here" in the way that the colors and shapes and numbers move together. I was wondering what you were thinking when you were making the . . .

HARRY: I think that's a function of, as Wittgenstein says, "The world is always the case." Red is red and yellow is yellow. Purity in the

earth realm—I had never thought of that. It requires a great examination of the colors to see if they are pure or not. What I meant to say is, whether they have corruption in them, like that lipstick you're wearing.

DAWN-MICHELLE: All Day Starlit Pink?

HARRY: Is that what it's called?

DAWN-MICHELLE: Yes. All Day Starlit Pink.

HARRY: I'd be careful of that. I notice certain things like that. If you think of psychiatrists' wives, who most often use brighter reds as their lipstick—I'm not making jokes—truly...

DAWN-MICHELLE: No, I was just wondering...

HARRY: They wear lighter powder and redder lipstick. Some kind of contrast. By the way [pointing to notebook], is that your handwriting?

DAWN-MICHELLE: Yes.

HARRY: I'm also a handwriting expert, and I'm leaving!

DAWN-MICHELLE: Wait! This was scribbled in the dark while your films were playing. I wasn't even able to see what I was writing. This is regular writing.

HARRY: That's what I'm afraid of.

DAWN-MICHELLE: I'm going to move on to *Heaven and Earth Magic*. Now, what I noticed in there was the Rosicrucians. Certainly, there are so many Egyptian symbols. Do you have any affiliations with either...

HARRY: King Tut? Oh my, yes. You know if you deal with people like art—it was my parents' fault. Naturally, Tutankhamen's tomb being discovered in 1923, the year I was born, my early childhood was—you have no idea. Everything was in Egyptian style. I particularly think of the masses of jewelry. And what is that around your neck, the Nubian mode?

DAWN-MICHELLE: It's a replica of a pendant from a Nubian pharaoh's necklace.

HARRY: I've already said that. Nubian is a type of bronze casting. I've

always found Egyptian art to be very beautiful, although I have a tendency to consider the Egyptian feeble-minded.

DAWN-MICHELLE: Because?

HARRY: There's a lack of humanity in their writing. There's no real colloquial literature, whereas the Babylonians can make you laugh and cry alternatively. The earliest Akkadian—about the same time as the Nubian period in Egypt—their literature seems so much more realistic to me, but that may be because I got interested in it. In our high school a play was put on that had an Egyptian theme and everybody wore Egyptian dress. Egypt permeated society, the same way our life today is permeated with ecological disaster, sort of what everybody thinks about. Not that I've run into anyone who thinks about it. But I'm sure they do.

The Egyptian city of death was somehow in vogue because of the large number of peculiarities that surrounded the discovery of Tutankhamen's tomb. You know, on the last day they had the license to dig, they found it. Ed Sanders thinks that's really because Carter had broken in and looted the place, and it may be that way. It was chaos in the first room, but never mind about that.

DAWN-MICHELLE: Well, tell me, when a viewer is watching *Heaven and Earth Magic*, did you have in mind a symbolic interpretation? I kept thinking, "This is a story, and I can follow it." I was just wondering what was going through your mind when you were putting those images together in a particular order.

HARRY: I would say it was done by collecting all the available images. In other words, they were in glassine envelopes that were arranged—the first one was an amoeba. It was to be much longer. The backgrounds and things had all been made for the Flood and all kinds of fantastic animals form Noah's Ark. It was never shot. I utilized the pattern of dreaming. So little is known about dreaming. If you go in at a very deep level and find out what a person really dreams, it's sort of like the symbols of the symbols. At the time, I would sleep—it was very exhausting work—and when I got tired, I'd sleep,

then I'd try to put it in the movie. Maybe not in the same form, but let's say I used what I had dreamed. My sleep patterns were completely haywire. I'd sleep for two hours, work for fifteen, then sleep for eighteen hours and work for two days. So the same material of the dreams is used, but at a different level of interpretation. My feeling about that film—about all my films—is that at this point they're in desperate need of editing. Some change has perhaps taken place in the time, in the tempo we listen to music or live, or this, that, and the other, and they would be helped by being cut down, although the audiences here have been the most attentive, I believe, that I've ever had. I'm more interested in things as they exist now than in their formative stage, because the viewing of the films seems to me hard to prove that you were there. You can be given a pencil and a piece of paper, and you can write forever, and arriving at even the symbols of Shambhala logic would never allow you back to *then*. In that sense the film doesn't exist. I think *Heaven and Earth Magic* is too long.

DAWN-MICHELLE: But I kept having the experience that we were going through deeper and deeper layers of story, coming through the layers as you were speaking of layers of dreams, stories about stories, symbols about symbols. It was an alchemical story, essentially, for me.

HARRY: Yes, by that point, when that film was made, I had already tried a number of alchemical experiments. I had a magic circle drawn in ink that glowed under ultraviolet light on the floor, and all kinds of glass chemical ware and . . .

DAWN-MICHELLE: So did you actually do it? Did you try?

HARRY: Of course! But I never got good results unless I'd taken peyote or other drugs. [To Diane di Prima] Dawn's asking all these questions that essentially, I don't think have much to do with the thing. I was invited to talk about Surrealism.

DAWN-MICHELLE: I'm moving from film to film. I'm moving up to there.

Harry: Because all my speeches, or elocutionary exercises, are supposed to be on Surrealism, and as I tried to explain the other day, Surrealism is a state of mind that everybody both has and hasn't. I do believe in some creative force. I hesitate to call it "God," because that's too limiting.

Dawn-Michelle: So have you made a study of psychology?

Harry: There's no subject I haven't studied.

Dawn-Michelle: What were your influences there?

Harry: Due to my own inability to cope with the world, I cannot find solutions. It's as if the language was built incorrectly for discussing the subjects that I really want to discuss.

Dawn-Michelle: I see. So when you were making *Late Superimpositions*, there was an extraordinary synchronicity between layers. Was that Surrealist chance?

Harry: It is totally through chance. There was no attempt at all to synchronize, although it was impossible not to remember that this part was light over the top, so the next time around, I'd vary it and put the light at the bottom and the dark up there, but there was no attempt at all. I think the entire film was a run through four times: once in Oklahoma, once on Ninth Street [in New York City], part at Dorothy Rice's house where the beads . . .

Dawn-Michelle: The pearls.

Harry: They were fake! You know, it was just run through arbitrarily. But as I said in the preliminary remarks before the showing, we need a whole new vocabulary, a whole new artificial language has to be devised.

Dawn-Michelle: Yes, Francis Yates goes into that.

Harry: If you saw that book *The Hunting of the Greene Lyon* from Cambridge University Press [Betty Jo Teeter Dobbs, 1975] they say that the Sotheby catalog will forever remain the primary source on the Newton manuscript. People bought alchemy books and then tried to keep other people from finding them.

Dawn-Michelle: Right. The great cover-up.

HARRY: A large number of them were bought in Israel, which I thought was interesting. Sir Geoffrey Keynes has tried to make an annotated version of the Sotheby catalog. Anyhow, he also devised an artificial language and other stuff. There's a history of artificial languages published by the University of Toronto. They're very strange. All language is peculiar. In Sanskrit, for example, there are no words which contain real substantiality. The whole philosophy is based on things being illusory in nature, that language itself is constructed in such a way that it formulates ideas like two sides of the same coin. There's no concept of real solidity like this table, which I prefer to imagine is solid.

DAWN-MICHELLE: Although the findings of physics tell us that the table is mostly empty space. The closer you look . . .

HARRY: Although the standard physicist, once he's slammed his finger in a car door, will admit the substantiality of the car door. Any further questions?

DAWN-MICHELLE: What about your feelings in terms of archetypes?

HARRY: Well, I tend to think of archetypes as a Jungian concept. There's no doubt that I was reading Jung and got over into what you think of as occult literature.

DAWN-MICHELLE: After *Heaven and Earth Magic*, where do the films go?

HARRY: Well, I began making films of situations that would probably cause trouble, about people going insane and so forth. The last one that I made—I guess two years ago—it's on string figures. I can't go into all this, except that I would like to mention Kandinsky's painting.

DAWN-MICHELLE BAUDE (formerly Dawn Kolokithas) is an award-winning writer, editor, and Senior Fulbright Scholar. The author of several nonfiction books, translations, and volumes of poetry, she is a prolific art critic and journalist. She makes her home in Provence, France, and blogs art on *WhiteHot*.

A Conversation with Harry Smith Recorded at His Naropa Cottage on December 18, 1988

Harry Smith served as "shaman-in-residence" at the Naropa Institute from 1988–1991. The following is excerpted from a conversation between Professor Smith, Beth Borrus, Liz Belile, and Rani Singh, recorded at his Naropa cottage on December 18, 1988.*

> *You can't taste the peanut butter, but it thickens the soup and makes it more nutritious.*
>
> <div align="right">Harry Smith</div>

Harry Smith: Now, you had asked me a question regarding why I, Bishop of the, I can't, I don't have of their stationary here, I can't pronounce it, something like Ecclesiastic Agnosticora of, which is connected with the Ordo Templ[i] Orient[is], uh, and yet on another occasion, stood publicly on the Mall, outside Sundown, and admonished that wicked street.

From then on, I went to the Crossroads Mall. It's much closer. Next question?

Beth Borrus, Liz Belile, and Rani Singh: Do you have any brothers or sisters?

Harry: My parents claim I don't. If they are my parents. I would like to pick up that—never mind!

Interviewers: When did you . . .

Harry: However, I'm from the CIA, now you can't treat me like this. I decided that in Boulder it might be the best possible move, because every—"What do you DO with these tapes? When we were doing the Tibetan devil dance, you were there recording it." The—I was, too—and I explained that I learned from the recordings made

*This interview with Naropa students was originally published in *Bombay Gin: A Literary Journal*, volume 1, number 4, in 1989.

there of the lessons, because that's one thing that Naropa has in a few individuals.

INTERVIEWERS: What are you teaching?

HARRY: Alchemy in the summer. If I haven't been raised to such an exalted rank and, I mean, the Great Crystal Dome has to be built. I mean, in Anne Waldman I saw a second Katherine Tingley, if her first name was Katherine, Miss Tingley of Point Loma. [Laughs.] You know, they started off the founding of the site of this place by putting four grains of corn in, Miss Tingley, who was supposed to have appeared in her apparitions as MacGregor Mathers and she... [laughs]

INTERVIEWERS: What was that place you were talking about?

HARRY: Point Loma. A major Theosophical movement took place. The dream of Naropa is—continuing our tour of Puget Sound—[laughter] we're dancing at Naropaland.

So moving back to the Northwest, I often have thoughts of my mother and father, who were interested in nature and that sort of thing, when I see the sunrises and sunsets and things. On the day that spectacular news arrived at Naropa, I thought the horizon was on fire, lots of people saw the sunrise that day, it was spectacular, it was a Monday...

I don't know anything about the Buddhist teachings. They're like anything else, you either accept the whatever it is, Eight Global Truths or something—I find, generally speaking, that the place is declining. The reason that I brought up the Theosophists was that they have turned basically into an organization that is a foundation for old folks. Naropa has plans of opening an old folks' home.

Now, the well-known sounds heard when practicing Hatha Yoga, which I hope, well, and practicing is all you can ever do—Have I read you my epic poem? Something about a school that stands where Quonset huts once grew.

Now, I, uh, getting back to the sunrises and sunsets, I often think of my parents but in particular my mother, who grew up

in sort of the tradition of late Victorian Romanticism, so forth. I can't look at a beautiful sunset or something without thinking of her. Other phenomena, such as crystals we saw in the sky, or the rainbow, affect me thinking about me more. I don't remember thinking about my mother when I saw the rainbow on the Fourth of July. The people were spoiling my tape, they were, one person after another, I got so tired of people saying, 'cause they didn't realize that a recording was being made, [evil voice] "You gotta come and see the rainbow!"

INTERVIEWERS: But there was that great moment when the sprinklers came on. You had to admit—[laughter]. That was a classic. The tent and the sprinkler.

HARRY: It is extraordinary, beautiful here and the clever things that the squirrels and the birds do to foil my scientific investigations.

INTERVIEWERS: They think you're from the CIA too.

HARRY: Well, there's a color photograph of me in the March 1943 issue of *National* magazine,* a big one, too. In the Boulder Public Library, recording the remains of the Salish whatever you wanna call 'em, *grups*, on Lummi so-called Reservation near Bellingham, Washington, where I was going to school. And, uh, it's a peculiar photograph; of course I'm clean-shaven and I combed my hair. . . . red Pendleton shirt on and the people, who I wish the information had survived from, I can't even remember who was in the picture— I certainly should be able to remember the Chief's name at that time, because he'd given such elaborate genealogies, that was the peculiarity of the Salish in that area, the Gulf of Georgia in Puget Sound, was the keeping of elaborate genealogies that went back maybe twenty generations and there were two golden women that came from the sky. Yeah, two sisters. They came from the other side of the Rockies and the coast range. . . . They probably came from the Rockies, but they definitely came over the coast range. At about

*This refers to the March 1943 issue of nationally syndicated *American Magazine*.

the same time that cooking by putting food, that fire was brought there by Coyote, carried it down from the high snowy mountains. Humans at that point had been cooking by putting meat in their armpits or trying to hold it up to the sun.

INTERVIEWERS: What was the name of that group?

HARRY: They're generally lumped together as Salish. That's a word that's used in ethnographic literature to cover a great number of different people. Like the word "American." You know, America's made up of a great number of different elements, and I'm happy as Bishop of Longmont to pardon me, it was such a busy day—it's Bishop of Leadville.

INTERVIEWERS: Mudville? [passing a joint] (Why don't you do a toke?)

HARRY: Because I've never tried this stuff before. [Laughter.] Makes me rather dizzy. Where *do* you get it? I presume over at the Performing Arts Center. From that strange little man in constant meditation, face down. [Laughter.]

They're very good teachers here. But they have this fatal flaw of getting along with the students. They should knock the *shit* out of the students. At times, I mean, uh—Alexandra David-Néel, I think I've mentioned that before, mentions that Lama Kazi Dawa Samdup, yeah, who was the translator for Evans-Wentz, and Sir John Woodroffe and so forth, uh, he was a teacher, but he was suspected of—she says, "I suspect you of worse business with the teenies, I'd heard it, farther down the valley." Anyhow, his method of teaching was to come out once a day, line the students up, he had a bundle of bamboo that he beat them with, then he went back in.

INTERVIEWERS: Maybe if Jack had done that to us, we would have shaped up.

HARRY: Well, it's basically what happens. Only it's sort of spread out over a long time. Then the students perhaps fail to take advantage of—to be gentle. Like a warrior.

Crash! We are now back at the old ivy-covered manse. An

interesting manuscript of John Greenleaf Whittier's first American notebook was found in Boulder. I don't know when it runs from, 1838 to 1840, or something. First thing I ever read by him that I found interesting. Hundreds of little short scenarios and stories he found—anyhow, Whittier of course wrote, after *The Scarlet Letter*'s great success, had earlier written—drew things from his life to write on, these stories from the old manse so these are more stories from the Naropa manse. And his wife knew him as "N. M., the order"— this is how Oscar Wilde talks on the early phonograph record of him. [Laughter.] Which I'll bring back around. [Pause.] People I know—I have a copy of that—hmmm [pause]. Anyhow, continue on with your interrogation, doctor; what am I going to do with this stuff, I don't know what I'm going to do with it. What are you gonna do with it? Ha, ha, I'm leaving it here. [Laughs.] For Deadeye Dick or somebody to . . .

INTERVIEWERS: Bishop . . .

HARRY: Bishop J—yes, arrange for the mob to riot. [Laughs.]

Oh. Now, what should have been done at the beginning of this tape that I forgot to do is cough onto it; if you make a tape it helps to cough every so often because nobody can imitate your cough [interrupted by loud coughing]. It's also very simple to put special words into the cough. Like names. It's often used by a certain class of people to communicate. By calling each other through a certain cough that imitates the contour of, sound contour of the name. Because if you listen to recordings of large masses of people, such as occur under a great number of different situations, the individual voices are seldom heard. An occasional word is. Things are kept quiet, and refrigerators turned up and clocks and all that. The—here recorder can pick up, but—so, intonation being the, I'm quoting somebody, the intonation is the overriding factor in communication, which you can tell from the tone of their voice, whether a person is angry or jealous or you know, there's a certain stylized way, that's very, uh, dull. As far as the use of any tapes that I might have made, I

have no idea. A very great inventor that I know, Arthur Young, who writes—I'll put in an ad for Arthur, too—both of his books are for sale at Boulder Books, *The Reflexive Universe*, and the other one, I don't remember the title, but it's under Young on the computer. He invented, he made the helicopter possible, he's now credited with it, through this Young Differential, which allowed the rotors to be turned. Somebody told me that when you make an invention or make a discovery you don't—when he made the helicopter, he had no idea what it was going to be used for. . . . I was going to say they didn't bother, you never worry about, I have NO idea what these tapes are going to be used for. But in order to get back to Boulder with better equipment, it helps to have a sample. Because I come back here prepared to look for the things that I had bypassed. It was a long time before I realized that the squirrels were carrying on highly intelligent communication between each other, which reached a peak the day that they were able to stop the birds from singing when the sun came up, which is why I was recording the thing anyhow. They evidently had some prior agreement, the Dawn Chorale, somebody thought it was a corral that you put horses in? When I was speaking about the Dawn Chorale, and, the chickadee is this time of year, around this, yesterday I think, no, day before yesterday, the chickadee as usual was the first, I mean the last to start singing in the morning, and the last to give the final croak at sundown . . .

Everybody should have a tape recorder; it's nice, I'm happy to say that everybody does, even if it's like sort of a streamlined, you know, what are those things called? Ghetto blasters? Something . . . ?

She should see some of the things that came out of the building from the meditation thing today. They may have been shrunken . . . by the experience. Or something. Or else were children or cretins, I have no idea what but very short, fat people. But, under three feet high, or around three feet high . . . oh! Now, I hear via the grapevine that you said that squirrels all over the world talk

differently. No, no. What if these turned out to be Buddhist squirrels? It's the ideal place to—what is that thing called, a prayer wheel . . . it's a book put out by missionaries, I'm sure, um . . . I put it on an electric fan blade, "om mahne padme hum," when I made my movies, it'd blow air on the lights, but it could be put in a squirrel cage, and it determined whether the squirrel was a Buddhist or not. I would tend to think they are around here.

I contacted Liza B. Cheney, who was one of the main singers of interesting songs in Anadarko, Oklahoma. And, uh, they held me for, I don't know what it was, ten days for investigation, and when I got out of the uh, jail, I went to the telegraph [unintelligible] but I went to the bank. When I came out of the bank, this seventy-nine-year-old woman with a handmade sunbonnet was standing there. I thought, Oh, my god, if I could only record her. And, uh, well, finding out later more about Mrs. Cheney, she arranged that whole thing, you see everybody discounted from the very beginning, "Ah! She saw your name in the newspaper." But she did it legitimately, she knew what I was looking for, she didn't sing any important old ballads, because she recognized them from the tunes, she said, "Oh, those love songs." "Barbara Allen," that sort of thing. But she had many hundreds [of] songs written on sheets of paper in a box under her bed, her ballad box. And a lot of them were extremely good songs. . . . Like you find good poetry in high school yearbooks. High school literary magazines are usually better than college magazines as far as a certain dreamy type of poetry is concerned.

INTERVIEWERS: What sort of role would sound play and—this is a real general question, but—what kind of role would recording sound play with magic or with alchemy? Do you see them as connected at all?

HARRY: Well, on the basis that the Crowley canon, which seems to be the oldest, not the sort of best, but the oldest, is the Hinayana Buddhist tradition, is that karma produces sound . . . weird, isn't it? The only way to contact other people is through karma. . . . In

the New Testament, the paraphrase of Genesis or Exodus, I think it's John or Mark, something like that, I have it in Navaho, I didn't realize they had it in English first, but I didn't realize they had a Bible, uh, in the beginning, anyhow, it's written in Greek, because it, well, I think it says, "In the beginning, was the word." And the word was God, uh, sort of implies that sound is the primary thing. It's one of the things that brought me to Boulder, noticing that jet planes going over in certain winds sounded exactly like those large Tibetan horns. Now, logically, being as I didn't see the thing, I don't know, how could I be sure it was an airplane? Simply because the third time I looked up there, I remember the one time, Tibetans flew by on a pink cloud. . . . You must be very careful in deciding what is the result of your personal interpretation and what is the result of formal reality. I'll have to define formal—duality?

But—now, there's been a tendency also, when someone picks up a book, to tend to believe the book, because I might . . . I have . . . [unintelligible]. It's a damn lie. This morning when I was recording the birds, I heard this saxophone. . . . You understand why it's funny; it's because Charlie Parker was called Bird. I'm recording the birds and I suddenly hear the saxophone.

Interview from *Cantrills Filmnotes*, No. 19 (October, 1974)

Arthur Cantrill

Harry Smith, Elder of the Film Tribe, lives and works in a room high in the Hotel Chelsea, New York. He shares it with a small flock of Australian budgerigars which are free to use the room as a huge aviary. The interview we recorded has an incessant background of bird calls.

HARRY SMITH: In some obscure language of Southern Australia where the Aboriginals have all died, it means "pretty bird." And from my

teachers in Australia, particularly Ronald and Catherine Berndt who are now working in the interior of New Guinea, they provided the answers to these questions; they opened up the Aboriginal literature to the Western world. And of course, Sir Baldwin Spencer's and F. J. Gillen's photography also inspired me because my earliest film works, which are hand drawn are partially derived from looking at pictures in their books, particularly certain ground drawings by the Warramunga. They're in a book called *The Northern Tribes of Central Australia*, and that dotted technique, which is prevalent all over Australia, but is particularly developed among the Warramunga, was one of my inspirations for my earliest films. So in a way I go back to what the Arunta call the Alcheringa, I go back to the eternal Dreamtime as much as I can in my films.

ARTHUR CANTRILL: Some of your work is similar to Aboriginal art in another respect: it lacks a European concern for gravitational up and down—there's a sense of the image being in the round: it can be looked at from any point. And the Aborigines often work like that; the people sit and paint from many angles so there's an overall comic feel as though it belongs to the universe rather than this world. Your work often seems to draw on these and similar ethnic philosophies.

HARRY: Yes, during the brief period I went to the university I majored in anthropology. I've always been interested in this particular subject and as a consequence my work is derived to a great degree from various so-called primitive arts, whether it be in the form of film or the form of painting. I can't say music, although I've written a few songs.

ARTHUR: So you've had a training in anthropology, it's your background.

HARRY: Well, not much of a training—a couple of years in university, but I remained interested in the subject because it seems fundamental to the survival of humanity: to get back to a . . . well, somehow the population has to be reduced. You have to kill your child! In, like, some brutal murder that will be written up in a full page of

the *Adelaide Sunday Herald* or something! Australia's in an ideal position to be the forerunner of a great number of societies, because I understand there are more kangaroos in Australia than there are human beings. I mean I saw it in the *New York Times*, and everybody believes the *Times*!

ARTHUR: Australia could be the last hope for some kind of reversal of prevailing trends. We hope to get back and do some work on the land—perhaps reforest an area, because lots of it has been laid to waste of course.

HARRY: Oh yes, as nearly as I can understand, the Australian government wants Australia to be sort of another United States, whereas there is still a chance that knowledge that the Aboriginals had can be put to use. It was proved years ago that all human beings have the same intellectual capacity; that there are no lower races or higher races or anything like that. They all have the same capacity for thought, but the historical background of the thought is different in all societies. The historical material that is run through the brain is different in here and in there.

The Aborigines work with things that I'm interested in, which are poetry and music and painting. I really don't care about governments or organized societies. I'm more interested in the Aboriginal system, which has sometimes been referred to as an "ordered anarchy." A. P. Elkin, who is another great anthropologist, was the first one who really got down to the Aboriginal culture. The wonders of it had been seen in the photographs that Spencer and Gillen took. But it was only Elkins that opened up the mystical world of the Aborigines. He was some kind of Baptist minister or some damn thing.

ARTHUR: I didn't know that. I have met him.

HARRY: He must be a grand old man.

ARTHUR: He's a very old man now. He wrote a book called *Men of High Degree* and that was his definition of the song men and the magical men. Yes, it's just possible that Australia hasn't gone too far. Certainly, younger people are going out and absorbing what's left of

Aboriginal culture and philosophy and bringing it back and using it to change attitudes.

HARRY: Yes, if there's one place I'd like to go it's Australia. I could go there; I have somebody who would pay my way to go there, but I'm too paranoid; I don't like to leave my room. I mean, the Eternal Dreamtime is here, just as much as it is in Ayers Rock. There's a picture of Ayers Rock: it's a postcard from Allen Ginsberg. It's very interesting; all the marks on it represent certain people of the Dreamtime who were later transformed into rock and so forth. It's peculiar to imagine that such thoughts are still kept.

Oh dear, I forgot to answer the questions in the Aboriginal fashion. Is there any tape left?

ARTHUR: Hours of tape!

HARRY: Well, I'll answer questions in the Aboriginal manner, but they are to apply exclusively to my films and the questions are to begin with "why" or "does" or something like that, so they are actual questions. Because you see I've been spending a lot of time lately going into a great number of trances, through simple self-hypnotic techniques, where I was using the so-called "Cold Spot" technique where you breathe in through your nose and feel a cold spot at the back of the throat and then transfer that cold spot to the feet and on the next inhalation you transfer it to the ankles or something; you work up through the body. It's often described in mythology as water rising over a person, but I learnt a lot about Australian mythology during that period, so that [in] this particular interview I would like to make a . . . I keep trying to get it back to the subject, but you know I'm also an alcoholic. I'm not only a filmmaker, I'm also an alcoholic. You ask the questions and try to make them fundamental to art or something, I don't want any trivialities.

First question.

ARTHUR: Why did you start making films back then in the early 1940s?

HARRY: Because an old woman with a bullroarer that had a snake drawn on it, swung it and I heard it.

ARTHUR: In numbers 1 to 3 of your *Early Abstractions*, you chose to paint, draw, and batik directly on to the film itself, and you weren't aware of anyone else having done that at that time. What interested you in working directly on the film?

HARRY: Because a trench was dug in the ground that is shaped like a T and faces the east.

ARTHUR: You had made quite a body of work before anybody knew about it, at least on the east coast. Why was that?

HARRY: Because of the two sisters, the Wauwalak Sisters I think their name is, drew the serpent from the billabong.

ARTHUR: *Early Abstractions No. 2* was cut down from thirty minutes in order to synchronize it to a Dizzy Gillespie number, but most of your films you chose to show without sound. Why was that?

HARRY: Because there is an island where twenty-two forms of the Morning Star arise and where the dead reincarnate from, off Arnhem land.

ARTHUR: Would you like to say something about each of your films in these terms?

HARRY: How many films have I made is what I don't know.... I'd have to look that up. But *Heaven and Earth Magic* is number twelve and since then I've made four, so I'm sixteen. Sixteen is a very important number because it is four times four; it shows, like, fire, air, water, and earth interacting with each other. I'm now getting off into the Aleister Crowley school of filmmaking. So there are four times four things at this point. Because generally speaking I follow the existential philosophers. I became interested in Aboriginal philosophy because it was so exquisitely preserved of all the places. So I don't know what those sixteen things are.

They're something like: the Great Void; Middle Void; the Lesser Void.... The only word I can think of for the fourth one is the Crown, but it doesn't exactly express what it is: the effulgence of things. The fifth one is the Feminine Force and the sixth one is the Male Force and the seventh one is what is called in the Bible the Tree

of Life, and the eighth one is what I refer to as the Old Woman with the Bullroarer With the Snake Drawn On It, and the tenth one is the trance that I referred to. The eleventh one is Sir Baldwin Spencer collecting bark paintings in Arnhem Land and the twelfth one is a dog with a leash around its neck, and the thirteenth one is a very interesting chapter in Spencer's book *Across Wild Australia* where he was trying to stamp out the opium traffic, but the relationship between the Chinese and the Aborigines is what is referred to in the thirteenth although in Hebrew it is *jotay votay*, what is called in the Bible Jehovah but it refers to the numerals 10, 5, 6, 5 and adds up to 26, which encompasses the entire universe, both the microcosm and the macrocosm: both that which is within and that which is without and 13 is half of 26 so it represents the midway point. Fourteen is the number by which I have lived. Fifteen is the name of God that I will not mention, and sixteen is the result of certain inscriptions made in the sand by the Mohammedans. It's the geomancy, which means Earth divination, but it is a specialized form of divination for which a number of unfortunate Europeans got burned at the stake for believing in.... So those are the sixteen things.

ARTHUR: Is the film you're working on now, *Mahagonny*, number 16?

HARRY: I'm not sure it's the right number, it may be 17, yes, I fiddle along with a film. But no! I'm not answering these questions in the European sense, I'm going back to the Aboriginal sense.

We will now sing the telephone song: Ding-a-ling, ding-a-ling! At which point everybody stands on one leg and puts the other leg like this, because Professor Scougal, I don't know where he was, the university of something or other, Melbourne maybe, wrote about the various ways the Aborigines placed their legs in one way and another. So the answer to that comes from ... I don't know if those islands are named: Darwin is the northern part of Australia isn't it? Yes, there's two islands off there....

ARTHUR: There's Melville Island....

HARRY: Melville Island! That's what I'm talking about, where they

have those funerary monuments that are beautifully done; they're very good. C. P. Mountford has written about them extensively; it was his work that I was referring to when I mentioned that. This has little to do with films.

ARTHUR: It has to do with your films, and as we publish this mainly for Australia it's interesting to relate your work to . . .

HARRY: You must be despised, though, in Australia. They must really hate you there; bringing out a magazine in the USA.

ARTHUR: Oh, we have plenty of Australian content—there are enough filmmakers in Australia working away and having nothing to do with the regular film scene.

HARRY: Well, you undoubtedly have wealthy parents or grandparents or something. You can't put out a magazine like that with no money—now come on!

ARTHUR: But in Australia we used to sell it on the street, so in that way there was no loss. So we managed to pay the printer, who was a wonderful friend who let us help with it and didn't charge very much. And we actually had a grant for about two issues.

HARRY: Oh, that's great.

ARTHUR: Why did you turn to the Aborigines rather than the American Indians as a source of inspiration?

HARRY: Oh, I just showed you my Folkways album of Indian songs, which is the most complicated album ever brought out on the subject. It costs thirty-seven dollars and fifty cents and has three records in it—it's the most complex American Indian album yet brought out. So of course, I'm interested in the Indians. But I was interested in the Aborigines because first Baldwin Spencer had written very good, illustrated works. The text doesn't mean any more in Baldwin Spencer, because he claimed to have discovered things like the Australians didn't realize any connection between copulation and childbirth, but that was proved to be phony.

So of course I am interested more in the American Indians than I am in the Australian Aboriginals, but because you're Australian—

not AustrAYlian but AustrEYElian or something—I have chosen to discuss the Australian Aborigines. You come from the land where they live, and I sort of wanted to turn you on to them a little bit. That there is a philosophy as great as that of Greece at your very doorstep, but it's difficult: you have to learn very difficult languages. I don't know any of them: I don't even know the principles that Australian languages are based on.

There must be two more Australian questions regarding my films. I mean I'm not interested in questions regarding the political state of the country or anything. But there are two more Aboriginal ones you have to ask. This will give us six, I think. And they spell Mother. Oh, dear . . . Gracie Fields! How old are you people, you're not very old; you're in your thirties aren't you? [Pours a vodka.] OK, the two further Aboriginal questions.

[Interviewers give up.]

ARTHUR: Well, I guess you'll have to ask them.

HARRY: No, no; you're interviewing. Is the machine still running?

ARTHUR: OK, I'll ask the questions. How is *Die Dreigroschenoper* by Kurt Weill and Berthold Brecht connected with those things which have been spoken before?

HARRY: Tibet is connected with Australia because of the escape of people from Tibet who didn't want to wear clothing and didn't want pottery. Who wanted to simplify life as much as possible and thus they went to Australia, the land of the duckbilled platypus and the various other koala bears or whatever you call them. And there they found a land which was suitable for their reckoning.

And the last question describing Australia is: Why does Australia exist? Australia exists for a great number of reasons. It is a continent upon the earth upon which we dwell and was made separate at a very early time so that a great number of animals and philosophical ideas grow there that don't grow in other parts of the world, except maybe a little bit in New Guinea, but not really. I mean the Torres Straits don't explain anything. But some of the string figures from Australia

are very like those from New Guinea, so there was undoubtedly a passage from Cape York to New Guinea. If it selects the proper road to follow, Australia will be the Empress of the world. But unfortunately, it is not selecting the correct road to follow; it has imitated England and America and thus has sealed its doom. The Australians will be happy when they get a hydrogen bomb. When they get something to destroy the world, they'll be happy, because they're like the Americans: they're fools. And because they don't care about these things that the Aborigines have: they don't care about the music, they don't care about the art, they don't care about the poetry. They're slaves to a government and mental system that is outdated by many, many years. And yet the fact that people like you come around, interested in something. You're not doing a good job, you're doing a bad job; but it's pleasing to meet you, and even if it's a bad job, it's a job, so that it's better than nothing.

ARTHUR: Did you know our filmmaker friend, Dick Preston?

HARRY: The name is familiar, but I don't know him. I don't know anybody. I'm a loner. I don't really do anything. I slowly, slowly work upon my films.

ARTHUR: Can we say a little more about your films?

HARRY: I wrote a poem about my films; I'll read a little of it. It's a poem regarding the film I'm working on now. It's a very complex thing that I can't raise money for. I can't even pay the rent; nothing. And I've been working on it for three years. I'm going to put a whole bunch of slides and things over it. I'm getting ready to build some kind of machinery that will matte the picture out to certain degrees. I wonder what part of this is about Australia. Anyway, this is a description of my most recent film. I can't possibly read the whole thing; I'll read a portion of it:

> O rose thou secret scented flower
> Whose petals hoard thy fire and thorny power,
> Arise from earth's dull flavoured soil

And upwards toward the heavens toil,
Till like a roseate bird of rest
You leave the world that was thy nest.

A secret man stood on the hill,
His belly to with folktales fill.
And shiny balls he kicked around
When certain stones shone on the ground.
That ground was cleft as by a sword
Locked in a rock which people toward
Their own desire to find a place
Led only to their own disgrace.

A giant held the land 'twas there,
And scourged the shiny players lair.
He had his central tooth knocked out
By Equinox and Golden Cloud.
This story tells of how the search
Was made through willow tree and birch
To find the tooth that held the key
Of contrast between you and me,
Of contrast between towers high
Where kings and princes slowly die.
Of contrast between sky and beast,
Of contrast between beer and yeast.
Of contrast between snot and spit,
Of contrast between piss and shit.
Of contrast elevated high
By men ordained at birth to die,
Or tell these tales in winters cold
When roses shrink from snowflakes bold

These snowflakes land upon the hill
Where white displays its merry will,

And clogs the window and the door.
At right a saint, at left a whore.

Within this cavern small and neat
There lived two peacocks cheek to cheek.
A grandpa with his grandchild dwelt.
As god with god or smelt with smelt.
Her raiment was the finest hue
From top of head to tip of shoe.
Her bird-like radiance extended
Into three arms unintended
That gave her of an eminence
That seemed to grandpa commonsense,
And seemed to him to be the prey
Of clearing issues of the day.
Up to this simple woodman's hut
There came a man who called out "Slut!
If you be of the rosy cross
Then this trip through snow can't be a loss.
Where should I knock to gain the way
Into the fourth part rosy ray?"
The voice within the hovel spoke:
"If fire is fire and smoke is smoke
If water rills still lead the way,
And still the rocks interlock with clay,
Then try the doors and you will find
That one that interlocks your mind
And makes the forepart answer to
The me of me and you of you."

This riddle is not easily guessed,
But if you have within your breast
The passion to seek out the way
Where angels swear and devils pray,

Then try yourselves these four fold doors
That change the virgins into whores.

Our hero then, who's not been named,
Saw four doors, as one inflamed.
With wands and cups and earth and air,
Entwined in one long serpent's lair.
This serpent spent his opal breath
In trying to hack the sword to death,
But failing in this enterprise
Became the angel of all eyes
Who judges man when he departs
Into the kingdom of the farts,
Or other regions of Tibet
Which haven't joined the loca yet.

First to the east our hero struck
But rising sun gave not a fuck.
And when he travelled to the south
And heard that world's rejecting mouth,
So then he knocked upon the west
And tried to suckle on her breast.
Being spurned, he sought the point
Where astronauts and fish disjoint
Into the fair similitude
Of customs bad and manners rude.
And breed this one pure hominid
Beneath the vomits sheltering lid.*

That's enough of that. It goes on for pages and pages and pages and pages and pages.

*Editor's note: this poem is transcribed from tape and there may be errors in punctuation and phrasing.

Now my films are all arranged along anthropological lines for the betterment of humanity.

There's a description of children's games here. These are things I dictated when I was in a trance and this part was derived particularly from Australia, so I'll read a part of it: "The children now having ended the play have reached an age when the holy men and women of the two moieties should determine their reliable marriages.

A T-shaped pit (I'd mentioned this earlier) is dug in the ground about four feet wide and six feet deep in which the children assemble themselves, boy against girl. The eldest of the preceding generation of initiates walks around this pit in a counterclockwise direction, swinging a bullroarer. He is unclothed except for a horizontal stripe of blood drawn from the cut in his penis to which white downy feathers are adhered.

The elderly men of the tribe around the northwest sing those songs that the neophytes will learn later. The women of the family are behind the screen of bushes in the southeast, repeating the songs they knew before the men stole their secrets.

As the secondary initiator walks around the pit, he sings the song: 'O, you two sisters who at that pool where the serpent of rainbow-colors dwells and was aroused by the odor of the menstrual blood of the youngest of the two, let you now perform the string figure that makes us pure.'

The initiates now sing the song and perform the string figure proper to the lineage. The most elderly men and women from the ceremonial positions in the northwest and southeast crawl on all fours to the . . ." And so on. It's very long. Skipping a page it goes on. (As I say, I didn't write this, I just dictated it while I was in a trance, and I'm not used to Miss Van Kirk's writing.) But the next page begins: "As well as those organs of the body which are possessed by women alone. The initiates in the pit shall now get down on all fours and crawl around and then get out of the longer

extension of the pit where they then stand facing and arrange themselves in the form of a human body—youth against maiden. The younger women of the southeastern camp now sing the song which begins: 'Ha, ha, ha, ha! Though they have stolen our secrets we remain triumphant!'

This alternated with the song form the northwest camp which begins: 'My bullroarer has a snake burned into it.' These two songs shall be alternated for a sufficient length of time for the male initiates to separate themselves from the mixed configuration of the human body into the form of a phallus on the western side. At the same time the females arrange themselves on the eastern side in the form of a vulva.

A man especially hired from the next camp up the river shall now sing the song beginning, (it's hard to read), something like:

> The abbots of the rosy cross
> Believe that [inaudible] is no boss
> But even get to far Australia
> And thus destroy Earth's entralia.

At the conclusion of this song the male and female groups should dissemble themselves into joyous and exuberant parties and march towards their respective sides of the trench. There they will examine the branches that the elders have arched, for such things as bird nests, ant colonies, wasp nests, and other signs of that which climbs through the alembic and whose tail flies in a cloud of gold.

When the bird's nest is found, whether it be by the male or female group, the song beginning 'There is no death within the valley of the kings' is to be sung by both parties. The strings which have been used to form the string figures and which to this point have been hung round the necks of the initiates are to be removed, broken, and thrown to the earth surrounding the trench.

All the signs found in the branches are now to be carried to the

southern point of the trench, through it, and out of the L-shaped projection. It does not matter which way the male and female are intermixed at this time but as they enter the tunnel, the three eldest men and the three eldest women of each clan shall hand the symbol of that family to their closest relative. For example, they may receive a wooden model of a tortoise, or another, a wooden model of a snake. That whole act should be performed with the utmost ecstasy, particularly while leaving the L-shaped projection that now represents the mouth of a snake. At this point, the children of the tribe who are able to carry out such tasks are to bring in two hundred knives with red handles, sixty-seven brown kettles, eighteen sewing machines, and the heads of three missionaries and those of Taylor, Frazer, Spencer, and Gillen, and Elkin and throw them to the ground at the south end of the trench. The sand is to be piled over these objects and a drawing of a rose surrounded by a chameleon inscribed upon the surface.

At this point shall be sung the song beginning: 'When you two came from that island where the string is covered in parakeet feathers, did you observe the morning star correctly?' The youths and maidens who have been standing at the mouth of the serpent shall now regather the broken strings from the respective sides of the trench and, swinging themselves, approach one another, one party slapping that other party with their respective strings until they have paired themselves off, male and female. Each of these pairs shall now throw their strings on the ground, and, lying down, copulate. The six elders mentioned before, three men and three women, who had handed out the symbols representing the clans, shall now examine the positions of the youths and maidens and determine if their sexual embrace would have been improved on by Queen Victoria. If this is found to be the case, the ones who have been observed as being."

And it goes on for a large number of pages but is an initiation of Australian ritual. It really gets complex. All this stuff takes place

on an island that is shaped like a toroid—like a doughnut—a sphere with a hole through it, and this island continuously changes itself from a sphere to a toroid. Like, we're in the spherical form of it now. And it outlines in this particular manuscript the great dolors that I have experienced while going from incarnation to incarnation. I mean, at one point I'm blown up in a powder mill, another time burned to death in an insane asylum.

Do you have any specific questions about films? I can't hold out much longer.

ARTHUR: What form is your latest film taking? Is it hand painted, or animated?

HARRY: No, it's actual photographs.

ARTHUR: Are you using superimposition?

HARRY: No. I may, but I've been working on it for a very long time. [Bird flies over.] I had a real Aboriginal bird at one point—the real budgerigar with green feathers. Green and yellow. It died. It was named Abo. This one's just called Aussie!

ARTHUR: When you're filming now, do you do it all here, or do you go out?

HARRY: Well, I haven't gone out for several days.

ARTHUR: So you're filming in this room?

HARRY: No, the film is all completed. It's all done. What I have to do at this point is edit the film according to certain epistemological principles. And that is a hard thing to do. These are the only statements I am able to make about my work [improvises]:

> I've tried to labor every day and never yet to shirk
> But from these people from Down Under,
> I don't know what they are,
> But maybe they are the Seventh One
> Within that group of star.

❧

O hurry back now, fated ones
Who labor at the breast
Where platypuses lie on banks
And kangaroos at rest.
Let their young children seek the dawn
And ever else wise meet
The thing that is not part of me
But only is a treat,
Devised for mankind's incestuous breast.
Leave now the earth and seek thy rest.

All of the statements made on this recording are arbitrary and should be corrected by some authority. I would suggest that the authority is somewhere in western Australia. And grows corn.

And that is all I'm able to say regarding these subjects.

References

INTRODUCTION.
HEAVEN AND EARTH MAGIC
Peter Valente

1. Charles Baudelaire, *Les Fleurs du Mal*, trans. Richard Howard (Boston: David R. Godine Publishers, 1982), 15.

1. MYSTIC TRAVELER
Raymond Foye

1. Richard Ellmann, *The Man and the Masks* (New York: W.W. Norton & Company, 1948), 55.

4. HARRY SMITH:
THE ALCHEMY OF CAPRICE
Scott Feero

1. Dawn-Michelle Baude, "Interview with Harry Smith," in *Think of the Self Speaking*, ed. Rani Singh (Seattle, WA: Elbow/Cityful Press, 1998), 112–24.
2. Baude, "Interview with Harry Smith," 112–24.
3. H. P. Blavatsky, *The Secret Doctrine: Volume II* (CA: Theosophical University Press), 421.

5. INTENTION, VISION, AND ACTION
Paola Igliori

1. Paola Igliori, "Harry Smith, American Magus," uploaded by user Mike Fiorito, 2020, YouTube, 1:32:03.
2. "Charles Baudelaire's Fleurs du mal / Flowers of Evil: Correspondances," FleursDuMal website, accessed 2023.

6. THE FIRST SURREALIST IN NEW YORK CITY
Srijita Banerjee

1. John Szwed, *Cosmic Scholar: The Life and Times of Harry Smith* (New York: Farrar, Straus and Giroux, 2023), 67.

7. HARRY SMITH ON THE HOLY CITY
Darrin Daniel

1. George Casey, "Indian Life and Radio Building Are Interests of Two B.H.S. Boys," *Bellingham High Beacon*, December 5, 1942.
2. Paola Igliori, ed., *Harry Smith: American Magus* (Los Angeles, CA: Semiotext(e), 2022), 274.
3. Darrin Daniel, *Methane Cocktail* (Colorado: Self-Published, 1990), 35.

9. THE WOMEN IN HARRY SMITH'S EARLY WORLD
Bret Lunsford

1. Bret Lunsford, *Sounding for Harry Smith: Early Pacific Northwest Influences* (Washington: Know-Yr-Own Publishing, 2021), 113.
2. Lunsford, *Sounding*, 40.
3. Lunsford, *Sounding*, 68.
4. Lunsford, *Sounding*, 28.
5. Farmer Dirks, "Artist Louise Williams Achieving Fame at 72," *American Bulletin*, 4 April, 1955.
6. Lunsford, *Sounding*, 157.
7. "Locals," *Anacortes American* 44, no. 14 (10 August 1933).

8. Lunsford, *Sounding*, 162.
9. Lunsford, *Sounding*, 207.

10. HARRY SMITH'S ALCHEMY AND MAGIC
Charles Stein

1. The quote is: "Belief is a cramp, a paralysis, an atrophy of the mind in certain positions" (from Ezra Pound, *Selected Prose 1909–1965*, ed. William Cookson [New York: New Directions, 1975], 49).
2. Gerrit Lansing, *Heavenly Tree, Northern Earth* (Berkeley, CA: North Atlantic Books, 2009), 262.

11. HARRY SMITH: COSMIC COLLAGE
Maggie Corrigan

1. Kevin M. Moist, "Collecting, Collage, and Alchemy: The Harry Smith Anthology of American Folk Music as Art and Cultural Intervention," *American Studies* 48, no. 4 (2007): 117.
2. Moist, "Collecting, Collage, and Alchemy," 117.
3. John Szwed, *Cosmic Scholar: The Life and Times of Harry Smith* (New York: Farrar, Straus and Giroux, 2023), 95.
4. Stephen Fredman, "Forms of Visionary Collage: Harry Smith and the Poets," in *Harry Smith: The Avant Garde in the American Vernacular*, ed. Andrew Perchuck and Rani Singh (Los Angeles, CA: Getty Research Institute, 2010), 226.
5. David Chapman, "Chance Encounters: Serendipity and the Use of Music in the Films of Jean Cocteau and Harry Everett Smith," *Soundtrack* no. 21 (2009): 13.

12. THE TREE WITH ROOTS
Mike McGonigal

1. Greil Marcus, "A Booklet of Essays, Appreciations, and Annotations Pertaining to the Anthology of American Folk Music," in *Anthology of American Folk Music*, ed. Harry Smith, Smithsonian Folkways Recordings, 1997, 6 compact discs, 25.
2. Harry Smith, Foreword to "American Folk Music" by Harry Smith, in

Anthology of American Folk Music, ed. Harry Smith, Smithsonian Folkways Recordings, 1997, 6 compact discs.
3. John Cohen, "A Rare Interview with Harry Smith," in *Harry Smith: American Magus*, ed. Paola Igliori (Los Angeles, CA: Semiotext(e), 2022), 277.
4. Cohen, "A Rare Interview with Harry Smith," 281.
5. Cohen, "A Rare Interview with Harry Smith," 281.
6. Smith, Foreword to "American Folk Music."
7. Jeff Place, "A Booklet of Essays, Appreciations, and Annotations Pertaining to the Anthology of American Folk Music," in *Anthology of American Folk Music*, ed. Harry Smith, Smithsonian Folkways Recordings, 1997, 6 compact discs, 59.

15. AUTOMATIC SYNCHRONIZATION
David Chapman

1. Fred Camper, "Sound and Silence in Harry Smith," forum discussion post (Western Connecticut State University) web page, 1999; accessed June 17, 2008. Site no longer accessible.
2. Camper, "Sound and Silence in Harry Smith."
3. Paola Igliori, ed., *American Magus Harry Smith: A Modern Alchemist* (New York: Inanout Press, 1996), 103.
4. Mary Hill, "Harry Smith Interviewed," *Film Culture* no. 37 (1972): 1–7.
5. P. Adams Sitney, ed., *Visionary Film: the American Avant-Garde* (Oxford: Oxford University Press, 1979), 242.
6. William Moritz, "Harry Smith, Mythologist," Center for Visual Music website, 2001, accessed September 12, 2023.
7. Igliori, *American Magus*, 108.
8. Scott MacDonald, *Art in Cinema: Documents Towards a History of the Film Society* (Philadelphia: Temple University Press, 2006), 227.
9. MacDonald, *Art in Cinema*, 215.
10. MacDonald, *Art in Cinema*, 237.
11. Rani Singh, "Harry Smith," *Film Culture* no. 37 (1972): 13–19.
12. Igliori, *American Magus*, 26.
13. Jean Cocteau, *Beauty and the Beast: Diary of a Film* (New York: Dover, 1972), 129.
14. Michel Chion, *Audio-Vision: Sound on Screen* (New York: Columbia University Press, 1994), 189.

15. Chion, *Audio-Vision*, 137.
16. Chion, *Audio-Vision*, 136.
17. J. James Gibson, *The Senses Considered as Perceptual Systems* (Boston: Houghton Mifflin, 1966), 271.
18. Moritz, "Harry Smith, Mythologist."
19. Igliori, *American Magus*, 107.
20. Paul Virilio, *Unknown Quantity* (New York: Thames & Hudson, 2003), 24.

16. BACKSTAGE OF A GLYPH
Rose Marcus

1. Paul Arthur, "The Onus of Representation: Harry Smith, Mahagonny, and the Avant-Garde Film in the 1970s," in *Harry Smith: The Avant-Garde in the American Vernacular*, ed. Andrew Perchuk and Rani Singh (Los Angeles: Getty Research Institute, 2010), 141; Sherill Tippins, *Inside the Dream Palace: The Life and Times of New York's Legendary Chelsea Hotel* (Boston: Mariner Books, 2014), 296–97.
2. Author's unpublished interview with Khem Caigan, July 21, 2017.
3. Analysis of Getty Research Institute collection; author's email exchange with Rani Singh, October 21, 2020.
4. Harry Smith's Planning Notes, Photocopies, N.D., Series V.I.B, box 14–16, Getty Research Institute.
5. Harry Smith's Planning Notes, Photocopies, N.D., Series V.I.B, box 14–16, Getty Research Institute.
6. Arthur, "The Onus of Representation," 141.
7. "Smith, Harry," *Film-Maker's Cooperative Catalogue No. 3* (1965), 57.
8. P. Adam Sitney, *Visionary Film: The American Avant-garde, 1943–2000* (Oxford: Oxford University Press, 1979), 261.

17. VISIONARY CHARLATAN
Ed Hamilton

1. Walt Whitman, "Crossing Brooklyn Ferry," in *The Poetry of Walt Whitman* (London: Arcturus Publishing, 2018), 92.
2. Lisa Jo Rudy, "What Is Theosophy? Definitions, Origins, and Beliefs: The Writings and Teaching of Madame Blavatsky," Learn Religions website.
3. Rudy, "What Is Theosophy?"

4. John Cohen, "A Rare Interview with Harry Smith, Part Two," *Sing Out!* 19, no. 2 (June/July, 1969). Reprinted in Paola Igliori, ed., *American Magus Harry Smith: A Modern Alchemist* (New York: Inanout Press, 1996), 139.
5. John Szwed, *Cosmic Scholar: The Life and Times of Harry Smith* (New York, Farrar, Strauss and Giroux, 2023), 29, 37.
6. R. Bruce Elder, "Harry Smith: Collecting Thought Forms and Programming the Aerial Computer," in *Harry Smith's Anthology of American Folk Music: America Changed Through Music*, ed. Ross Hair and Thomas Ruys Smith (London and New York: Routledge, 2017), 103.
7. Annie Besant and Charles Leadbeater, *Thought Forms* (Aydar, India: Theosophical Publishing House, 1901), 104.
8. Sarah Bakewell, *At the Existentialist Café: Freedom, Being, and Existentialist Cocktails* (New York: Other Press, 2016), 231–32.

21. HARRY SMITH'S UNIVERSAL (DIGITAL) STRING FIGURE
Henry Adam Svec

1. John Cohen and Terry Winters, "String Figures: A Conversation with John Cohen and Terry Winters," in *String Figures: The Collections of Harry Smith*, eds. John Klacsmann and Andrew Lampert (New York City: J & L Books and Anthology Film Archives, 2015), 42.
2. Katherine Skinner, "'Must Be Born Again': Resurrecting the Anthology of American Folk Music," *Popular Music* 25, no. 1 (2006): 57–75.
3. Justin Parks, "Harry Smith, the Anthology, and the Artist as Collector," in *Harry Smith's Anthology of American Folk Music: America Changed Through Music*, eds. Ross Hair and Thomas Ruys Smith (New York City: Routledge, 2018), 65–81.
4. Rani Singh, "Harry Smith, an Ethnographic Modernist in America," in *Harry Smith: The Avant-Garde in the American Vernacular*, eds. Andrew Perchuck and Rani Singh (Los Angeles, CA: Getty Research Institute, 2010), 15–62.
5. John Klacsmann and Andrew Lampert, "Introduction," in *String Figures: The Collections of Harry Smith*, eds. John Klacsmann and Andrew Lampert (New York City: J & L Books and Anthology Film Archives, 2015), 15–30.
6. Harry Smith, "Indices + Notes on," in *String Figure Studies*, Harry Smith Papers, Getty Research Institute, box 6, folder 1.

7. Harry Smith, "List of Figures," undated, in *String Figure Studies*, Harry Smith Papers, Getty Research Institute, box 6, folder 4.
8. Harry Smith quoted in P. Adams Sitney, "Film Culture No. 37, 1965," in *Thinking of the Self Speaking: Harry Smith—Selected Interviews*, ed. Rani Singh (Seattle, WA: Elbow/Cityful Press, 1998), 47.
9. Bruce Elder, "Harry Smith: Collecting Thought-Forms and Programming the Aerial Computer," in *Harry Smith's Anthology of American Folk Music: America Changed Through Music*, eds. Ross Hair and Thomas Ruys Smith (New York City: Routledge, 2018), 100–122.
10. Harry Smith quoted in John Cohen, "Sing Out!, Volume 19, No. 1, 1969," in *Thinking of the Self Speaking: Harry Smith—Selected Interviews* (Seattle, WA: Elbow/Cityfull Press, 1998), 81–82.
11. Anne Friedberg, *The Virtual Window: From Alberti to Microsoft* (Cambridge, MA: MIT Press), 2006, 213.
12. Paul Arthur, "The Onus of Representation: Harry Smith, Mahagonny, and Avant-Garde Film in the 1970s," in *Harry Smith: The Avant-Garde in the American Vernacular*, eds. Andrew Perchuck and Rani Singh (Los Angeles, CA: Getty Research Institute, 2010), 147–49.
13. Harry Smith, "Project Description," in *Mahagonny*, Harry Smith Papers, Getty Research Institute, box 15, folder 3.
14. John Cohen, "Sing Out!," 81–82.

23. LIKE A TALISMAN FOR THE GUARDIAN ANGEL
Peter Valente

1. Paola Igliori, ed., *Harry Smith: American Magus* (Los Angeles, CA: Semiotext(e), 2022), 17.
2. Igliori, *Harry Smith*, 93.

27. CORRELATING IRRATIONALITIES IN THE MOVING MATHS OF HARRY SMITH
Robert Podgurski

1. Gerhsom Scholem, *Kabbalah* (Dorchester, England: Dorset Press, 1987).
2. Aleister Crowley, "The Psychology of Hashish," in *The Equinox* 1, no. 2 (New York: Samuel Weiser, 1972): 51.

3. Aleister Crowley, *Konx Om Pax* (Des Plaines, IL : Yogi Publication Society, 1982), viii.
4. Harry Smith, *String Figures: The Collections of Harry Smith Catalogue Raissone*, vol. 2., ed. John Kalcsmann and Andrew Lampert (Atlanta, GA: J&L Books, 2015), 29.
5. Aleister Crowley, *777 and Other Qabalistic Writings of Aleister Crowley*, ed. Israel Regardie (New York: Samuel Weiser, 1973), 20.
6. Algis Uzdavinys, *Sufism & Ancient Wisdom* (Cambridge, England: Archetype Books, 2020), 115.
7. Crowley, *777*, 25.
8. Gareth Knight, *A Practical Guide To Qabalistic Symbolism* (New York: Samuel Weiser, 1978), 165–66.
9. David Godwin, *Godwin's Cabalistic Encyclopedia* (Woodbury, MN: Llewellyn Publications, 1979), 100.
10. Gerrit Lansing, *Heavenly Tree, Northern Earth* (Berkeley, CA: North Atlantic Books, 2009), 221.

28. ESSAYS ON HARRY SMITH'S LETTER TO ARTHUR M. YOUNG (AUGUST 30, 1960)

ARTHUR YOUNG AND HARRY SMITH: AN ODD ENCOUNTER
Kathy Goss

1. Arthur Young, *Nested Time* (Cambria, CA: Anodos Foundation, 2004), 121–22.
2. Young, *Nested Time*, 180.
3. Arthur Young, *The Reflexive Universe* (Cambria, CA: Anodos Foundation, 2021), 255.

Index

Page numbers in *italics* refer to illustrations.

7 (numeral), 264–65, 276–79
72:13, 116–17, 160
96 Apparitions of 96 Alchemical Formulae, 261–71
 symbolism in, 266–67
 text of, 272–75

Aboriginal culture, 319–22, 325–26
Aboriginal presentation (by anthropologist), 238–39
Abulafia, Abraham, 262
abyss, 224
Agrippa, Heinrich Cornelius, 288–89
Ain Soph, 230, 233
alchemist, Harry Smith as, 1–5, 49, 104–5, 212–13, 309
alchemy, 90–91, 223
 alchemical texts, 88–89
 chief concern of, 91–92
 and sound, 318–19
 visionary alchemist, 263
American Magus (Igliori), book party for, 252
"Amulets," 55–56

Anger, Mark, 250–51
animator, HS as, 21
Anthology Film Archives, 135
Anthology of American Folk Music, 25, 104, 137, 209–10
 beginnings of, 126
 changed the music scene, 2–3
 as collection of commercial recordings, 130
 connections in, 191–92
 impact of, 110, 123–29, 156–57
 1997 conference on, 126–27
 as story of civilization, 224
 summarized, 220–21
 why it is a big deal, 108–12
 why it's not segregated, 125
anthropologist, HS as, 33, 186, 320
apparitions, 266
Apple, Heart, Daisy, 25–27
archetypes, 311
arc model (Young), 278–79
art, came first for HS, 225
art, transformative power of, HS's belief in, 213

Arthur, Paul, 215
Art in Cinema program of HS films, 162–63
art works of HS. *See also* paintings by HS
for D. Daniel book, 55–56
Asch, Moe, 127, 210
Ashkenazi, R. Joseph, 232
astrology, Arthur Young and, 278
Australia, 321, 325–27
automatic drawings, 165
automatic-synchronization, 156–72, 160–62
defined, 157–58
in HS films, 105
and Naropa classes, 164–65
ayin, 225

Babylonian culture, 308
Baez, Joan, 127–28
Banerjee, Srijita, biography, 52
Banger, Tom
biography, 155
at Naropa with HS, 137–55
Baraka, Amiri, 125
"Barbara Allen," singing a verse for HS, 135–36
Bard, Stanley, 9, 13
Baude, Dawn-Michelle, 81
biography, 311
Baudelaire, Charles, 45
Bauer, Rudolph, 302
beard metaphor, 184–85, 187
Beatles, 158–60, 221
and HS films, 117, 200
beekeeping, 58–59, 61–62
belief, 87

Belson, Jordan, 47
Berger, Marc, *Plate 2*, 35
Berndt, Catherine, 320
Berndt, Ronald, 320
Besant, Annie, 40, 302
Betzalel, Pesach
biography, 245–46
as HS's bodyguard, 238–39
meets HS, 234
Bialey, Harvey, 44, 101
Biderman, Peggy, 9–10, 13–14, *Plate 17*, *Plate 18*
bird calls, HS identification of, 72
blackening process, 91
black magic, 38
Blaisdell, Henrietta, 76–78, 80
Blake, Elinor, 27, 30
Blavatsky, Helena P., 41–43, 185, 302
Boas, Franz, 3, 33
Böhme, Jakob, 43
book collection of HS, 8, 61–62, 143–45, 148–49
booksellers, HS and, 148–49
bookshelves, 143
Borrus, Beth
biography, 202
meets HS, 196–97
Boulder, HS in, 140. *See also* Naropa, HS at
Brady, Mark, 257
"Brain Drawings" (HS), 165
Brakhage, Stan, *Plate 4*, 62–63, 169, 196–97
Breeze, William, 18, 137–38
Breslin Hotel, HS in the, 13–14, 132, 206
Breton, André, 47, 50

Brooks, Alan, *Plate 10*
Bruno, Giordano, 43
Buddhist iconography, HS and, 68–69
budgerigar, 319, 334
Burke Museum, 53
Burroughs, William S., 144, 165
Butthole Surfers, 152

Cage, John, 134, 166
Caigan, Khem, 45–46
　biography, 233
calligraphy, by HS, 122
Camper, Fred, 168
Cantwell, Robert, 111
cardboard, HS's love of, 240–41
card collection, of HS, 149–50
card tables, 11
Carr, Lucien, 237–39
Carroll, Lewis, 10–11
Carter, Ed, 308
Catholic ceremonies, 301–2
cat's cradles, vs. string figures, 217–19
cats of HS, 142
Celtic tradition, HS and the, 20
Chapman, David, biography, 172
charlatan, HS as? 194
Chelsea Hotel, 9–10
　criminality in the, 14
Chelsea Hotel, Harry Smith at, 183
　HS leaves the Chelsea Hotel, 13
　Raymond Foye meets Harry, 6–7
Chemical Wedding, The (Andrea), 263
Cheney, Liza B., 318
Cherry, Dave, 252
children's game, 331–34
children's literature, HS and, 10–11, 144

Chion, Michel, 166–67
choice, 269–70
Chomsky, Noam, 193
"Choose Your Own Adventure" books, 144
circumambulation of topics, 94
Clemente, Francesco, 19–20
Cleopatra's pee, 39
clothing/appearance of Harry Smith, 7, 59–60, 139, 150, 197
Cocteau, Jean, 165–66
Cohen, Joel, 110
Cohen, John, 209
Cohen, Leonard, 10
collagist, HS as, 103–7
collecting things, 123
collector, HS as, 47, 101, 107
　record collecting, 110
colors, 306–7
　correspondence with letters, 2
Compo, Charles, 14
connections and HS, 44
Conrad, Tony, 169
correspondences, 104
　and magic, 1
"Correspondences" (Baudelaire), 1
Corrigan, Maggie, biography, 107
Corso, Gregory, *Plate 6*, 10, 16, 28
coughing, 316
Crowley, Aleister, 18, 37, 97, 208, 261–71, 323
　HS and, 267–69
　on symbols, 266
crown, used by HS in opera, 120
culture, HS's contribution to, 146
cut-up method, 105–7, 144, 165

Daniel, Darrin, biography, 57
data accessed by HS, 67
Dawkins, Richard, 193
death of Harry Smith, 133
 recognition since the, 53
Dee, John, 37–38, 100, 221
DeLanda, Manuel, 29
delineator, HS as, 21
demonology, HS on, 18
Descartes, René, 86
Desolation Row, 33–34, 35
development, 94
diet of HS, 65–66, 114, 132, 140, 207
 grocery list, *207*
digital media, 98
DJ Free Simon, 257
DJ Spooky, 171, 222–23, 252
doctrine of sympathies, 1
Dreamtime, 320, 322
Duchamp, Marcel, 175, 214
Dylan, Bob, 8, 127–28

Early Abstractions (film), 115–17, 190–91, 196, 200, 221–23
 and Beatles soundtrack, 158–60
 colors in, 303, 306
 and Kandinsky, 137
 M. Henry Jones studies, 248
 music in, 303–4
 showing at the Hellfire Club, 249
 and working directly on film itself, 323
ecological theories of perception, 167–68
Edison, Thomas, 306
eggs. *See* Ukrainian Easter eggs

Egyptian culture, 307–8
Egyptian symbols, 307–8
Elder, R. B., 187, 213
Elkin, A. P., 321
Ellmann, Richard, 20
Elohim, 269
Enochian magic, 147
Enochian tablets, 37
Ensure, 65
entanglement, 214–15
Ernst, Max, 50

Faithfull, Marianne, *Plate 7*, 119–20
 Seven Deadly Sins production, 199–202
Feero, Scott, 14
 biography, 43
Feliu-Petter, Rosebud, 159, 168
fiddle from Nepal, 56
filmmaker, HS as, 190–91
Films 1, 2, 3, and *5*, 162–63
Film No. 2, 161–62
Film No. 5, 171
Film No. 10, 159
Film No. 11, 168
Film No. 13: Oz, 222, 244–45
Film No. 14: Late Superimpositions, 214, 236–37, 245
films of HS. *See also Harry Smith: A Re-Creation* (installation), *and individual films*
 beginnings of, 322–23
 and the betterment of humanity, 331
 and biological rhythms, 179
 glyphs and, 181–82
 hand-painted, 162–63

his poem about, 327–30
influence on his writing, 266
and intoxicants, 170
mini-festival at Naropa, 115–17
music and image in the, 156–72
"My movies are made by God," 220
painted films, 105–6
in a sense, never completed, 12
and sleep deprivation, 170
viewed by Peter Valente, 222–23
Fischinger, Oscar, 171
Five, Tom, 253
Florida Everglades, 34
Fludd, Robert, 104, 164, 221, 229, 297
folklorist, HS as, 119
folk music
defined, 152
as patriotic, 128
forms (universal), 188
four-level evolutionary process, 278–79
Four Worlds, the, 230
Foye, Raymond, 194
biography, 22
Frank, Robert, *Plate 11*, 29, 206
frankincense, 197–98
Fredman, Stephen, 106
Freeman, Debbie, 225
Freudian constructs, 193
Fugs, The, 159, 221

Garcia, Jerry, 119
Geldzahler, Henry, 18
generosity, of HS, 225
geomancy, HS and, 17
Gibson, James, 167–68

Gillespie, Dizzy, 160–61, 221, 323
Ginsberg, Allen, *Plate 10*, 14, 16–17, *Plate 21*, 54, 56, 58, 140, 197, 200
apartment of, 114
on how HS served changing consciousness of America, 111
Howl, 229
HS at Ginsberg's apartment, 132
HS's time with, 206–8
letter from, 72–73
meets HS, 113–14
postcard from, 322
Glass, Philip, 171
Globus, Ronnie, 23–24, 28
Gluey Louie, 33–34
glyphs, and film frames, 181–82
"God makes no mistakes," 245
Goss, Kathy, biography, 280
Grammy Award for Harry Smith, 2, 111, 136, 154
Grateful Dead grant to HS, 54, 66, 119
gruel, 140

Hamilton, Ed, biography, 195
Hammond, Esther, 78
Harris, Suzanne, 247
Harry. *See* Smith, Harry
Harry Smith: A Re-Creation (installation), 32
history of, 247–60
itinerary, 258–60
"Harry Smith Lecture in Strange Anthropology," 118
"Harry's Song"—poem (Patricia Pruitt), vi
haute magie, 92

health crises of HS, 29–30, 133
Heaven and Earth Magic (HS film), 50–52, 96–99, 115–17, 165, 169, 196–97, 221–23, 248, 250–51, 307–11, 323
 creation of, 308–9
 cut-up method in, 106–7
 and Ernst, 137
 finding of lost slides, 249–50
 how it was made, 242–44
 as scary, 240
Heidegger, Martin, 194
Heinrich, Bernd, 61–62
helicopter, 277–78
Hermeticism, 90
hidden hand, 165, 166
historicity sense of HS, 9
Holm, Bill, 83
Holtmeir, Mathew, 107
Household Affairs (film), 207
Howard, Luella Hurd, 78–81
Hulsey, Patrick, 15
human being, HS teaches how to be a complete, 245
Huncke, Herbert, 34

Igliori, Paola, 252
 biography, 46
indeterminacy, 166
Indigenous Art, HS and, 34, 83
Indigenous cultures, HS and, 103–4, 117, 129, 132, 146–47, 161, 192, 314–15, 325–26
 early interest in, 48, 53
 early studies of, 75–76
influence of HS, 44, 54, 169–72, 201, 240

integration of the higher self, and HS's work, 225
intensification, 94
interlocking, 179–80
Interruptor device, 251–52
interviews with HS, 301–35
 with Arthur Cantrill, 319–35
 in conversation at Naropa cottage, 312–19
 with Dawn-Michelle Baude, 301–11
inventing the derailment, 171–72
Isaacs, Robert, 184

Jacobs, Jane, 76–77
jazz, 125–26, 160–62, 187, 189, 191
jazz paintings, 160, 189–90, 221
Jehovah, 324
Jones, Charles Stansfeld, 37n[*], 267–68
Jones, M. Henry, *Plate 20*
 biography, 31–32
 HS stays with, 23–32
 meets HS, 248
Jung, C. G., 311

Kabbalah, 223–25, 281–99, 305
 defined, 227–29
 flexibility of, 261–62
 not a static pursuit, 268–69
 primary groupings in, 229–31
 and the Tree of Life, 227–31
Kandinsky, Wassily, 189–90, 302–3, 311
Keynes, Geoffrey, 311
Kiensherf, Barbara, 171
Kiowa Peyote Meeting, recorded by HS, 14, 129, 137, 157n[*]

350 Index

Kircher, Athanasius, 232
Klee, Paul, 50
Knight, Gareth, 269
Korzybski, Alfred, 146

language, cultural importance of, 146
Lansing, Gerrit, 88, 93, 270
Late Superimpositions, 310
Leadbeater, C. W., 302
legacy of HS, 44, 54, 169–72, 201, 240
LeMar, 100
Leroy, Felix Morrisau, 207–8
Levi-Strauss, Claude, 19
Lévi, Éliphas, 92, 229
library, public, Luella Howard and the Anacortes, 79
light shows, and HS, 126
Lummi Indian culture, 314–15
 Harry's recordings of, 6, 186
 HS and, 48, 103–4
Lunsford, Bret, 54
 biography, 84
Luvera, Phyllis, 83
Lye, Len, 168

magic
 ceremonial, 97–99
 defined, 85–86
 in HS works, 100–101
 imagery and theology of, 89
 magical initiation, 89
 magician's work as subversive, 93
 meaning of, 37
magician, HS as, 3, 17–18, 36–37, 46, 86, 92–93, 100–101, 194, 267–69
 HS discusses natural magic, 38

Magickal Childe, HS at the, 36–39
magus
 defined, 85–86
 HS as, 85
Mahagonny (Number 18: Mahagonny), 11–13, 214, 222, 245
 completion of, 18–19
 contrapuntal images in, 175
 interlocking in, 179–80
 language of, 173–74
 organizational charts for, 11–12
 palindrome for sequence, 174–75, 180
 patterns in, 179
 premiere of, 19
 soundtrack of the opera, 174
 structure of, 173–82
 title card, 175–76
 and universality, 4
mandala patterns, in HS works, 49
Mapplethorpe, Robert, 178
Marcus, Rose, biography, 182
Marsan, Tom, 25, 27
matter, 96
Mayer, May Benzenberg, 278
McGonigal, Mike, biography, 112
McLaren, Norman, 168
Meany, Edmond, 79–80
Mekas, Jonas, 163, 165
Melville Island, 324–25
memes, 193
memory, 58
memory, magickal, 232
Mickey Mouse card deck, 150
Milgram, Heather, 237
Miller, Henry, 302

Mingus, Charles, 201
Mirror Animations (film), 45
Misterioso (film), 45
Monk, Thelonious, 45, 161, 221
Moritz, William, 161
moths, 63–65
Mountford, C. P., 325
movie-going, by HS, 16
moving maths, 263
"Mr. Ubebwe" string series, 219
Müller, F. Max, 41
multimedia experiences, 170. *See also* films of HS
multiphonics, 4
music
 as central part of HS life and work, 156
 and image in HS films, 156–72
music collection by HS, early, 126
mystic numbers, 269

Nabisco logo, 235
Naropa, HS at, 58–73. *See also* Naropa lectures of HS
 his arrival at Naropa, 113–15
 his role at Naropa, 119
Naropa lectures of HS, 87–88, 87n*, 92, 101
 screening of *Heaven and Earth Magic* in, 96–99
 syllabus for final, 153–54
 topics of, 93–94
nature, as teacher, 13
Nederland bar bluegrass, recordings by HS, 67–68
Neoplatonists, 96
Nepal, 55

New Lost City Ramblers, 128
Newton, Isaac, 310
Normal Love (Smith), 15
Nubian casting, 307–8
number mysticism, 90–91

occultism. *See also* alchemy; magic; Theosophy
 HS background in Theosophy, 40–43, 81, 185
 popular, 87
Olcott, Henry, 41
One Bubble, 76–78
optical solo, 163, 167
oral traditions, in music, 125
ordered anarchy, 321
Orensanz, Angel, 257
Orlovsky, Julius, *Plate 10*, 207
OTO (Ordo Templi Orientis), HS as bishop in, 18, 109, 137, 221, 267, 312
Outer Limits, The, all-energy alien episode, 189

Pacheco, Rob
 biography, 73
 meets HS, 59
paintings by Harry Smith, 50, 109, 129, 160
 jazz paintings, 160, 189–90, 221
 non-realistic, 303
Pan-African Congress of 1919, 154
paper airplanes, HS and, 69–70, 123
parents of HS, 313–14
 as Theosophists, 40–43, 81, 146, 185, 301
Parker, Charlie, 4, 221, 319

Parker, Robert, 253
Patterson, Clayton, *Plate 13*
peanut butter, 312
Peer, Ralph, 124–25
Peterson, David, 234
Phillips, John, 241
philosopher's stone, 91
photographs of Harry Smith
 1990, *Plate 30*
 with Allen Ginsberg, *Plate 21*
 with Allen Ginsberg, Julius Orlovsky, and Alan Brooks, *Plate 10*
 in Allen Ginsberg's apartment, *Plate 22*
 with Anne Waldman, *Plate 8*
 at the Breslin Hotel, *Plate 31*
 with dice, *Plate 14*, *Plate 15*
 Easter, 1992, *Plate 29*
 with Ed Sanders and Jerome Rothenberg, *Plate 19*
 with Giorgio Della Terza, Marianne Faithfull, Hal Willner, *Plate 7*
 with Gregory Corso, *Plate 6*
 Harry Smith, *Plate 1*
 HS in *The Seven Deadly Sins*, *Plate 9*
 with Jack Smith, *Plate 24*, *Plate 25*, *Plate 26*
 lecture at Naropa, *Plate 5*
 with Linda Twigg and Clayton Patterson, *Plate 13*
 making a field recording, *Plate 23*
 and Marc Berger, *Plate 2*
 with M. Henry Jones, *Plate 20*
 at Naropa cottage, *Plate 27*, *Plate 28*
 with Peggy Biderman, *Plate 17*, *Plate 18*
 reading, *Plate 3*
 with Robert Frank, *Plate 11*
 with Stan Brakhage, *Plate 4*
 with string figure, *Plate 16*
 at summer writing program, *Plate 12*
photon, and pure freedom, 278
pinnipeds, 63–65
Plato, 188
Plotinus, 96
Podgurski, Robert, biography, 271
poems of HS, 272–74, 334–35
 poem about his films, 327–30
Point Loma, 313
polymath, HS as, 85
Polyphemus, 64
"pop-up book," 144
Pound, Ezra, 87
pre-Columbian culture, 145
Preston, Dick, 327
Primitivism, and HS, 48
prisca thologia, defined, 43n[*]
"proto-light-shows," 170
Pruitt, Patricia, vi, 105
psychedelic mushrooms, HS growing, 24
psychologism, and HS, 185–86
Puharich, Andrija, 204

qliphoth, 270
Qor Corporation, 234–35

rambling propensities of HS, 141
"random," notions of the, 170
reality, 106
record collection of HS, 7–8

recordings by HS, 3–4, *Plate 23*, 59, 130–31, 151–52, 316–18
 ambient recordings, 134, 198, 206–7
 at Naropa, 118–19
 Nederland bar bluegrass, 67–68
 recording equipment, 8–9
reference papers of HS, 66–67
renovating intelligence, and HS's work, 225
rhythm, HS understanding of, 162, 164
Rimbaud, Arthur, 2
Ritual ov Thee Three Liquids, 138
Rome shows, 254–55
Rooks, Conrad, 245
"Rosebud Falling and Rising on Roof" scene, 178
Rosen, Judi, 251–54, 256–57
Rosenthal, Bob, 113–14
 biography, 208
Rosicrucianism, 307
Rothenberg, Jerome, *Plate 19*
Rowan, Peter, HS and, 71–72
Ruth, Ariella, biography, 136

Salinger, Sue, 116
Salish culture, 314–15
Sanders, Ed, *Plate 19*, 83, 152
Sang d'un poète, Le, 166
Sanskrit, 311
Sante, Luc, 135
sarcasm, 90, 99
Schele, Linda, 145
scientific thinking, 38
scientist, HS as, 185–86
screen test, for Andy Warhol, 214
secrets of the unseen universe, unlocking the, 276–81

Seeger, Charles, 127
Seeger, Pete, 127–28
Sefer Yetzirah, 230–31
Sefirot, 233
Seminole clothing, 241
Seminole culture, 34–35
Seminole films (HS), 35
Seminole patches, 241
Sephiroth, 230
service to the universe, 226
Seven Deadly Sins production, *Plate 9*, 199–202
seven stages of evolutionary process, 278–79
sexuality of HS, ambiguous nature of, 11
shadow side, 270
shaman, Harry Smith as, 6, 140, 312
shaman's shack at Naropa, 60–62
Sharits, Paul, 169
Singh, Rani, 58–60, 115, 133, 135, 141–42, 168, 197, 199, 249
 on automatic-synchronization, 164–65
 as HS assistant, 65
Sitney, P. Adams, 212
sixteen (number), 323–24
Slater, Herman, 36
Slivka, Charlotte, 254
Smith, Harry. *See also* photographs of HS; *and topics under individual entries*
 as artist of extremes, 4
 biographical sketches, 2–4, 109–10, 203–5
 charm of, 60

could size up your weaknesses, 16
as cult figure, 21
early art studies of, 82
early household library of, 81
early life of, 74–75
as fun to go out with, 15, 121
high school biography of, 53–54
humor of, 17
interviews with, 301–35
invented identities of, 21
losses in his life, 95
mother of, 75–76
move back to NYC after Naropa, 54
moves to Allen Ginsberg's place, 114
not good at parties, 15
and search for truth, 2–3
as seeker of unity, 46
seemed to know everyone, 150–51
skepticism of, 17
Smith, Jack, 15, *Plate 24*, *Plate 25*, *Plate 26*
Smith, Mary (HS's mother), 75–76
Smithsonian and HS, 134–35
SnakeMonkey studio, 25
solids, HS geometric structures, 241
Sontag, Susan, 19
Sotheby catalog, and Newton, 310–11
sound, and alchemy, 318–19
Spare, Austin Osman, 266
Spencer, Baldwin, 325
Spiders, Scorpions, Centipedes, 70–71
spiderwebs, 215
Spoerri, Johanna, 254–56

Stauffacher, Frank, 163
Steenbeck editing machine, 248
Stein, Charles, biography, 102
"Stomp," 192
store windows, HS and, 235–36
string figures
 authentic creation of, 211
 and brain development, 218
 and cat's cradles, 217–19
 easily learned, 211
string figures, HS and, *Plate 16*, 35, 45–46, 210–16, 217–19
 HS manuscript on string figures, 210–16
 "Little Finger" description, 211–12
sunset, comment by HS, 13
Surrealism, 47–50, 165
 defined, 310
Surrealist, HS as, 47–52
Svec, Henry Adam, biography, 216
symbolism, 20–21
symbols, 266
syntax, 88
Szwed, John, 105
 biography, 204

Taoism, 304
tapestries, Buddhist, 68–69
tarot, 223–24
Taubin, Amy, 248
Taylor, Steven, 201
 biography, 136
 conversation about HS, 113–36
teeth, of HS, 114, 148
Teitler, Big Joe, 256–57
Ten Numbers, the, 230

Terza, Giorgio Della, *Plate 7*
Tesla, Nikola, 305–6
Tetragrammaton
 correlation with zodiac signs, 281–99
 defined, 281
Thee Temple ov Psychick Youth, 137–38
Theory of Process (Young), 278–80
Theosophy, 301–3, 313
 described, 185
 HS background in, 40–43, 81, 185
 HS parents as Theosophists, 81, 146, 185, 301
 and idealism, 188–89
 three Objects of, 41
third eye, 224
Thirty-Two Paths of Wisdom, 230
"This Land Is Your Land" parody, 152
thought forms
 defined, 187–88
 and HS, 189–95
Thought-Forms, 303
thralldom, and magic, 90
Tibet, 326–27
Tibetan painting, 304
Tin Woodsman's Dream (film), 222–23, 248, 253
Titon, Jeff, 131
torus, 276–77
trances, of HS, 322
transmutation, 91, 104–5
Tree of Life, 2, 270
 in HS works, 49
 and the Kabbalah, 227–31
Tree of Life (HS painting), 49

Tree of Life in the Four Worlds (HS), 227–33, *228*
 as map of divine consciousness, 232
Tremblay, Susan, 27
Trevor-Roper, Patrick, 145
tribal model, 6
Trungpa Rinpoche, Chogyam, 122
truth, Harry Smith's search for, 2–3
Tut, King, 307–8
Twenty-Two Letters, the, 231
Twigg, Linda, *Plate 13*
Tzabaoth, 269

Ukrainian Easter eggs, 149
universal grammar, 193
Ute Mountain Reservation, 146
Uzdavinys, Algis, 266

Valente, Peter, biography, 5
Van Ronk, Dave, 123–24
Virilio, Paul, 171–72
visionary, role of the, 266–67
visual impairments, 145
VJ, emergence of the, 171

Waldman, Anne, *Plate 8*, 313
Walewski, Count, 144–45, 305
Walsh, Sophie, 80–81
Warhol, Andy, HS's screen test for, 214
Wasserman, James, biography, 231
Weavers, 128
Wee Wisdom magazine, 302
Weill, Kurt, 7–8
Whitman, Walt, 183
Whittier, John Greenleaf, 316
Williams, Louise, 81–83

Willner, Hal, *Plate 7*, 201
Winters, Terry, 209
wit, of HS, 147
Wittgenstein, Ludwig, 194, 306
Wolfson, Elliot, biography, 300
women in HS's early world, 74–84

Yanacito, Don, 115
Yates, Frances, 38
Yeats, William Butler, 20
Young, Arthur M., 204, 317
 biography, 277–78
 and HS, 276–81
 HS letter to, 281–99, *300*
 and invention of helicopter, 277–78
"yoyo shaped like a hamburger" request, 202

Ziprin, Joanne, 234
Ziprin, Lionel, 234, 235
Ziprin, Zia, biography, 246
zodiac, 281
 correlation with Tetragrammaton, 281–99
Zohar, 229